MODERN PRINTMAKING

MODERN PRINTMAKING

A Guide to Traditional and Digital Techniques

Sylvie Covey

Vincent Longo, *To Admiral Meaulness*, 1959,
woodcut, 43 x 30 inches (109.2 x 76.2 cm).

WATSON-GUPTILL
Berkeley

CONTENTS

FOREWORD

Ira Goldberg
Executive Director,
Art Students League
of New York
September 2014

To be an instructor at the Art Students League of New York is to hold a position of distinction among artists. The League's faculty is an elite group of professional artists who are all recognized in their fields. Each instructor has a unique voice that puts a signature to his or her work and ultimately identifies its creator. The mastery and knowledge they convey to their students come from a lifetime of dedication and exploration of their chosen mediums. It is that dedication, as well as their ability to teach the techniques and means to understand the language of art, that inspires the thousands of students who study at the League each year and the literally hundreds of thousands who have trained here for nearly a century and a half.

Sylvie Covey exemplifies those qualities of professionalism, mastery, and dedication. An émigrée from Paris, where she studied at the prestigious École Nationale Supérieure des Arts Décoratifs, Ms. Covey came to the League to continue her studies, taking classes with master printmakers Michael Ponce de Leon and Seong Moy. She went on to study at Hunter College in New York, receiving an MFA in printmaking, drawing, and works on paper. Through this intensive study Ms. Covey became a master printmaker, not only mastering the traditional techniques of intaglio, lithography, and relief printmaking but also using that knowledge to establish her own voice within the contemporary oeuvre of digital printmaking and photo-etching as well as photolithography.

Ms. Covey has proved to be as notable an instructor as she is an artist. Every year as part of the League's annual student concourse, her class exhibitions reveal the highly polished professionalism of her students, who have availed themselves of their instructor's rich and in-depth knowledge of the entire medium. Students at the Fashion Institute of Technology and the Art Center of Northern New Jersey continue to benefit from Ms. Covey's expertise.

As Executive Director of the Art Students League, I am very proud to call Sylvie Covey a League instructor. Along with the other members of the League's faculty, she is helping to pave the way for today's generation of artists to explore the potential of a traditional medium in ways that will allow them to speak eloquently and poetically in the future. Ms. Covey herself is a luminous example of that potential realized.

Gregory Haley, *#13*, 2007, color mezzotint, 6 x 8 inches (15.2 x 20.3 cm).

ACKNOWLEDGMENTS

I wish to thank all the talented participating artists, without whom I would not have been able to write this book, in particular Vincent Longo, for whom I have the utmost respect, admiration, and fondness; Michael Pellettieri, for all his valuable support, help, and kindness over the years and particularly for his participation in the lithography and silkscreen sections of the book; Richard Pitts, for his talent, tremendous inspiration to numerous artists, and continuous creative enthusiasm for and support of many art endeavors, including my own projects; and Mike Lyon, for generously sharing his knowledge and expertise in Japanese block printing and new technologies in post-digital graphics, as well as for providing access to his ukiyo-e prints collection. I thank all my faithful students and esteemed colleagues for opening their hearts and sharing their creative thoughts and work and for their valuable contributions to this book overall.

Greatful thanks also to Watson-Guptill's Jenny Wapner, my editor Lisa Westmoreland, copyeditor James Waller, designer Kara Plikaitis, and publicist Natalie Mulford. I thoroughly enjoyed this process and learned a lot. Thank you all for your guidance and experience.

Sylvie Covey, *Space Tree #5*, 2015, digital print, 40 x 30 inches (101.6 x 76.2 cm).

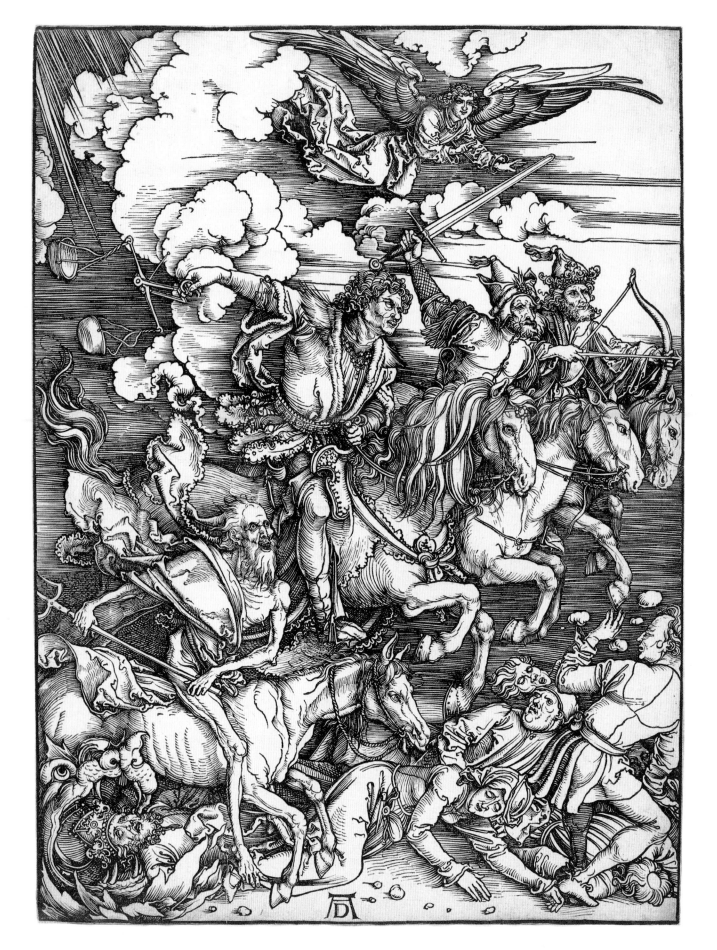

Introduction

William M. Ivins Jr., curator of prints at the Metropolitan Museum of Art in New York City from 1916 to 1946, had a strictly functional definition of printmaking. In *Prints and Visual Communication* (1953), he wrote,

> *The various ways of making prints (including photography) are the only methods by which exactly repeatable pictorial statements can be made about anything. . . . This exact repetition of pictorial statements has had incalculable effects upon knowledge and thought, upon science and technology, of every kind. It is hardly too much to say that since the invention of writing there has been no more important invention than of the exactly repeatable pictorial statement.*

Albrecht Dürer, *The Four Horsemen of the Apocalypse*, c. 1496–1498, woodcut, 15 ³⁄₈ x 11 inches (39 x 28 cm). Staatliche Kunsthalle, Karlsruhe, Germany.

The beginnings of printmaking go all the way back to 3500 BC, when the civilizations of Mesopotamia started using carved cylinder seals. Rolled on wet clay tablets, these little stone seals produced raised designs that acted as signatures—each an "exactly repeatable pictorial statement," to use William Ivins's phrase. Over the following centuries, many cultures used carved reliefs to print on fabrics and ceramics, but the practice of printing on paper had to wait until paper's invention, which happened in China, probably sometime between 140 BC and the early first millennium AD. From China, papermaking spread to Tibet, Korea, and Japan, and then into Central Asia, the Middle East, and North Africa, reaching southern Europe (Spain and Italy) in the twelfth century. It was not until the invention of the printing press in the mid-fifteenth century, however, that paper supplanted parchment and vellum, which had long been used in Europe for hand-written religious texts and official documents.

Unlike paintings or sculptures, prints were "mobile." Inexpensive to produce and easy to distribute, early European prints found their way to a very large audience. At first, prints illustrated religious themes or commemorated historical events, but as printmaking techniques evolved over time, artists were increasingly attracted to the medium as a vehicle for artistic expression. Eventually, art collectors began to appreciate high-quality original prints, and printmaking was transformed from a merely reproductive process to a fine art.

Some Basic Terms and Definitions

Proofs are never included in the numbered edition; they are, however, often sought by collectors and may be of great interest and value in analyzing an artist's method of working. A proof is an impression pulled prior to the running of an edition, often while the work is in progress; a succession of proofs may show the artist's revisions of the work. The successive stages of revision are labeled first state, second state, and so on. The final proof is called the *bon à tirer* (pron., bone AH tee-ray; sometimes abbreviated b/a/t), or the printer's proof. Bon à tirer is a French phrase meaning "good to print," and this proof becomes the standard by which the quality of each of the prints in the edition is measured. During the run of the edition the artist and/or the printer will constantly check the prints coming off the press against the bon à tirer. A print labeled *artist's proof* is also not part of an edition, but is retained by the artist, often for his or her own record. The number of artist's proofs should be no more than 5 percent of the number of prints in the edition, again to protect the value of the prints.

ONE-OFF PRINTS

Although a print is often defined as a multiple, an artist could certainly choose to print only a single impression, and, in fact, some kinds of prints are one-offs by definition. A classic example is the monotype, in which ink or paint is applied to a piece of Plexiglas or other smooth-surfaced plate. When the image is printed on a press, the ink or paint is lifted off the plate; since the image cannot be exactly re-created, each monotype is a unique impression.

The criteria for originality in a print usually include the following:

> The image is created by the artist on a matrix.

> The image is printed by the artist or under the artist's supervision.

> The print meets the standards of excellence established by the artist.

There is thus a traditional and important distinction between a reproduction of a work of art, such as a drawing or painting, made by photographic or other methods, which cannot be considered an original print, and a print made from an image created from scratch on a matrix (such as a master plate or block) and then hand-printed. Today, however, the use of pigment transfers, digital photography, and computer numerical control devices (see page 46) has brought us to a new era in which such a rigid distinction may no longer apply. Respectable museums and galleries around the world accept prints made in these new ways as original works. Such original prints are, in fact,

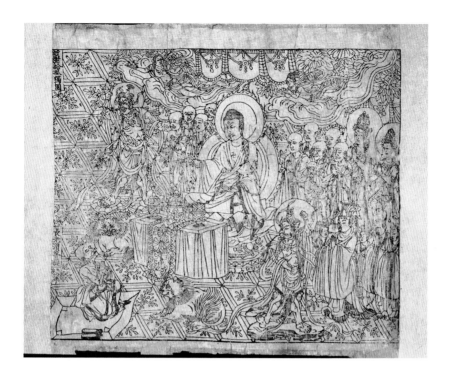

Frontispiece from the *Diamond Sutra* from Cave 17, Dunhuang, China, c. 868, ink on paper. According to the British Library, the sutra is "the earliest complete survival of a dated printed book." British Library.

still printed from a matrix, but the definition of matrix has evolved and grown with the new technology. In my view, a limited edition still protects the value of a print, no matter what technique is used, traditional or new.

Today, some artists have adopted an "all digital" approach, in which the output of a digital device, such as a desktop laser or inkjet printer, is the final print. Other artists have developed hybrid techniques that combine digital output, such as film positives, machine-engraved plates, computer-carved woodcuts, and tracings of screened imagery, with traditional mediums. Prints made using new technologies are of a quality comparable to the highest standards of traditional etchings, engravings, block prints, screen prints, and lithographs.

The computer enables the artist to integrate new imagery and ideas with traditional mediums, combining printmaking with other forms of artistic and scientific expression. Computer graphics enable the artist to access and utilize a greater number of sources, offering new ways of manipulating and combining images and turning creative ideas into prints. I ardently believe in using digital techniques in printmaking, not merely as a means of reproduction, but as a means of making a specific kind of art in which the content and the medium are truly inseparable. I use these mediums because they truly convey what I want to express.

The process of making art is a continuous learning experience. As a multimedia artist, I attempt to celebrate, transcend, or reverse the conventions of visual languages. In today's world we want to embrace new technologies while also holding onto and comparing them with more traditional methods of making art. And new communication possibilities keep emerging: Printmakers are now even using 3-D software.

When new mediums proliferate and lines between genres dissolve, philosophical questions arise about the nature of printmaking. Nowadays, sculptural, environmental, and performance works may contain print components. One of my goals in this book is to highlight printmaking's continuing relevance to contemporary art. I am dedicated to the process of making art with new technology, but I still want to use my hands, my eyes, and my heart while using different tools, on different surfaces, and at different scales to keep on printing.

The United States saw an explosion in fine-art printmaking during the Great Depression of the 1930s, largely the result of the federal government's Works Progress Administration (WPA), which funded all sorts of artistic enterprises and kept the arts—and many individual artists—alive in this time of extreme economic hardship. Many printmakers and print shops received WPA support.

Modern American Printmaking—A Brief History

American printmaking received a further boost during World War II, when numerous artists fled Europe for the United States. Among them was British-born painter and printmaker Stanley William Hayter, who in 1940 transplanted his famous Atelier 17, founded in 1926, from Paris to New York. While in France, Hayter had taught intaglio printmaking techniques to Pablo Picasso and Georges Braque, and he continued his role as a printmaking mentor on this side of the Atlantic. His profound influence on American printmaking can be seen, for example, in the widespread adoption of intaglio techniques by printmaking instructors at American colleges and art schools. Among the many artists associated with Atelier 17 over its lifetime were Pierre Alechinsky, Louise Bourgeois, Hans Haacke, Max Ernst, Joan Miró, Robert Motherwell, and Jackson Pollock.

During the same period, the Art Students League of New York was also playing an important part in raising interest in printmaking and disseminating printmaking skills among American artists. Acclaimed painter and printmaker Will Barnet (1911–2012), whose relationship with the League lasted for fifty years, served as the League's professional printer from 1935 through 1941, producing prints for Louise Bourgeois, Louis Lozowick, and José Clemente Orozco, among many others.

Another graphic artist of stature was Harry Sternberg (1904–2001), who first exhibited at the Whitney Museum of American Art in 1931 and who, like John Sloan, taught printmaking for many years at the Art Students League. After meeting Mexican artist Diego Rivera and his wife, Frida Kahlo, in 1934, Sternberg became politically active and participated in the printmaking explosion of the era, using the medium to promote socialist causes.

The late 1950s and early 1960s witnessed another far-reaching change in American printmaking, with the founding of a number of influential printmaking studios. The first of these was Universal Limited Art Editions, established by Tatyana Grosman in West Islip, New York, in 1957. Artists such as Jim Dine, Jasper Johns, Robert

Rauschenberg, and Larry Rivers, then at the beginning of their careers, investigated printmaking techniques under Grosman's tutelage. When she died in 1982, ULAE continued under the direction of master printer Bill Goldston, who expanded the studio's publishing program and worked with artists including Lee Bontecou, Elizabeth Murray, Barnett Newman, James Rosenquist, Susan Rothenberg, Kiki Smith, and Terry Winters.

Then, in 1960, artist-printmaker June Wayne opened the Tamarind Lithography Workshop in Los Angeles, eventually moving it to Albuquerque (where it now thrives as a division of the University of New Mexico). Wayne's career as a printmaking educator had begun a few years earlier, when she received a grant from the Ford Foundation to revive the medium of lithography and train a new generation of lithographic printers.

A revival of etching soon followed. In 1962, artist Kathan Brown founded Crown Point Press in the San Francisco Bay Area. Specializing in etching, it became one of the most notable American print shops. In the 1970s Brown inaugurated a relationship with Parasol Press, printing editions for artists such as Mel Bochner, Chuck Close, Sol Lewitt, and Robert Mangold. Crown Point Press established a Japanese woodblock-printing program in 1982, in which artists including Close as well as Francesco Clemente, Richard Diebenkorn, and

Wayne Thiebaud worked with traditional woodblock printers in Kyoto.

In 1965, artist Kenneth E. Tyler left Tamarind, where he had been technical director, to start Gemini G.E.L. (Graphic Editions Ltd.) in Los Angeles, in partnership with art collectors Sidney B. Felsen and Stanley Grinstein. Always interested in technical innovation, Tyler worked at adapting industrial processes for contemporary fine-art printmaking. Gemini G.E.L.'s major early publications included works by Jasper Johns, Roy Lichtenstein, Claes Oldenburg, and Robert Rauschenberg. In 1974, Tyler left Gemini G.E.L. and founded Tyler Workshop Ltd. (later

Tyler Graphics Ltd.) in Westchester County, New York. Tyler, who set up his own paper mill and experimented with handmade paper, went on to publish prints for David Hockney, Ellsworth Kelly, Kenneth Noland, and Frank Stella, among others.

From the 1960s onward, artists like Rauschenberg, Johns, Stella, and Andy Warhol, by working with print shops/print publishers like those mentioned, almost made independent printmaking obsolete. Today there are more than six thousand print shops and publishers in the United States. (A list of some of them appears in the Resources at the end of the book, page 296.)

Will Barnet, Untitled, lithograph, 7 x 11 inches (17.75 x 28 cm), from the *Dead Birds* portfolio produced by Elena Lazza and Christopher Erb, 1988. Collection of the author.

Harry Sternberg, *Self Portrait*, woodcut, 2001, 14 ¼ x 7 ¼ inches (36.2 x 18.4 cm), from the *Twenty-first Century Print Portfolio*, published by the Art Students League, 2002. Collection of the author.

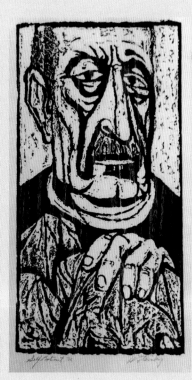

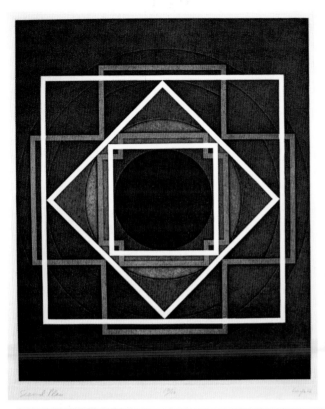

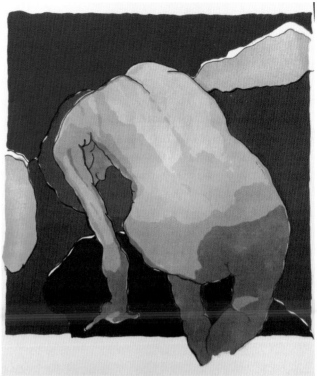

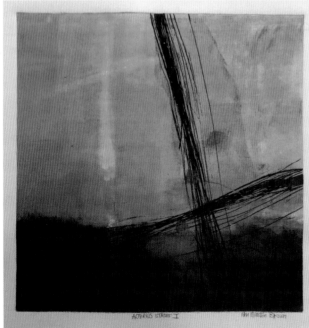

About This Book

Modern Printmaking is intended for all who want to discover and learn about contemporary printmaking and to improve their printmaking knowledge and skills. It encompasses both traditional and contemporary techniques and processes, and it also presents profiles of thirty-one contemporary printmakers (including myself).

My selection of the participating artists was personal but also cultural. I chose experienced artists I admired and loved; I chose current colleagues and students; and I also chose artists whose work I had seen but whom I had never met before writing this book. Although I assigned each artist one specific technique because of his or her particular experience with it, most have worked with multiple printmaking techniques. Printmakers are constantly crossing boundaries and inventing new visual languages. I interviewed all the artists profiled, either orally or through the exchange of emails and letters. I asked questions relating to the artist's involvement in printmaking, and after reading the initial answers I went back and requested more detailed information. Finally, when it seemed we had covered enough ground, I reworked the texts to create the profiles you'll see in this book.

This book covers the six main branches of printmaking:

> ❭ Relief processes, in which the raised surface of the printing block is inked while the carved areas are not.

> ❭ Intaglio, the direct opposite of relief, in which a copper or zinc plate is used as a matrix and the incisions created by etching, engraving, drypoint, mezzotint, or aquatint are inked and printed.

> ❭ Lithography, a planographic method of printing based on the principle that oil does not mix with water.

> ❭ Serigraphy, or screen printing, a stencil technique using a screen mesh to push the ink onto the printing surface.

> ❭ Mixed media, in which multiple techniques are combined to achieve a print.

> ❭ Post-digital printmaking, a hybrid and intimate connection between printmaker and machine in which image-making is both conceptual and physical. Post-digital printmakers use mechanical and electromechanical devices to manipulate traditional art-making tools while still hand-printing the resulting matrix.

Though I discuss printmaking history, the book mainly focuses on methods in use today. The art supplies I recommend are readily available from stores and online vendors in the United States and Canada. Because the book deals with printmaking techniques from the simplest to the most sophisticated, it will be of value to anyone interested in printmaking, from professional artists looking to further their artistic research, to teachers wanting to acquire more knowledge, to fine arts students pursuing degrees, to high school students intending to apply to fine arts programs.

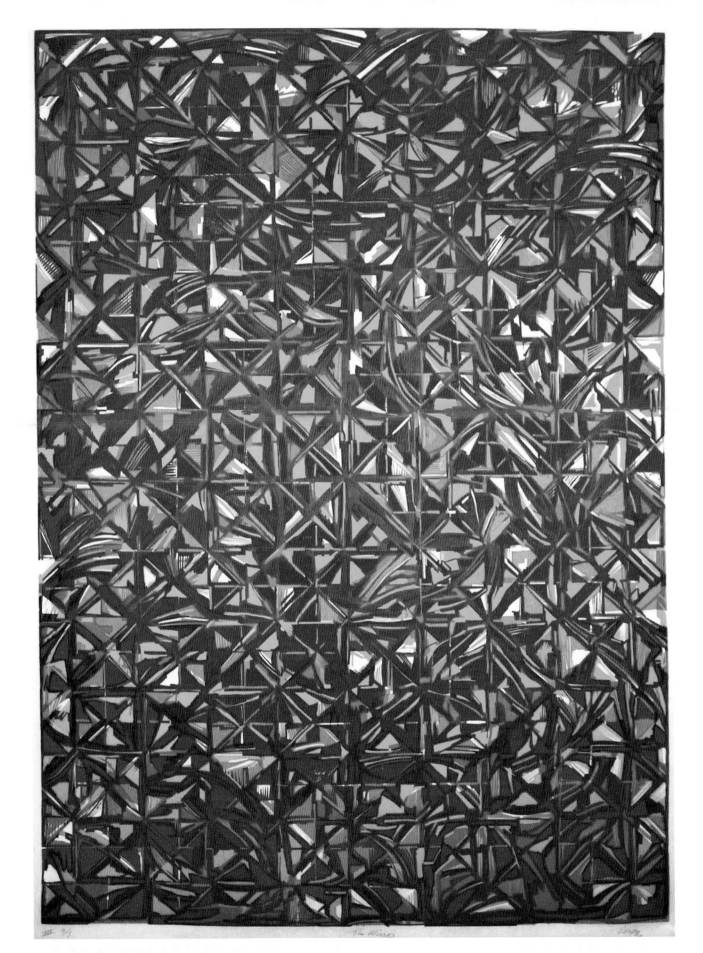

Relief Printmaking

□

Vincent Longo, *Mirrors*, 1982, color three-block woodcut,
24 x 37 inches (61 x 94 cm). Courtesy of the artist.

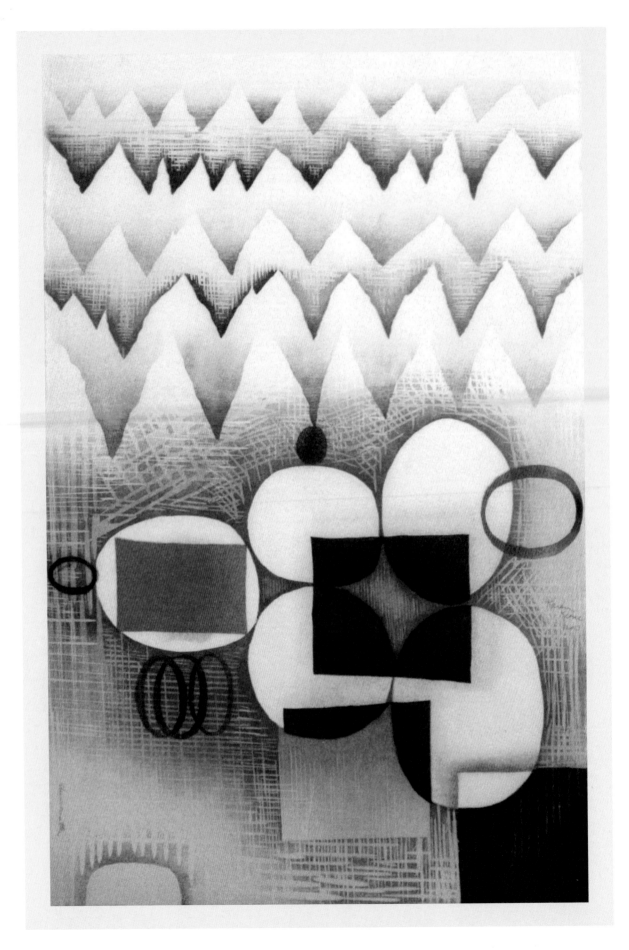

1

Relief Printmaking Background and Basics

A relief print results from a raised printing surface. A block of wood or linoleum is carved, and those portions that remain raised receive the ink, while the portions that are carved away are not printed. Ink is brushed or rolled on the raised surface, and paper is pressed on it. The paper is then rubbed by hand or with a tool called a baren or run through a press to produce a relief print. Relief printing is the most ancient method of taking an impression from one object and reproducing it. Handprints made from soot and charcoal can be seen in many prehistoric caves and testify to human beings' affinity for leaving a trace—a print—to posterity.

A Brief History

Karen Kunc, *Elusive Matter*, 2013, color woodcut, 17 x 11 inches (43.2 x 28 cm). Courtesy of the artist.

The first surviving prints on paper come from China: a set of woodcuts illustrating Buddhist themes that were printed in northern China in the seventh century AD. Over the following centuries, Chinese artisans created many woodblock images for books on a diverse range of subjects (agriculture, literature, medicine, botany, poetry); these prints later influenced the development of ukiyo-e prints in Japan. From China, printmaking followed the Silk Road to the Mediterranean. The concept of printing text and images spread rapidly in Europe and by the early fifteenth century was well established there.

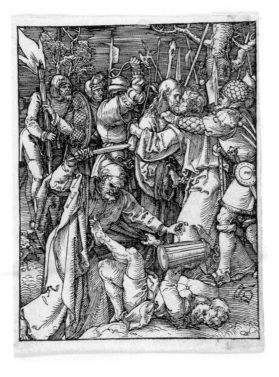

Albrecht Dürer, *The Betrayal of Christ*, 1509–1510, woodcut, plate 11 from the *Small Woodcut Passion* series, sheet measures 5 15/16 x 4 inches (15 x 10.2 cm). Los Angeles County Museum of Art.

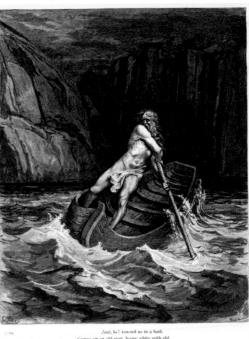

Gustave Doré, *Arrival of Charon*, 1857, wood engraving, plate IX from *The Divine Comedy: Dante's Inferno*.

And, lo! toward us in a bark
Comes on an old man, hoary white with eld,
Crying, "Woe to you, wicked spirits!"

Canto III., lines 76–78.

Before the mid-fifteenth century, however, pictures and words for book pages were cut from the same block. But around 1439, in Germany, goldsmith Johannes Gutenberg developed a method of printing with movable cast-metal type. Letterpress printing—in which a worker would compose a text, lock the movable type into the bed of a printing press, ink it, and print it on paper—soon became the preferred technique of relief printing. Throughout Western Europe, printing shops multiplied, quickly leading to the decline of illuminated handwritten manuscripts. For the first time, the middle class had access to the written word, and the church, the state, and the universities promptly adopted this new means of communication and propaganda.

Letterpress printing remained the usual method for printing text until the nineteenth century and remained in wide use for books until it was replaced by offset printing, a technique in which the inked image is transferred—or offset—from a plate to a rubber blanket, then to the page.

For illustrations, the intaglio techniques of etching and engraving on metal were long favored over woodcut because they produced more finely detailed results. That changed in about 1780, when English engraver Thomas Bewick invented a technique for engraving wood blocks. In the late nineteenth century, the wood-engraving technique was combined with photo-offset processes, revolutionizing the commercial printing world and opening a world of possibilities for illustrations and advertisements in newspapers and magazines and the mass-market reproduction of paintings and other works of art. This had little effect on fine-art printmaking, with the exception of the prolific

Ichirakutai Eisui, *The Courtesan Hanaogi of the Ogi House*, published by Maruya Bun'emon, 1790s, color woodblock print, 10 ¼ x 15 inches (26 x 38.1 cm). From Ukiyo-e Prints in the Mike Lyon Collection, courtesy of Mike Lyon.

Shunbaisai Hokuei, *Nakamura Utaemon III, as Ju-unryu Kosonsho*, from the series *108 Heroes of the Theater Suikoden*, published by Kinkado Konishi, 1835, color woodblock print, 9 ⅘ x 14 ¾ inches (24.9 x 37.5 cm). From Ukiyo-e Prints in the Mike Lyon Collection, courtesy of Mike Lyon.

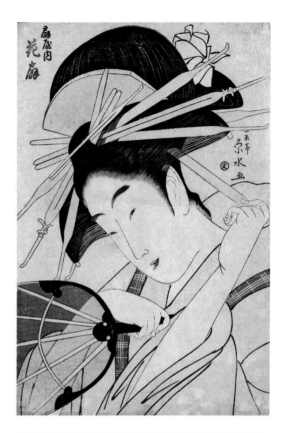

French illustrator and engraver Gustave Doré, who worked with wood as well as steel engraving. Doré's wood engravings epitomize the medium's strengths—the purest expression of black-and-white mark-making.

MERGING CULTURAL INFLUENCES

In China, early color woodcuts appeared mainly in treatises on painting and other luxury books about art. Although color woodcut prints, known as chiaroscuro woodcuts, were invented in Germany in 1508, European printmakers generally eschewed color woodblock printing until the mid-1800s, when Japanese woodblock prints of the ukiyo-e genre were introduced in Europe. Ukiyo-e means "Floating World"—the name applied to nightlife districts that flourished in Japanese cities during the Edo period (1600–1867)—and many ukiyo-e prints depict scenes from this demi-monde, including fashionable women, courtesans, and famous kabuki actors, although other urban scenes, natural landscapes, and pictures of flora and fauna are also common ukiyo-e subjects. (Some ukiyo-e are erotic.) Although these beautiful images, printed from multiple blocks, were made by major artists such as Harunobu, Hiroshige, Hokusai, Sharaku, and Utamaro, ukiyo-e prints sold for very little money, and their artistry was undervalued in Japan. Then, Western travelers who had assembled ukiyo-e collections exhibited prints at the 1867 Paris International Exposition, and they were finally recognized as high art.

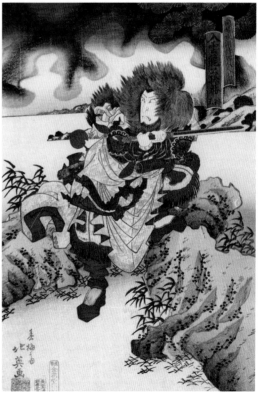

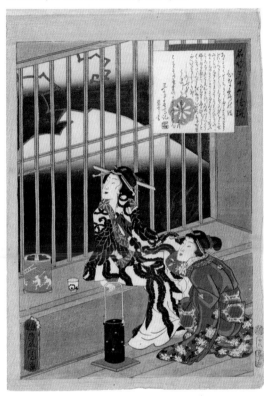

Utagawa Kunisada (also known as Utagawa Toyokuni III), *No. 18, Hinazuru*, from the series *An Excellent Selection of Thirty-six Noted Courtesans*, published by Tsutaya Kichizo, 1861, color woodblock print, 10 x 14½ inches (25.4 x 36.8 cm). From Ukiyo-e Prints in the Mike Lyon Collection, courtesy Mike Lyon.

Ukiyo-e prints had a profound influence on the Western art world from the 1870s on, and the japonisme style they spurred was reflected in many artistic mediums, including painting. Interest in ukiyo-e prints also spurred a European revival of woodcut, which had almost disappeared as a fine-art medium. Prints by artists such as Mary Cassatt, Henri de Toulouse-Lautrec, and Paul Gauguin show the influence of the ukiyo-e style in their composition and use of patterns and areas of flat color.

Gauguin took notice of the Japanese woodblock prints before his departure for Tahiti, where he lived from 1891 to 1893 and again from 1895 until his death in 1903. The Polynesian art forms he discovered in Tahiti also profoundly influenced him. Merging cultures, Gauguin created many woodblock prints, cutting the blocks freely and creating images that combine primitive symbols with heroic figures. The Norwegian artist Edvard Munch, who was living in Paris at the time, saw Gauguin's prints and was inspired to carve the first of his many woodcuts in 1898.

EXPRESSIONIST WOODBLOCK PRINTMAKING

In Dresden in 1905, German expressionist artists Fritz Bleyl, Erich Heckel, Ernst Ludwig Kirchner, and Karl Schmidt-Rottluff formed a group called Die Brücke, which rejected the prevailing academic art of the time and searched for a new kind of expression—one they hoped would connect the past and the present (hence the group's name, which means "The Bridge"). Drawing upon Germany's artistic tradition, the Die Brücke artists (who later included Otto Mueller, Emil Nolde, and Max Pechstein) revived the long-neglected medium of woodblock printmaking, and the group's prints had a major impact on the evolution of twentieth-century art. Another group of avant-gardists likewise found woodcut's simplicity and directness appealing: the Munich-based Russian emigrant artists who called themselves Der Blaue Reiter ("The Blue Rider"). Founded by Wassily Kandinsky and Franz Marc in 1911, Der Blaue Reiter eventually included Paul Klee, Alexej von Jawlensky, August Macke, Gabriele Münter, and Marianne von Werefkin, and these artists, too, helped foster woodcut's revival.

Utamaro Hitsu, *Fishing with a Four-Armed Scoop Net*, c. 1801,
color woodblock print triptych, 30 x 15 inches (76.2 x 38.1 cm).
From Ukiyo-e Prints in the Mike Lyon Collection, courtesy
Mike Lyon.

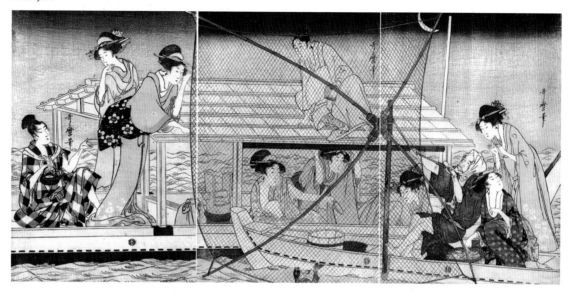

WOODBLOCK PRINTMAKING IN AMERICA

During the 1930s, U.S. artists such as Milton
Avery, Stuart Davis, and Louis Schanker became
keenly interested in printmaking. Meanwhile,
American printmakers were discovering new ways
of selling their work: Museum-sponsored print
clubs flourished, and an organization called Asso-
ciated American Artists (founded 1934) marketed
low-priced prints to an eager audience of middle-
class art lovers.

After World War II, Leonard Baskin and the
Uruguayan-American artist Antonio Frasconi
were among those exploring woodcut. Of this
new generation of artists emerging in the postwar
period, Vincent Longo was immediately noticed
for his spectacular woodcuts. Other U.S. art-
ists experimenting with color relief prints were
Seong Moy, Michael Ponce de Leon, John Ross,
Clare Romano, and Carol Summers. Among the
most important of the American artists contribut-
ing to the development of relief printmaking was
Robert Blackburn.

After graduating high school in 1940, Blackburn
attended the Art Students League in New York,
where he worked with and befriended the illustri-
ous painter and printmaker Will Barnet. He went
on to become a freelance graphic artist, working
for institutions including the Harmon Founda-
tion, the China Institute in America, and Asso-
ciated American Artists, before establishing the
Robert Blackburn Printmaking Workshop in Man-
hattan's Chelsea neighborhood in 1948. There, he
produced various ambitious collaborative projects,
such as *Impressions: Our World* (1974), a portfolio
by notable African-American artists with introduc-
tory texts by artist Romare Bearden and art his-
torian Edmund Barry Gaither. Blackburn's legacy
lives on today in the Robert Blackburn Printmak-
ing Workshop Program operated by the Elizabeth
Foundation for the Arts.

FROM WOODBLOCK TO LINOLEUM BLOCK

Linoleum blocks were first used as a cheap sub-
stitute for wood. Because linoleum-block print-
making (often called linocut for short) is not as

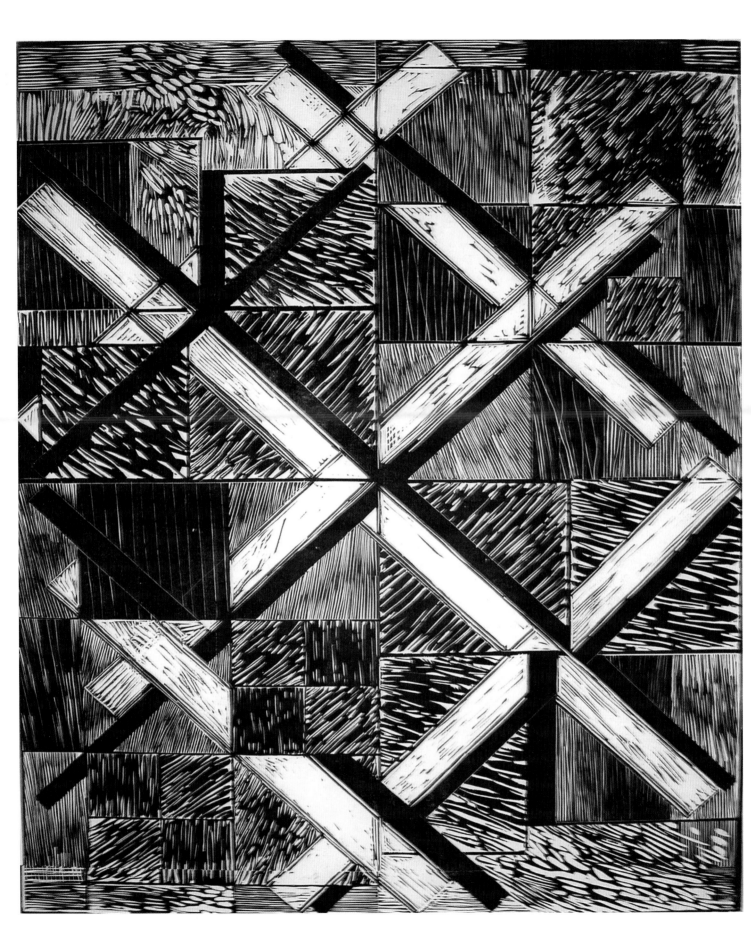

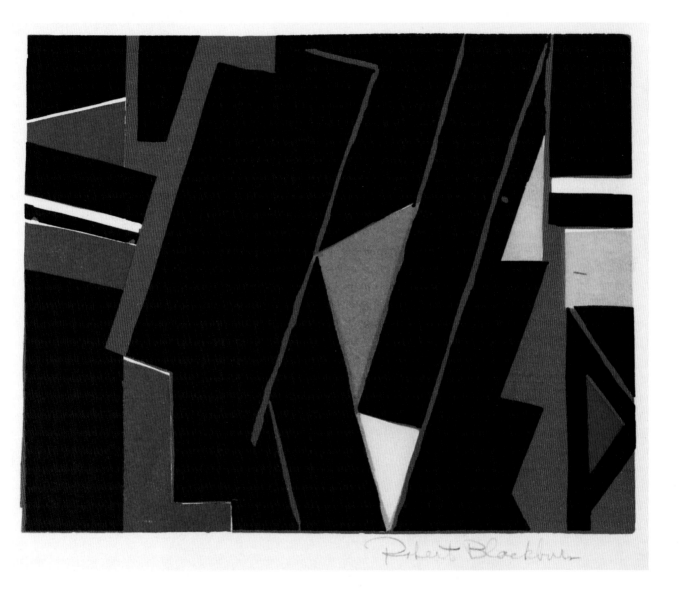

Vincent Longo, *B&W Overlap*, 2008, woodcut, 25 x 36 inches
(63.5 x 91.4 cm). Courtesy of the artist.

Robert Blackburn, Untitled, 1998, relief stencils, 9 x 11 inches
(22.9 x 28 cm). Collection of the author.

time-consuming as woodcut, the medium is ideal for dramatic responses to political events. Early Soviet artists used linoleum blocks to create overnight posters for the Agitprop movement, and linocut was also popular in the WPA program of the Great Depression.

In France, Pablo Picasso gave new life to the art of relief printing. Picasso disliked the texture of wood and the limitations of woodcut, so he abandoned the traditional material for the modern material of linoleum, a composite of powdered cork, resin, and oxidized linseed oil. Because linoleum has no grain, it allows for more fluid carving, and linocut is capable of producing tonal areas that are completely flat. At first, Picasso—who was introduced to linoleum by the young printer Hildago Arnera in 1939—considered linoleum appropriate for boldly graphic posters, and so his first linocuts were relatively simple and straightforward. But exploring the limits of artistic techniques always appealed to Picasso, and, after years of experimentation, he produced his best linocuts from 1952 to 1964, transforming a previously underdeveloped medium through images of dazzling technical virtuosity.

CONTEMPORARY RELIEF PRINTMAKING

Today, much attention focuses on digital printmaking. These new printmaking processes, which exploit the possibilities of electronic prepress devices, have emerged through collaborations between artists and a small group of professional printing studios, including Adamson Editions, Cone Editions Press, Nash Editions, Pamplemousse

Press @ Pace Editions, Ribuoli Digital Studio, and Two Palms. Contemporary artists who employ computer-operated laser-cutting machines to carve woodcuts include Denise Bookwalter, Barbara Foster, Artemio Rodriguez, Tom Spleth, Jack Stone, and Marius Watz. The laser-cut blocks are then often hand-printed. Kansas City artist Mike Lyon is unusual in that he actually writes the programs for the computer numerical control (CNC) devices he uses. Working from photographs, Lyon creates fifteen or more laser-cut woodblocks for one print. Joining the technological new world with the traditional old world of printmaking, Lyon then hand-prints the blocks in a Japanese fashion, creating multi-toned images of superior quality. (Lyon's work is covered in more detail in chapters 2 and 15.)

Western- versus Japanese-Style Relief Printing

Relief printing can be done in two basic ways. The Western-style method uses oil-based ink that is applied to the relief block with a roller called a brayer; it usually involves printing on a press. The Japanese-style method uses water-based colors, and printing is done with a baren.

THE WESTERN STYLE

Using a press ensures that an even pressure will be applied to the whole surface of the printing block. Relief prints can be printed on several kinds of presses, including letterpresses, but an etching press (see page 72) is most often used for relief printing. On an etching press, the cylindrical roller

To transfer ink from the woodblock to the paper, traditional
Japanese printmakers use a rubbing tool called a baren.
Photo courtesy of Jacques Commandeur.

above the press bed is raised to the height of the
block. The inked block with the printing paper is
placed at the center of the press bed and covered
with paper, a board (optional), and two thin blan-
kets. The pressure is then adjusted to ensure that
the roller will easily roll onto and across the block.

Besides a press, a smooth, flat, easily cleanable
surface is needed for spreading and rolling out the
ink. Printing shops have glass- or marble-topped
tables or slabs for this purpose, but a large sheet of
Plexiglas laid on a flat surface will also work.

Printmaking papers made by BFK Rives, Somer-
set, Lenox, and Stonehenge are all suitable, as is the
Domestic Etching paper made by Legion. Many
smooth commercial offset papers can also be used
for block printing; these produce better results if
they are lightly dampened and printed on a press
with heavy pressure, but they can also be used with-
out dampening. Japanese papers such as Mulberry,
Sekishu, Hosho, and Moriki are excellent for color
and black-and-white oil-based inks, and the Japa-
nese papermaker Awagami offers a wide range of

quality papers. These papers do not have to be
sized nor dampened when using oil-based ink.

Oil-based inks, which are made of pigments mixed
with an oil vehicle, produce more opaque, layered,
and textural effects than water-based inks; because
they are not soluble in water, they also allow prints
to be re-soaked, reprinted, and then worked on
again on after drying. Oil-based inks made specifi-
cally for relief are a little softer than oil-based inks
made for etching or lithography. Readily avail-
able brands of oil-based ink include Speedball,
Graphic Chemical & Ink Co., Akua, and Gamb-
lin. In general, inks for relief printing should be
rather stiff and dense and have little tack (sticki-
ness) to prevent details from being filled in. A print
should lift cleanly from the block onto the paper.
Lithographic inks, which are extremely stiff, can
be modified for relief printing if an anti-tack com-
pound such as Easy Wipe or Setswell is added to
the ink. Adding burnt plate oil, linseed oil, or a
vegetable oil (such as canola oil) along with a little
magnesium carbonate to lithographic ink will also
make it suitable for relief printing.

Brayers are used for rolling ink onto the block in Western-style relief printing.

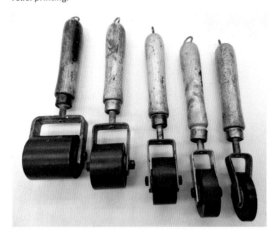

Brayers (rollers) for relief printing should be neither too hard nor too soft. If the roller is too hard it will not ink evenly; if it's too soft the ink will squeeze out over the edges of the uncarved area of the block and into the cut areas. So choose a medium-hard brayer made of composition rubber or plastic. Polyurethane and polyvinyl chloride rollers last forever and resist all types of solvents well.

OTHER TOOLS AND MATERIALS

In addition to paper and ink, you'll need these tools and materials for Western-style relief printing:

- ❱ Palette knives for working the ink
- ❱ Mylar sheet for registration
- ❱ Newsprint pad for keeping prints dry
- ❱ Tracing paper for transferring the design to the block
- ❱ Gamsol or a mineral spirit solvent for cleaning up
- ❱ Paper towels for cleaning up

Relief Printing from a Single Block Using Oil-Based Ink

Here are the basic steps for printing a relief print of a single color on an etching press. (See page 72 for basic instructions for using an etching press.) Note that when inking a relief block, you should use a brayer that is smaller than the image. Note, too, that the term *registration*, used in the following instructions, means making sure that the printing block or blocks are correctly aligned on the exact same area of the printing surface. For a monochrome print, registration ensures that the margins of the paper will be correct; for a multicolor print, registration ensures that the colors appear exactly where they should within the same frame.

1 Fold the printing paper and tear it to the desired size using a heavy ruler to guide the tear. The printing paper should be larger than the printing block, with margins of 2 to 4 inches all around.

2 Prepare a clear Mylar sheet for registration. The Mylar sheet should be larger than the printing paper. On the back of the Mylar, mark where the paper and the block will be placed.

3 Using a palette knife, spread a little ink on the inking slab.

4 Work the ink back and forth with a firm roller, forming a square whose sides are the length of the brayer, until you've laid out a thin, even layer.

5 With the roller thinly loaded, roll a layer of ink onto one area of the block. Work one area at a time. It is important not to over-ink the surface of the block so as to preserve the details and delicacy of the impression.

6 Reloading the brayer as necessary, roll the ink in different directions on the block to ensure a strong, even, solid inking across the whole block.

7 Place the Mylar registration sheet on the bed of the etching press, and place the block on it, ink face up.

8 Place the printing paper on the inked block, following the registration marks.

9 Cover the paper with the press's felt blankets, set the appropriate pressure (which is calibrated to the thickness of the block), and, using the crank or wheel, roll the bed through the press.

10 Lift the blankets, and pull a proof by carefully peeling the paper from the block.

The proof will show you whether additional carving is needed. If the carving is satisfactory, re-ink the block and continue printing. The Mylar sheet can be cleaned with alcohol between prints and reused for registration.

Hang the prints to dry for a few days. The block can be cleaned when printing is done, using Gamsol solvent for oil-based ink.

Relief Printing from Multiple Blocks Using Oil-Based Ink

When printing from multiple blocks, you use a separate block for each color. While this requires a lot of carving, it also means that you do not have to print the entire edition all at once. When you are using oil-based ink, you do not necessarily have to dampen the paper, so there is no real time limit between the color passes. And because each block is inked separately, it is possible to experiment with color variations of the same image.

While some artists go with their gut and work impulsively without real planning, the intricacy of the multiblock method means that you should probably plan ahead. You'll want to decide where you want colors to layer on top of one another and where you want colors to stand alone without layering, and you'll also have to take into account that, in some cases, a new color will be created when one color is printed atop another: printing blue on top of yellow will, for example, create a greenish hue.

The key block, holding the entire design, is generally first printed in black. This step-by-step describes how to register the key-block image on additional blocks prior to carving and inking them:

1 Prepare a sheet of tracing paper the same size as or larger than the printing block. If larger, draw the outline of the block on the tracing paper.

2 Prepare a Mylar registration sheet, larger than the printing paper. On the back of the Mylar, mark where the paper and the block will be placed.

3 Lay a strip of black ink on the inking table, and charge the brayer with a thin, even coating. (Do this by lightly tapping the brayer into the ink well—the small mound of ink on the inking table—and then rolling the ink on the table.)

4 Roll the black ink on the key block in several directions to ensure an even coating.

5 Print the key block on the tracing paper.

6 While the print is still fresh, place and register the tracing paper facedown on a second block, the same size as the key block, and press the inked image onto its surface. The second block now has the same image as the first one, precisely registered.

7 Once the ink has dried, the color areas on the second block can be defined and cut. After cutting the second block, print it on another sheet of tracing paper, and, while the print is still fresh, press it on the third block.

8 Repeat this process until all the blocks have been imprinted and cut to ensure that previously printed colors will shows when each block is printed.

Note that it is not absolutely necessary to use a press when printing relief prints with oil-based ink. When the ink has been evenly applied to the block, place the printing paper over it, and use the back of a wooden spoon or a Japanese baren to burnish the back of the paper, making sure to rub all areas of the block. Keep in mind that better prints are achieved with thin inking and heavy rubbing rather than heavy inking and light rubbing. A wide variety of smooth papers can be used for printing in this manner. Mold-made and handmade papers should be lightly dampened before printing. When oriental papers are printed, the ink will generally show through on the back of the print because of the thinness of these papers.

THE JAPANESE STYLE (UKIYO-E)

When printing relief in the Japanese style, you use water-based pigments and apply pressure when printing by hand, using a baren. In the ukiyo-e process, the artist makes a key drawing with brush and ink, then pastes it facedown on the key block and rubs the back of the paper until it becomes transparent and the ink design can easily be seen for carving. With the paper still attached, the key block is carefully carved. The design remains in relief as areas around the drawing lines are cut away with a knife, gouges, and a chisel. All the blocks should be well seasoned to prevent uneven shrinking and ensure perfect registration.

Two registration guides—called kento guides—are carved into each block: One guide (called the corner kento) is cut into a corner; its right-angle shape accepts the corner of a sheet of printing paper. The other (the side kento) is placed three-quarters of the way down the side of the block and accepts the adjacent edge of the paper. The paper is "bumped" into the corner and side kentos and held there by thumb pressure. Each block must be quite a bit larger than the image to allow for the registration guides and provide enough room for the margins of the paper.

A number of impressions of the whole block, including the kento guides, are made in black ink and pasted on the different blocks prepared for each color. The color blocks are then carved according to the color placement planned for the image. Traditionally, Japanese woodblock print-making involves the carving of anywhere from a dozen up to twenty-five or thirty blocks, each uniquely carved for each color to be printed.

Baikosai Shunkei, *The Actor Arashi Rikan II as the Tobacconist Sankichi in the Play "Keisei Some Waka Tazuma,"* 1834, color woodblock print, 10 x 14³⁄₅ inches (25.4 x 37 cm). From Ukiyo-e Prints in the Mike Lyon Collection, courtesy Mike Lyon.

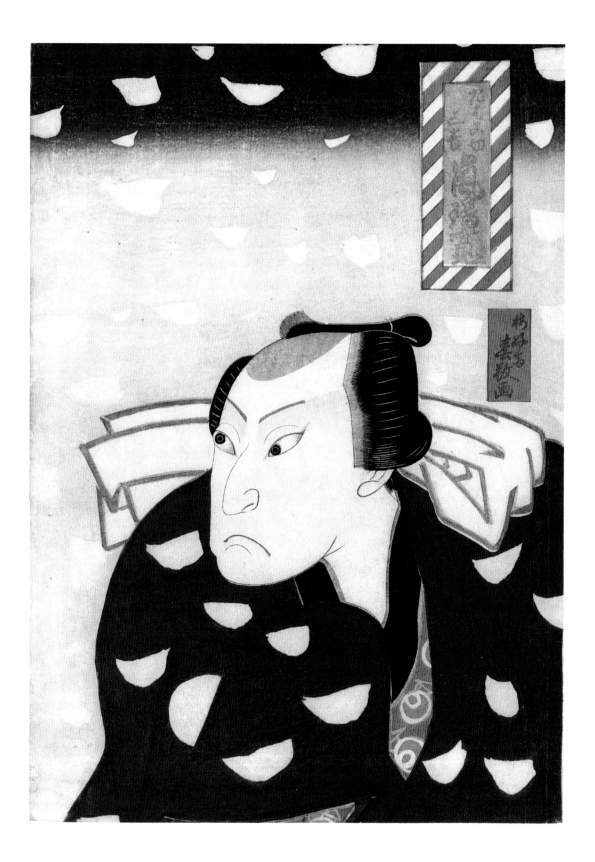

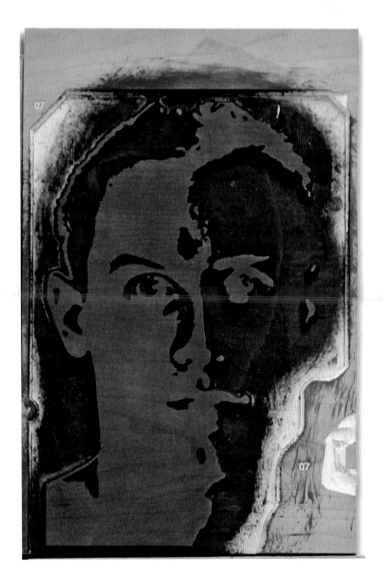

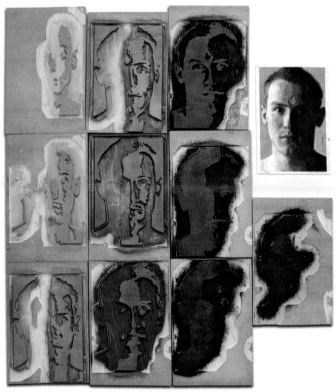

This woodblock, carved by Mike Lyon for his print *Max*, shows kento guides at the upper right corner and three-quarters of the way down the right side. Photo courtesy of the artist.

Mike Lyon, *Max*, 2004, ten cut cherry plywood blocks and final print, print size 10 x 7 1/2 inches (25.4 x 19 cm). Courtesy of the artist.

The illustrations opposite show the computer-carved printing blocks and the final print made by printmaker Mike Lyon using a contemporary adaptation of the ukiyo-e style—specifically, the aizuri-e ("blue printed picture") style that became popular in Japan in the 1830s and 1840s, after Prussian blue pigment had been introduced there.

CHOOSING AND PREPARING PAPER

The paper chosen for ukiyo-e depends on the print being made and on the experience and preference of the printmaker, but in general it must be soft and absorbent, with a smooth surface and long, strong fibers. The best Japanese paper is hand made by Iwano Ichibei, a ninth-generation papermaker in Japan's Echizen province who has been certified a Living National Treasure by the Japanese government. Iwano makes a number of different papers, but his natural Mokuhanga Kozo Washi stands out. Other excellent papers are Masa and a very thick unsized Gampi. You may want to experiment with other Japanese papers, such as Kitakata, Gampishi, Shunyo, Sekishu, Atsukushi, Shiramine, and Awagami, available through many art supplies vendors.

Paper used for ukiyo-e should be sized (pre-treated) with a solution of gelatin and alum to strengthen its fibers and prevent the pigment and paste from being absorbed too rapidly. To make the sizing, mix 8 ounces of gelatin powder into 1 gallon of water. Let the mixture sit for several hours, then boil it until all the glue is dissolved. Then add 3 to 4 ounces of potassium alum, letting it dissolve in the mix while the water is still hot. (Potassium alum can be found in art supplies stores, in the pigments section, as well as in the spices section of grocery stores.) Using a broad, soft, flat brush, brush the sizing mixture evenly on both sides of the paper, and let it dry. (If you wish to avoid this step, you may buy pre-sized paper.)

The paper must also be dampened and stored for a while before printing. After being sized, the paper should be cut into enough identical pieces for the entire edition. When you are ready to print, you must dampen the paper to ensure that it will accept pigment properly and will not wrinkle or expand from the moisture of the paste and pigment with which it will be printed. The paper must be evenly moist throughout. To achieve this, you insert a wet sheet between sheets of dry paper and then store the paper in a plastic bag weighted down with a heavy board for a few hours, or preferably overnight, until all the sheets are uniformly dampened and fully expanded and relaxed. The sheets are stacked with the chosen printing side facing down, with the corner kento registration guides aligned. The ratio of wet to dry sheets depends on the weight of the paper: For paper of medium thickness, insert a wet sheet between every three dry sheets; for heavier paper, between every one or two dry sheets; and for very thin paper, between every four or five dry sheets. Very thin papers such as Kitakata or Okawara Scroll can be dampened with a spritzer, but very heavy papers such as BFK Rives should be dipped in a tray of water, drained, and then inserted between the dry sheets.

When being stacked, the dampened papers should be crawled—that is, stacked in such a way that the edge of each paper protrudes slightly beyond the edge of the paper on top. One method of crawling the paper stack is to grip one edge of the stack firmly, then loosely fold the stack and grip the opposite edge while releasing the first edge. While holding the second edge, flatten the stack again, and the sheets will slide slightly laterally relative to each other. To ensure that the sheets become evenly dampened, repeat this action several times, until there is an offset of one-eighth to one-quarter inch from sheet to sheet.

INK FOR UKIYO-E

Traditionally, ukiyo-e blocks are inked with a mixture of pigment powder, rice flour, and water. The pigment powder should be finely ground, and mixed readily with a little water. (Be cautious when using powdered pigment, always wearing a face mask to avoid breathing the powder.) Besides vegetable and oxide pigment powders, pigment is now also sold as a pigment-saturated liquid, which mixes freely into water and is known as pigment dispersion. The Guerra Paint & Pigment website (www.guerrapaint.com) offers a wide range of pigment dispersions, and they are also sold by other North American art suppliers.

A paste made from rice flour adds body to the pigment, acting as a vehicle to evenly disperse the pigment on the printing block, which results in a smooth color on the paper. If too much paste is added, the inking brush may leave ridges on the block, and these brushstrokes will appear on the print.

When printing very pale colors, dry pigment or pigment dispersion is added to rice paste, mixed well, dabbed onto the dampened block, and brushed across the raised areas of the block. For more saturated colors, a substantial amount of dry pigment is mixed with a bit of paste and water, left to stand overnight, and then stirred well prior to printing. Pigment dispersion can also be used directly on a damp area and brushed out until an even and satiny surface, suitable for printing, is achieved.

To make the rice paste, use 1 part refined rice flour to 5 to 10 parts water. Add the water to the flour little by little until the mixture is smooth. Then heat it in a small double boiler until it becomes translucent. Stir well, let it cool, and store it in an airtight container. The consistency of the paste must be tested by trial and error; it should be fluid, but it should also cling to the brush in small globs. Methyl cellulose powder, corn starch, or wheat flour can be substituted for rice flour, but the feel during printing and the quality of the resulting print are different: Wheat flour and corn starch are not as transparent, producing a slight milkiness in the print. Methyl cellulose works quite well and is stronger than rice-flour paste, but it feels different during inking and printing and produces a print with transparent colors. The wetness of the paste also changes how the pigments spread.

TOOLS FOR UKIYO-E

Flat hake brushes in a variety of sizes are used separately for dampening the block and applying paste and pigment. The brushes must be fine but not too soft; some stiffness ensures that the application of the paste and pigment stays uniform. (Fine hake brushes made of goat, horse, or deer hair can be found at hiromipaper.com.) A bristle stencil brush can be used to ink smaller blocks.

A baren—a small circular pad with a handle—is used to apply pressure on the back of the paper while printing. (See the photo of a baren on

OTHER TOOLS FOR UKIYO-E

Besides water-based ink, hake brushes, rice paste, and a baren, some other tools are essential for ukiyo-e printing:

› Newsprint to keep prints flat

› Mortar and pestle to grind pigment

› Jars or other containers for pigment and sizing

› Spritzer bottle to dampen the paper

page 19.) The traditional Japanese baren consists of a knotted spiral of cord, made from white bamboo sheathing, that is placed on a backing disk and wrapped in bamboo sheathing. The backing disk is made of many layers of paper pasted together and lacquered, with narrow lips that hold the spiral cord. It's the bamboo sheathing that comes in contact with the back of the paper.

INKING THE UKIYO-E RELIEF BLOCK

To ink a ukiyo-e block, follow this procedure:

1 Prepare a shallow dish of pigment mixed with water and a separate shallow dish of rice flour paste, each with its own brush. The size of the brushes will depend on the size of the area to be inked.

2 Dampen the block with water using a wide brush, brushing the water evenly onto the block. Place a small amount of rice paste on the block with a hake brush, then add some pigment, dabbing the pigment onto the rice paste and mixing the two together with the brush using a circular motion over the image area.

PRINTING THE UKIYO-E RELIEF BLOCK

Until it's time to print, the dampened paper should be kept in a plastic bag or other tight container to keep the moisture constant. When printing, follow these steps:

1 Register the dampened paper on the block, aligning it with the corner kento guide first and then with the side kento. The paper must be held up off the inked block until the guides are found, to keep the print clean. When the paper is aligned above the registration marks, carefully lay it on the inked block.

2 If the paper is very delicate, or too soft and damp, place a piece of newsprint on the back of the dampened paper to protect it from the friction, and use the baren to quickly rub the ink evenly from the block onto the printing paper. A backing sheet significantly slows down the printing process, however, so use it only when necessary. To prevent the paper's borders from drying, which will prevent the paper from properly relaxing on the block and cause it to curl, brush a little water on those areas while printing.

3 Keep the prints in a humidity-controlled area or container until the end the whole edition has been printed so that the paper does not dry. The stacking method is also important: The sheets should be pulled facedown from the stack but stored faceup after printing to allow the ink to dry.

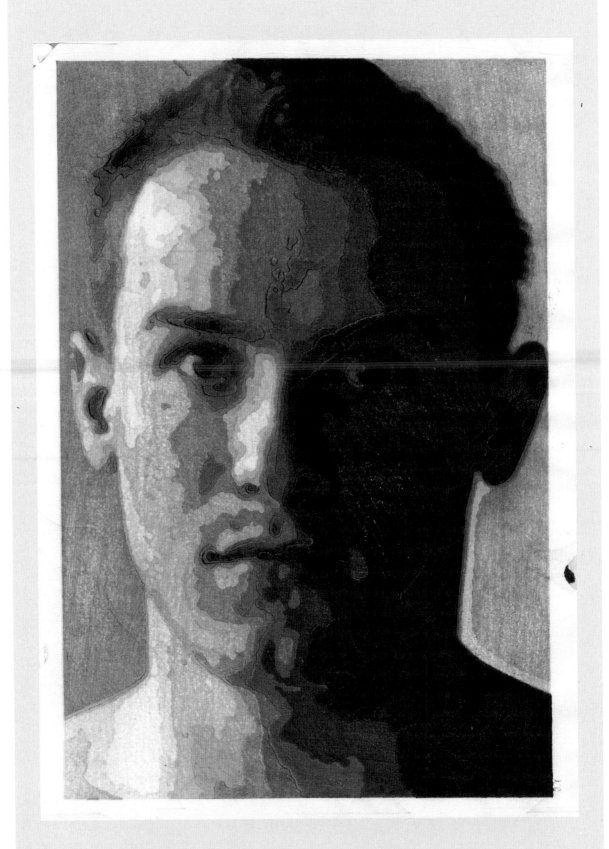

2

Woodblock Printing

Our word *relief* comes from the Latin *relevo*, meaning "to raise." When a relief is cut from a surface, such as a woodblock, the uncarved parts appear to be raised. In this chapter, we will look at several methods for creating woodcuts—relief prints from carved woodblocks—including reduction carving for single-color (usually black and white) prints, the single-block reduction method for multicolor prints, Western-style multiblock carving, and Japanese-style multiblock carving.

Equipment and Materials for Woodcuts

Choosing which type of wood to use is an important first step when doing a woodcut. Woods are broadly categorized as either hardwoods or softwoods.

Maple and birch are very hard woods and difficult to cut, but they hold fine details. Woods from nut and fruit trees, such as walnut, beech, cherry, pear, and apple, are even-grained and will also hold details well. Oak is extremely hard but has an open grain. Mahogany is softer but splinters easily.

Mike Lyon, *Max*, 2004, woodcut from ten computer-carved cherry plywood blocks, 10 x 7 ½ inches (25.4 x 19 cm). Courtesy of the artist.

Among softwoods, pine has long been used for woodcuts. Pine species are abundant throughout northern Europe, Asia, and North America. A superior variety for woodcutting purposes is the sugar pine found on the east coast of the United States. Firm and even grained, it can be cut either with or against the grain. Other softwoods are the strong and resilient poplar, which has a smooth and even grain, and basswood.

Tenjin Ikeda, *Pearl Beyond Price*, 2005, woodcut, 12 x 36 inches (30.5 x 91.4 cm). Courtesy of the artist.

By its nature, plywood is never as good as a solid piece of wood for holding details, because the grains of the layers of wood in plywood do not match. The most common plywood, fir plywood, has a strong grain and splinters easily, but it does produce great wood-grain textures. Note that plywood made from basswood or birch will hold more detail than pine, and that plywood is useful for large woodcuts because it is available in four-by-eight-foot sheets. Beginners should choose a softwood such as pine, poplar, or basswood because these woods are easier to cut and less expensive than hardwoods.

Woodblocks are cut with knives, gouges, and chisels. The woodcut knife has a blade that has a 45-degree angle on one side and is flat on the other. Most woodcut artists prefer to have a large, heavy knife for basic cutting and a smaller one for detail. Gouges are used to clear the wood between the edges of the image areas. There are C-shaped, U-shaped, and V-shaped gouges. The C-shaped gouges are the most versatile. Gouging is usually done in the direction of the grain of the wood.

Sharpening stones are rectangular or round India stones with one coarse side and one fine side, as well as synthetic stones made of carborundum (silicon carbide). The stones are used as an abrasive for grinding the tools' edges and are lubricated with light machine oil. Soft or hard Arkansas stones are used for a final sharpening in which the edge is finely honed.

OTHER TOOLS AND MATERIALS

Besides woodblocks, knives, gougers, and sharpening stones, you'll need some other tools and materials for woodblock printing:

> 2B graphite pencils, India ink and brushes, and/or fine Sharpie pens for drawing on the block and tracing or transfer paper for transferring a design to the bloc

> Mylar sheets for color registration on multiple blocks

> Brayers for applying ink to the block (Western-style printing)

> Oil-based relief ink (Western-style printing). Brands include Hanco, Graphic Chemical & Ink Co., Speedball, and Gamblin.

> Printing paper. Paper for relief should be smooth, without texture. Suitable papers are made by BFK Rives, Somerset, Fabriano, and Arches (the Arches Cover line). Oriental rice papers can also be used for relief (Western-style).

Reduction-Method Woodblock Printing

In the reduction method, a single block of wood is cut and printed, then recut and printed again—with the process repeated until the desired outcome is achieved. In this manner, various areas of the block's printable surface are successively carved away, with a fixed number of sheets of paper (which will ultimately make up the edition) printed at each step.

SINGLE-BLOCK, SINGLE-COLOR REDUCTION METHOD

The single-block reduction method can be used for single-color (usually black and white) prints or for multicolor prints. Let's look at the single-color technique first.

As areas of the block are successively cut away and the remaining uncarved areas of the block are repeatedly inked and printed, the areas on the print that continue to receive ink become darker and darker with each overprinting. The lightest areas of the print are those that were first carved out, and the darkest are the increasingly smaller areas that are never carved out and receive repeated inking. Producing prints from a single block, a technique sometimes called the "suicide method," can be nerve-racking because if a mistake occurs, there is no going back: the block is progressively destroyed as more and more portions are cut away. The two Vincent Longo prints on the next two pages show the successive stages of an image printed using the single-block, single-color reduction method.

When creating your design, you can draw directly on the block with a pencil, a Sharpie marker, or a Japanese sumi-e brush dipped in India ink, or you can transfer a design onto the block using tracing or transfer paper. Always keep in mind that the print will be a mirror image of the drawing, so you'll need to flip the original drawing when transferring to the block.

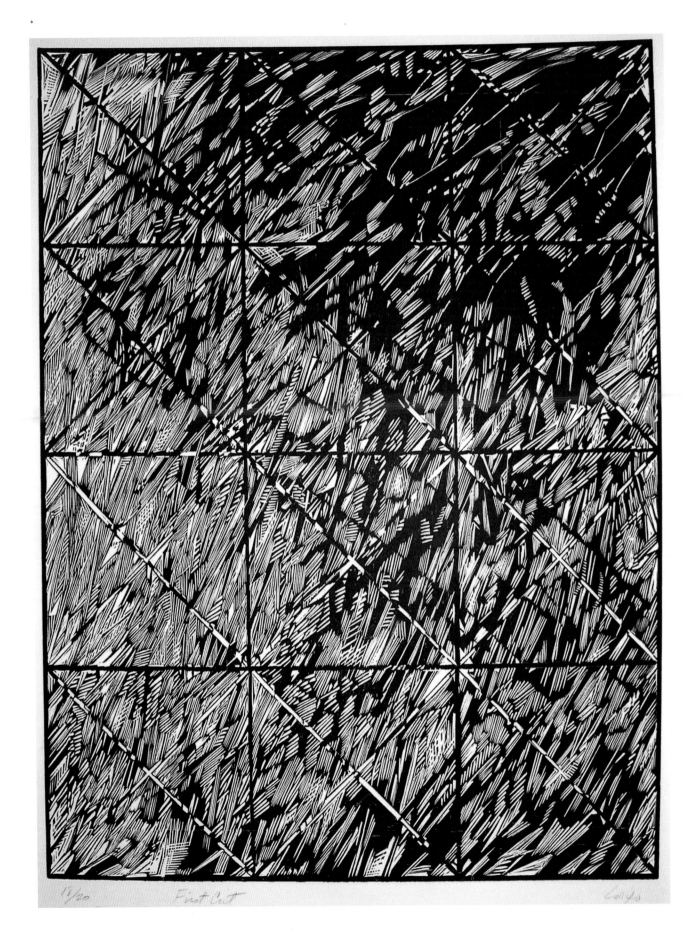

18/20 First Cut Col 9

Here are the basic steps for creating a single-color reduction woodcut:

1 Prior to printing, outline the block area on each sheet of printing paper to ensure consistent margins throughout the edition.

2 Carve out the area of the block that is to remain unprinted. Print the first-state proof.

3 Carve the block some more. Print the second-state proof.

4 Carve the block again, and print it again. Repeat until the final carving and printing.

When completed, the edition of a reduction print is considered closed, as most of the block's surface has been cut away and no more prints can be printed from the block. This is in contrast with the multiblock method (see page 43), in which proofs can be created and corrections made to the blocks at any point. In the reduction method, the artist can view and correct the work only as it progressively develops.

REPAIRING THE BLOCK

Although I say that there is "no turning back" when using the reduction method, it is possible to make small repairs to the block. If you accidentally chip off a piece of the image—which is easy to do if you are working against the grain of the wood—immediately glue the chipped piece back in place with wood glue and let it dry thoroughly before proceeding. If you lose the chipped-off piece, you can use plastic wood or acrylic modeling paste to recreate the original surface.

Vincent Longo, *Second Cut*, detail, 1974, reduction woodcut, 18 x 24 inches (45.7 x 61 cm). Courtesy of the artist.

Opposite: Vincent Longo, *First Cut*, 1974, reduction woodcut, 18 x 24 inches (45.7 x 61 cm). Courtesy of the artist.

When Vincent Longo began making woodcuts in 1953, he set himself the problem of countering the "indirectness" of prints as best he could. Printmaking usually consists of fragmented methods and processes; Longo countered this by never working from a primary sketch but instead painting directly on the wood's surface and then carving it out. He carved freely

His technical mastery developed in the doing. Longo's carving became increasingly free and brushy. He was after an "autographic" art—abstract writing without any tightness. He tried to push printmaking away from the then-prevailing mystique of graphic technique and out from the confining, intimate scale of the book. He worked large and rapidly,

and etchings; for the most part, his woodblocks have continued along more expressionist lines even into the later years of his career. Thus, even when he uses grids in his woodcuts, a direct, spontaneous approach remains a constant attribute.

Longo says about his work, "As Picasso once said, 'I do not seek, I find.' I try to choose the right means for what is most important, what I consider to be the essential qualities of the medium. In woodcut, it is carving. In etching, it is drawing with acid, impress of plate to paper. Printmaking has the finality, the absoluteness, of stamp and seal. Means only serve formal aims and considerations. The aim is not to celebrate process, but to use it for specific effects, to explore predetermined sets of problems, in which images occupy a central role. Hence, the artist must find the means that suit his purposes and inclinations. Sometimes, he must invent them. Making art has to do with leaving traces. That's what human life is about, leaving a trace of yourself."

About the print *Imago*, shown on page 37, Longo says that it was "cut from a pine plank—thirty-two by eighteen inches. I found it in a tool shed at Yaddo, in Saratoga Springs, New York. It had a long triangular gash from the bottom

PRINTMAKER PROFILE: Vincent Longo

vincentlongoartist.com

"As Picasso once said, 'I do not seek, I find.' I try to choose the right means for what is most important, what I consider to be the essential qualities of the medium."

over and into the areas of India ink that he had painted roughly on the block, and the image evolved from the overall activity. Proofs were taken only when the image was in its final stage of development. Then, during the middle and late 1950s, Longo looked closely at the woodcuts of Paul Gauguin, Ernst Ludwig Kirchner, and Wassily Kandinsky. His understanding of these masters helped him to control the black-on-white and white-on-black interchange between positive and negative space within a single print. He was also influenced by Abstract Expressionism, particularly by the works of Jackson Pollock and Willem de Kooning, and he wanted to apply the same sort of free expressiveness to the resistant wooden block.

celebrating the power of black and white but also making the directness and energy of the cutting inseparable from the image. Some two-by-four-foot prints were cut in just one or two working sessions.

Longo's elimination of preliminary studies and his willingness to allow image quality to be determined by the method and act of carving brought his woodcuts as close as possible to being primary creative works rather than synthesized copies of drawings several times removed. It was as if the drawing and its repetition occurred simultaneously.

Around 1964, Longo's work became more ordered, incorporating circle/square imagery and lattices. But this development was more apparent in his paintings

Vincent Longo, *A Turning*, 1963, color woodcut, 24 x 50 inches (61 x 127 cm). Courtesy of the artist.

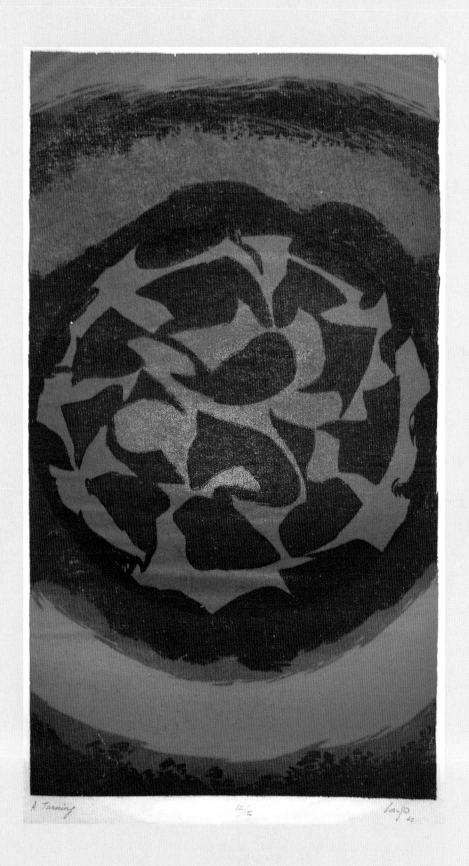

A Turning 15/15 Lloyd 45

rising toward the center. I used this imperfection as the beginning of a black-and-white improvisation about expanding the center by brushing black lines and forms on the surface and carving into and around them to create an image that represented, in my mind, how something might begin to be—as though I did not invent it, it appeared, a burst of energy."

Of his color reduction prints, Longo says, "Traditionally, multi-color relief printing requires a key block plus another block for each additional color. In 1956 I resided in Sanary-sur-Mer, a small fishing village west of Toulon in the South of France. Planks of wood were not readily available, so I asked a carpenter to prepare one for me with which I was to devise a method of color printing from a single carved surface. I had to find a way to control the placement of each color. I made a register frame (or jig) to hold the block in place as well as the sheets of paper to be printed. I then did some initial carving and printed the first color, which was done by inking the block and rubbing the back of the sheet with a wooden burnisher. I pulled several proofs and proceeded to cut into the block's surface and printed the next color. As the print develops, the surface of the block is gradually reduced. This simple process was particularly suited to my way of making art, which is usually done without prior sketching or exact layouts. Since that time many of

Vincent Longo, *On a Drawing Board*, 1986, color reduction woodcut, 29 x 22 inches (73.7 x 55.9 cm). Courtesy of the artist.

my color woodcuts were done in this reductive way, which entails printing an entire edition automatically without the benefit of a bon à tirer proof. I have been told that I was the first printmaker to make and exhibit reduction woodcuts. I know that Pablo Picasso began a series of linocuts that were done in a similar way, and around the same time, also in the South of France.

"This particular print, *On a Drawing Board*, [shown above] was printed on my etching press, which was not designed for relief printing. It requires a carrier frame to block the heavy rollers from damaging the surface and edges of the woodblock during the press run."

(The profile of Vincent Longo continues in chapter 6, Acid Intaglio Techniques, page 128.)

Vincent Longo, *Imago*, 1954, reduction black-and-white woodcut, 54 x 39 inches (137.2 x 99 cm). Courtesy of the artist.

SINGLE-BLOCK MULTICOLOR
REDUCTION METHOD

You can also use the single-block reduction method for multicolor prints. For each color pass, you remove more material from the block. Any area that is not cut away will pick up the ink. Each color is printed on top of the previous one. The entire edition must be printed while the carving occurs, because the printable area of the block is reduced with each pass. Generally, colors are built up from light to dark, so that the darker colors are not dulled by being overprinted with lighter colors. Depending on the opacity of the ink, underlying colors may influence the hue of the colors printed over them. (For example printing red over yellow will create orange.) As with the single-color reduction method, the edition is closed when the last color is printed.

Printmaker Karen Kunc used the reduction process for her color woodcut *Along an Event Horizon.* First, she drew thumbnail sketches of ideas with a pen, then made a graphite drawing on several sheets of frosted Duralar scaled to the size of the print (14 x 50 inches). She transferred the drawing onto three woodblocks using carbon paper, then followed the procedure here.

1 Kunc carved the receptive birch plywood surface with gouges for the white areas and the patterns, shapes, and textures that would appear during the successive reduction carving stages. Kunc also used other tools to mark the surface, including drypoint needles, wire brushes, knives, and nails.

2 Kunc then used a paper stencil when applying oil-based lithography ink onto the wood surface, enabling her to selectively ink different colors in different areas.

3 Kunc then used her fingers to soften the edges of the ink on the woodblock. The ink is very transparent, which will give it a luminous quality when it is embedded into the fibers of the paper.

4 This photo of the three blocks shows the last stage of the successive carvings and reductions that destroyed the blocks as the print evolved. The three blocks were printed on an etching press with a thin pressboard on top of the paper and inked block, without felts. The final print appears opposite.

Karen Kunc, *Along an Event Horizon*, 2013, three-block reduction color woodcut, 14 x 50 inches (35.6 x 127 cm). Courtesy of the artist, photo by Max Yela, University of Wisconsin.

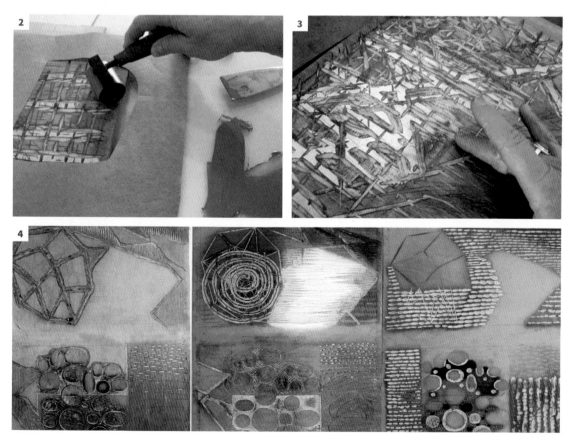

Photos in this series by Max Yela.

Joining a wave of artists reacting against the cold conceptual work of the 1970s, Karen Kunc has helped lead the resurgence of interest in woodcut. She is interested in the surface of the wood—its sensitivity to scratches, dents, carved marks, wire brushing, and so on—and she tries to extend the vocabulary of marks she makes across this surface. She considers all such marks a

incising into a "living being," is a destruction/creation cycle, and is the artist's task.

The woodcut always conveys a "reductive" way of working: The process starts with everything intact, then removes material, carving it away to reveal the idea, the image. Some of us think best in this reductive process, as opposed to additive processes. Working in

focusing on how colors warm it up. The shapes are organic and responsive to nuances of placement, proximity, and electric tensions between edges. I see spirit and a sense of connectedness to my inventive forms, and also to the void between; I animate it all with my attention, with the marks, with reversals of positive to negative and also negative areas then becoming significant, even when my choice is to do nothing, to not put ink on emptiness or on an object."

PRINTMAKER PROFILE: **Karen Kunc**
karen-kunc.com

"I see spirit and a sense of connectedness to my inventive forms, and also to the void between."

"translation," and she is fascinated by how they are transformed in the making of the woodcut and how they are visible in the inked impression. She investigates the surface of the block as a means to make large areas of color that go from full saturation to delicate transparent washes even while retaining the wood grain, so that the transferal from the wood surface is evident. She likes the engagement with intractable materials: the wood that wrestles with her as it asserts its grain and growth pattern while capturing the energy and physicality of her muscles pushing the tools to carve the marks. She conceptualizes on the wood itself, which was once alive but is being "sacrificed" for human needs. This destruction of the block, this carving and

this this way accentuates thinking in positive/negative modes, which is always very challenging.

In Kunc's *Urban/Rural Divide* series, water is also a subject, metaphorically and symbolically. For her entire life she has asked herself, "How did things come to be the way they are?" So she thinks of the forces of nature, the influences of environmental conditions, human beings' effects on the earth, the changing conditions over eons—or in a cataclysmic instant—and the scientific revelations and imaginings of the invisible forces that drive all things, including human desire, avarice, and drives to nurture and destroy.

As Kunc says, "I think that I tend to personify forms, give inanimate shapes a sense of being,

Many forms recur in her work, becoming her vocabulary, but they are always recut, renewed in a new context, all to expand her understanding and speculation on what they mean. In her handmade way, all these forms and motifs have personality. They are not cold; they are considered and then become charged spaces or shapes. All vibrates visually and conceptually.

Karen Kunc, *Verse from Macrocosmica*, 2010, color woodcut, 29 x 24 inches (73.7 x 61 cm). Courtesy of the artist.

Karen Kunc, *Fermentation*, 2010, woodcut, polymer relief, mixed media, 17 x 56 inches (43.2 x 142.2 cm). Courtesy of the artist.

Western-Style Multiblock Woodcuts

The multiple-blocks technique, in which there is a separate block for each color, requires a lot of carving, but the advantage over the single-block technique is that, when printing Western style with oil-based inks, the artist does not have to print the entire edition all at once. When using oil-based inks, the printing paper does not necessarily have to be dampened; therefore there is no real time limit between the color passes. And because each block is inked separately, it is possible to experiment with color variations of the same image.

As with the Japanese method (see page 44), this process requires cutting a key block and additional blocks for each color. The key block holds the main design, while additional blocks are carved to enhance and complete the key block. Careful registration of each block on the paper is crucial to achieve a successful print, so the blocks should be of exactly the same dimensions. In order to plan the color print and visualize how the work will progress, it is a good idea to first print each color on a clear Mylar sheet and place the sheets on top of one another. The Mylar layers should be cut to the same size as the printing paper and marked for registration.

There are two main methods of registering a design on multiple blocks: the tracing paper method and the color transfer method.

TRACING PAPER METHOD

For the tracing paper method, follow these steps:

1 Make a tracing of your composition with a graphite pencil, then transfer the image to each separate block by placing the tracing paper facedown on the block and going over all the lines with a ballpoint pen, which will transfer the lead to the block.

2 Use magic markers or ink to fill in the area that each block will print. Cut the blocks accordingly, and proof them while the cutting progresses.

COLOR TRANSFER METHOD

In the color transfer method, ink is used to transfer the design onto the blocks. Follow this procedure:

1 Draw the design on the key block with pencil. Cut the key block of the main composition and print it on a Mylar sheet.

2 While the ink is still wet on the Mylar, transfer it to the second block, to secure the exact placement of the image on the block. Place the inked Mylar sheet facedown on the second block, and transfer it by burnishing the back. Dust the fresh ink with talcum powder to avoid smearing during cutting.

3 Using this same technique, transfer the image to each subsequent block, making sure the image is correctly registered on each block.

Karen Kunc, *Song of the Lark*, 2010, multiblock color woodcut, 29 x 24 inches (73.7 x 61 cm). Courtesy of the artist.

Japanese-Style Multiblock Woodcuts (Ukiyo-e)

The basics of the Japanese woodblock print process have been explained in chapter 1 (see pages 22–27). Here are the steps for beginning a ukiyo-e print:

1 Draw a design on thin white paper.

2 Draw the kento registration marks on the paper, one in the lower left corner and the other three-quarters of the way along the bottom side. (Remember that the orientation will be reversed when the drawing is pasted down on the block.)

3 Spread rice paste evenly on the key block, tapping it with the palm of the hand to raise tiny peaks of paste, and paste the drawing facedown on the block.

4 Carve out the lines of the drawing, making incisions on both sides of each drawn line.

5 Use a shallow round chisel to clear away waste wood in the interior spaces of the design, and to cut trenches around the cut lines.

6 Use a smaller chisel to clear away waste wood along the lines.

7 Use a wide chisel to carve out the wood around the edges of the design.

8 Carefully carve around the registration marks.

9 Print the key block in black as many times as needed for the color blocks.

10 Paste these prints on all the other blocks. Carve each according to the planned color separation.

Mike Lyon, *Madeline and Kit*, 2012, ukiyo-e-style woodcut, 5 $7/10$ x 13 inches (14.5 x 33 cm). Courtesy of the artist.

Contemporary Kansas City printmaker Mike Lyon works in an updated version of the ukiyo-e method, using a computer numerical control (CNC) device to carve the blocks. Here's a look at the process Lyon followed for his print *Madeline and Kit.* The finished print is shown opposite.

An Updated Ukiyo-e Process

1 An image of all eighteen blocks to be used in the print was computer generated. Lyon then carved the eighteen images from a single 48-by-48-inch sheet of birch plywood using a CNC router, and the individual blocks, each measuring 16 by 7½ inches, were cut apart on a table saw. (One block was later ruined and discarded.)

2 After dabbing it with rice paste, Lyon inked each block with water-based pigment using a wide brush.

3 Lyon registered the paper on each block, following the raised kento registration marks.

4 Lyon rubbed the baren on the back of the paper.

5 While printing, Lyon stacked just-printed prints facedown in a drawer of a cabinet designed to keep moisture in. The sheets were shifted vertically and horizontally to help equalize the moisture throughout each sheet.

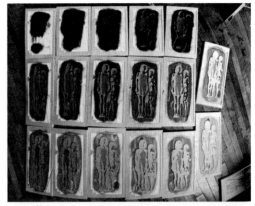

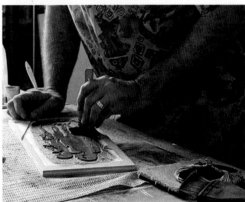

Photos in this series by Mike Lyon.

PRINTMAKER PROFILE: **Mike Lyon**

www.mlyon.com

"The artistry is really in printing, not carving."

Mike Lyon, who is based in Kansas City, has always been driven to build things. In recent years he has been making large drawings, paintings, and woodblock prints using computer software he has written or adapted for computer numerical control (CNC) machinery, which he has also invented or adapted. He continues to use traditional materials, but his processes are very unconventional.

In the mid-1990s, long before getting into computer carving methods, Mike Lyon spent five weeks studying Japanese ukiyo-e technique with Hiroki Morinoue, which led to his 2004 exhibition of woodblock prints, entitled Mike Lyon: My Life, at the prestigious Ezoshi Gallery in Kyoto, Japan. During that time he developed a special appreciation for Japanese printmaking, and his interest in collecting Japanese prints really took off.

After years of hand-carving blocks—a process that is both time-consuming and painful—Lyon decided in the spring of 2004 that he needed assistance to produce the new body of work in large format that he was envisioning. This assistant turned out to be a ShopBot CNC (computer numerical control) router. This device can handle the cutting of woodblocks as large as 48 by 96 inches and can be programmed to accurately follow the artist's drawings to within a few thousandths of an inch. Coded instructions control the movement of the ShopBot's router bit along the X (length), Y (width), and Z (height) axes. When Lyon struck on the idea of adapting the ShopBot to carve his blocks, he developed a program to extract the information contained in a digital photographic file and convert it to a format the ShopBot understands. The photo opposite shows Lyon's CNC router carving a large panel in the artist's studio.

Responding to occasional criticism about using a computer-controlled carving tool rather than hand-carving, the artist observes, "Although I am able to carve much finer details by hand than I can by using my machine, my machine-carved blocks are superior in some ways to blocks I carve using hand tools, and I can produce larger blocks much more rapidly. The artistry is really in printing, not carving, although that may be difficult for non-printers to understand."

Using a CNC router allows Lyon to use what amounts to a reduction-carving approach with multiple blocks rather than a single block. On each successive block, the carving of preceding blocks is essentially repeated along with additional reduction.

(The profile of Mike Lyon continues in chapter 15, Post-Digital Graphics, page 292.)

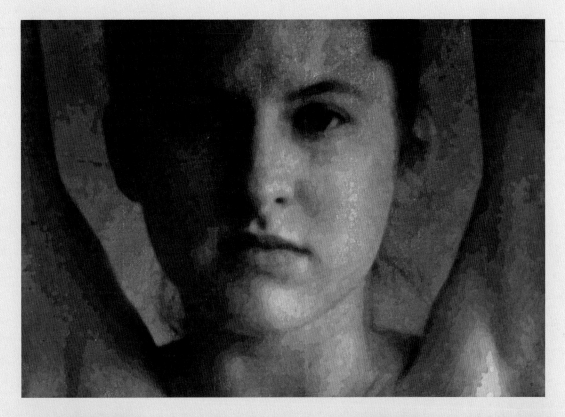

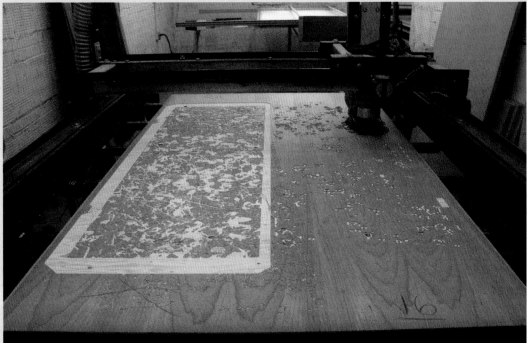

Top: Mike Lyon, *Sarah*, 2004, woodblock print from 19 cherry
wood blocks, 30 x 21 inches (76.2 x 53.3 cm). Bottom: Mike Lyon's
CNC router carves a sheet of plywood. Photo by Mike Lyon.

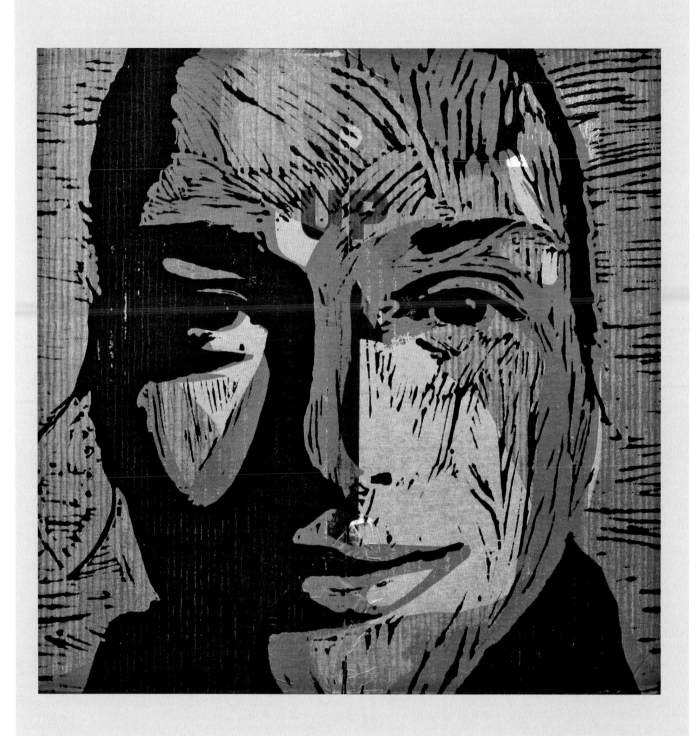

3

Linoleum Block Printing

Linoleum block prints—also called linocuts—can be boldly graphic or intricately detailed. Like carving a woodblock, carving a linoleum block is a subtractive process: The cutaway areas will not print. Unlike woodblocks, however, linoleum has no directional grain, and this homogeneous surface often produces greater contrast between the printed and unprinted areas. The medium has long been popular in educational institutions because linoleum blocks are relatively inexpensive and the procedure for cutting them is simple. But linoleum block printing isn't just child's play; the medium can permit the highest degree of artistic creativity.

Equipment and Materials for Linocuts

Linoleum blocks, which are available in a wide range of sizes, are made of resin, powdered cork, and linseed oil, with burlap backing. Some linoleum blocks are unmounted, and some are mounted on a wood base. (Large linoleum blocks are usually unmounted.) The only difference between mounted and unmounted blocks is their thickness, and the need to adjust the press accordingly.

I recommend you try the Speedball brand's S4386 Smokey Tan linoleum blocks if you're working with oil-based inks. Speedball's S4308 Smokey Tan blocks are made for use with water-based inks, and Speedball's 4366 Gray blocks are suitable for either water- or oil-based inks. There are softer block-printing materials, made for children, that are easier to cut, but these deteriorate quickly and break

Slavko Djuric,
Muy Divertido 6, 2013,
linocut, 16 x 16 inches
(40.6 x 40.6 cm).
Courtesy of the artist.

apart under pressure during printing. Harder lino-leums are more difficult to cut but allow for a lot of detail and hold up to a longer print run. If you wish, you can use a clothes iron to heat up the block and soften it before carving.

Knives and gouges with either V- or U-shaped cutting heads are used on linoleum. Wide U-shaped or C-shaped gouges are used to clear broader areas. Speedball offers inexpensive sets of linoleum-carving tools with several types of blades, but these blades are made of soft steel, which is impossible to sharpen. The Speedball tools are appropriate for school students, but professional printmakers prefer hard steel gouges (with wooden handles) that can be sharpened on a sharpening stone.

Single-Color (Black and White) Linocuts

There are three main approaches to creating a single-color linocut:

1. A linear approach, in which the image is created by carving out lines that will remain unprinted, or white, when the block is printed.

2. A three-dimensional or positive/negative approach, in which line is ignored in favor of bold shape cutting, emphasizing the form through negative and positive spaces. A shape can be defined by clearing the areas around it with a gouge or, oppositely, by carving out the shape itself and leaving the surrounding areas intact.

OTHER TOOLS AND MATERIALS

Besides linoleum blocks and cutters, you'll need some other tools and materials for linocut printing:

- ❯ 2B graphite pencils and/or fine Sharpie pens for drawing on the block
- ❯ Tracing or transfer paper for transferring a design to the block
- ❯ Mylar sheets for color registration with multiple blocks
- ❯ Brayers for applying ink to the block
- ❯ Oil-based relief ink from Speedball, Hanco, Graphic Chemical & Ink Co., or Gamblin. These makers also produce water-based inks for linocut.
- ❯ Printing paper. Paper for relief should be smooth, without texture. Suitable papers are made by BFK Rives, Somerset, Fabriano, and Arches (the Arches Cover line). Oriental rice papers can also be used for linocut.

3. A tonal approach, in which tones are introduced and various textures are obtained by making many small cuts on the block. Tones can be achieved through cross-hatching and parallel lines cut with a small V-shaped tool and can be varied by moving the lines closer together or farther apart.

French artist Jacques Moiroud does large-scale relief linocuts based on photographs he takes of his models. Choosing an image that inspires him, he then makes a linear drawing, the same size as the intended print, on Mylar with a graphite pencil (2B or higher). Opposite are the steps he followed when carving and printing the mono-chrome linocut *Timbuktu*.

Photos in this series by Jacques Moiroud.

Monochrome Linocut

1 Moiroud placed the Mylar drawing face-down on the linoleum block and traced it, transferring the graphite to the linoleum. He then redrew the image on the linoleum using a fine-tipped Sharpie.

2 He then carved the linoleum using various sizes of carving blades: #1 is good for detail work; #3 is handy for clearing out large white areas.

3 Moiroud used a palette knife to spread some oil-based relief ink on the inking table, then rolled out a thin film of ink with a brayer. Once the brayer was charged with ink, he coated the surface of the linoleum block evenly, rolling the brayer across it in many directions.

4 He then placed the inked block face up on the bed of an etching press and laid the paper on top. He covered the paper with a large Plexiglas sheet and pulled the first proof. The photo below, left, shows Moiroud lifting the print off the block. The final print of *Timbuktu* appears below.

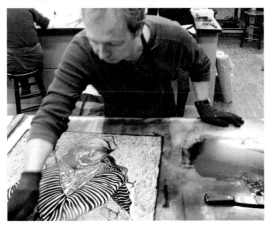

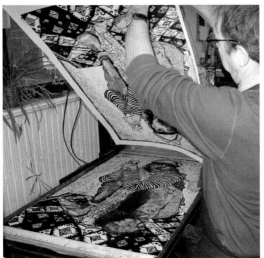

Jacques Moiroud, *Timbuktu*, 2009, linocut, 24 x 32 inches (61 x 81.3 cm). Courtesy of the artist.

Jacques Moiroud likes to quote Jean Cocteau: "Poets don't draw. They untie handwriting and then knot it up again in a different way." Drawing is writing, therefore a poem and a story.

Moiroud's subjects are life, space, and time. When asked how he approaches these concepts, he answers, "Improvisation, always. If I wanted to plan anything, I'd

About the print shown here, Moiroud tells this story: "I saw this girl at the cafeteria, working behind the cash register: beautiful, unsmiling, a little scary. Didn't know how to ask her to sit for me. I bribed some guy—it cost me a (plain) croissant—to go talk to her on my behalf. Turned out she was very happy and willing since she knew and liked my work. So

Jacques Moiroud, *The Distance between You and Me*, 2011, linocut, 24 x 32 inches (61 x 81.3 cm). Courtesy of the artist.

PRINTMAKER PROFILE: **Jacques Moiroud**
www.jacmo.com

"I like scratching that linoleum for weeks. It keeps me from thinking too much."

go back into the box, working for the man. Printmaking is essential for me, as a daily challenge to my lack of patience and discipline. Printmaking takes no prisoners. It is hard work, and a somewhat punishing process, with no result guaranteed. Of course, the definitive nature of a linocut is part of the whole thing. Frankly I don't consider myself a 'technical' printmaker and wouldn't vacation at printmakers' conventions. Linocut is a straightforward process, the way I do it. Not too much fussing around.

"And I like scratching that linoleum for weeks. It keeps me from thinking too much. Call me a lazy printmaker if you like. My technique has gotten better. My style? I don't know. You tell me."

I drew her on a piece of Mylar the size of the final print. Later I would transfer the sketch to linoleum, redraw it with permanent markers, and start cutting. This process may take up to two months, since I work with small V-shaped gouges on large plates.

"As we were talking, while I was drawing her, I realized this portrait was as much about her as it was about me, and therefore about all that keeps us apart from each other—time, space, culture . . . and that this was valid for all the portraits I had done before. That's how I came to title this one *The Distance between You and Me*.

Color Reduction Linocuts

The color reduction method, also called the elimination or suicide method, was favored by Pablo Picasso. Color reduction for linocuts works the same way as color reduction for woodcuts. The highlights are carved out first, and the block is rolled with ink and printed on every sheet of paper for the whole edition (plus extra sheets for the artist's proofs). Further cuts are made, the block is inked with the second color, and all the sheets are printed again. This goes on until all the colors are printed and very little is left of the block. The order of printing the colors is usually from light to dark.

Linocut color reduction can be done from a single block, or, in a more exacting method, by using several reduction blocks for one image: One block is used for all the yellows and related colors, another for the reds, the next for all the blues, and the last for the grays and blacks. Beginners are encouraged to prepare a design on layers of tracing paper at the correct scale and including color references.

Artist Tenjin Ikeda has worked extensively with color reduction linocuts. On the following page are the steps he followed to make a seven-color reduction linocut from one block.

Tenjin Ikeda, *Power Concealed*, 2007, reduction linocut, 9 x 12 inches (22.9 x 30.5 cm). Courtesy of the artist.

Color Reduction Linocut Process

1 Ikeda drew directly on the linoleum block in pencil, then went over the drawing with a Sharpie. (Because the Sharpie's ink is permanent, the original drawing remains on the block after the first color is printed.) Ikeda carved out some areas that were to remain unprinted.

2 Ikeda used a brayer to coat the block with the first ink, which was yellow. The block was then printed on an etching press. To ensure proper registration, the paper was laid on the bed of the press first, and the block was placed on top, ink side facedown. The entire numbered edition was printed with the first color before the carving was done for the second color. The block was then carved further and inked with a second color, a golden yellow. Again, the entire edition was printed. Then the block was carved again for the next color, green.

3 Ikeda carved the block even further, inking it with the next color, blue. He then printed the whole edition again.

4 Further carvings were performed on the block, and the whole edition was again printed at each stage, in pink, then purple, and finally brown. The final print, shown opposite, is a seven-color linocut reduction print.

Photos in this series by Tenjin Ikeda.

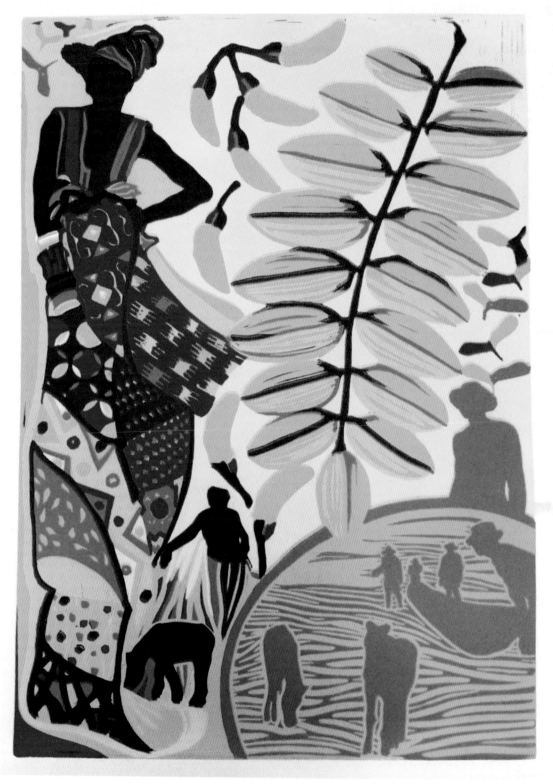

Tenjin Ikeda, *Blue Sea Vibrant Cloth*, 2014, color reduction
linocut, 12 x 18 inches (30.5 x 45.7 cm). Courtesy of the artist.

PRINTMAKER PROFILE: **Tenjin Ikeda**
www.adesoji.com

"It started from a dream that I had."

Tenjin Ikeda gets ideas for pieces he wants to create from his imagination, as well as from dreams, conversations, music, and poetry. Relief printing speaks to him of something ancestral, something that is "in his DNA." He thinks of his work as storytelling—like the storytelling his ancestors did, setting down their tales for future generations, although Ikeda's stories can at times be fragmented and abstract. He likes to tell stories through texture, and he is interested in being "in the moment" of creation. He likes working with his hands, building and creating. For him, working is like meditation—keeping silent and being one with his materials and tools while processing the multitude of thoughts and emotions that are running through him. The end result is amazing, but he gets the most fulfillment from the process. Today he mostly works in linocut and woodcut because these mediums offer him such engagement in the art-making process.

About the print called *The Gatekeeper*, shown opposite, Ikeda says, "It started from a dream that I had. With the color reduction process you ideally should know and plan the colors you are going to use and start with the lightest color first. You need to establish what your edition is going to be because between each layer of color you are cutting away material to reveal the previous color that you printed. The first color printed was yellow, and then I had to decide where I wanted the yellow to show through. After determining that, I cut those areas away on the piece of linoleum. I let the ink dry, which takes about a day, sometimes longer, depending on the ink that is used. For some reason different pigments work differently. The next color was a raw sienna printed exactly where the yellow was, and since I've cut the material away, the second color prints only where I want it to. Then I go through the process of letting the ink dry and cutting the last color, which was graphite. I did this process for each of the sections. The top is a two-color reduction and the center and bottom are a three-color reduction. Altogether, the image has four colors plus white."

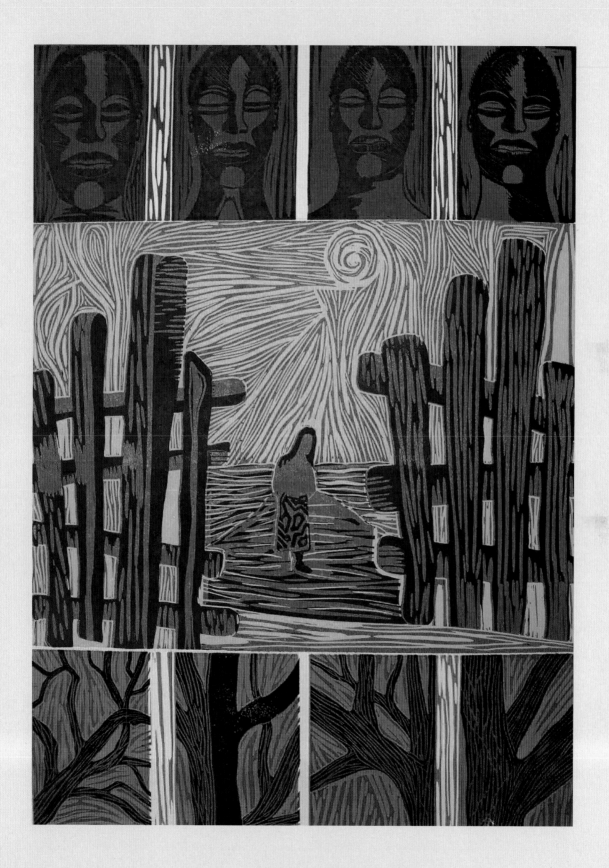

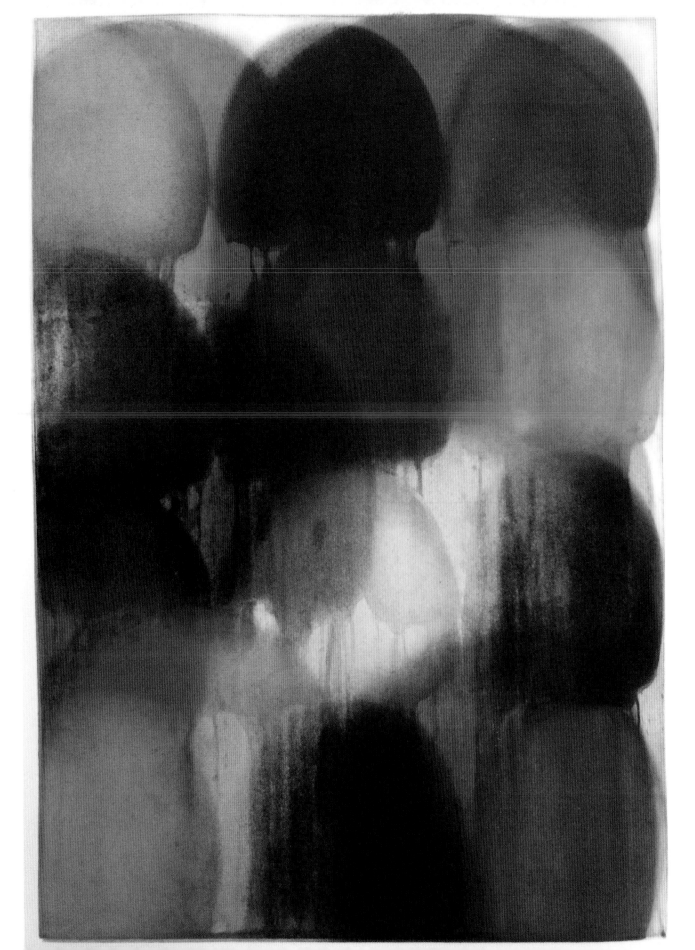

Intaglio Printmaking

PART II

Intaglio Printmaking Background and Basics

The term *intaglio* comes from the Italian word *intagliare*, meaning "to carve" or "to cut into." Intaglio is the opposite of relief, in that the incisions on a metal plate are what are inked and printed; in relief, only the top surface is inked. After lines, tones, and textures have been cut or etched and filled with ink, the surface of the plate is wiped clean, leaving ink only in the incisions and indentations. Dampened paper is pressed against the plate with enough pressure to force the paper into the grooves to pick up the ink.

Patricia Acero, *Rodeo 1*,
2009, sugar lift aquatint,
18 x 24 inches (45.7 x 61 cm).
Courtesy of the artist.

Intaglio processes can be divided into two categories: the non-acid techniques and the acid techniques. In the non-acid methods, tools are used to directly engrave, cut, or scratch the metal plate. Non-acid methods include the following:

› **Drypoint.** A line is scratched in the metal with a sharp tool, displacing the metal and raising a burr. When the plate is inked and wiped, the incised groove holds the ink, producing a rough line with soft edges, unlike the crisp line of an engraving or etching. The burr is fragile and flattens after a few impressions.

› **Engraving.** Sharp and smooth lines are cut in the metal with an engraving tool called a burin. Tonality is achieved by engraving parallel lines close together (hatching) or through intersecting lines (cross-hatching). The lines of an engraving are clean and rigid, vary in thickness and length, and are noticeably tapered at the ends.

> **Criblé.** Holes or dots are punched in the metal plate using a variety of pointed tools. One of the earliest intaglio techniques, criblé is rarely used today but is sometimes combined with other intaglio methods.

> **Mezzotint.** An entire plate is roughed up with a tool called a rocker, so when rocking is completed, the plate prints as a solid black. Working from black to light, tones are achieved by burnishing areas of the plate, flattening the burr created by the rocker to create light areas. Sometimes called *manière noire*, mezzotint is the only intaglio method that is a reverse process; it is known for its rich, luscious black tones and soft, subtle areas of light. (Manière noire can also be achieved from a black aquatint instead of a rocked plate; see page 63.)

> **Collograph.** A surface is built up rather than being cut or etched. The additions—of cardboard or other materials of varying thickness—are glued in layers to the surface, and the surface is varnished before being printed as an intaglio plate. In some collograph techniques, acid is applied to the plate's surface.

> **Photocollography.** A silkscreen light-sensitive photo emulsion is applied on a thin wood board or Masonite panel and let dry in the dark. A positive image printed on acetate or another transparency is placed on the coated panel, which is then exposed to UV light. After exposure, the emulsion is washed off the board. (The photocollograph can be printed as an intaglio or as a relief using a brayer.)

E. Valentine DeWald, *Crown Graphic*, 2011, mezzotint,
3 x 4½ inches (7.6 x 10.2 cm). Courtesy of the artist.

In the intaglio techniques that use acid, the plate is chemically processed and drawn on with various grounds and coatings, then exposed to the action of the acid. The longer the metal plate etches, the deeper it is bitten, determining how much ink the plate will hold. Acid methods include these:

> **Hard-ground etching.** A plate is coated with acid-proof hard wax ground, and lines are drawn with the etching needle. The plate is then etched in acid to make the lines permanent in the metal, and the ground is removed before printing the plate. Etched lines have blunt terminations and look similar to lines drawn with a pen. Cross-hatching is used to create volume and contour.

> **Soft-ground etching.** A plate is coated with slow-drying etching ground and a thin tracing paper is laid on the soft ground. The artist draws on the tracing paper with a pencil, pressing through the soft ground. When the paper is lifted from the surface, the soft ground is pulled away from drawn areas, leaving a granular soft line similar to a pencil-drawn line. Fabrics, leaves, and other textures can also be pressed onto the ground using the etching press, leaving an impression that is then etched in acid.

> **Aquatint (also called aquaforte).** This intaglio process creates a tonal field. Particles of acid-resist material (powdered rosin or lacquer spray paint) are deposited and fixed to the plate. When the plate is immersed in acid, only the interstices around the particles are etched, creating a granular tone. Depending on the size of the particles and the timing in the acid, a whole tonal range from white to black can be achieved.

Sylvie Covey, *Maternity*, 1979, soft-ground aquatint,
4 x 4 inches (10.2 x 10.2 cm).

Spit bite. In this aquatint technique, an aquatinted plate is brushed with acid rather than being immersed. The depth of the bite is regulated by the amount of acid on the surface and the time it is allowed to remain there. To control the application, a small amount of saliva, ethylene alcohol, or gum arabic is added to the acid; traditionally, a clean brush was coated with saliva, dipped into acid, and brushed on the aquatinted plate, hence the term spit bite.

Embossing. A raised impression is created on dampened paper by a deeply etched metal plate, a cut Plexiglas shape, or a collograph plate. Embossings can be made with or without ink.

Lift-ground etching, also called sugar lift. In this painterly intaglio technique, a sugary solution is painted on a plate, then covered with a thin liquid hard ground and left to dry. When immersed in warm water, the sugar dissolves and lifts the ground, exposing the metal. The plate may also be aquatinted before etching in acid.

Open bite etching. Unprotected areas of the plate are exposed to acid, producing a light continuous tone that is uncontrolled (unlike the dotted tones of an aquatint). An acid bath lowers the surface of the plate around any stopped-out areas, but since both the bitten and stopped-out areas remain relatively smooth, ink is mostly held around the periphery of the raised design.

Photo-etching. An etching plate is laminated with acid-resist light-sensitive polymer film, covered with a positive halftone photographic image printed on clear acetate, and then exposed to UV light. The UV light hardens the exposed non-image areas. After the plate is developed and etched, it retains ink only in the image areas.

Francisco Feliciano, Untitled, 2008, aquatint with chine-collé (Ezchizen Shikibu Gampi on Arches Cover), image 9 x 12 inches (22.9 x 30.5 cm), support paper 22 x 30 inches (55.9 x 76.2 cm). Courtesy of the artist.

Bernard Zalon, *NYC Mandala*, 2006, embossing, 5 x 5 inches (12.7 x 12.7 cm). Courtesy of the artist.

Photogravure. This photographic intaglio process uses a pre-coated light-sensitive plate. A stochastic screen laid on the plate is exposed to UV light, and then a positive image, printed on another transparency, is placed on the plate, which is again exposed. The result is a very high-quality monochromatic photographic image.

A Brief History

Although several printmaking techniques were known in Europe before the fifteenth century, they were not widely used; large-scale printmaking had to wait until paper became commonly available. That began to happen in the 1390s, when the first paper mills opened in Italy and Germany. The first European woodcuts appeared at about that time, and by the middle of the fifteenth century, intaglio methods of plate making—cutting or incising a metal plate—were in widespread use. The two main early styles of engraving developed first in Germany, where northern European artists' imagery and approach remained medieval until the mid-fifteenth century, and then in Italy, where printmakers were inspired by the aesthetics and classical ideals of the Renaissance.

EARLY ENGRAVING IN NORTHERN EUROPE

Fifteenth-century engraving, like early woodblock printing, served two distinct purposes: depicting religious subjects and creating prints for popular recreation—especially playing cards. One of the most significant engravers in northern Europe was an anonymous artist now referred to as the Master of the Playing Cards, who worked in Germany from the 1430s to the 1460s, producing more than sixty engraved playing-card designs. Another noted artist, likewise anonymous, signed his prints "E.S.," and is therefore known as Master E.S. Like the Master of Playing Cards, Master E.S. was highly skilled in linear patterning and in the creation of tone through cross-hatching. Yet another important anonymous German engraver at the end of the fifteenth century was the Housebook Master, so-called for his engravings of household objects that appear in a manuscript known as The Housebook. One significant fifteenth-century German engraver whose name we do know is Martin Schongauer (1440–1494), whose ability to convey human expression lifted printmaking to a new, superb level of artistry.

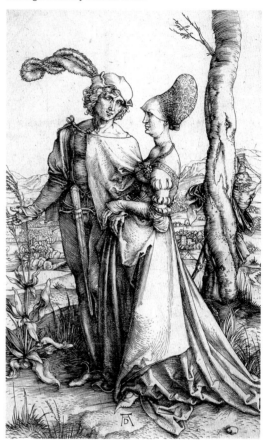

Albrecht Dürer, *The Promenade*, c. 1496–1498, engraving, sheet measures 7 3/4 x 4 11/16 inches (19.7 x 11.9 cm). Los Angeles County Museum of Art.

Schongauer had a profound influence on the work of Albrecht Dürer (1471–1528), who was the most talented artist of late fifteenth- and early sixteenth-century Germany. A skilled draftsman and painter, Dürer was also a master of woodcut, engraving, etching, and drypoint. Dürer's artistic genius, intellectual curiosity, and technical virtuosity enabled him to create engravings of a complexity unique to his era. He traveled to Italy, where he was inspired by the works of Giovanni Bellini and Andrea Mantegna, and his search for perfection and beauty served as a bridge between the northern Gothic and the southern Italian Renaissance. Dürer's talent greatly contributed to intaglio's rising to the same level as other, rival art forms.

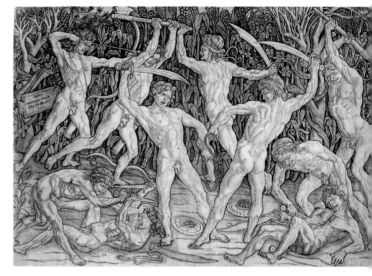

Antonio del Pollaiolo, *Battle of the Nudes*, 1470–1490, engraving, 15 ¾ x 22 ¹³/₁₆ inches (40 x 57.9 cm). Yale University Art Gallery.

EARLY ENGRAVING IN ITALY

At the end of the fifteenth century, two main schools of engraving—the Fine Manner and the Broad Manner—flourished in the city of Florence, the center of the Italian Renaissance. The most notable engraver of the Fine Manner school was Maso Finiguerra (1426–1464), who worked with a process known as *niello*, in which lines are engraved into silver or gold, then filled with a black substance called nigellum. A mixture of silver, copper, lead, and sulfur, nigellum bonds with metal when heated; after the gold or silver surface is polished, a black design is revealed against the bright background. Fine Manner engraving developed from the niello technique and, as its name suggests, is characterized by fine lines, which are closely cross-hatched to produce a tone.

Broad Manner engravers used broader lines suggestive of pen drawings. Grand pictorial scenes from the work of Renaissance painters and architects inspired Broad Manner artists. One of the most powerful and influential Broad Manner engravings in the history of printmaking is *Battle of the Nudes* by the artist Antonio del Pollaiolo, shown above.

COMMERCIAL REPRODUCTIVE ENGRAVING

In the sixteenth century no engraver came close to Dürer's artistry. However, commercially printed engravings took over the world. The skill of copying an image and cutting a plate to reproduce it commercially became just as important as artistic creativity, if not more so. As a consequence, commercial engravings degraded the art form, and, for a while, printmaking lost the shine given it by the previous masters. But commercial engraving did serve the useful function of spreading information: Reproductions of Italian Renaissance art traveled all over Europe, and it was commercial engravings that eventually gave Rembrandt, who never ventured beyond Holland's borders, the opportunity to study these achievements.

EARLY FRENCH ENGRAVING AND ETCHING

The earliest known French engraver is Jean Duvet (1485–after 1562), from Burgundy, whose most important work is a series of monumental engravings depicting the Apocalypse, circa 1540. One of the most illustrious of the early French masters was Jacques Callot (c.1592–1635), who trained as a goldsmith and had studied the works of Martin Schongauer. Under the patronage of the Medici family, Callot also spent ten years in Florence studying engraving and experimenting with etching, a new process in which a waxed copper plate was drawn on and then bathed in acid. Callot made an important technical advance in etching technique when he developed the échoppe, a type of etching needle with a slanting oval section at the end, which enabled etchers to create a swelling line, as engravers could with a burin. (Although Dürer also made etchings, the process of etching

Rembrandt Harmenszoon van Rijn, *The Angel Appearing to the Shepherds*, 1634, etching, sheet measures 10 1/2 x 8 3/4 inches (26.7 x 22.2 cm). Los Angeles County Museum of Art.

with acid on copper plates is credited to German artist Daniel Hopfer, c. 1470–1536, whose technique quickly spread around Europe.)

REMBRANDT

Rembrandt van Rijn (1606–1669), probably the most gifted artist of his century, dominated seventeenth-century Dutch art. Born in Leyden, Holland, he moved to Amsterdam in 1631 and by studying engraved reproductions became exposed to the other artistic movements of his time. He was clearly inspired by the Italian painter Caravaggio's dramatic use of light and shadows—a technique called chiaroscuro—and by the sensuality and muscular strength of the work of Flemish painter Peter Paul Rubens.

Early in his career, Rembrandt made a series of religious etchings showing the influence of these masters and revealing his own spirituality and humanity. No other printmaker has expressed such profound spiritual feeling as did Rembrandt in his interpretations of religious subjects, and contemporary and later Dutch artists were largely overshadowed by Rembrandt's talent, genius, and productivity.

The invention of mezzotint, a tonal intaglio process, is credited to an amateur printmaker from Amsterdam, Ludwig von Siegen (1609–1680), who in 1646 used a small spike-toothed wheel, or roulette, to produce pits and dots on a metal plate. When inked and wiped, the printed plate produced a fuzzy black tone that could be lightened up with burnishing. This new reverse tonal procedure (going from dark to light) offered new and exciting possibilities for creating tonal areas

Frank Short, *Diana and Endymion*, 1891, mezzotint on Japanese paper, sheet measures 21 1/8 x 24 7/8 inches (53.66 x 63.18 cm). Los Angeles County Museum of Art.

in reproductions of paintings. A more accomplished artist, Prince Rupert, Count Palatine of the Rhine (1619–1682) refined von Siegen's technique, using it for a soft overall tone rather than just in sporadic places. A nephew of Charles I of England, Rupert had frequent contact with the royal courts of Europe and traveled throughout the continent gaining access to artists' circles and spreading the mezzotint process. The roulette, however, produced rough-toned prints—a roughness that was eliminated when English artist Abraham Blooteling (1634–1690) introduced a new tool, the rocker. Rocking a plate allowed a wider range of tones and created a better surface for achieving a uniform black.

DISCOVERY OF DRYPOINT

Invented by the Housebook Master, the simplest method in intaglio printmaking is the drypoint technique, in which a sharp stylus or needle is used to scratch lines directly into the metal. Scrapings on either side of the scratched line, known as the burr, hold a dense film of ink that prints as a rich, velvety black. In the nineteenth and twentieth centuries many artists produced drypoints, including Milton Avery, Max Beckmann, Hermann-Paul, Emil Nolde, and James Abbott McNeill Whistler. Mary Cassatt produced color drypoints by adding aquatint on her plates. Others who used drypoint with great success include Marc Chagall, Joan Miró, and Pablo Picasso, and Canadian artist David Milne is credited as the first to produce colored drypoints through the use of multiple plates, one for each color.

Giovanni Battista Piranesi, *The Round Tower*, 1761, etching, sheet measures 30 ⅝ x 20 ⁷/₁₆ inches (77.79 x 51.91 cm). Los Angeles County Museum of Art.

INTAGLIO IN EIGHTEENTH-CENTURY ITALY

Four artists dominated printmaking in eighteenth-century Italy: Giovanni Battista Tiepolo and his son Giovanni Domenico Tiepolo, Canaletto, and Giovanni Battista Piranesi. Piranesi (1720–1778) was the most ingenious of these printmakers. With a background in engineering and inspired by the ruins of ancient Rome, Piranesi produced fantastical architectural visions, the best known of which are the fourteen grandiose etchings known as the *Invenzione Capricciosa di Carceri*, or, in English, *The Prisons*. These imaginary prisons have huge building stones, multilevel interiors, walkways, chains, and engines—a gigantic and frightening world. Cross-hatch etched in dramatic contrasts of light and shadow, they suggest an infinite and dreadful confinement. Piranesi's *Prisons* series, made in the 1750s, remains a true jewel in the history of intaglio prints.

WILLIAM BLAKE

An eccentric genius, the English poet and artist William Blake (1757–1827) was intent on uniting the natural and the supernatural, the body and the soul, the real and the imagined. As a printmaker, he is renowned for devising his own unconventional methods: For example, in the illuminated books he made to illustrate his writings, Blake reversed the traditional intaglio method, printing some of his plates as relief. To etch the words in reverse, he devised a way of writing his text in an acid-resist substance on paper, then transferred the text to the surface of the plate, which was then deeply etched. Blake also advanced color printmaking considerably and anticipated modern processes.

William Blake, *The Vision of Eliphaz*, from *The Book of Job*, second edition, 1825, engraving on laid India (or China) paper, sheet measures approx. 7 3/4 x 5 7/8 inches (19.69 x 14.92 cm). Los Angeles County Museum of Art.

Francisco Goya, *Until Death (Hasta la Muerte)*, 1799, plate 55 of *Los Caprichos*, etching, burnished aquatint, and drypoint, plate measures 8 1/2 x 5 15/16 inches (21.59 x 15.08 cm). Los Angeles County Museum of Art.

FRANCISCO GOYA

To say that the humanist visionary artist Francisco Goya (1746–1828) was the only significant printmaker in Spain in the late eighteenth and early nineteenth centuries is not to underrate his achievement. Goya possessed extraordinary skill in the newly invented aquatint technique, which he transformed into an expressive medium by fully exploiting its range of tonal gradations. In 1787, Goya became the Spanish royal family's official court painter, from which position he witnessed the corruption of the Spanish monarchy, clergy, and government, all of whom ignored the suffering and poverty of the rest of the population. This firsthand knowledge inspired Goya to make political and social statements in his prints, including a series of satirical etchings, drypoints, and aquatints known as *Los Caprichos* ("The Caprices"— a highly ironic title; 1799) and another ferocious series of aquatints, *The Disasters of War*, done during the 1810s.

INTAGLIO IN NINETEENTH-CENTURY FRANCE AND ENGLAND

Many artists experimented with intaglio methods in France during the nineteenth century. Impressionist painter Edgar Degas (1834–1917) produced aquatints in multiple states, and his protégée and friend Mary Cassatt (1844–1926) created etchings and aquatints of great delicacy,

developing a subtle method of inking multiple plates *à la poupée*—that is, using small bundles of tarlatan (a fabric made of starched cheesecloth) to wipe areas of a plate with different colors of ink. Born in Philadelphia, Cassatt came to Paris at the age of twenty-one to study art and promptly joined the Impressionist group. Inspired by the Japanese color woodcuts just appearing in Paris (see page 13), Cassatt's prints sensitively observe the everyday domestic life of women and children.

Another American in Paris at the time was James Abbott McNeill Whistler (1834–1903). Whistler, who eventually relocated to London, tirelessly experimented with printmaking and produced numerous etchings, lithographs, and drypoints, including portraits as well as closely observed street scenes in London and Venice. At the beginning of the twentieth century, the expatriate Whistler was the most influential "American" printmaker.

PABLO PICASSO

The early twentieth century saw a true revolution in art making, as European artists realized that they could create new, imagined abstract worlds rather than just copying reality. In Paris, the Cubist group—cofounded by the Frenchman Georges Braque and the Spanish-born artist Pablo Picasso—reflected this new thinking. Picasso (1881–1973) went on to become the most influential artist of the entire century, working in a wide variety of styles and even creating new genres of art, such as assemblage sculpture. To printmaking Picasso brought the same inventiveness displayed in his painting, sculpture, and collage, and he made prints throughout the whole of his long career, from his first masterpiece in etching, *The Frugal Repast*, in 1904, to his famous *347 Series* of etchings, completed in 1968. Unbelievably prolific, he produced a total of about 2,200 prints using virtually all printmaking techniques.

INTAGLIO IN AMERICA

During and after World War II, printmaking came to vibrant life in America. Exiled because of the war, European artists like Marc Chagall, Max Ernst, Jacques Lipchitz, André Masson, Joan Miró, and Yves Tanguy gathered at William Hayter's Atelier 17 in New York, where they were joined by Americans such as Alexander Calder. Hayter's studio helped build a bridge between European Surrealism and Abstract Expressionism, which would become the preeminent American style in the postwar years.

Outside Atelier 17, experimentation that would extend the potential of intaglio printmaking was carried out by the likes of Mauricio Lasansky and Gabor Peterdi and, later, by Chuck Close, Jim Dine, Jasper Johns, Vincent Longo, and James Rosenquist. Robert Rauschenberg (1925–2008), one of the most important American artists of the late twentieth century, was also one of its greatest printmakers and had a profound influence on printmaking aesthetics and technical innovations as well as on critics' valuation of the print as an art form.

INTAGLIO TODAY

More recently, artists such as Vija Celmins, Enrique Chagoya, Susan Crile, Jane Hammond, Kiki Smith, and Nathaniel Stern, among others, have made significant innovations in intaglio printing. Traditional intaglio techniques on metal are, of course, still practiced, but a growing number of printmakers are also embracing hybrid processes such as photo-etching, photocollography, and photogravure. And even when they remain committed to working with physical materials, some artists are simultaneously devising ways of integrating digital imaging with traditional printmaking techniques. Paul Catanese and Angela Geary, authors of *Post-Digital Printmaking: CNC, Traditional and Hybrid Techniques* (2012), have devised a way to replicate

an aquatint tonal range using Photoshop, applying it to a computer numerical control (CNC) laser cutter. Printmakers such as Alex Dodge, Josephine McCormick, and Jon Pengelly use laser cutters to draw and etch images, combining the method with traditional techniques. Polymer film emulsion has replaced harsh chemicals for light-sensitizing copper plates, and transparencies are printed on laser printers rather than in darkrooms. Tools and materials continue to evolve, and the possibilities are endless.

Equipment and Materials

Unlike relief printing, intaglio printing requires a lot more pressure than hand-rubbing can provide. The pressure required to force the paper into the finely cut grooves of the intaglio plate necessitates the use of a press equipped with two steel rollers and a steel bed set in between them. The inked plate and dampened paper are placed on the bed and covered with a padding material to cushion the pressure; pressure settings are made according to the thickness of the plate; and the bed goes through the steel rollers. The right degree of pressure ensures that the cushioned dampened paper will pick up all the ink from the incised plate, resulting in a successful intaglio print. Characteristics of an intaglio print include the beveled plate marks on the paper created by the edges of the plate and the distinctive way in which the ink sits on the surface of the paper rather than soaking into it.

PRESSES AND OTHER INTAGLIO TOOLS

An etching press consists of a steel press bed mounted between a pressure steel drum, or roller, on top of the bed and a drive steel drum beneath the bed, all held together by a frame unit. The diameter of the drums varies from press to press, with stronger presses having bigger drums.

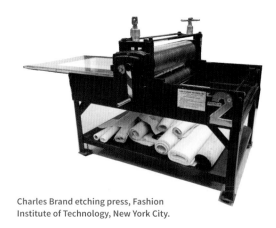

Charles Brand etching press, Fashion Institute of Technology, New York City.

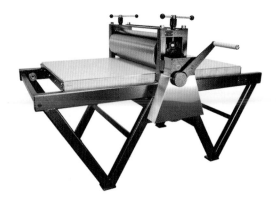

Takach etching press, photo courtesy of Takach Press Corporation.

Micrometer pressure dials control the pressure and make sure it is evenly applied. Bed stops at each extremity of the bed ensure the bed stays on the stand. The upper pressure drum is raised or lowered according to the thickness of the plate or block and the desired pressure. A wheel or crank (hand operated or electric) moves the press bed horizontally between the upper and lower drums from one end of the bed to the other, allowing full-bed travel and maximizing the printing area.

The inked etching plate is placed on the press bed, ink faceup, and dampened printing paper is positioned on top of the inked surface. Dampening the paper is necessary for intaglio etching, ensuring that the softened paper fibers pick up every detail of the inked plate.

OTHER TOOLS FOR INTAGLIO

A number of other tools are also needed
for intaglio. Chief among these are tools for
scratching and drawing on the plate, which
include diamond- and ruby-point needles,
etching needles, and échoppes. Depending
on the technique, the following tools may
also be necessary:

> An inking table covered with thick glass
> to allow for rolling ink with a brayer and
> for easy cleaning

> Burins, used to engrave lines

> Deburring tools and fine metal files, used
> to bevel the edges of the metal plate

> Burnishers, used to flatten cut lines or to
> soften the raised surface of the metal plate

> Scrapers (pointy three-faced flat blades
> made of hard steel), used to remove burrs

> Rockers, used in mezzotint to rough up the
> surface of the metal plate

> Roulettes, used to create a burr for tones
> on small areas

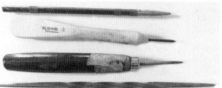
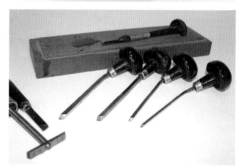
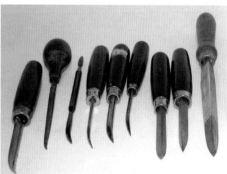

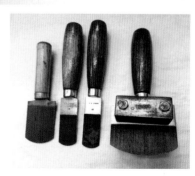

Clockwise from top: Intaglio tools: Metal
files, cutting tools, steel wool and sandpaper.
Engraving tools. Burins and Florentine liners
with an Arkansas sharpening stone. Scrapers
and burnishers for mezzotint. Rockers for
mezzotint. Roulettes and burnishers for
mezzotint.

A set of blankets, woven or felted, is used to cushion and distribute the pressure between the upper drum and the paper and plate on the press bed. The wool blankets also help push the paper fibers into the fine grooves of the inked plate. Usually, an etching press has two blankets: The thinner, finer-textured blanket (⅛ inch thick), which is called the sizing catcher, is always laid on the paper first, then covered with the thicker blanket, called the cushion blanket (¼ inch thick), which comes in contact with the pressure drum. On some presses, a third blanket, called the pusher blanket, is laid on top of the cushion blanket.

Over the twentieth century and up until the present day, American press manufacturers have greatly improved etching presses, and a number of high-performing etching presses are available. Unfortunately, some of the best were made by the now-defunct Charles Brand company, which built presses in New York City from 1958 to 1993. The Conrad Machine Company, based in Michigan, began manufacturing presses in 1956 and is recognized around the world as a superior manufacturer of fine-art printing presses. Numerous leading universities in the United States use presses made by Takach Press Corporation, based in Albuquerque, New Mexico, which is a major supplier of equipment and art supplies for the fine-art printmaker. Some smaller, less expensive tabletop etching presses are made and sold by Dick Blick Art Materials, based in Illinois.

METALS FOR INTAGLIO

The metal plates used for intaglio etching today are made of either copper or zinc. Copper is an ideal metal for all intaglio techniques. It performs well for all fine etching and for engraving in particular. Copper can be purchased in a couple of forms:

PRINTING RELIEF ON AN ETCHING PRESS

Etching presses can also be used to print relief. When printing relief, the wool blankets may be replaced with a flat piece of cardboard—a harder cushion that is more desirable for relief since the ink is picked up from the surface of the block, not from the incisions. Because relief blocks are a lot thicker than etching plates, it is also a good idea to place the relief block on the press bed between two rails (long, narrow pieces of wood) of the same thickness as the block; because the rails are longer than the block, they catch the pressure from the upper drum before the block does and therefore help prevent the block from jumping and the ink from smearing.

SAFETY FIRST!

Today, most print shops in the United States and Canada are highly concerned for users' safety and have adapted their setups accordingly. When using any corrosive agent, you should always wear goggles and protective gloves.

Photoengraver's copper is polished to a mirror finish and has an acid-proof backing; thickness is 16 or 18 gauge. Unpolished and uncoated copper is less costly, can be cleaned and polished manually, and has the advantage of offering two usable surfaces; thickness ranges from 16 to 22 gauge.

Zinc is cheaper than copper but performs almost as well. But it is also softer: A drypoint on zinc yields many fewer impressions than one done on copper, and tools dig into a zinc surface too fast to achieve fine engraving. However, zinc can easily be reworked, scrapped, burnished, and polished, as can copper.

ACIDS AND OTHER CORROSIVE AGENTS

The use of chemistry by printmakers has evolved over time, adapting to the available choices of metals, corrosives, and solvents. Specific metals are etched with specific chemicals: copper with ferric chloride, zinc with nitric acid.

The great advantage of etching copper with ferric chloride ($FeCl_3$, also known as iron chloride and iron perchlorate) is that it does not emit any fumes. Ferric chloride is a corrosive salt, not an acid, and therefore has no serious effect on the skin except staining. Still, it is corrosive; you should always wear gloves when using it, and it should never be ingested.

Ferric chloride gives a clean, sharp bite, resulting in crisp, detailed lines because it etches only in depth, not sideways into the area surrounding the line. When used for etching, the deep brown liquid slowly turns green as it becomes oversaturated with copper, indicating that the solution has weakened and should be replaced. Ferric chloride is available from most chemical suppliers in the saturated 42 baume strength. For etching and aquatint, 42 baume works best when diluted

Sylvie Covey, *The Inner World*, 1979, viscosity etching on zinc, 18 x 36 inches (45.7 x 91.4 cm).

with water, at 1 part ferric chloride to 1 part water. A 45-minute etch is necessary to achieve a medium-strength etching line. The longer the plate is immersed in the bath, the deeper the line is etched, and the more ink it holds. For aquatint, the time range is up to 20 minutes, maximum, to achieve a black tone before the aquatint burns out. If you are working in a personal studio where no one else is using the ferric chloride, it is often useful to make a personal etching-chart plate, recording various etching times, and to print this aquatinted test plate as a guide to tonal range.

Used for etching zinc, nitric acid (HNO_3, also known as aqua fortis) is a colorless, highly corrosive solution that is usually sold at a concentration of 68%. When the concentration is more than 86%, the solution is referred to as fuming nitric acid, but even at 68% it must be diluted with water and handled very carefully, wearing goggles and thick gloves. Nitric acid can cause severe burns to the skin and damage to the eyes and lungs if proper precautions are not taken. Before etching, a 68% solution of nitric acid should be diluted at 7 parts water to 1 part acid to achieve a regular etched line in a 10- to 15-minute acid bath. (When diluting, always pour the acid into the water; never pour the water into the acid. As the acid solution grows weaker with use, a longer bath period may be needed, or a small portion of fresh acid may be added.)

INKS AND MODIFIERS

Etching ink is made of ground pigment powder mixed with thick burnt-plate linseed oil and has a buttery consistency. It is sold in tubes or in cans, and several reliable brands are available at art supplies stores everywhere. The Charbonnel, Gamblin, Faust, Graphic Chemical & Ink Co., and Hanco brands all offer a large range of colors in oil-based etching ink. (Gamblin and Akua also offer lines of water-based inks.)

The consistency of the ink may need to be modified before inking a plate. For example, if the ink

Aquatint etching test plate, etched in ferric chloride.

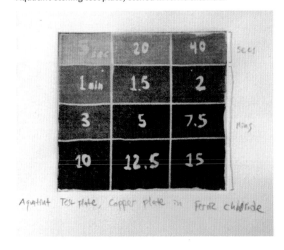

Aquatint Test plate, Copper plate in Ferric chloride

COPPER OR ZINC?

Nitric acid is a much faster etching agent than ferric chloride: A plate must rest only 10 minutes in nitric acid, versus 45 minutes in ferric chloride, to produce a regular etched line. Nitric acid's rapid etching time and the lower cost of zinc are reasons why some college art classes use these materials; a 45-minute wait to etch a copper plate is often not feasible in a class with numerous students. But zinc does not hold fine detail as well as copper does, because nitric acid bites sideways as well as in depth, resulting in a less sharp line. Also, nitric acid emits noxious fumes, so precautions are necessary. Many professional print studios therefore opt for etching copper with ferric chloride, which not only performs better but is also safer.

is too stiff or dry, burnt-plate oil can be used to thin it. Buttery compounds sold under the brand names Easy Wipe and Setswell can also be added when the ink is too stiff or tacky. A palette knife is used to mix the ink with the oil or compound. Magnesium carbonate powder is added to ink to make it stiffer when it is too oily. Brands like Akua, Hanco, and Gamblin carry their own lines of ink modifiers.

PAPER

A number of excellent American and European papers are available for intaglio printing; among them are domestic etching paper; Arches' Cover, Text, and Wove papers; Fabriano's Rosaspina and Tiepolo papers; Hahnemühle's Copperplate and German Etching papers; Lana's Cover and Gravure papers; the Legion paper company's Lenox 100, Murillo, and Somerset papers; Magnani Pescia; Rives's BFK, Heavyweight, and Lightweight papers; Stonehenge; and Strathmore Etching.

Paper must be dampened before intaglio printing so that the softened fibers of the paper, under pressure, can pick up the finest details from the inked plate. It must therefore be of a high enough quality that it can be soaked in water without falling apart. The amount of time a paper should be soaked depends on the paper; the list at right provides some very rough suggestions.

Preparing the Plate

A metal plate must be properly prepared prior to processing. First, the copper or zinc sheet must be cut to the desired size, using metal shears or a plate chopper. It can also be cut into various shapes using a power saw. (Use great caution with power tools; always wear goggles to protect your eyes.) It is also possible to cut irregular shapes using the plate chopper, or by using long, strong acid baths to etch away unwanted parts of the metal.

Proper beveling of the metal plate's edges is important to ensure safe handling of the cut metal. Sharp unbeveled edges or corners might also cut the paper or the blankets on the press, and beveled plates produce cleaner, better-looking prints. After the plate is cut to size, a deburring tool (found in hardware stores) is used to cut away the top edges of the metal plate. Holding the tool against the edge of the plate at a 45-degree angle, place your index finger in the crook of the swiveling head, and, beginning at the top of each edge, firmly pull the tool toward you. A curly ribbon of copper will

PAPER SOAKING TIMES

Here are some suggested paper soaking times for intaglio. Please note that soaking-time suggestions are approximate; actual soaking times will depend on personal experience and the artist's own preference.

Domestic etching paper	20 minutes
Arches Cover	1 to 2 hours
Arches Text	5 minutes
Arches Wove	5 minutes
Fabriano Rosaspina	30 minutes
Fabriano Tiepolo	30 minutes
Hahnemühle Copperplate	10 minutes
Hahnemühle German Etching	No more than 5 minutes
Lana Cover	30 minutes
Lana Gravure	30 minutes
Lenox 100	30 minutes
Magnani Pescia	30 minutes
Murillo	20 minutes
Rives BFK	8 minutes to 2 hours
Rives Heavyweight	20 to 60 minutes
Rives Lightweight	5 minutes
Somerset	30 minutes
Stonehenge	30 minutes
Strathmore Etching	30 minutes

peel off the edge. (Many artists prefer to do the final beveling and filing after the etching process has occurred, since acid will attack the edges of the plate.)

A metal file should be used before and after the plate has been etched to hone the edges' angles until they feel smooth to the touch. The corners of the plate can also be filed to a softer, rounder shape. The file should be held at a 45-degree angle

OTHER MATERIALS FOR INTAGLIO

You will also need these materials for plate-making and printing:

- ❯ Hard or soft ground (liquid or ball) to coat the plate before applying a design
- ❯ Adhesive contact paper to protect the back of the plate
- ❯ Stop-out varnish (liquid asphalt) to resist acid
- ❯ Permanent red Sharpie markers to resist acid in small areas
- ❯ Lithographic pencils (Korn's #1 to #5) and lithographic crayons (Korn's #1 to #5) for drawing on the plate
- ❯ Foam brushes, fine rounded paintbrushes, and a small brayer for applying ground to the plate
- ❯ Palette knives to work the ink
- ❯ Plastic ink spreader or pieces of mat board for spreading ink
- ❯ Tarlatan to wipe ink off the plate
- ❯ Pages from a telephone book, or newsprint, for final wiping
- ❯ Newsprint or bath towels to blot excess water from the paper
- ❯ Brayers for rolling ink

- ❯ Water tray for soaking the paper
- ❯ Blotters and newsprint to keep the prints clean, dry, and flat after printing
- ❯ Hot plate for melting ball ground and aquatint
- ❯ Arkansas stone or other sharpening stone, as well as lubricating oil, for sharpening burins and other tools
- ❯ Fine metal file for filing the edges of the plate
- ❯ Abrasives such as fine steel wool and emery paper #400 to #800 for removing scratches
- ❯ Metal polish, whiting, salt and vinegar, and rubbing alcohol for cleaning and polishing the metal plate
- ❯ Plastic acid-bath tray for biting the plate
- ❯ Gloves, goggles, and a face mask for protection
- ❯ Paper towels for cleaning up
- ❯ Gamsol or turpenoid solvent for cleaning up
- ❯ Magnifying glass for working on small details

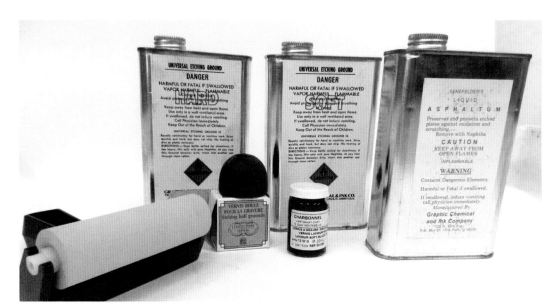

Liquid and ball grounds, hard and soft.

Holding the deburring tool against the edge of the plate at a 45-degree angle.

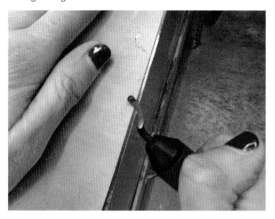

on the edge of the metal and pushed away so that it shears the metal. The file should not be too rough, to give a fine, smooth feel to the edge of the metal.

In acid techniques, it is necessary to protect the back of the plate from the acid. If the plate does not have a factory coating on the back, use adhesive contact paper. Cut a piece of contact paper larger than the plate, remove the backing paper, press the adhesive side on the back of the plate, and trim the excess off with a razor blade.

If the plate is scratched, use emery paper to remove the scratches. Rub the emery paper in a circular motion on the surface of the place, and gradually increase the fineness of the emery paper, first using #400 grade, then #600, and finally #800. The plate can be sanded wet or dry and should then be rinsed in water.

After beveling, filing, and removing scratches, the plate must be properly degreased before further processing. New metal is usually coated with a thin film of oil to prevent oxidation, so degreasing is crucial to all intaglio techniques. To degrease the plate, rub it with a cleaning agent such as kitchen ammonia or rubbing alcohol, or with whiting (calcium carbonate). If using whiting, add a little

vinegar, alcohol, or water to 1 teaspoon of whiting to make a paste. Rub the paste all over the surface of the plate, then rinse with a power hose to remove all whiting residue. The plate is completely free of grease when water flows over the surface in a thin, unbroken film without beading. (Note: Heavily oxidized plates on which the metal has darkened can be de-oxidized by wiping them with a mixture of 1 cup of white vinegar and 1 tablespoon of salt.)

Intaglio plates are polished at one stage or another, depending on the technique. In drypoint, the plate must be polished before working on the plate to avoid damaging the burr. In aquatint, the plate must be polished before applying the aquatint to ensure that the white areas stay truly white while not damaging the etched grain. Etchings can be polished after the acid bath, because an etched line will hold well and remain intact after polishing. You can use any of the metal polishes available in hardware stores; brands include Never Dull, Putz Pomade, Cape Cod, Tarn-X Pro, and Noxon 7, as well as various brands of jeweler's rouge. Apply the polish with a soft cotton rag, paper towels, or cotton balls, and rub the plate to a mirror finish. A well-polished plate ensures that white areas will print bright white, without any plate tone dulling the image.

07/1999 The Living Thing 1/10 edition S评 Vartanov

Non-Acid Intaglio Techniques

The non-acid intaglio techniques of drypoint, engraving, and mezzotint involve manually scratching, engraving, or roughing up the surface of a plate with a variety of tools but without the help of corrosive chemicals. When the plate is inked and its surface wiped clean, the ink from the incised marks produces the final print. Drypoint can be done on a traditional metal plate but also on Plexiglas, which today is often used in school environments. (Plexiglas is not as costly as metal and is available in large formats.) Engraving, however, only really works on a soft metal such as zinc or copper, and mezzotint only on copper. Zinc is softer than copper, and a rocked zinc plate will not hold many prints; considering all the work involved in rocking a plate for mezzotint (see page 87) only the best metal, copper, should be used.

Slav Varlakov,
The Living Thing, 1999,
engraving, 22 x 30 inches
(55.9 x 76.2 cm).
Collection of the author.

Another non-acid intaglio technique, collography, is unusual in that it involves building up a surface with a variety of glued materials, mediums, and textures rather than incising a plate, which is why its given its own chapter (page 137). Depending on the technique used to ink and wipe a collography plate, the raised textures may be printed along with the lower, ink-holding areas of the plate. Collography is nevertheless considered intaglio because both the raised and lower surfaces are printed, while with relief only the top surface of the block is inked and printed.

Franklin Tyler Wood, Untitled, undated, drypoint etching, 8 x 12 inches (20.3 x 30.5 cm). Collection of the author.

Franklin Tyler Wood, Untitled, undated, drypoint etching, 8 x 12 inches (20.3 x 30.5 cm). Collection of the author.

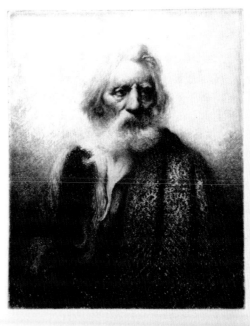

Drypoint

The drypoint method is the most direct means of creating an intaglio image, because it simply involves scratching on a metal or Plexiglas plate with a sharp tool, such as an etching needle or a diamond point. Although Plexiglas plates are less expensive than metal plates, metal gives richer, deeper results. Tones can be obtained with hatched and cross-hatched marks by rubbing the surface with a roulette, or by scratching the surface with an abrasive paper.

Drypoint tools need to be very sharp and pointy. Among the tools used for drypoint are diamond- and ruby-point needles and etching needles. Nails, wheel rollers, blades, roulettes, and electric tools such as those made by Dremel offer other possibilities for mark-making. A scraper or burnisher can be used to alter the drypoint marks and burrs.

After the plate has been scratched, it is inked and wiped. The ink stays in the grooves, and the design is formed by the depressions scratched into the plate as well as the burrs thrown up at the edges of the incised lines, which also retain ink. The larger the burr, the more ink it will hold, producing a characteristically dense and velvety line that greatly distinguishes drypoint from other intaglio methods such as etching and engraving, which produce smooth, hard-edged lines. In drypoint, the size and characteristics of the burr depend not on how much pressure is applied, but on the angle of the needle when working on the plate. A perpendicular angle will leave little to no burr, but the lower the angle becomes, the larger the burr it raises. The most sharply angled drypoint lines leave enough burr on either side that they prevent the paper from pushing down into the center of the stroke, creating a feathery black line with a fine white center. A lighter line may have no burr at all, and because it holds very little ink it will create a very fine line in the final print. After a few impressions, the burrs of a drypoint plate will fade under the pressure of the press, and the lines will get weaker. For that reason drypoint is useful only for very small editions, of ten to fifteen prints maximum.

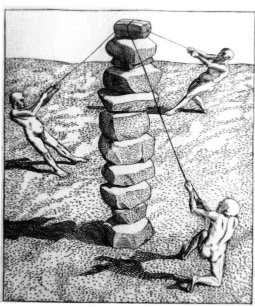

Slav Varlakov, Untitled, 1999, engraving, 3 x 3 ½ inches (7.6 x 8.9 cm). Collection of the author.

Here are the steps for creating a metal drypoint plate. (When using a Plexiglas plate, simply file the edges with a metal file and scratch the design with an etching needle as described below.)

1 Choose a metal plate and prepare it as described in the previous chapter (see pages 77–79). You may draw an initial sketch on the plate with an ink marker.

2 Choose a tool for scratching the plate. Holding the tool as you would a pencil, draw into the metal, raising a burr. Try holding the tool at different angles to produce different line qualities. (Note: At a very low angle the tool may skid on the metal surface without making an adequate incision.)

3 You can use a wheel roller to produce a series of dots and lines. Tonal areas can be achieved with densely cross-hatched lines, or by using an abrasive such as sandpaper or steel wool to rough up the plate. Different grades of sandpaper and steel wool will produce different tones.

4 To make corrections and remove scratched lines, use the scraper, then the burnisher, to smooth the surface of the plate.

Engraving

In engraving, grooves are incised into a hard, usually flat surface with a sharp burin (also called a graver). The burin produces a recognizable quality of line characterized by its steady, deliberate appearance and clean edges. Burins remove metal from the plate; the burr produced is cut off at the end of the stroke with a scraper, leaving a clean, precise line that swells or tapers according to the amount of pressure applied.

Burins come in a variety of shapes and sizes that yield different types of lines. The burin consists of a square or rectangular steel shaft whose end is cut at a 30- to 45-degree angle; the shaft is mounted in a rounded wooden handle shaped to fit the palm of the hand. Some burins have bent shafts, while others are straight. A lozenge burin creates a fine line that is deeper than it is wide, while a square burin creates broader lines of equal depth and width.

Besides burins, engravers may also use Florentine liners (also called multi-liners), which are wedge-tipped tools with multiple points used to create uniform shade lines or for fill work in larger areas. A scraper is used to remove burr from engraved lines, and a sharpening stone is used to keep burins and scrapers sharp.

A sharp burin is critical to success when engraving. Use a fine-grained Arkansas sharpening stone with lubricating oil to sharpen the sides of the burin first, and then sharpen the tip, following the angle. The burin's tip should remain flat to its edges. Burins should be sharpened routinely to keep them well-honed. Once your burins are sharp, follow these steps to create an engraving plate:

1 Choose a metal plate and prepare it as described in the previous chapter (see pages 77–79). Plan the image by drawing on the plate with a marker.

2 Select a burin. Burins come in different shapes and different sizes, ranging from #1, which is very small with a shaft that can easily break, to #10, which is so large that it can be difficult to push the tip through the metal. #6 is a good all-purpose-size burin.

3 Hold the burin's handle in the center of your palm, and gently wrap your thumb and first two fingers around the shaft. Use your fingers only to guide the burin, not to apply pressure.

4 Dig the angled tip slightly into the plate to engage it, correct the angle of the shaft to make it parallel to the plate and table, and push straight ahead.

5 In the beginning, avoid engaging the point of the burin too deeply, because this may cause the burin to stall or slip. Deep-line engraving comes with experience and practice. A larger burin will engrave a bolder line but will also encounter more resistance from the plate.

6 After practicing straight lines, begin working with curved ones. Rather than using the burin to create a curved line, use the hand that is not holding the tool to rotate the plate, to create a curve in either direction.

7 Bold lines can be obtained by engraving many parallel lines. To create a linear tone, engrave densely hatched or cross-hatched lines. Different sizes of burins should be used when cross-hatching to obtain different sizes of line. A smaller burin will produce a narrower line than a large burin.

8 The curls of metal (burrs) cut by the burin can be removed, for a clean and sharp engraving, or, if you wish, left in place for dramatic tonal effect. To remove the burr, place a sharpened scraper flat on the plate, and push it against the line, scraping the burr off the surface.

Drypoint and engraving are often used in combination. The different tools used for each technique give different results in the printed line. Michael Hew Wing used both drypoint and engraving technique on the plate for his engraving *Tempest*. Opposite are some of the states the image went through as the artist progressed, as well as the print's final state.

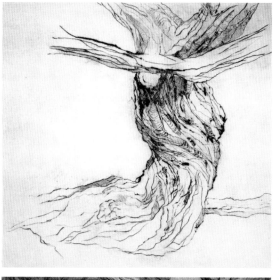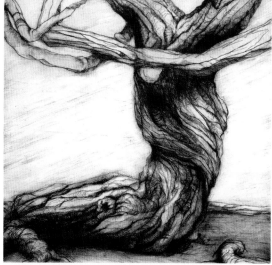

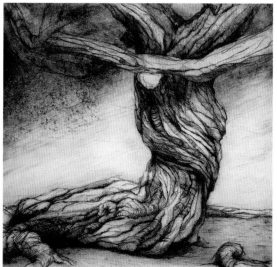

First state. The artist took a photograph as inspiration for the image and then drew a sketch based on the photo. He started engraving the copper plate and pulled the first proof, wiping the surface of the plate completely to produce a clean background. The first-state proof is shown here. Images in this series courtesy of Michael Hew Wing.

Second state. The plate was further engraved with stronger lines and deeper shapes.

Third state. The plate was further engraved and proofed. For this third-state proof the background was only partially wiped; some plate tone was left on the surface to create a mood.

Fifth state. The artist then inked the plate again, leaving some dark plate tone on its surface to create a moody effect.

Final state. Michael Hew Wing, *Tempest*, 2007, engraving (final print), 24 x 24 inches (61 x 61 cm). For the print's final state, the artist wiped the plate in some areas to create highlights but left ink in the shadow areas.

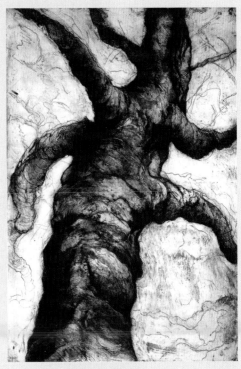

PRINTMAKER PROFILE: Michael Hew Wing

hewwing.com

"The printmaking I know is about labor. It is about the struggle to find the image in the plate, in the lines, as much as it is discovering that final image in one's mind."

Michael Hew Wing does not limit the imagery of his work to one subject. After making biographical pieces related to his family as well as pieces with social and cultural commentary, he lost interest in making work about conflicted and tumultuous emotions because of the mentally and emotionally exhaustive process involved. Enter the *Tree* series, which he has worked on for several years. These tree images, initially about freedom of expression, remain refreshing, intuitively natural, and calming. There is no examination of the self, no examination of one's feelings or relationships with others, no visual interpretation of ambiguous emotions. The creation of each Tree print focuses on physical shapes and forms that are reflections of inner, subconscious conflicts that eventually resolve themselves.

Working on a metal plate that can withstand hours of scraping and burnishing, acid baths, and extreme pressure from presses, Hew Wing believes that the constant reshaping of the plate surface is an integral and necessary process in the discovery of an image. Any accidents on the plate surface add to the overall language of the imagery. As Hew Wing says, "The working and reworking of a plate surface is an essential part of the printmaking experience. The printmaking I know is about labor. It is about the struggle to find the image in the plate, in the lines, as much as it is discovering that final image in one's mind."

Mezzotint

Mezzotint is a tonal technique that usually works from dark to light. In this reverse intaglio process, the plate is uniformly roughened with a mezzotint rocker. A dense tone is produced by repeatedly working the curved, serrated rocker over the copper plate in multiple directions until its surface is completely and evenly roughed with tiny dents and burrs, a dense texture that ensures that enough ink will be held to produce an intense, luxurious black (or other color). Smoothing this texture with a scraper or burnisher produces the lighter and softer tones, bringing out the light shapes from the dark background. Mezzotint enables a wide range of halftones to be produced without using the line- or dot-based techniques of hatching, cross-hatching, or stipple.

Mezzotint tools include rockers, scrapers, burnishers, and roulettes. A mezzotint rocker has a curved steel blade fitted on a wooden handle. One side of the blade is beveled and smooth, while the other is flat, with even vertical grooves ending in sharp fine teeth. As the edge of the tool is rocked back and forth, the teeth cast a rough burr on the copper. Rockers may have anywhere from 45 to 150 lines, or teeth, per inch. The texture created depends on the gauge of the rocker's teeth and on how many times it is rocked over the surface of the plate. Rockers are sometimes mounted on a wooden jig and weighted for added support in the rocking process.

A scraper has three flat faces with sharp blades meeting at the pointy tip of the tool. In mezzotint, the scraper is used to slice off the top of the burr to lighten an area of the image. The more burr is cut away, the less ink is retained, and the lighter

the scraped area will print. Using the scraper alone alters the density of tone but will not produce a pure white, because scraping leaves the surface of the plate grazed.

A burnisher has a wooden handle and a round or elliptical metal shaft that comes to a point at the tip. Burnishers come in a variety of sizes and shapes, usually curved and smooth. This tool is used to polish small areas of a plate, pushing down the metal and smoothing out any roughness. Burnishing is often done after scraping, but the burnisher can also be used without scraping, which will ensure that polished areas will print white.

Roulettes, which come in a variety of sizes and shapes, consist of a toothed wheel, or drum, that rotates on the end of a rod attached to a handle. The wheel produces a particular gauge of tone on

E. Valentine DeWald, *Girths*, 2010, mezzotint, 3 x 4½ inches (7.6 x 11.4 cm), shown with mezzotint plate. Courtesy of the artist.

the metal depending on the number of rows of teeth and their size. Roulettes are used to create a tonal burr that will hold ink, and are also useful for repairing tonal areas on a mezzotint plate. To create a dark and even tonal range on the plate before burnishing the image areas, follow these steps:

1 Choose a metal plate and prepare it as described in the previous chapter (see pages 77–79). Prepare a diagram to indicate the angles and the number of passes required to achieve a uniform rocking ground. For example, horizontal, vertical, then 45 degrees, 22½ degrees, and so on. Such a diagram is like a visual checklist, helping you remember to rock the plate evenly in all directions, which is very important to get an even tone. A minimum of twenty-four directions of rocking lines is usually required to create a dense texture capable of printing completely black. If the planned image contains large white areas, it is not necessary to rock those areas unless you want to create a smooth gradation between white and black areas. You may also protect the areas you want to remain white by covering them with tape or adhesive contact paper prior to rocking.

2 The rocker can be held with either the grooved or beveled side facing the user, provided that the tool is not tilted toward the beveled edge, which would risk breaking the rocker's teeth. Grasp the rocker firmly by the handle; if the grooved side is facing the wrist, hold the handle slightly toward the body, at an angle of 10 to 30 degrees. This position helps when moving the tool forward. If the smooth, beveled side is facing the user, the tool should be tilted away from the body. This angle results in greater pressure and

Rocking a copper plate.

deeper indentations. To achieve an even tone everywhere on the plate, do not alternate the position you've chosen after you've started the process.

3 Begin working on the side of the plate closest to you and move toward the farther end. Slowly move the rocker side to side across the plate, applying firm pressure, to create rows of dots in a close zigzag pattern. Each sideways motion creates a row of lines containing tiny pits and burrs.

4 The number of passes required to create an evenly toned ground depends on the rocker and the desired result. It is not uncommon for a plate to require as many as twenty to thirty hours of rocking to achieve an even ground. Some artists opt to attach the rocker to an electrically powered machine that moves the rocker across the plate and gets the job done much more quickly.

Gregory Haley, *#13*, 2009, color mezzotint (three plates) with etching aquatint, 6 x 8 inches (15.2 x 20.3 cm). Courtesy of the artist.

Once the plate has been fully rocked, you can outline the contours of the image on the plate surface with a soft pencil. If you wish, you can forgo scraping and immediately use a burnisher to polish areas that you want to be lightly toned. Burnishers come in a variety of shapes; at this stage, use one with a fat rounded end; place a drop of oil on the area to be lightened and apply the rounded end of the burnisher to the surface, pressing into the metal and flattening the burr. Start with light pressure, gradually increasing the pressure as needed. If you need to re-create the rough surface in an area you've burnished, you can use a roulette and then further burnish that area, as required.

You might also consider using a "light to dark" process when preparing the mezzotint plate. This process differs from the one just described because it is additive rather than subtractive. In the light-to-dark method, you rock the blank plate selectively, only in those areas where the image will be darker, and leave the rest of the plate unrocked. The areas left unrocked can be worked with other intaglio techniques, such as etching or aquatint.

Artist E. Valentine DeWald followed the steps that follow when creating his monochrome mezzotint *Tesia Tendencies*.

Monochrome Mezzotint Process

1 First, DeWald rocked the copper plate with a rocker attached to a wooden jig and a weight.

2 DeWald based the image on a photo, which he traced on tracing paper with a pencil. He then placed the traced drawing face down on the rocked plate, retracing it with a pen and transferring the graphite marks to the plate. He scraped the areas that were to remain white and then burnished them down to the plate's surface. Next, he applied the burnisher to the lighter gray areas, adjacent to the whites, to bring the image from dark to light in a graduated way. The image slowly appeared as some rocked areas were gradually flattened with the burnisher.

3 When the entire image was burnished with a wide range of tonal grays, the artist inked the plate and wiped it with tarlatan for proofing.

4 After printing on an etching press, DeWald pulled the print off the plate. The final print is shown opposite.

1

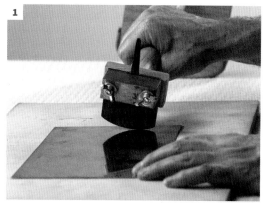

2

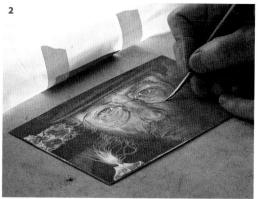

3

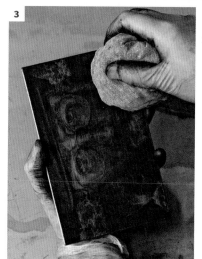

4

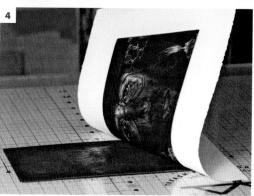

E. Valentine DeWald, *Tesia Tendencies*,
2014, mezzotint, 4 x 8 inches (10.2 x 20.3 cm).
Courtesy of the artist.

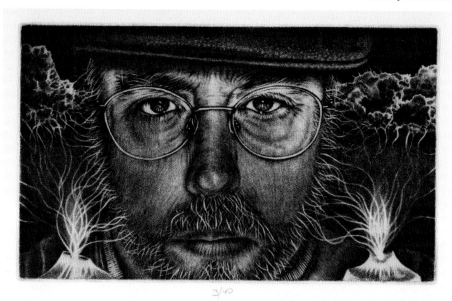

E. Valentine DeWald, *Muybridge Racing Crown Graphic*, 2011, mezzotint, 12 x 8¾ inches (30.5 x 22.2 cm). Courtesy of the artist.

PRINTMAKER PROFILE: E. Valentine DeWald

instagram.com/valdewald

"I wanted to tie this modern still camera to images of the past and something equine."

Horses and photography are very important in E. Valentine DeWald's life. Equestrian tack often has attractive textures and interesting combinations of leather and metal. Looking for intricate patterns in everything, DeWald finds the difficulty of reproducing those textures appealing. DeWald has created a series of mezzotints based on the five traditional elements: earth, fire, water, air, and metal. He started this series as a way to study forms and patterns found in nature.

About his mezzotint *Muybridge Racing Crown Graphic*, DeWald says, "I collect old cameras. I own several portable large-format Graphlex cameras from the 1940s and 1950s. One in particular is a four-by-five-inch version called the Crown Graphic. I wanted to tie this modern still camera to images of the past and something equine. I admire the work of the nineteenth-century photographer Eadweard Muybridge, particularly his work on equine locomotion, and thought it would be fun to include his locomotion studies of horses from around 1870. I spent quite a bit of time searching the Internet for Muybridge studies and decided on one in particular that showed a horse and rider in a gallop. It illustrates what Muybridge was trying to prove: that a horse leaves the ground with all four feet while in a gallop. Originally, the sequences were created using many large-format cameras set up along a path following the moving object of the study. I wanted the horse stills to be in the foreground, so I decided to present them as a modern 35mm film roll, with sprockets, stretched across the scene. The images should be in the proper order to show the correct motion of the galloping horse."

COLOR MEZZOTINT

In color mezzotint, a design is planned in color separation and a separate plate is rocked, burnished, and inked for each color. The plates are registered and printed one at a time on the same sheet of paper, starting with the lighter color and finishing with the darkest, to produce the full color range.

When doing a color mezzotint, you need not process each plate completely. Depending on where the colors will appear, you can do the color separation and then use mezzotint technique to partially process each plate, leaving some areas blank according to the color distribution. For example, if the print will have one area that is only red, this area can be left blank on the plates for the other colors. This is the method Gregory Haley used when making the color mezzotint called *#17*. Here are the steps Haley followed.

Color Mezzotint Process

1 Haley rocked three separate plates in specific areas only, burnishing each according to the planned color. Each plate—one for yellow, one for red, and one for black—was then inked and wiped with tarlatan.

2 Haley first printed the yellow plate on dampened paper. He made registration marks on the bed of the etching press for the subsequent plates. The paper was kept in place with one edge secured under the blankets during the entire printing process. The yellow plate was then replaced with the red plate, following the registration marks, and printed over the yellow. The photo shows what the print looked like after these two colors had been printed.

3 Haley then removed the red plate and replaced it with the black plate, again following the registration marks. Here, the three-color print is being pulled from the plate. A full image of the three-color mezzotint is shown on page 95.

Photos in this series by Gregory Haley.

Gregory Haley, *#12*, 2006, color mezzotint, 6 x 8 inches (15.2 x 20.3 cm). Courtesy of the artist.

PRINTMAKER PROFILE: **Gregory Haley**

gregoryhaleyprints.blogspot.com

"I want to print out of the depth of the night. The moon profoundly influences me, and many of my works draw inspiration from lunar light and its effects."

Gregory Haley's work reflects the view that the natural world is constantly eroding the world of human constructs. It requires constant work and energy to maintain any construct against the inevitable effects of entropy. Social conventions are similarly vulnerable to a different, though no less irresistible, sort of decay. Such an outlook is by no means new, but Haley brings a different perspective to it.

He rarely begins a piece with a firm idea of what the finished design will look like. Instead, he seeks some effect involving line, light, and darkness that he wants to capture. Then he works from that initial idea until the composition reveals itself.

Haley begins to conceptualize using the rocking tool as if it were a paintbrush. Then he begins composing with color, often growing excited by the contrast of color against the profound mezzotint blacks. He finds that the random lines the rocker makes when rolled into an empty area are at the heart of his mental image. These random lines purposely interact with swathes of color. As black invades a white void, tension arises, as it does between black and the other colors and between the other colors themselves.

About his mezzotints, Haley says, "The plate should say everything without post-intaglio manipulation. I want to print out of the depth of the night. The moon profoundly influences me, and many of my works draw inspiration from lunar light and its effects. Mezzotint has given me the ability to express the effect subtle light in the depth of night has on me."

Gregory Haley, *#17*, 2009, color mezzotint (three plates),
6 x 8 inches (15.2 x 20.3 cm). Courtesy of the artist.

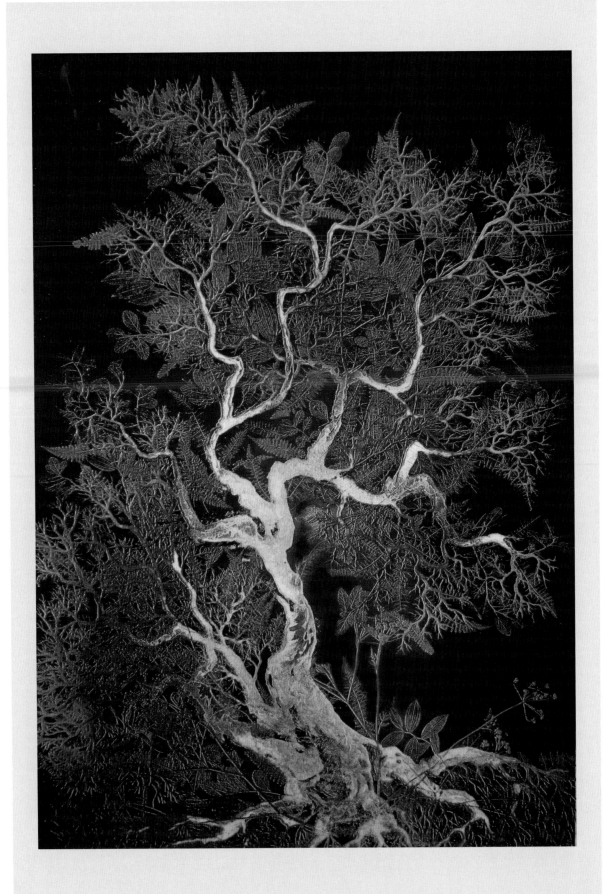

6

Acid Intaglio Techniques

Acid intaglio techniques use a mordant—a corrosive solution such as ferric chloride or diluted nitric acid—to produce grooves, lines, tones, and indentations in a copper or zinc plate. When a metal plate is submerged in the mordant (a French word meaning "biting"), the corrosive agent gradually etches, or "bites," the areas of the metal that are left exposed. The longer a plate is exposed to the corrosive, the deeper the plate is bitten, and the more ink it will hold. At various times during the etching process the plate can be removed from the acid and some areas may be "stopped out," meaning covered with an acid resist to stop the action of the acid in specific areas.

Acid techniques produce lines (hard ground etching), textures (soft ground etching), tonal ranges (aquatint), as well as various levels of etched metal that hold ink on their edges and open areas (open bite, sugar lift, embossing). Note: photo-etching and photogravure are given their own chapter (page 143).

Hard Ground Etching

Sylvie Covey,
The Impossible Tree, 1994,
soft ground etching,
24 x 36 inches
(61 x 91.4 cm).

A ground is a substance that can be drawn on and that resists acid. Hard ground etching employs an acid-proof mixture of asphalt, beeswax, rosin, and solvent, sold commercially as hard ground. In brief, hard ground etching involves coating a metal plate with ground, drawing an image through the waxy ground with an etching needle, and then etching the plate in a corrosive solution (ferric chloride for copper, nitric acid for zinc). The acid bites into

the surface of the plate where it has been exposed by the needle. The length of etching time determines the strength of line achieved: The longer the etching time, the deeper the lines get, and the more ink they hold, resulting in stronger, darker printed lines.

Hard ground etching requires less effort than engraving when processing the plate: The etching needle encounters little resistance as it cuts through the waxy ground, and the acid does the hard work of incising the plate. While it is difficult and cumbersome to correct an engraved line, mistakes in hard ground etching can easily be fixed before the acid bath simply by recoating an area and redrawing on the ground.

Materials and tools for hard ground etching include a metal plate, preparation and cleaning supplies for the plate (see pages 77–79), hard ground, foam brushes or a brayer for coating the plate, and an acid bath (see pages 75–76).

There are many formulas for making grounds from scratch, but it is safer and more efficient to buy pre-made hard grounds, which come in two forms: liquid hard ground, which is brushed onto a cleaned plate using a foam brush, and hardball ground, which is melted directly on the plate heated on a hot plate and evenly applied to the plate with a brayer. When melting hardball ground, set the hot plate at 350 degrees; if the printing plate starts smoking it should be quickly taken off the hot plate and allowed to cool.

Whichever kind of ground you use, the goal is to achieve a thin, even coating across the whole plate. Liquid ground is better for large plates, because it is much easier to coat a large area with a foam brush than to heat the plate on a hot plate and roll the ground across the plate with a brayer. (Also, hot plates heat unevenly.) Using a foam brush prevents painting streaks; the brush should be dry and clean to avoid air bubbles in the ground.

Hardball ground does have an advantage over liquid ground, however, in that it spreads more thinly, enabling you to achieve finer details. A disadvantage is that it can sometimes cause false bites (unwanted etched marks) because the ground's

Mark Pagano, *57th Street*, 2007, etching,
12 x 13 ¾ inches (30.5 x 34.9 cm). Courtesy of the artist.

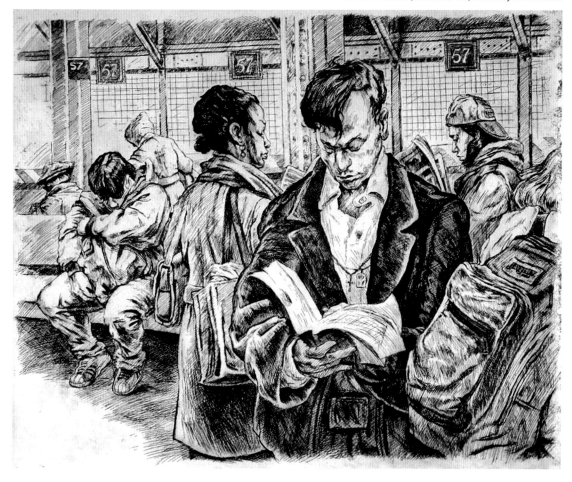

thinner consistency may not hold up in the etching bath.

Hard ground can be applied to a plate in advance, but do not wait more than a couple of days before drawing on it with the etching needle; if the ground is old it may become too dry and chip away.

When using an etching needle to draw through the ground, it is not necessary to dig too hard into the metal, because etching in acid will ensure the depth of the mark. Tones can be achieved by cross-hatching or stippling—punching little holes through the ground with the point of the steel needle.

After you have finished drawing on the ground with the needle, you place the plate in an acid bath (see pages 75–76). When the plate is sufficiently bitten, remove it from the acid, wash it in water, and remove the ground with a solvent such as Gamsol or mineral spirits. Then clean the plate with alcohol before inking and printing. This, in essence, is the process used by artist Mark Pagano in creating his etching *21st Queens Bridge*. The steps he followed are given on the next page.

Hard Ground Etching Process

1 Pagano began with a drawing, which he traced on tracing paper and transferred to the ground. He then redrew the image, incising through the ground with an etching needle, creating lines, cross-hatched areas, and stippled areas. Note that when cross-hatching or drawing lines close together, keep the lines distinct so as not to create an "open bite" area that would print as a solid grayish area rather than as separate lines.

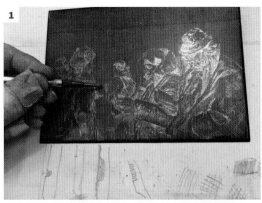

2 When Pagano finished drawing on the plate with the etching needle, the plate was ready to be etched in an acid bath. (Putting a copper plate in a ferric chloride solution for 45 minutes will produce a normal bite.)

3 To achieve various strengths in the etched line, Pagano added lines with the etching needle and re-etched the plate for 10 or 15 minutes, then removed the plate from the acid bath, washed it with water, and then painted over some of the areas with liquid asphaltum (the black areas on the plate) to protect the highlights. He then briefly re-etched the plate to develop the shadow areas.

4 After etching, Pagano removed the ground with a solvent. (Before removing the ground from the entire plate, you should test the depth of the bite by using the solvent to clean a very small corner area of the plate and then wiping a little ink into the cleaned corner to see the depth of the etched line. If it holds enough ink, the bite is good. Remove the ground completely with the solvent, then wash the plate with water.)

5 After cleaning it with alcohol and paper towels, Pagano inked and wiped the plate and printed a proof on dampened paper. The photo shows him pulling the proof. The final print, opposite, shows all the subtleties of the etched lines.

5

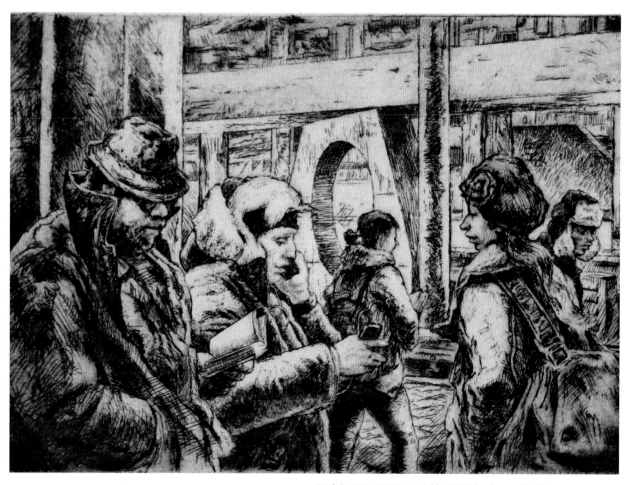

Mark Pagano, *21st Queens Bridge*, 2014, hard ground etching,
5 x 7 inches (12.7 x 17.8 cm). Courtesy of the artist.

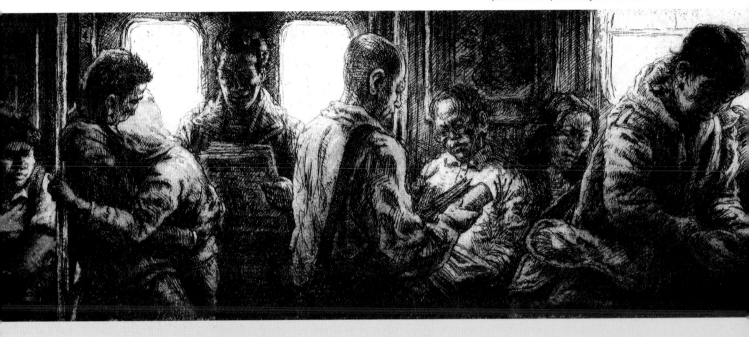

Mark Pagano, *The 7 Train*, 2013, etching, 4 x 10 inches (10.2 x 25.4 cm). Courtesy of the artist.

PRINTMAKER PROFILE: **Mark Pagano**

markpagano.blogspot.com

"Living in New York, it's hard not to be aware of the masses pressing against one's consciousness."

Mark Pagano's work is straightforwardly realistic, with enough information and subtlety to draw immediate interest. The combination of detail and loosely described areas is integral to his work. His compositions are not forced but come across as a well-rehearsed choreography. Pagano often draws people he sees on the New York City subway; he has had many positive (and a few negative) experiences doing this, but all have led him to believe that art reaches everyone.

The hatching and cross-hatching Pagano uses to create tones and form are often modified by longer and shorter baths in the acid to vary the line intensity. This method enables him to create both delicate and vigorous modeling, as well as to emphasize important areas of a composition. Surface tone and incidental false bite are welcome for the character they bring to the image.

Although his work is crowded with people, Pagano's goal is not to record contemporary life in a reportorial or illustrative manner but rather to transcend the mundane subject matter and explore the fundamental qualities of the human condition. "Living in New York, it's hard not to be aware of the masses pressing against one's consciousness," he says. "The concept that we are all essentially the same but at the same moment completely unique can sound trite, but I see it in such a vivid way every day while riding on the subway, and I have to draw it!"

Sylvie Covey, *Leaves*, 1992, liquid soft ground etching with aquatint, 24 x 36 inches (61 x 91.4 cm). Courtesy of the artist.

Soft Ground Etching

Soft ground is a ground that contains 60 percent more grease than hard ground, so the ground stays soft in order to receive an impression. To obtain a good impression, soft ground should be applied just 20 minutes before processing. If left to dry longer, the ground becomes harder and the impression will be faint or will not occur at all. When a drawing is retraced on the ground using tracing paper or when materials placed on a soft-grounded plate are run through a press, the impressed mark or texture lifts some ground, exposing the metal. Then, when the plate is placed in an acid bath, the exposed impression is etched into the metal.

There are two kinds of soft ground: solid and liquid. Solid soft ground comes in paste form or ball form (actually a half-sphere). The ground is spread on a metal plate and the plate is heated on a hot plate at 325 degrees; the ground is then rolled across the plate with a brayer. This method is convenient for small plates, producing a very thin coating that ensures finer details.

Liquid soft ground, which is painted on the plate with a foam brush, is better for larger plates and works well when you are applying textured materials, because although liquid soft ground is a little thicker than solid soft ground, the run through the press ensures a good impression.

When a drawing is made on thin tracing paper and placed on top of a plate coated with soft ground, pressure applied by the drawing tool—usually a pencil—causes the ground to lift wherever the tool comes into contact with the paper. The harder the pressure, the more ground is lifted and the darker

the line will etch. A hand-drawn soft ground etching replicates the look of pencil, but the technique actually produces a greater tonal range than that of an ordinary pencil drawing because of the etching the plate later undergoes; depending on the pencil used, it can also produce a soft grading effect in the line.

Instead of drawing on the soft-grounded plate through tracing paper, you can create an image by impressing the coated plate with textured materials. Because the materials and the grounded plate will be put through a press to create the impression, the materials should be soft to avoid tearing the blankets, damaging the press roller, or breaking while on the press. Dry leaves, fabrics such as lace and embroidery, string, crushed aluminum foil, and crushed wax paper are among the options.

In this technique, a plate is coated with soft ground; then, about 20 minutes later when the ground is no longer wet but is still soft, the textured materials are placed directly on the ground and covered with a sheet of wax paper to ensure that the soft ground around the materials will not lift. A hard cardboard sheet covers the wax paper, ensuring a sharp impression. After the plate has been run through the press, the materials are removed from the plate, leaving their impressions in the soft ground. The plate is then etched in acid, rendering the impressed marks permanent in the metal.

Ophelia Webber chose to use both methods on the same plate to create the print Dark Fall. On the following pages are the steps she followed, first using the drawing method and then the textured-materials method.

Ophelia Webber, *Hunting*, 2012, hand-drawn soft ground etching, 7 x 7 inches (17.8 x 17.8 cm). Courtesy of the artist.

Ophelia Webber, *Falling*, 2012, soft ground etching, 10 x 15 inches (25.4 x 38.1 cm). Courtesy of the artist.

Soft Ground Etching— Drawing Method

1 Webber first hand-drew the first stage of the image on tracing paper. Then she cleaned, beveled, and polished the copper plate, heated the plate on a hot plate, melted a small amount of soft ground paste on the plate, and used a brayer to roll out the ground into a thin, even layer. Removing the plate from the heat, she let it cool for 10 minutes before proceeding. When the ground had cooled but was still soft, Webber placed the tracing paper on the grounded plate with the drawing facedown. As shown here, she taped the top edge of the paper to the table to prevent the tracing paper from moving as she traced the image and also to allow Webber to lift the paper and check on the progress of the ground-lifting as the drawing progressed. The plate was kept in place within the registration marks taped on the table.

2 She then used a sharp pencil to redraw the lines and tones. She lifted the tracing paper from time to time to make sure that the ground was lifting well, adhering to the tracing paper where the lines were drawn.

3 When the drawing was done, Webber checked the lines on the ground again to ensure they had properly lifted from the plate onto the tracing paper, exposing the metal.

4 She removed the tracing paper and covered scratches and unwanted marks with liquid asphaltum before etching the plate in acid. After etching, she used solvent to remove the ground from the plate and then inked and wiped the plate. The photo shows the inked plate ready to print.

5 Webber printed the plate for the first proof before continuing to work on it using the second method of soft ground etching.

Soft Ground Etching—
Textured-Materials Method

1 The second stage of the work was done on the same plate. Webber re-grounded the plate with a new soft ground on top of the etched hand-drawn leaf. After 20 minutes, when the ground was no longer wet but still soft, she arranged textured materials—in this case, dry leaves—on the plate.

2 She then placed the plate with the textured materials on the press bed and covered it with a sheet of wax paper (shown) and then a piece of hard cardboard. She adjusted the pressure of the press to the combined thickness of the plate, textured materials, and cardboard. When using this method, you should start with very low pressure; after running it through the press and checking a corner of the plate, add more pressure if necessary to thoroughly impress the texture through the ground.

3 When the impression looked good, Webber removed the cardboard and wax paper and carefully picked off the leaves. Note: If some of the textured material sticks to the ground, place the plate in a tray of cold water and very gently rub the stuck materials with your fingers to release them.

4 After removing the leaves, Webber etched the plate, then rinsed it with water and removed the ground with solvent. When the plate was rewashed with water and degreased with alcohol it was ready for the first proof (shown).

5 This process can be repeated, adding several layers of textures. For her print, Webber chose to protect some areas of the background with liquid asphaltum before toning it with a dark aquatint. (For more on aquatint, see page 109.) After trying several ways of color inking, Webber decided to color-ink the plate using the à la poupée method—daubing the ink on the plate with wadded tarlatan. She hand-blended the color inks on the plate, printed it, and later re-inked the plate with black and reprinted it on the same paper. The final print is shown opposite.

4

5

Ophelia Webber, *Dark Fall*, 2014, soft ground color etching,
12 x 16 inches (30.5 x 40.6 cm). Courtesy of the artist.

PRINTMAKER PROFILE: Ophelia Webber

opheliawebber.weebly.com

"I placed dried leaves onto the drawn, etched soft ground."

Ophelia Webber sees her prints as being a conduit between nature and the urban environment. She seeks to capture the organic and incorporate it into our city lives, to find a balance between organic and modern environments. The straight edges of the copper plate act as a frame for her organic shapes, growing and overflowing from an industrial surface into the realms of the living earth.

Webber finds inspiration by collecting natural residues and testimonial traces of passing seasons— acorns, leaves, branches, feathers, seed pods. The changing colors of the leaves, the way they dry and curl into mini-sculptures, become the subjects of her soft ground prints.

About her print *Dark Fall* (page 107), Webber says, "I placed dried leaves onto the drawn, etched soft ground. The plate was recoated with new soft ground. I then selected some leaves and placed them onto the plate. Wax paper was placed on top to avoid over-lifting the ground, and the plate was run through the press at a light pressure. The wax paper was removed and the leaves gently peeled off, revealing the impression of the leaves in the soft ground, with the tiniest detail. The main center leaf was painted with acid-resist liquid asphaltum, and the plate bitten again in acid. The shadows were achieved with aquatint. This print was printed twice. I first inked the background à la poupée to get the fall colors of the leaves, making sure not to touch the main center leaf. I let it dry for a week, then inked the whole plate in black and printed on the same paper."

Aquatint

Whereas engraving techniques use sharp tools to create lines or other marks in the plate, the aquatint method uses dots etched in acid to create tone. Despite the aqua in its name, the aquatint process does not involve water; rather, the name refers to the watercolor-like effect aquatint often produces.

Aquatint can be achieved in several ways: by spraying a clean metal plate with enamel spray paint, by pressing sandpaper into a soft ground, by using photo processes and halftone screens before etching in acid, and so on. For the greatest control in creating quality tones, however, the method most often used is done with rosin, which is made of sap from pine trees. In the pages that follow, we will look first at the rosin method, then focus on three other aquatint methods—the lithographic pencils method, the acid-resist liquid asphaltum method, and the spit bite method—while also looking briefly at the enamel spray paint and dark-to-light (à la manière noire) techniques. Note that aquatint is often applied after lines have been previously etched in a plate, to tone a design. (It is not uncommon, and often useful, to combine several intaglio processes on the same plate.)

ROSIN AQUATINT

In rosin aquatint, fine grains of rosin are deposited on a plate and the plate is then heated to make the rosin adhere to it, forming a screen ground of uniform density. Varnish or an acid-resist drawing medium is applied to protect areas that are to stay white. After the plate has been etched in acid, any exposed surface will result in a dark area on the print. A range of tones is achieved with successive turns of varnishing some areas and again biting the plate in acid; the longer the bite, the darker the tone. Aquatint should not be over-etched, however. Depending on the metal and the corrosive agent used, aquatint can burn out and lose its grit after a certain time in the acid, resulting in loss of tone control.

Sylvie Covey, *Sylfide*, 1980, rosin aquatint with sugar lift, 18 x 24 inches (45.7 x 61 cm).

MATERIALS AND TOOLS FOR ROSIN AQUATINT

Because rosin aquatint involves crushing the rosin and then melting the powdered rosin onto the plate, some specialized tools and materials are needed:

› Rosin lumps

› Facemask to avoid breathing powdered rosin

› Mortar and pestle or coffee grinder to grind the rosin

› Aquatint box, nylon-stocking material, or fine mesh to spread rosin

› Electric hot plate or alcohol lamp to melt rosin

› Fireproof platform and heat-resistant gloves (kitchen mitts) to handle the hot plate

› Liquid asphaltum to resist acid on the aquatint

Svetlana Rabey, Untitled, 2013, color spit bite rosin aquatint
(three plates), 24 x 36 inches (61 x 91.4 cm). Courtesy of the artist.

Rosin is harmless to the touch, but when inhaled in a powdered form it can cause serious respiratory problems. A simple cotton-fiber mask with elastic straps that fit around the head and under the chin will prevent you from inhaling rosin.

Grinding the Rosin

Pre-ground rosin, used in stone lithography, can be bought from art suppliers, but pre-ground rosin is uniformly fine grained and can sometimes bite in patches, creating an uneven tone. Most print shops prefer to buy rosin in lumps and grind it in-house because a varying consistency of rosin grain creates dramatically different textures and tones that are desirable in intaglio aquatint.

Coarse-grained rosin creates white spots on a toned aquatint, which are sometimes welcome for special effects such as stars or a galactic effect in a sky. In general, though, a fine to medium grain is suitable for most tonal fields. You will learn which results you like best through experiment and practice.

When very fine grains are desired, lump rosin can easily be ground in an electric coffee grinder. But to see the progression of the grinding, use a mortar and pestle instead. The mortar and pestle should be large enough for the chunks of rosin. Work the pestle firmly in a circular motion against the inside of the mortar. Use pressure to squash the lumps, reducing them to powder. Rosin lumps have an amber tint that grows whiter and milkier as the powder gets finer.

Rosin can also be ground with a rolling pin or other roller. To do this, place chunks of rosin in a folded newspaper on a hard surface and roll over it with the rolling pin (or with a round glass bottle), crushing the lumps into powder. Open the pages of the paper from time to time to check the grain quality, again noting that the whiter it gets, the finer it is.

Once you have ground the rosin powder, you can store it in a jar or sealable plastic container for future use.

Dusting and Heating the Rosin Aquatint Plate

Rosin can be dusted onto the plate by hand, sprinkled through stocking nylon or other fine mesh, or distributed across the plate with an aquatint box. The hand-dusting method is usually used on very small plates or when different grains of rosin are required for specific textural tones. The rosin grains are sprinkled on the prepared plate as desired.

To sprinkle the rosin through stocking nylon or other fine mesh, first prepare several small bags made of the cloth. If you sprinkle the rosin through just one bag, it will fall heavily onto the plate, but if you double or triple the bags, creating layers of mesh, the rosin powder falls less densely, the result depending on the number of layers you use.

Most print shops have an aquatint box—an enclosed structure, usually built of plywood, whose purpose is to create and contain a little dust storm. A simple model has a wide, rotating broom on a paddle wheel inside the box at the bottom, connected to a hand crank that sticks out of the box. Powdered rosin is loaded into the aquatint box through a door at the bottom. Near the middle of the box is another door, opening to a shelf made of widely spaced thin wooden rods. The metal plate is placed face up on this shelf, and the door is closed. As the hand crank is vigorously turned, the broom on the paddle wheel rotates, causing the powdered rosin to rise, creating a dust cloud throughout the box. Rosin dust settles on the plate, and any rosin that does not settle on the plate falls through the spaces between the rods back down to the box's floor.

Coarser, heavier grains of rosin fall faster than fine grains. To avoid a heavy, coarse coating on the

plate, crank the handle, wait 10 seconds to let the heavier grains fall, then open the door to the shelf and place the plate inside. Close that door quickly, waiting 6 minutes for the dust to completely settle before removing the plate from the box. The plate is now ready to be heated.

Plates can be heated directly on a hot plate or with an alcohol lamp or blowtorch. If using the latter method, place the rosin-dusted plate on a simple fireproof platform—a metal screen mounted on a metal frame—and use the alcohol lamp or blowtorch to heat the bottom of the plate, fusing the rosin grain to the metal. Use heat resistant gloves to move the plate to a cool surface. You may need to repeat the dusting and heating process two or three times to achieve a solid, evenly aquatinted ground.

Artist Svetlana Rabey coats her large copper plates with rosin aquatint and heats them before processing further. Her procedure follows.

Rosin Aquatint Process

1 After cleaning, beveling, and polishing the plate, Rabey degreases it with whiting paste, then washes it with a high-power hose.

2 Wearing a face mask, Rabey loads the rosin into the bottom of the aquatint box, then vigorously turns the crank twenty times to create a dust storm inside the box. After waiting 10 seconds, she opens the plate-shelf door and places the plate inside atop a larger piece of mat board, closing the door quickly. Stepping away from the box, she waits 6 minutes for the dust to settle, then retrieves the plate from the box (shown) without touching the dust coating on top of the plate to avoid getting fingerprints on the aquatint. Tips: The amount of powdered rosin used depends on the size of the box, so experiment: load some in, then turn the crank and briefly peek inside the box to see whether you've created a dust cloud. When doing this, do everything possible to avoid breathing the dust.

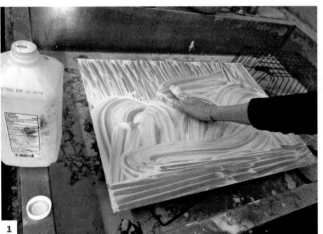

1

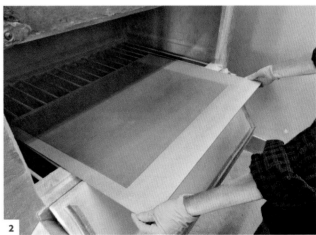

2

3

3 The plate now needs to be heated to make the rosin adhere to the metal. The photo shows Rabey placing her copper plate on a hot plate, cradling it in a large sheet of newsprint, which protects her hands from being burned and ensures that no fingerprints get on the plate. (If your plate is too large for handling with newsprint, wear kitchen mitts or other heat-resistant gloves.) The goal of heating is to ensure that the rosin grains stay firmly fused to the plate, with each grain keeping its individual round shape. The hot plate should be set at 350 degrees. If underheated, the rosin grains will dissolve in the acid bath, resulting in open spaces on the plate. If overheated, the rosin will melt too much, clogging the areas between the grains, which must remain clear for the acid to create a tooth. The perfect aquatint is achieved when the spaces between the grains are equal to the size of the grains.

4 Here, you can see the resin powder becoming transparent as Rabey heats the plate. When doing this, move the plate around to ensure even heating. When the rosin coating turns transparent but before it starts smoking, take the plate off the heat by lifting it with the newsprint.

5 Here, the heated plate has been set on a table to cool. Note that the rosin grains are now completely transparent.

4

5

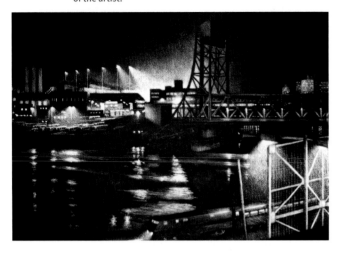

Bill Behnken, *Harlem River Nocturne*, 2008, enamel spray aquatint on zinc, 18 x 24 inches (45.7 x 61 cm). Courtesy of the artist.

ENAMEL SPRAY PAINT AQUATINT

Enamel spray paint is sometimes used instead of rosin to create an aquatint ground. In a well-ventilated area, spray a fine mist of enamel evenly on a cleaned plate. Be sure not to over- or under-spray. Spaces between paint droplets should be the same size as the droplets themselves. Check the plate with a loop to see if the spray is successful. Always wear a face mask when doing this procedure.

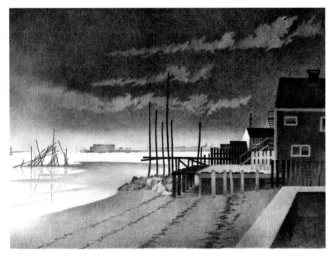

Bill Behnken, *A Welcome Light*, 1987, lithograph, 14 x 19¼ inches (35.6 x 48.9 cm). Courtesy of the Old Print Shop.

Etching the Aquatint Plate

Aquatint bites a lot faster than an etched line: For a copper plate, just 20 minutes in ferric chloride will usually result in a dense black; for a zinc plate, 8 to 10 minutes in nitric acid (diluted at 10 parts water to 1 part acid) will produce black.

You can achieve gradations of tone by putting the plate into the acid bath and taking it out at intervals and painting areas of the plate with an acid-resistant substance each time you take it out. If you do this, keep close track of the total number of minutes the plate has spent in the acid bath, and do not exceed 20 minutes for copper in ferric chloride or 10 minutes for zinc in nitric acid, when the acid is new. If, for example, you are biting a copper plate in ferric chloride, you might want to time the successive baths like this: 3 minutes for the light gray areas; 5 minutes more for the medium-gray areas; 6 minutes more for dark gray; and 6 minutes more for black, for a total etching time of 20 minutes. (White areas are painted with an acid-resist substance before beginning the etch.) As has been mentioned, over-etching a plate will cause a loss of the rosin grain and result in a burnt-out aquatint.

AQUATINT WITH LITHOGRAPHIC PENCILS

In aquatint with lithographic pencils, an image is built up gradually by drawing on an aquatinted metal surface with greasy, acid-resist lithographic pencils and crayons. Anything containing grease will repel acid, at least for a while, and can therefore be used for stopping out. Lithographic pencils and crayons, made of a wax-based substance, work well and produce graded reverse tones in an aquatint print. The number of the pencil or crayon indicates the amount of grease it contains. Lithographic pencils range from #1 (softest) to #5 (hardest); crayons range from #00 (softest) to #5 (hardest). The only brand available is

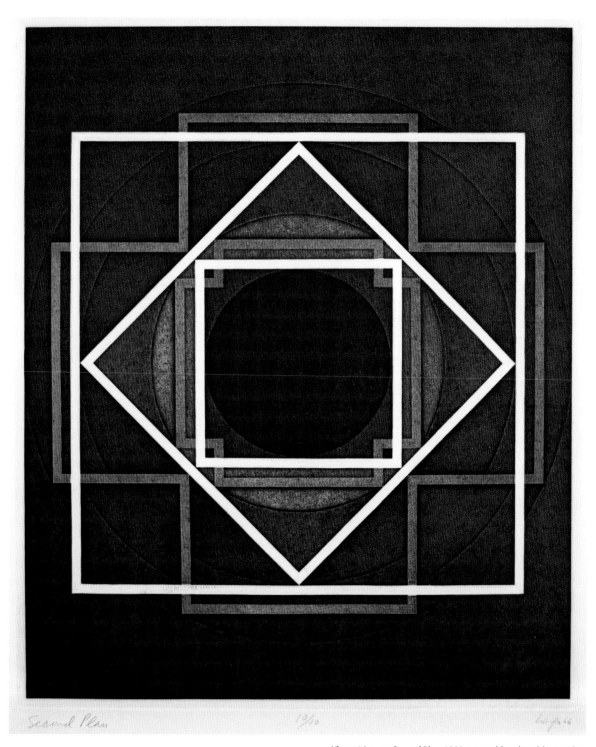

Second Plan 13/50

Vincent Longo, *Second Plan*, 1966, tape acid-resist with aquatint,
17 ¾ x 14 ¾ inches (45 x 37.5 cm). This print shows five aquatint
tones: the white unetched area and four gradations of tint from the
lightest to the darkest circle in the middle. Courtesy of the artist.

William Korn. When drawing on a plate, start with harder pencils, sharpening them with a blade as needed. As the image develops, gradually change to softer pencils.

After the plate has gone through the acid bath and been printed, the drawn-on areas will be light, while the aquatinted areas will be dark. Unlike stop-out varnishes like liquid asphaltum, which create hard edges around an unprinted area, lithographic pencils produce soft edges and gradations, like a negative pencil drawing.

With this method, the etching in acid is usually done only once, opting for the darkest tone desired, because a range of gradations can be obtained from the pencil work.

Biting an aquatint drawn with lithographic pencils requires a specific mixture of corrosive and a specific amount of time in the acid. If you are biting a copper plate, mix 1 part water to 1 part straight ferric chloride (48 degrees baume) in a glass bottle. Pour the solution into a plastic tray, and place the copper plate in the bath for 20 to 25 minutes. Wash the plate with water, clean it with solvent and then alcohol, ink it, and print. To bite zinc plates, mix 12 parts water to 1 part 68% nitric acid in a glass container, always adding the acid to the water, not the water to the acid. Pour the diluted acid in a plastic tray, place the plate in the bath, and etch for 35 minutes. Wash the plate with water, clean it with solvent and then alcohol, ink it, and print. Always mix corrosives in a well-ventilated area, wearing goggles and gloves for protection.

Printmaker Bill Behnken uses a spray of enamel paint instead of rosin for aquatint, then draws on the plate with acid-resist lithographic pencils. His process follows.

STOP-OUT ALTERNATIVES

When working on very small and delicate areas, you can draw on parts that you want to resist the acid with permanent red Sharpies. Other substances that can also be used for stopping-out areas include these:

> Korn's Lithographic Tusche
> petroleum jelly
> plate oil
> Z*Acryl stop-out resist

Aquatint with Spray Paint and Lithographic Pencils

1 Behnken first made a tonal drawing using white and light yellow Prismapencils on black BFK Rives paper that he would use as a guide when drawing on the plate. This reverse light-on-dark effect approximates the effect of the final aquatint print.

2 To create the aquatint, Behnken used the enamel spray paint method (see page 114) on a zinc plate.

3 He then developed the drawing on the plate using a variety of lithographic pencils. The photo shows the design in progress.

4 The photo shows the completed drawing on the plate, which is now ready to be etched. Note that the range of tones appearing on the plate are a "negative" of the final printed image.

5 This photo is a close-up view of the zinc plate in the acid bath, showing the nitric acid bubbling on the plate's surface while biting. During the etching process, the bubbles can be wiped off using a feather or left alone for

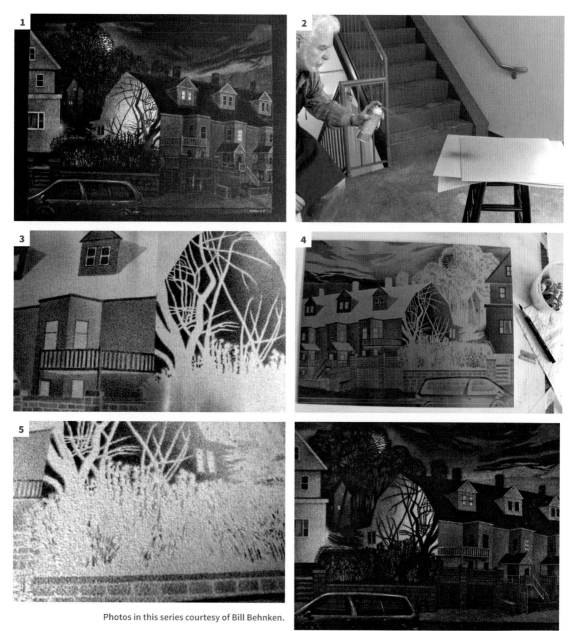

Photos in this series courtesy of Bill Behnken.

Bill Behnken, *Early Autumn/In Memoriam*, 2014, aquatint,
14 x 18 inches (35.6 x 45.7 cm). Courtesy of the artist.

their textural effect. Then, after etching, the plate was carefully washed with water, and the greasy pencil matter was removed with a wide brush and mineral spirits. Then the plate was cleaned, inked, and printed on an etching press. The final print is shown at bottom right.

Note the grainy effect from the greasy pencil work on the etched spray aquatint. The light areas were the ones that were penciled, resisting the acid, while the dark areas were open and thus etched in darker tones.

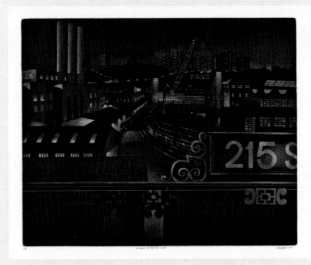

PRINTMAKER PROFILE: Bill Behnken
oldprintshop.com

"My goal is to create a bold, unifying impression that draws the viewer in close to look carefully at the varied and often subtle tonal harmonies."

Bill Behnken's artwork is not intended to be a topographical or historical record of a location nor a carefully made facsimile of objects. Neither is he driven to voice gender issues or a political agenda. Instead, he sees his work as "experiential," hoping to elicit from the viewer a moment of reverie and the recall of felt moments of connection to one's inner life, of the experience of a poetic harmony.

When he was invited to teach printmaking and act as director of the Provincetown Art Association and Museum summer school on Cape Cod in 1984, Behnken, like many artists before him, found the light and atmosphere of Provincetown magical and enchanting. The environment, the numerous artists there, and the town's tradition as a vital American art colony drew him in.

From 1977 until 1987, lithography was Behnken's chosen medium, but he eventually explored the technique that he has since primarily used for his prints: the "crayon aquatint." He liked the results, which showed the experience he had acquired over years of doing lithography but also recalled the surface textures and rich velvety blacks of the intaglio printmaking that he so loved.

The studio at the Provincetown Museum school had no rosin box for traditional aquatint, so Behnken improvised by using enamel spray paint to create a misted surface of paint particles that acted like rosin dust. After having worked for so many years with lithographic pencils, he thought to try those same wax pencils as a resist to nitric acid on zinc. Over years of working in this way, he came to realize his voice and saw his work mature. For him, the medium captures true sensations through the deeply sensuous blacks, the whispering gentility of silvery grays, and the glowing scintillation and brilliance of light. As Behnken says, "To these seemingly fleeting moments, I try to give a sense of permanence by a carefully worked-out design order that simplifies forms and organizes clearly constructed spatial relationships, and by the balance and rhythms of the passage of light throughout the image. My goal is to create a bold, unifying impression that draws the viewer in close to look carefully at the varied and often subtle tonal harmonies."

ACID-RESIST LIQUID ASPHALTUM AQUATINT

Liquid asphaltum is a thick acid-resist substance that you paint on the plate with a brush, using the asphaltum to define light areas and create crisp edges in a range of tones. The longer the aquatinted area is exposed to acid, the darker it will print. This technique can be used on a plate that already has etched lines, or you can use fine-tipped permanent markers to draw guides for the areas you will paint. The number of tones and the times in the acid bath can be as you wish, while staying within the 20-minute total for copper in new ferric chloride and the 10-minute total for zinc in new nitric acid. (Timing can be slightly adjusted according to the strength of the acid.)

SPIT BITE AQUATINT

Spit bite is an alternative way of etching an aquatint, in which you create tones by painting acid on some areas of an aquatinted plate instead of placing the whole plate in an acid bath. The acid etches only in the areas where it is painted. Spit bite is a very direct process that records every gesture of the paintbrush, with the artist controlling the amount and strength of the acid, the areas where it is applied, and the length of time the acid is allowed to bite the plate.

The method is called spit bite because spitting in the acid is often part of the process, although it is not required. Saliva is an excellent wetting agent and helps prevent the acid from beading on the plate. Some etchers spit on the plate and use a paintbrush to mix the saliva with acid on the plate. This helps control the etching areas, reducing the beading of liquid on metal. Gum arabic may be substituted for saliva and should be mixed with the acid prior to painting on the plate. Any acid bath eventually becomes exhausted, unable to etch

MATERIALS FOR SPIT BITE

Spit bite requires materials to ensure safe handling of the ferric chloride or nitric acid, including these:

- ❭ Disposable gloves for protection
- ❭ Plastic tray to hold plate while painting with acid
- ❭ Container for water and a glass container for the acid
- ❭ Synthetic (not natural fiber) paintbrushes with wooden handles for painting the acid on a plate
- ❭ Paper towels for blotting
- ❭ Glass jar for mixing and storing the acid

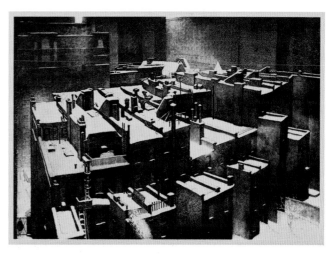

Michael Pellettieri, *Winter*, 1980, etching aquatint, 22 x 28 inches (55.9 x 71.1 cm). Courtesy of the artist.

more metal, but because paintbrushes can hold only a limited amount of acid, the acid exhaustion occurs much faster with spit bite. When spit biting, you must build the image slowly, repeatedly dipping the paintbrush in the acid and brushing it on the plate, etching for a longer time than if you were using an acid bath to compensate for the rapid exhaustion of the corrosive.

Gregory Haley, #23, 2011, spit bite aquatint, 6 x 8 inches
(15.2 x 20.3 cm). Courtesy of the artist.

The spit bite method requires specific solutions of corrosive agents for best etching results. Follow these procedures, always remembering to wear goggles and gloves and to work in a well-ventilated area when handling corrosives:

1 When preparing ferric chloride for spit biting on copper, pour the ingredients into a glass jar in this order: 2 parts water, then 1 part gum arabic, then 2 parts full-strength ferric chloride (48 degrees baume). To keep the ferric chloride from biting too fast when it is first applied to the plate, add a very small quantity of old, exhausted ferric chloride.

2 When preparing nitric acid for spit biting on zinc, pour the ingredients into a glass jar in this order: 2 parts water, then 2 parts gum arabic, then 1½ parts undiluted (68%) nitric acid. Pour the acid in very carefully and slowly. Stir the mixture with a wooden stick.

Once you've prepared the corrosive agent as well as the aquatinted plate, follow this procedure when spit biting:

1 Set the aquatinted plate in an empty tray to avoid spilling corrosive agents on the worktable. Use a synthetic paintbrush to paint the acid. Dip your brush in the acid container, and paint on the plate.

2 Rinse your brush in water as needed to create soft tones by adding water to the painted acid or to soften the edges of the painted bitten area.

3 Go over the brushstrokes, repeatedly painting them with acid for at least 30 minutes when using ferric chloride on copper or 15 minutes when using nitric acid on zinc.

4 When the biting is done, wash the plate thoroughly with water and wipe it with paper towels and alcohol to dissolve the rosin grain, then ink the plate and print.

Artist Svetlana Rabey's spit bite aquatints often involve drippings, so rather than laying the plate horizontally in a tray, she sets up the plate vertically, leaning it on a board set against a wall, to create the dripping effects when biting. On the next pages is the process she used when creating one of her untitled spit bite aquatints.

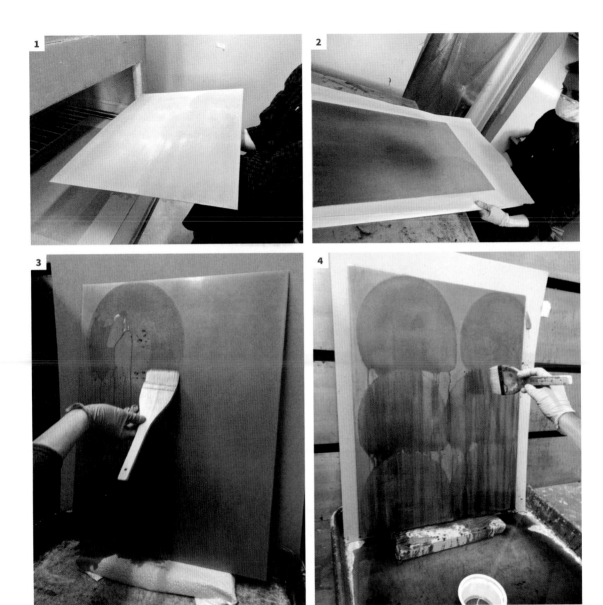

Spit Bite Aquatint Process

1 First, Rabey prepared the copper plate and coated it with rosin using an aquatint box.

2 She then heated the rosin-coated plate on a hot plate to fuse the rosin grains to the plate. Note that with very large plates, you may have to coat and heat the plate two or three times to achieve a solid, even aquatinted ground.

3 Rabey then placed the plate in a plastic tray, setting it up straight against a board leaning on a wall and elevating the bottom of the plate with a cushion to prevent the drips from gathering at the bottom of the plate. She dipped a wooden-handled brush in a container of ferric chloride and painted her first stroke.

Svetlana Rabey, Untitled, 2013,
spit bite etching with aquatint (three
plates), 24 x 36 inches (61 x 91.4 cm).
Courtesy of the artist.

4 By adding more strokes with ferric chloride and repeating them, she defined the image. This brush etching went on for 30 minutes. The ferric chloride, originally brown, turned green as it became exhausted. Three different plates were repeatedly aquatinted and brush-etched with ferric chloride to achieve a layered effect. After biting, Rabey washed the plates in water and dissolved the rosin with alcohol before inking and printing. The final, three-plate spit bite aquatint is shown above.

S. Rabey, Untitled, 2013, spit bite aquatint (two plates),
24 x 36 inches (61 x 91.4 cm). Courtesy of the artist.

PRINTMAKER PROFILE: **Svetlana Rabey**

svetlanarabey.com

"My philosophy is that there is a great amount of difference in repetition, and that the more control one has, the more freedom one can express."

Svetlana Rabey has explored many different styles and mediums in art making: painting from life, abstract painting, installation, drawing, and sculpture. She finds that abstract painting comes closest to her inner expression as an artist. Because her creative process is very intuitive and sometimes chaotic, she feels the printmaking process balances the chaos and structures her creativity. All the technical steps in printmaking slow down her process and allow her to think through her goals, which helps her gain more control over her materials.

As a young girl, Rabey received professional training in classical dance, and she continues to pursue it almost daily. She sees the repetition and variation of dance movement as a form of meditation, and it has a strong influence on her painting process, which is a kind of performance. She approaches a blank piece of paper, canvas, or copper plate and begins the process of creating abstract shapes. The process is intuitive, fast, and sometimes unconscious, though a strong element of control is involved.

Rabey is deeply interested in the relationship between control and release. About her work, she says, "My philosophy is that there is a great amount of difference in repetition, and that the more control one has, the more freedom one can express. I am interested in random choices of color. Like a child, I want all the colors in the crayon box. I am interested in blurring the perception of foreground and background, using transparencies, and manipulating positive and negative space."

AQUATINT FROM DARK TO LIGHT

As has been described, an aquatint tone is usually obtained by biting a rosin-coated plate in acid while stopping-out some areas with asphaltum or some other acid-resist material to prevent them from being etched. But some artists prefer the reverse option, in which a plate is fully aquatinted, then etched for the maximum time (which would produce an overall black tone if the plate were printed with black ink right after etching), therefore creating an aquatinted tooth on the surface. Then, a burnisher is used to smooth out portions of the surface, lightening the aquatint in the desired areas and gradually defining the composition. In this method, known as à la manière noire ("in the dark manner") or false mezzotint, the lighter image slowly appears from a black ground. The result looks much like a mezzotint (see page 87), although in this case the dark tone is held by the etched grain of the aquatint rather than the tooth raised by the rocker. It is much faster and easier for a novice printmaker to use aquatint rather than rocking a plate to achieve this effect, though mezzotint produces deeper and more dramatic dark tones than aquatint because the rocker cuts deeply into the metal plate while an aquatint is etched on its surface only.

The example of manière noire shown at bottom right was done from three plates that were aquatinted, burnished, and then printed in many color variations.

Acid-Resist Open Bite Etching

Acid-resist open bite is an etching technique in which open areas of the metal are exposed to the acid. The method creates a range of levels on the plate that hold different capacities of ink. The edges of the open areas hold ink, making dark, irregular lines, but the open areas themselves hold much less ink, yielding a mottled tone.

One acid-resist open bite method involves the use of masking tape. In this method, the plate's

Vincent Longo, Untitled, 1970, acid-resist open bite etching, 10 x 10 inches (25.4 x 25.4 cm). Courtesy of the artist.

Maya Hardin, *La Pania di Mary*, 2013, artist's proof, burnished aquatint (three plates), 12 ½ x 7 inches (31.7 x 17.8 cm). Courtesy of the artist.

Vincent Longo, *Tracking*, 1977, acid-resist open bite etching,
12 x 12 inches (30.5 x 30.5 cm). Courtesy of the artist.

surface is etched in depth in several successive stages; without an aquatint ground to provide a tooth on the plate, the acid bites all exposed areas to the same depth. Then, when areas of the plate are protected with masking tape and the plate is re-etched, another level of depth is created. The plate is then retaped and re-etched until several levels appear. When printing the plate, ink is retained between each level of depth, giving a crisp effect to the print. As with all intaglio processes, the longer the plate is etched, the deeper the etching and the darker the print. With this process, however, only the edges of the etched areas will print darker than the previous etch.

Vincent Longo is credited with inventing the tape acid-resist method, where thin adhesive tape is gradually added or removed at successive stages,

ALTERNATIVE OPEN BITE
ACID-RESIST METHODS

In addition to masking tape, plasticized adhesive paper such as contact paper, cut into different shapes, can be used to protect areas from the acid. The protected areas will print lighter, and unprotected areas will retain ink on their edges. It is also possible to tape portions of a plate, cover the whole plate with liquid asphaltum, and then lift the tape before etching. The area where the tape was lifted will retain ink on its edges.

preventing or accentuating the etching and thereby creating a design in an additive and subtractive way. Longo has written, "In 1964 I discovered an acid-resist method that was ideally suited to hard-edged geometric abstraction and the lattice patterns that began dominating my work. I employed common masking and charting tapes and, later, contact paper as well. It is the rubber-based adhesive [on the tape] that actually resists acid."

To prevent acid from creeping under the resist, the taped plate must be run through the press before it is put in the acid bath. While it is in the bath, constant feathering with a soft brush will keep the etched surfaces smooth. Tonal effects are created simply by the printing ink clinging to the edges of each shape and fading from it in the act of wiping the surface. Tape resist can also be combined with more traditional shading techniques such as aquatint, soft ground, lift ground, and cross-hatch etching.

The procedure for the tape acid-resist method is as follows:

1 Prepare a plate by beveling, cleaning, and degreasing it.

2 Protect the back of the plate with adhesive contact paper if the back of the plate does not have a factory coating.

3 Use masking tape to mask some areas of the plate.

4 Run the plate through the press to secure the tape on the plate.

5 Etch the plate in acid. (The time in the acid bath is calculated roughly, according to the level of depth you wish to achieve.) Wash the plate in water and wipe it dry.

6 Add more tape on the areas that were left open in the first taping. The tape can overlap previously taped areas. Run the plate through the press again.

7 Again etch the tape in acid. Repeat steps 3 to 7 as often as you desire, until there are no more open areas to tape and etch.

8 When the plate has an overall design etched to various depths, remove all the tape using Gamsol or mineral spirit, ink the plate, and print.

Vincent Longo, *Fade*, 1969, open bite etching, 10 x 8 inches (25.4 x 20.3 cm). Courtesy of the artist.

PRINTMAKER PROFILE: **Vincent Longo**

vincentlongoartist.com

After Longo began printmaking, it quickly became second nature to him. It was a relief from the often too intense and physically demanding action-oriented experience of painting.

Open bite etching was first used in Stanley Hayter's Atelier 17 studio in Paris, but only to create embossed white details. It was Vincent Longo's innovative use of tape grounds that gave intaglio printing an entirely new look. In many of his prints, Longo used tape in conjunction with traditional etching techniques such as aquatint, soft ground, and lift ground. In fact, tape is the simplest, most direct lift-ground method, and tape became Longo's favorite acid-resist material, ideally suited to his hard-edged, abstract geometric compositions.

After Longo began printmaking, it quickly became second nature to him. It was a relief from the often too intense and physically demanding action-oriented experience of painting. And while making prints entails a lot of steps before a visual image can be completed, the print shop itself is a relaxed, communal place for making art. Teaching the art of printmaking, which he did from 1953 to 2001, was a very rewarding part of Longo's life. From the beginning, he felt that his role as a printmaker was to find ways to make a highly technical and indirect creative activity be more immediately productive of spontaneous results. He tried to find ways to adapt it to his own particular aesthetic signature of abstract improvisation.

About his open bite etching *Fade*, shown above, Longo says, "A lattice pattern was laid out with quarter-inch masking tape and sealed in the press. The zinc plate was then etched in four successive states in times ranging approximately from 5 to 15 minutes in nitric acid and brushed constantly while in the bath. The grid framework itself was not etched and thus remains white. A graduation of tones from light to dark results from the etched areas. Since more ink is held in the deeper squares, a fading tonal effect is attained by the simplest and most direct etching means other than drypoint."

Bernard Zalon, *Soccer*, 2008, embossing with aquatint,
12 x 12 inches (30.5 x 30.5 cm). Courtesy of the artist.

Embossing

In embossing, a "sculptural" plate is printed, creating a three-dimensional effect. A deeply bitten intaglio plate or a textured collograph (see chapter 7) will display the embossed effect, whether inked or not. When a line or shape is deeply etched into the metal and printed on dampened paper, the line or form appears on the paper as relief, and the image is defined by the light and shadows created by this pressed relief.

Embossing can be done in combination with etching and aquatint. New York artist Bernard Zalon created a series of sophisticated, crisp prints of balls used in various sports. Dedicating himself to the perfect depiction of each ball, Zalon combined aquatint with embossing to achieve deeply etched textures and tones. On page 131 is the process he followed when making the print depicting a basketball, entitled *Pebbles*.

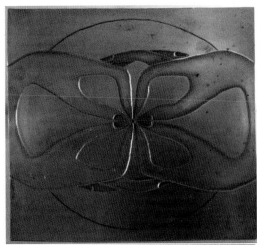

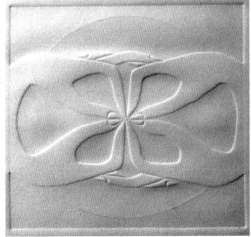

Michael Ponce de Leon, Untitled, 1980, embossed copper plate
and print, 8 x 8 inches (20.3 x 20.3 cm). Collection of the author.

Bernard Zalon is a self-taught independent artist with an early background in architecture. Based in New York City, he has for more than thirty years made his living selling his prints at street fairs across the United States.

Zalon's work is varied in style and subject matter. Printmaking expanded his style of drawing: He went from using only line and black tone to adding shades of gray when he discovered aquatint. Zalon likes the challenge of turning

McCartney woke up with the tune of 'Yesterday' in his head. He had to play it for people to see if he got it from somewhere else. I've always used bicycle imagery in my work. I like riding a bike; a bike is very graphic—straight lines and circles. It fits with my style."

Describing his basketball print, *Pebbles*, Zalon says, "The first plate is a flat color aquatint. The second plate has the pebbled surface texture, done as a deeply etched photo-etching. This plate

Bernard Zalon, *Spokes*, 2008, etching aquatint, 12 x 12 inches (30.5 x 30.5 cm). Courtesy of the artist.

PRINTMAKER PROFILE: **Bernard Zalon**
bernardzalon.com

"It's hard to say where ideas come from. They're like songs."

an idea into an etching, forcing the medium to do whatever is needed to get the idea across. His sports ball series started that way—a challenge to achieve the right texture and feel of a basketball, a tennis ball, a golf ball, and so on.

When not working in the studio at New York City's Art Students League, he sometimes takes a grounded plate with him to bars, the street, or the subway and uses a needle to draw on it directly from life. He also gets a lot of ideas while selling his prints on the street, where there is a lot of time to think: "It's hard to say where ideas come from. They're like songs. I've heard songwriters say they don't know where songs come from. It's more like they're given to them. Paul

goes through the press without any ink, just to get the texture on the flat-color aquatint. On the third plate I etched the outlines of the seams of the ball, then did an open bite between the seams completely through the plate, so I was left with curved metal bands crossing an empty hole. I did a surface roll of black ink on them, the result being that the seams get pushed into the paper, the color kind of puffs out, and the pebbled surface is, well, pebbled!"

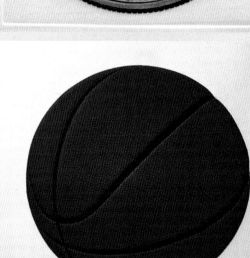

Bernard Zalon, *Pebbles*, 2008, embossing with aquatint and roll-up etching, 12 x 12 inches (30.5 x 30.5 cm). Courtesy of the artist.

Embossing Process

1 Zalon etched three plates: The first to hold the main color, the second to emboss the form and texture, and the third to outline the basketball's seams. He aquatinted the first plate and printed it in brown. The photo shows him inking and wiping the first plate.

2 For the third plate (defining the ball's seams), Zalon rolled black etching ink on a table with a brayer and inked the plate by rolling the charged brayer across its surface, as a "surface roll."

3 Zalon printed the first plate on a sheet of dampened paper. He taped one edge of the paper to the press bed to secure it.

4 He pulled the print, with the tape holding the paper in place. Then he placed the embossed plate on the bed of the press in the exact position of the first plate, using a metal corner to guide the registration.

5 Finally, Zalon printed the third (seam) plate, adding black ink to the image. The final print is shown opposite.

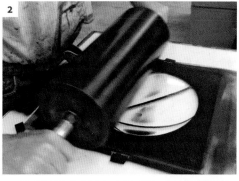

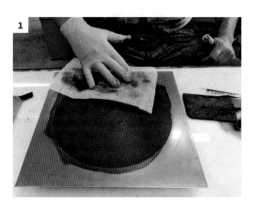

Sugar Lift

Sugar lift, also known as lift ground, is a painterly etching technique that enables a positive image to be etched on metal. The sugar solution is applied either randomly or in a controlled way: It can be painted or dripped onto the plate, and it allows painterly gestures and brush marks.

In sugar lift, a design is painted on the plate with a water-soluble sugar solution. (Recipes appear at right.) When dry, the plate is fully coated with a thin liquid hard ground, which is also allowed to dry. The plate is then dipped in a bath of warm water; the sugar dissolves in the water, lifting the ground on the painted areas and exposing the metal. The exposed areas are then bitten in acid. These lifted areas produce positive marks that will print; this is unlike an etching process in which a stop-out varnish is painted on as a resist, resulting in an unprinted area. Sugar lift can be done with or without an aquatinted ground; the exposed areas may be bitten as an open bite or aquatinted, depending on the desired effect.

For predictable results, the sugar lift solution must be painted on a clean, bare plate. On wide open areas, a rosin aquatint is needed to hold tone; however, the aquatint ground should be added after the lifting process, for two reasons: First, sugar laid on rosin aquatint lifts in a grainy, patchy, unpredictable way. Second, etching without an aquatint permits a very long acid bath, resulting in deeply etched areas whose edges will richly retain ink. An aquatint can be added before cleaning the hard ground to gain a tone in the center of the open areas.

MATERIALS FOR SUGAR LIFT

Besides a metal plate and an acid bath for etching, sugar lift requires the following materials:

> Sugar solution
> Paintbrushes
> Liquid hard ground for coating the plate
> Container in which water can be heated
> Hot plate to heat the container

SUGAR LIFT RECIPES

There are several recipes for sugar lift solution. Different recipes bring different results, allowing controlled effects or effects that are more random and textural. A controlled lift allows for painterly gestures and details; an uncontrolled lift offers accidental and interesting textures, such as granular and bubbly effects. No matter which recipe you use, make sure to mix it well.

> Controlled lift recipe #1. In a glass jar, mix 1 cup of Karo light corn syrup, 3 tablespoons of water-soluble India ink of a dark color (to make the solution easier to see on the plate), and a dash of liquid dish soap.

> Controlled lift recipe #2. In a glass jar, mix 1 part corn syrup, 1 part gum arabic, and 1 part liquid tempera paint (any color).

> Uncontrolled lift recipe #1. In a glass jar, mix 1 cup of granulated white cane sugar with ¼ cup of warm water, making a syrupy paste. Add a few drops of liquid soap.

> Uncontrolled lift recipe #2. In a glass jar, mix 1 cup of sweetened condensed milk with ¼ cup of warm water. Add more water for a thinner solution.

Here are some of the steps that artist Patricia Acero followed when making her sugar-lift aquatint *Rodeo 2.*

Sugar Lift Process

1 Acero painted sugar lift solution on a plate that had been previously line-etched.

2 When the sugar solution had dried, she coated the entire plate with liquid hard ground and let it dry, too.

3 Acero then dipped the plate in a bath of warm water to lift the sugar ground.

4 The sugar melted in the warm water and lifted the hard ground in the painted areas. Note: If the lift is slow, add more warm water. The water should never be boiling hot, to avoid melting the hard ground.

5 Acero etched the plate in acid, washed it in water and dried it, and then coated it with rosin aquatint powder. After heating the plate to fuse the rosin, she again placed the plate in an acid bath. Note: The time for the initial acid bath should be 2 hours for copper in ferric chloride or 30 minutes for zinc in nitric acid. The second acid bath should be no longer than 20 minutes, maximum, for copper in ferric chloride and no more than 10 minutes for zinc in diluted nitric acid.

After etching, wash the plate in water. Remove the hard ground and sugar ground with solvent, and then rewash the plate in warm water with soap. Remove the rosin grain with rubbing alcohol before inking the plate and pulling the print. Patricia Acero's finished, multicolor sugar lift aquatint is shown on page 135.

PRINTMAKER PROFILE: Patricia Acero

http://artistsunite.ning.com/profile/Patriciaacero

"Printmaking has allowed me to become an artist."

Patricia Acero loves creating evocative organic textures. Observing the movement of clouds in the distance or trees blowing with the wind or simply gazing at still water holds a magical, hypnotic attraction that she tries to emulate. She is also entranced by works from native cultures, keenly appreciating their sense of design and exquisite interpretation of nature. Making art brings her close to nature in an abstract sense—not intending to copy it, but going beyond the mere superficial aspects of appearance. Acero is attracted to abstract symbols in which she sees magical powers. Her dreams conjure the help of her ancestors for inspiration and courage. Once an idea has germinated, combining the idea and the process of image-making through printmaking presents a challenge.

After experimenting with and learning all the techniques of printmaking, Acero concentrated on gestural ways of working. The sugar lift technique in particular offers Acero flexibility in playing with shapes and forms in a painterly, free-form fashion. She approaches printmaking as a painter, although she appreciates the opportunity of making several versions of an image that printmaking gives her. She likes to create textures, or to lay an initial color on the printing paper, or to print with chine-collé (see page 239). Acero is not concerned with printing editions; each of her prints has its own unique character. Talking about her experience with printmaking, Acero says, "Printmaking has allowed me to become an artist. Although the process of creating art is individual, working in a printmaking studio and sharing ideas with other artists has been an important part of my development."

Patricia Acero, *Rodeo 2*, 2008, sugar lift aquatint, 18 x 24 inches (45.7 x 61 cm). Courtesy of the artist.

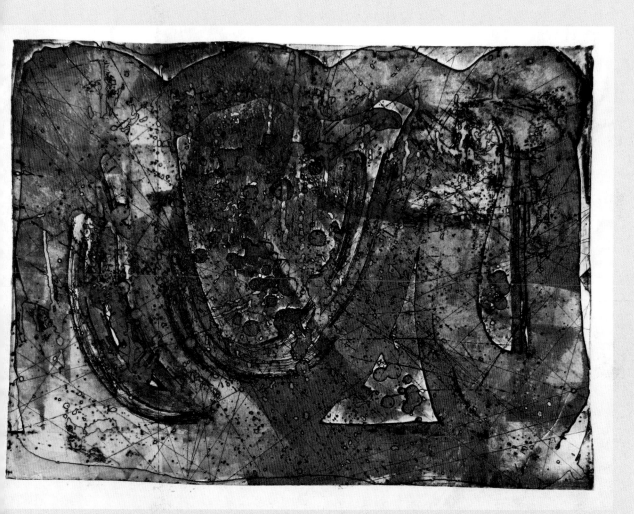

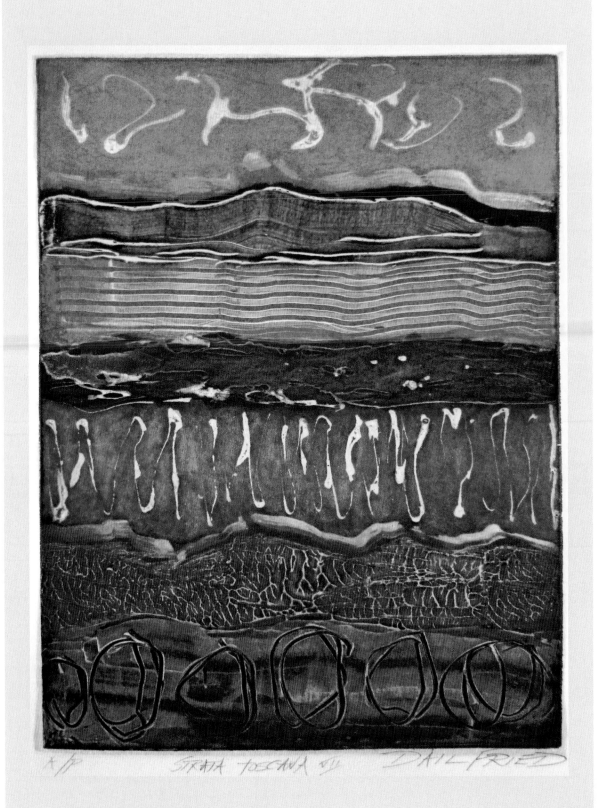

A/P STRATA TOSCANA VII DAIL FRIED

7

Collography

Collography evolved during the twentieth century; the word collography combines the ancient Greek words *koll* (or *kola*), meaning "glue," and *graph*, meaning the activity of drawing. A collography plate differs from other intaglio plates in that it is built up as opposed to being etched or cut down. Layers of fabric, string, pieces of cardboard, and/or other materials are glued on a rigid matrix surface, and the plate is then coated with acrylic gesso or acrylic medium to make it impermeable.

Collographs are often printed as intaglio but can also be printed as relief or as an embossed image with or without ink. Because of the multiple levels of the collograph, the medium lends itself beautifully to printing in color.

Some artists prefer to use a thin wooden block as the base for a collograph, but any hard board will work. The board should first be waterproofed by sealing it with acrylic gesso or medium; do this on both sides, to prevent warping. When the plate is dry, you can apply different pieces and textures to it—string, fabric, sandpaper, carborundum grit, and so on—gluing them down with acrylic medium. You can also use palette knives to make marks that will retain ink. Acrylic compounds make the best glues for collographs because they are waterproof when dry, allowing the dampened paper to print without sticking to the board. Layers of elements can be added and the whole plate given another coating of acrylic gesso or medium to keep it waterproof, but the combined height of the plate, from the surface to the highest glued-on elements, should not be greater than three-sixteenths to one-quarter of an inch so that

Dail Fried, *Strata Toscana VII*, 2012, collograph, 8 x 14 inches (20.3 x 35.6 cm). Courtesy of the artist.

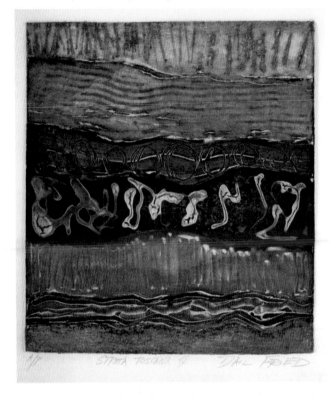

Dail Fried, *Strata Toscana IV*, 2012, collograph, 8 x 16 inches (20.3 x 40.6 cm). Courtesy of the artist.

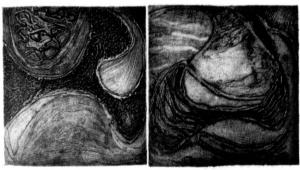

Dail Fried, *Mutation* Series, 2013, collograph à la poupée (two plates), 10 x 20 inches (25.4 x 50.8 cm). Courtesy of the artist.

MATERIALS FOR COLLOGRAPHY

Artists working in collography use a wide array of materials for both the matrix and the applied textures. Possibilities include

- ‣ Masonite, Plexiglas, or mat board on which to build the collographic image
- ‣ Acrylic gesso or medium for coating the board
- ‣ Mod Podge glue/sealer or acrylic medium for gluing pieces onto the matrix
- ‣ Acrylic gels (including textured gels) for creating textures
- ‣ Paintbrushes and palette knives for working with the mediums
- ‣ Fabric, sandpaper, string, cardboard, and other materials for building shapes and textures
- ‣ Carborundum of grades ranging from #80 (coarse) to #220 (fine) for creating tones

the printing paper does not tear under pressure. Papers between 200 and 350 gsm (approximately 135 to 236 lbs) are suitable for collograph prints. A collograph plate can also be cut into pieces, inked individually, and then pieced back together on the bed of the printing press, like a jigsaw puzzle.

Collography can also be done using carborundum as a tonal surface on a plate coated with gesso or medium. Carborundum is a sandy grit usually used to grind drawings off lithographic stones. When adhered to a board, different-size carborundum grits produce different tones, from coarse, dark, and rough to smooth, light, and fine. To adhere the grit to the board use either Mod Podge, Elmer's Glue-All, or an acrylic medium or gel; they work equally well. A carborundum collograph can be done on a coated board or on Plexiglas. If you are planning a color registration, Plexiglas is more convenient, because its transparency allows you to accurately register the plate simply by taping a copy of the design on the press bed and aligning each sheet of Plexiglas with it.

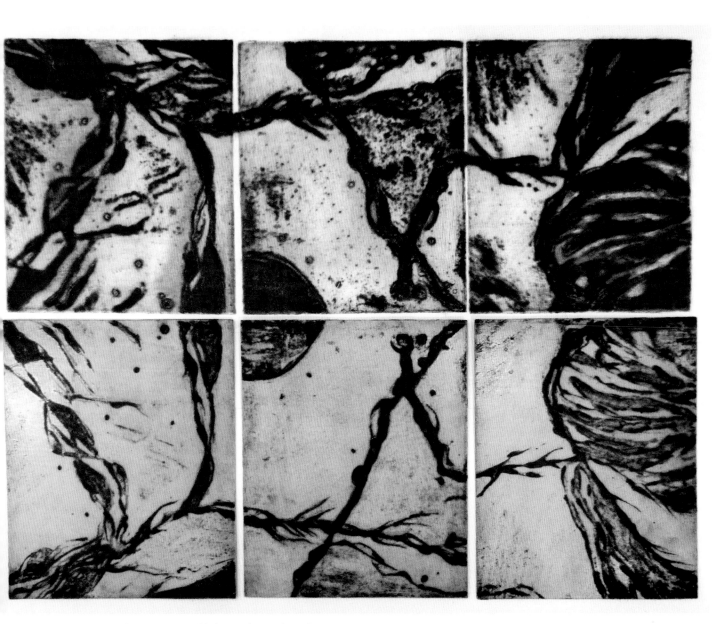

Ann Winston Brown, Untitled, 2012, three carborundum
color prints inked à la poupée with the three corresponding
carborundum plates, each 8 x 10 inches (20.3 x 25.4 cm).
Courtesy of the artist.

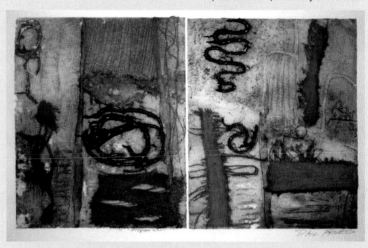

Dail Fried, *Capalbio*, 2013, collograph, 17 x 22 inches (43.2 x 55.9 cm). Courtesy of the artist.

PRINTMAKER PROFILE: Dail Fried

dailfried.com

"My aim as I strive to capture the inner landscape that resonates within me is that it be powerfully felt and seen simultaneously by the viewer."

Dail Fried likes to categorize her art expression as "liberal." Never interested in representation, figure, or precise detail, she concentrates instead on abstraction. Although inspired by nature and surrounding stimuli, she prefers to create a new reality by expressing emotions connected to experience. Intuitively and experimentally, she uses gesture and mark-making to transform the felt experience. The process involves surprises along the way, as well as an unknown destination. She chooses to choreograph art making in an expressive and improvised manner, all the while interacting with the moment. Free from any historical underpinnings, the result is a sensation of balance,

harmony, and excitement. There are no boundaries, and the viewer is as free to enter her work as she is to expand it. Having more than one way of seeing, she allows for different ways of working. Innovation, experimentation, and chance are major ingredients in the process. She sometimes paints freely and energetically but at other times creates with more structure and planning. Abstraction appeals to her because her intent is not to prescribe boundaries of a particular time or place.

When Fried discovered collography she embraced the possibilities of working with line, texture, and gesture combined with surfaces overlapping and recombining

via a multitude of textures. The appeal of collography is its three-dimensional quality. Although working in multiple mediums, Fried currently favors the results of a rich, textured, layered surface. Her palette of umber, raw sienna, terra cotta, and ochre relates back to the land and the earth. As the earth is a source for life and growing things, Fried seeks to assert the force of life and living things. She says, "Intuition and spontaneity are my tools as I experiment with endless variations of line, form, color, and texture. My aim as I strive to capture the inner landscape that resonates within me is that it be powerfully felt and seen simultaneously by the viewer."

The process that Dail Fried followed to create her carborundum collograph *Mutations* follows.

Carborundum Collography Process

1 First, Fried poured Mod Podge, a thick, milky, quick-drying water-based liquid glue, on the prepared board to act as glue and a sealer in the areas to be toned. (Acrylic gels can also be used, brushed on or applied with palette knives.) The thicker the glue or gel, the more carborundum grit it will hold, and the more intense the tone will be. The photo shows Fried drawing through the Mod Podge glue with a brush. (You may use any tool for this.)

2 Fried then selected grit sizes for the different areas to be toned. For each area, she shook the grit evenly over the wet glue and then shook the board to remove excess grit. As shown in the photo, only the glued areas retained the carborundum grit. She then let the board dry thoroughly overnight.

3 Fried inked the plate as an intaglio, pushing the ink into the depressed areas with an ink spreader and using the à la poupée method to blend several colors of ink on the plate. She printed the plate on an etching press and pulled a proof (shown). Fried made five other collograph plates, inked them with various colors à la poupée, and printed them together for the final print, shown below.

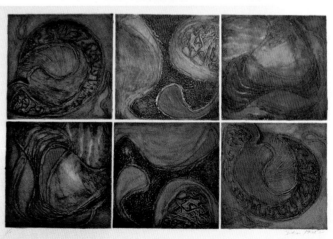

Dail Fried, *Mutations*, 2013, collograph (six plates), 18 x 28 inches (45.7 x 71.1 cm). Courtesy of the artist.

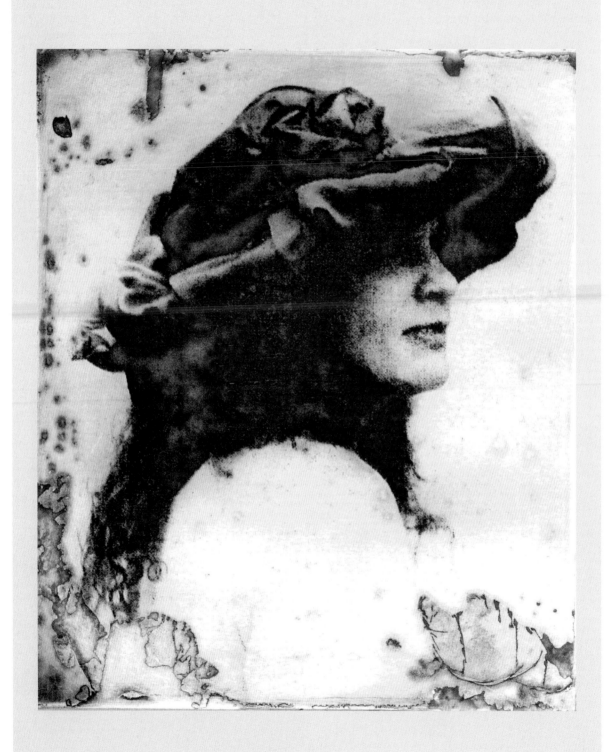

Photo-Etching and Photogravure

Printmaking began crossing paths with photography soon after photography's invention, and the mediums eventually merged, in the later nineteenth century, in the great fine-art technique of photogravure. Monochrome photogravure's continuous tones produce photographic intaglio prints of extraordinary quality, but the complexity of the photogravure plate-making process, requiring etchings in several baths of different strengths of ferric chloride, has mostly made the medium accessible only to professional print shops. Nowadays, however, new materials and techniques allow anyone to bring photography and printmaking together, with exciting results. Polymer photo-etching, toner transfer photo-etching, and polymer photogravure are the most successful current techniques.

Polymer Photo-Etching

Polymer photo-etching combines photography with intaglio printmaking. It requires the making of a positive halftone transparency image. A metal plate is laminated with a light-sensitive polymer emulsion film such as Puretch, Z★Acryl, or ImagOn. The transparency is placed on the laminated plate and exposed to UV light. The UV light hardens the emulsion in the non-image areas, preventing them from developing. When the plate is placed in a bath of diluted soda ash, only the image areas, formed of collections of dots from the halftone, soften and are developed. The plate is then etched in an acid bath, and the dots that are bitten into the plate retain the ink.

Sylvie Covey, *French Hat*, 2012, polymer photo-etching on copper, 5 x 6 inches (12.7 x 15.2 cm).

If the plate is correctly exposed and developed, the image areas will etch around the halftone dots, creating a texture that will retain the ink. Problems may occur if the transparency is too dense (i.e., if the dots are too small) or if the plate is overdeveloped, resulting in a loss of dots in the dark areas; the area where dots are missing cannot retain the ink, and the dark areas become reversed and light. Therefore great care should be taken when making the halftone transparency and developing the plate.

MAKING THE HALFTONE TRANSPARENCY

The most convenient and efficient way to create a halftone is with Adobe Photoshop. To create a wide range of tones, a laser or inkjet printer is used to print a positive monochrome laser or inkjet transparency. The pixel-mapped Photoshop image is converted by the printer's software into patterns of dots, distributed as dither patterns or clustered as simulated halftones. Some printers, particularly inkjet printers, will automatically output images using dithering. The tiny, randomized dots are useful for generating fine detail, creating different textures with different dot resolutions, and avoiding the moiré patterning that occurs when overprinting conventional halftones.

Dither patterns for photo-etching can also be produced with Adobe Photoshop. In the Image menu, go to Mode > Grayscale to remove any color from the image; returning to the Image menu, again go to Mode and click on Bitmap. In the Bitmap window enter 360 as the output resolution and select the Diffusion Dither method. An output resolution of 360 works well with the Puretch polymer film, producing a very refined photo-etching. Try lower output resolutions to achieve a varied dot pattern when using thicker polymer films.

Simulated halftones can also be used to create transparencies that will work for photo-etching. (Use a laser printer for this method, because most inkjet printers' default setting is dithering.) The halftone dots capture information from

MATERIALS AND TOOLS FOR POLYMER PHOTO-ETCHING

Polymer film is now the best material for producing high quality photo-etchings. Other materials and tools include

- A copper or zinc plate
- Positive halftoned image printed on a transparency
- Masking tape, scissors, a hair dryer, and newsprint for laminating the polymer on the plate
- Light exposure unit to expose the image on the laminated plate
- Soda ash and a water tray for developing the plate
- Acid bath for etching the plate
- Plexiglas can also be used to make photo-etching plates, but Plexiglas obviously cannot be etched in acid. The developed emulsion alone retains the ink, so a thicker brand of polymer film, such as Dupont's ImagOn, is recommended for photo-etching on Plexiglas. Because the depth of the dot is created by the developed emulsion alone, and because the emulsion is fragile if not properly looked after, this technique is tricky. It has been successfully done, however.

Kazuko Hyakuda, *Flower*, 2012, polymer photo-etching, 10 x 7 ½ inches (25.4 x 19 cm). Courtesy of the artist.

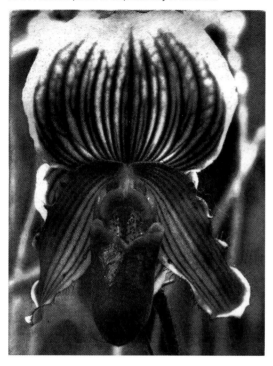

Christie Pavlik-Rosenberg, *L'edificio*, 2014, photo-etching on copper, 6 ¾ x 5 inches (17.1 x 12.7 cm). Courtesy of the artist.

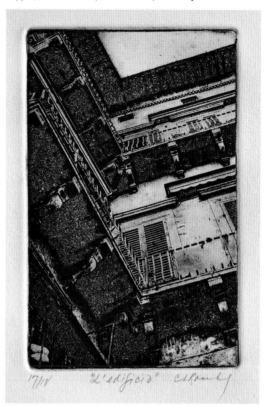

a pixel-mapped image and render it as accurately and with as much detail as possible. If the image resolution is low, information will be lost and the quality of the print will be poor. Here is a formula for calculating the relationship between the screen frequency (the number of lines per inch in the halftone) and the image resolution:

Halftone lines per inch (lpi) = image resolution in dots per inch (dpi) divided by 2

Each print process has an optimum range of screen rulings based on the amount of halftone information the plate can hold. For polymer photo-etching using Puretch emulsion film, the screen frequency can be raised from 85 to 100 lpi for the polymer emulsion to develop correctly,

and the scan resolution should be 300 dpi at a minimum. (The thickness of the polymer film has some impact on the quality of the resolution, with a thinner polymer film like Puretch allowing a higher resolution; ImagOn film is thicker than Puretch and will not take so high a resolution.) Photo-etching works best with low-contrast grayscale images. To make a halftone suitable for photo-etching using Photoshop, follow these steps:

1 Open the image in Photoshop. In the Image menu go to Mode > Grayscale and click OK to discard the colors. Then go to Image > Image Size. Ignore the Pixel Dimensions frame. In the Document Size frame set the resolution to 300 pixels/inch and set the width and height, in inches, to the dimensions of the final

image to be output. (The size has to fit the transparency in your laser printer, unless you intend to tile your image.)

2 In the View menu go to Proof Setup > Custom. In the Proof Conditions window open the Device to Simulate pull-down menu and click on Dot Gain 25%. Click OK. Go to the Image menu again and then to Adjustments > Levels. Double click on the white dropper in the Levels window, and set the K box to 5%. Click OK. Double click on the black dropper in the Levels window and set the K box to 95%. Click OK.

3 At this point make all necessary adjustments to your image. (Once converted to Bitmap, Levels adjustments will not be possible.) If your image has large black areas, you need to turn them into tone so that these areas will retain ink. You can do this by making your image semitransparent. Double click on the background layer in the Layers palette to turn it into layer 0. (Background layers cannot have transparency, but layer 0 can.) You may now use the Opacity slider in the Layers palette to reduce layer 0's transparency from 100% to between 70% and 80%.

4 In the Image menu go to Mode > Bitmap. In the Method window select Halftone from the Use pull-down menu. Click OK. In the Halftone Screen window set the Frequency to 85 line dots per square inch. Set the shape to Round and the angle to 45 degrees. Click OK.

5 Print on a laser transparency on a black-and-white laser printer only. If you do not have a laser printer, save your file on a CD or USB thumb drive and take it to a local copy shop to have it printed.

DEVELOPING THE PLATE

A copper or zinc plate the same size as the halftone image and a light-sensitive polymer photo-emulsion film roll are needed to make a photo-etching plate. I recommend the Puretch-brand polymer, but ImagOn and Z★Acryl films also work. After laminating the plate with polymer film, place the halftone transparency on the plate with the printed side of the transparency facedown on the laminated plate, and expose the plate to UV light, which will harden the light areas of the image. The developer for polymer film is just room-temperature water mixed with soda ash powder (½ teaspoon soda ash to 1 quart room-temperature water). When the plate is placed in this bath for a while—between 5 and 15 minutes, depending on the thickness of the film—the dark areas will soften and develop around the halftone dots to take the ink. While the plate is in the developer, brush its surface with a soft brush or a sponge to help develop the image areas until the polymer dissolves around the dots, revealing the copper. Remove the plate from the developing solution, rinse it in cold water, and quickly and carefully dry the plate with newsprint to avoid watermarks on the emulsion. If the plate is correctly exposed and developed, etch it in acid (45 minutes for copper in ferric chloride, 15 minutes for zinc in nitric acid) and then print. Some artists opt to remove the polymer emulsion before printing, but I recommend keeping it on the plate because it is often the emulsion alone that holds ink in subtle, light areas where the polymer has resisted the acid. Removing the emulsion would cause the loss of these subtle tones. To cure the

plate before printing, let the emulsion harden overnight or give it a quick exposure to UV light.

Photo-etching can be mastered only through constant experimentation. The emulsion often breaks at its edges or wrinkles during lamination. The procedure is delicate, but great results can be achieved with practice. It is important to know that polymer photo-etching film is destroyed by rubbing alcohol or distilled alcohol, as well as by repeated baths in a strong soda ash solution (which is the way to clean the emulsion from the plate if the laminating process goes wrong). So after a plate has been successfully photo-etched with polymer emulsion film, etched in acid, and printed, it should be carefully wiped with ordinary vegetable oil and paper towels to remove the leftover ink, let dry, and stored in clean newsprint.

POLYMER PHOTO-ETCHING PROCESS

The plate should be cleaned, beveled, and degreased. It should be well scrubbed but not polished so that the polymer can adhere securely to the plate. In a darkroom, cut the polymer emulsion film one or two inches larger than the plate all around. The light blue film comes sandwiched between two layers of clear protective plastic. Placing a piece of masking tape on a corner of the emulsion will help you peel one plastic layer off to open the sandwich and uncover the emulsion.

On the next two pages are the further steps that printmaker Kazuko Hyakuda followed when processing the plate for her photo-etching Midori.

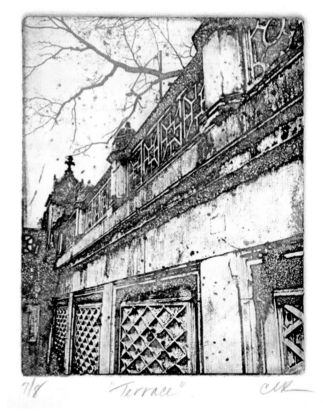

Christie Pavlik-Rosenberg, *Terrace*, 2014, photo-etching on copper, 4 x 6 inches (10.2 x 15.2cm). Courtesy of the artist.

Processing a Polymer Plate

1 Hyakuda placed the emulsion side of the polymer sheet facedown on the clean copper plate. She lightly sprayed water on the plastic coating on the back and used a squeegee, as shown, to laminate the emulsion on the plate and remove air bubbles and wrinkles.

2 She then heated the plate with a hair dryer for 5 minutes to firmly adhere the emulsion to the plate. (The plate may also be run through the press for better adherence; use newsprint to protect the laminated plate from white light.) Hyakuda then placed the halftone transparency facedown on the laminated plate and, as the photo shows, put the plate in a vacuum-framed light exposure unit.

(The light unit was previously tested to find the right exposure time, as each exposure unit is different. For this particular light unit, equipped with a 1,000-watt bulb, the plate was exposed to 65 light units. Other variables, as such as the distance between the light and the surface exposed, may affect exposure time.)

3 After exposing the plate and emulsion film to UV light, she removed the halftone transparency and trimmed the polymer emulsion film to the edges of the copper plate, as shown. The UV exposure caused the blue color of the film to darken.

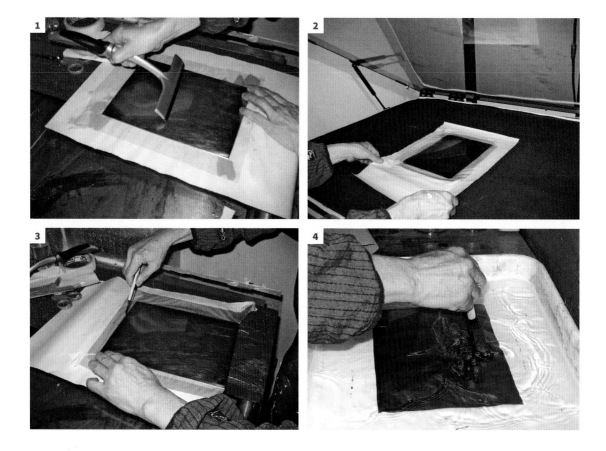

4 To develop the plate, Hyakuda removed the plastic layer protecting the polymer emulsion. (Use a little piece of masking tape to help you start peeling off the plastic; great care must be taken to avoid peeling off the emulsion itself.) She then placed the laminated plate in a lukewarm soda ash solution. Developing time depends on which brand of polymer emulsion is used; the Puretch brand is a very thin emulsion that develops in just a few minutes. Once developed, the plate was rinsed with water and quickly dried with several smooth sheets of newsprint to prevent permanent watermarks. Hyakuda then immersed the plate in a bath of ferric chloride etching solution. (The etching time varies from image to image, but a minimum of 45 minutes is recommended.) After etching, Hyakuda again exposed the plate to UV light to harden the polymer emulsion, before inking it as an intaglio etching. The final print is shown below. In this case, the darkest areas were purposely overdeveloped to achieve a solarized effect; the loss of dots in the darkest areas resulted in a reversed light area. (Note: I strongly recommend leaving the polymer emulsion on the plate, as it will hold subtler, lighter tones that may not have etched in the acid but are still there on the developed emulsion. Dissolving the emulsion might result in loss of information. Once the polymer photo emulsion has hardened, the plate can be used for editions of fifty or more prints.)

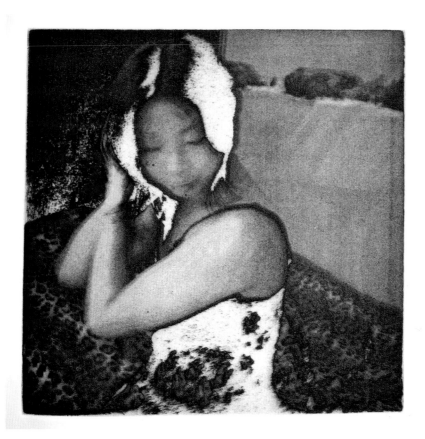

Kazuko Hyakuda, *Midori*, 2011, polymer photo-etching, 7 x 7 inches (17.8 x 17.8 cm). Courtesy of the artist.

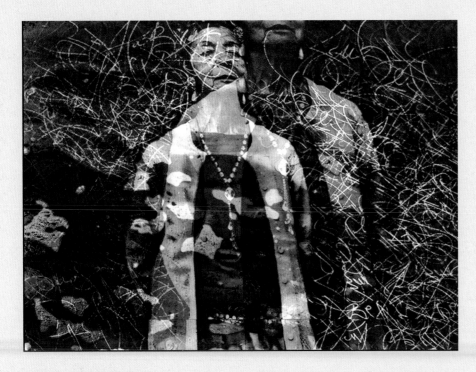

Kazuko Hyakuda, *And Ahead*, 2014,
polymer photogravure,
8 x 10 ½ inches (20.3 x 26.7 cm).
Courtesy of the artist.

PRINTMAKER PROFILE: Kazuko Hyakuda

gallerylabyrinth.com

*"There is a mysterious profundity in the floating black and white.
Might this be one of the answers, I wonder."*

Kazuko Hyakuda's background as a graphic designer led her to photography and eventually to photo-etching and photogravure. Hyakuda looks for origins and sources of our life on the planet, and in her work focuses on four motifs: women in reality, women appearing in advertisements, water surfaces, and flower petals. Her work is divided into two documentary motifs/spaces: the interiors of old buildings and street scenes in New York and Tokyo. Hyakuda feels spirits inside the centuries-old buildings and sees the living people outside the tombstone-like modern buildings as wandering the streets to assert their existences. Through these motifs, she seeks to render profundities: life and death, reality and illusion, and joy and vanity. Her experience as a photographer often brings her opportunities to create interpretations of reality.

About her polymer photogravure *And Ahead*, Hyakuda says, "For this piece, I selected two photographs that I took on the same day in the fall of 2013 in New York City: one is a woman seen on a mural in Chelsea; the other is of the surface of the Hudson River around Pier 64. I layered both images together as a digital multiple exposure. Thus the Western style of printmaking is manipulated with a Japanese taste: There is a mysterious profundity in the floating black and white. Might this be one of the answers, I wonder."

Toner Transfer Photo-Etching

Toner transfer is a technique I developed to produce photo-etchings without the need for UV light exposure. For toner transfer, I use Press-n-Peel blue film or IBM's heavyweight ultra-glossy photo paper.

Press-n-Peel film, distributed in the United States by Techniks.com and by Pulsar, has long been used in electronics to transfer computer board patterns to copper, and it has also been used in jewelry making. Recently, I have encouraged my fellow printmakers to experiment with Press-n-Peel film, using it as an etching acid-resist to produce photo-etchings without the need for exposure to UV light. Small images produce the best results.

For heat-transferring larger images to a copper plate, I use a laser printer to print black-and-white images on IBM's heavyweight ultra-glossy photo paper (11 x 17 inches). The print on page 298 was done using IBM paper. (Note: I have tried other brands of glossy photo paper without success, so I recommend only the IBM paper.)

When doing a Press-n-Peel transfer, use a photocopier or laser printer to print a negative photographic image on the matte side of the blue film, then iron the film onto a clean copper plate, with the toner side face down on the copper. The heat from the clothes iron, set on "Wools," will transfer the toner to the plate in about 2 minutes, ensuring that it adheres to the copper. Then cool the plate in cold water to make it easier to peel off the blue film.

For a transfer using IBM's glossy photo paper, print the image on the glossy side of the paper, then place the printed side face down on the copper and iron the back of the paper with the heat set on medium. While ironing, lift a corner of the image to check whether the toner is adhering to the copper. When the image is transferred, slowly remove the backing paper while the plate remains hot so that the paper does not stick to the plate.

MATERIALS AND TOOLS FOR TONER TRANSFER PHOTO-ETCHING

This technique makes photo-etching possible without a light exposure unit or developer. To use the technique, you will need the following:

> Laser printer or photocopier

> Copper plate

> Negative copy of a high-contrast black-and-white image, the same size as the plate

> Press-n-Peel blue film transfer sheets or IBM heavyweight ultra-glossy photo paper on which to print the image

> Clothes iron for transferring the image to the copper

> Flat wooden board on which you can safely iron with high heat

> Tray, filled with cold water, large enough to hold the copper plate

> Rosin aquatint to tone the plate

> Liquid asphaltum to resist acid in the white areas

> Ferric chloride bath

> Harsh solvent, such as acetone, for cleaning toner off the plate

Press-n-Peel blue film printed with a negative image of *Camouflage Canopy*, by Christie L. Pavlik-Rosenberg. Photo courtesy of the artist.

Only the toner, which acts as an acid-resist, adheres to the plate, which is then aquatinted with rosin and etched in ferric chloride. After etching, the plate is cleaned with acetone or another harsh solvent. (Always be cautious when using a harsh solvent.) Note that even if the toner stays on the plate it will not retain ink; however, the plate will print cleaner if the toner can be removed. When printed, the non-image negative areas on the plate remain white, while the aquatinted areas retain ink and produce a positive photo-etching.

Here are the steps Christie L. Pavlik-Rosenberg followed when making the Press-n-Peel photo-etching *Camouflage Canopy*.

3 Pavlik-Rosenberg then aquatinted the plate with rosin and heated the plate (shown) so that the positive open image areas would retain ink.

4 She then etched the plate with ferric chloride, with the toner/blue film acting as an acid-resist. The photo shows the plate after the etch; Pavlik-Rosenberg cleaned the plate with alcohol before inking to dissolve the rosin grain, now etched in the metal. After proofing the plate in black and white, she inked the plate with colors using the à la poupée method. The final print is shown opposite.

Press-n-Peel Photo-Etching Process

1 After the inverted image has been printed on the mat side of the Press-n-Peel blue film using a photocopier or a laser printer, the blue paper is partially trimmed. One side margin is left untrimmed for easier handling. A copper plate is cleaned with a metal polisher, rinsed with water, and degreased with alcohol. The copper plate is placed on a wooden or other heat-resistant surface. The printed blue film is placed image side facedown on the copper plate and ironed (with the iron set on medium heat) for 3 to 4 minutes, until the image appears through the back of the blue film, indicating that the toner has adhered to the copper. The photo shows Pavlik-Rosenberg ironing the toner onto the copper plate.

2 Pavlik-Rosenberg then placed the ironed plate in a tray of cold water to let it cool off, allowing her to peel away the blue film from the positive areas. The negative blue areas adhering to the toner on the plate will act as an acid resist.

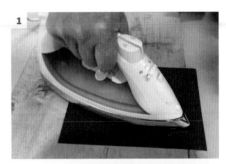

Christie Pavlik-Rosenberg, *Camouflage* Canopy, Press-n-Peel
photo-etching with aquatint, 2014, 5 x 8 inches (12.7 x 20.3 cm).
Courtesy of the artist.

Christie Pavlik-Rosenberg, *Other Side*, 2014, color photo-etching, 4 x 6 inches (10.2 x 15.2 cm). Courtesy of the artist.

PRINTMAKER PROFILE: Christie L. Pavlik-Rosenberg

facebook.com/ChristieRosenbergPrints?ref=aymt_homepage_panel

"When I choose family images, I do so to remember and celebrate occasions that have some significance in our lives. These prints are testimony of where I come from and of what has meaning in my spirit."

Printmaking has become the main expression of Pavlik-Rosenberg's creativity. After experimenting with many mediums, she now concentrates on photolithography, aquatint, and photo-etching The physical aspects of processing plates—the smell of the ink, the feel of tarlatan balled in the hand, the act of wiping the plate to reveal the image, and putting the plate through the press—give her intense satisfaction. She also holds in high regard the camaraderie in the shop: Her fellow printmakers readily share ideas and printing methods, and she notes that the technical aspects of printing are always expanding within the community.

Working from her extensive collection of photographs, Pavlik-Rosenberg carefully selects an image to capture the essence of what she wants to achieve, reworking it with Photoshop before deciding which method she will use to etch the plate and which colors she will print with. Because she often works in series, she often selects images based on a theme. The Press-n-Peel transfer-film process has been very successful for her, allowing her to give her photographic images new meaning and character.

When deciding on which photographs to re-create as prints, she looks for intriguing design elements with strong compositions or coloration. She says, "My images are often of a personal nature. When I choose family images, I do so to remember and celebrate occasions that have some significance in our lives. These prints are testimony of where I come from and of what has meaning in my spirit."

Polymer Photogravure

Photo-polymer plates are made of hard plastic or steel and are pre-coated with a light-sensitive emulsion. The advantage of using polymer photogravure plates is that because they come pre-coated, there is no need for etching chemicals. A water bath alone will etch the plate. The disadvantage is that they are more costly than polymer photo-etching film and cannot be repaired if something goes wrong, while polymer film can be removed from a copper plate, and the plate can be cleaned and relaminated before being etched in acid.

Polymer photogravure resembles traditional photogravure in its high-quality tonal range. Unlike photo-etching, it requires a dual exposure to UV light: In the first exposure an "aquatint screen" film is used to lay down dots in the plate; in the second exposure the image is exposed from another transparency, altering the dots in the image areas. The dual exposure contributes greatly to a refined and subtle blend, merging the dots into the tonal range and making them invisible to the eye, therefore almost re-creating the continuous tone of traditional photogravure.

Aquatint screens are printed on film and come in two forms: line screen and stochastic. Line screens are typically made up of dots organized in a grid pattern, like the simulated halftone used in photo-etching. Stochastic screens, which have a random dot pattern (similar to the dither pattern of an aquatint) and which can be output in a variety of dot sizes, are preferable for polymer photogravure. They are sold in a fine, medium, and rough grades.

SAMPLE EXPOSURE TIMES

Here are some exposure examples done with a medium-grade Precision Digital Negative aquatint screen:

> With a 1,000-watt lamp, the aquatint screen is exposed to 42 light units, then the image is exposed to 65 light units.

> With a 3,000-watt lamp, the aquatint screen is exposed to 21 light units, then the image is exposed to 38 light units.

> With a 5,000-watt lamp, the aquatint screen is exposed to 10.5 light units, then the image is exposed to 18.1 light units.

As you can see from these samples, the more powerful the light source, the less exposure is required, and the exposure time for the aquatint screen is usually less than the exposure time for the image.

Because different exposure units emit different levels of UV light, exposure times for the aquatint screen and the image vary. Prior testing is required for best results, but the sidebar above provides some sample exposures.

Images for polymer photogravure are printed on transparencies with the default printer settings, and a separate aquatint screen film is used to introduce dots. Follow these steps to create the positive image on a transparency:

1 Open the image in Photoshop. In the Image menu go to Mode > RGB Color > 16 Bits/Channel. At this setting, the process compensation curve will do less damage to the tonal continuity of the image.

2 In the Image menu, go to Mode > Grayscale to remove color (which will allow you to access Gray Gamma in step 4).

3 Clean up and modify the image content at will. Resize it to the dimensions of the transparency, in inches.

4 From the Edit menu choose Convert to Profile, and choose Gray Gamma 2.2 if using Windows or Gray Gamma 1.8 if using an Apple operating system. This will increase the tonal range.

5 Create Curves and Levels Adjustments layers to achieve the best possible tonal range.

6 Flatten your image (Layers > Flatten) and reconvert it to 8 Bits/Channel (Image > Mode > 8 Bits/Channel) before printing it on a transparency.

TOOLS AND MATERIALS FOR POLYMER PHOTOGRAVURE

For polymer photogravure you will need the following tools and materials:

> Adobe Photoshop software

> Laser printer

> Laser positive image on transparency

> Stochastic medium-grade screen aquatint film, large enough to cover the image (sold by PrecisionDigitalNegatives.com, Solar Plates/Hampton Editions, and Takach)

> KM73 polymer plates. "KM73" is a measure of the polymer's thickness, in this case 73 mils (thousandths of an inch). There are several brands of polymer plates, including Printight plates, Solarplates, Takach, and the KM73 plates offered by Boxcar Press (boxcarpress.com).

Kazuko Hyakuda, *Ten Months after the March 2011 Disaster #2*, 2014, polymer photogravure, 15 x 21 ½ inches (38.1 x 54.6 cm). Courtesy of the artist.

Expose the polymer plate to UV light, first with the stochastic aquatint screen film and then a second time with a positive-image transparency. This transparency can be printed with an inkjet or laser printer. Develop the plate in warm water; then dry and cure it before printing it as an intaglio. There is no need for etching in ferric chloride or nitric acid with this process. The dual exposures produce an "etched" polymer surface with multiple microscopic indentations, of various depths, that will hold ink and print on paper. Here are the steps for processing a polymer photogravure plate:

1 Place the aquatint screen facedown on the polymer side of the plate. Expose to UV light according to prior time testing.

2 Remove the aquatint screen and replace it with the continuous positive transparency, emulsion side down. Again expose the plate to UV light.

3 Remove the transparency and the protective plastic sheet from the pre-coated plate. Place it in the water bath. Let it sit in the water for between 40 to 60 seconds, depending on the exposure time; then, while it is still in the water, lightly brush the plate in all directions with a soft brush.

4 Many tests may be required to achieve a successful plate. When the plate is properly developed, remove it from the water and blot it on newsprint. Dry the plate completely with a hair dryer set on hot for 7 minutes.

5 To cure the plate, again expose it to UV light, doubling the previous exposure time.

Artist Kazuko Hyakuda peeling the transparency from an exposed polymer plate.

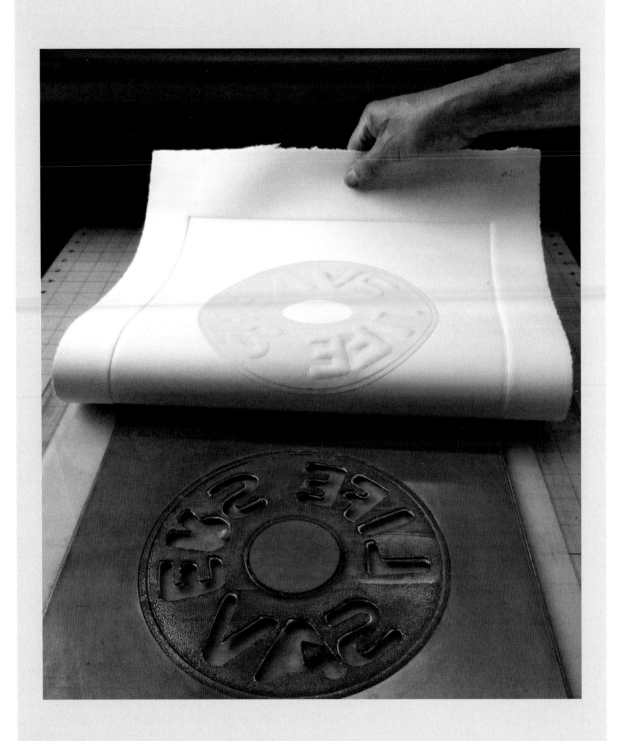

9

Printing Intaglio

Intaglio printing methods include single-plate monochrome, multiplate color separation, multiple colors on a single plate (the à la poupée method), and roll-up viscosity printing. In this chapter, we take a look at each.

Bernard Zalon printing *Lemon*, 2015, an etching/aquatint/embossing from his *Life Savers* series, 16 x 16 inches (40.6 x 40.6 cm). Courtesy of the artist.

Printing in Monochrome

When a plate is printed in monochrome, etching ink is pushed into the grooves of the etched plate and the excess is wiped from the surface with tarlatan (a fabric made of starched cheesecloth), leaving the etched areas inked and the non-etched areas clean. A dampened sheet of printing paper is placed over the plate on the bed of the press, and two wool blankets are added on top to cushion the pressure. When run through the press, the paper picks up all the ink from the plate. The demonstration on the next two pages gives the steps that artist Svetlana Rabey followed when printing an untitled spit bite aquatint in monochrome.

Svetlana Rabey, Untitled, 2013, spit bite aquatint, 24 x 36 inches
(61 x 91.4 cm). Courtesy of the artist.

Monochrome Printing Process

1 Using an ink spreader, Rabey pushed the ink deeply into the etched areas. (To avoid scratching the plate, the spreader should be plastic or cardboard.)

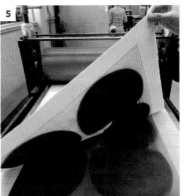

2 Rabey then wiped the plate with softened tarlatan, holding it in a ball shape and rubbing it against the plate in a circular motion to even out the ink and get rid of the excess. (Tarlatan can be softened by rubbing it against the hard edge of any piece of studio furniture or it can be rinsed with water and dried to remove some of its starch.) The goal is to wipe the surface of the plate clean without removing any of the ink held in the etched areas. While wiping, you should constantly reshape the ball of tarlatan to ensure that clean fabric is touching the plate.

3 After wiping the plate with tarlatan, Rabey finished wiping the white areas with flat pages from a telephone book. To avoid over-wiping, do not crumple the paper.

4 While Rabey was inking the plate, her printing paper was soaking in water. Here, Rabey is removing the wet paper from the water tray. Soaking the paper causes its fibers to expand so that the paper will pick up all the details from the plate. The paper is blotted to remove excess moisture before printing.

5 Rabey placed the inked plate faceup on the bed of the press and laid the dampened paper on top. She then covered the paper with the press's two wool blankets to cushion the pressure. After running the print through the press, she pulled it from the plate. The final black-and-white print is shown opposite.

Printing in Multiple Colors
à la Poupée

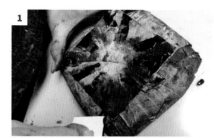

In the à la poupée method, a single plate is inked with several colors, which are carefully blended with small bundles (poupées) of tarlatan. Blending the edges of the colored areas produces a watercolor-like effect.

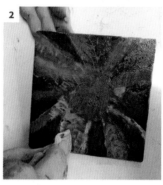

For her print *Hand Printing*, Christie Pavlik-Rosenberg photo-etched four copper plates using the Press-n-Peel method (see page 152) and then inked each plate à la poupée before printing all four on a single sheet of paper. Her steps for inking and printing the plates follow.

À la Poupée Process

1 Using a piece of cardboard as a spreader, Pavlik-Rosenberg carefully spread the inks on the copper plate.

2 She then wiped each color with a separate piece of tarlatan.

3 She then placed the four inked and wiped plates on the bed of the press to be printed together on one sheet of paper.

4 Pavlik-Rosenberg covered the plates with dampened BFK Rives paper and ran them through the press. The photo shows her pulling the print. The final print is shown at right.

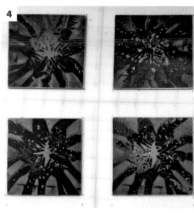

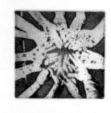

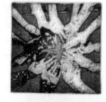

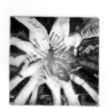

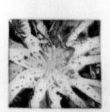

Christie L. Pavlik-Rosenberg, *Hand Printing*, 2013, photo-etching (four plates), 13 x 14 inches (33 x 35.6 cm). Courtesy of the artist.

Printing in Multiple Colors—Color Separation Method

With this method, an image is drawn and etched on several plates, with each color separated: one plate for yellow, one plate for red, and so on. The plates are inked, registered, and printed as layers on the same paper, until the full-color image is created.

Artist Akiko Asanuma created a four-plate color separation (yellow, red, blue, and black) for her soft-ground etching *Yin & Yang*. The yellow plate was printed first, and then the red plate was registered on the same paper and printed. The image top shows the print after these two colors had been printed, and the image below it shows the print after all four colors were printed.

Roll-up Viscosity Printing

The invention of the technique known as viscosity printing is credited to Stanley William Hayter (see page 4). Viscosity printing relies on the principle that oily ink will repel sticky ink. A single plate is etched deeply on several levels (like stair steps). Colored inks are then mixed; the color intended for the deepest levels is stiffened with magnesium carbonate, while the color intended for surface roll-up is mixed with oil.

Yin & Yang with two colors printed. Courtesy of Akiko Asanuma.

Akiko Asanuma, *Yin & Yang*, 2014, color soft-ground etching (four plates), 6 x 6 inches (15.2 x 15.2 cm). Courtesy of the artist.

Vincent Longo, Untitled, 1994, viscosity etching aquatint,
11 ¼ x 11 ¼ inches (28.6 x 28.6 cm). Collection of the author.

The stiff ink is applied to the plate, and the top surface is wiped clean with tarlatan. An oily second color ink is then rolled on the plate with a brayer; repelled by the stiff ink on the lowest levels of the plate, it will print brightly from the top levels of the plate. While the pressure applied on the brayer does slightly interfere with the repelling action of the oily ink, creating additional color tones in the medium levels of the plate, the differing viscosities of the inks produce color separation, and the intaglio color shows through the roll-up color.

In another, more intricate method of viscosity printing, the plate is inked as an intaglio and wiped, and then brayers of differing durometer (hardness) are used to ink different depths of the plate: a very soft brayer for the lower areas, a medium-durometer brayer for the areas of medium depth, and a hard brayer for the plate's top surface. Each of the brayers is loaded with ink of a different viscosity. This method produces prints with a greater number of colors.

In the print by Vincent Longo shown opposite, the plate was first inked with a stiff turquoise color and wiped as an intaglio, and then rolled up with oily sanguine-color ink. The brightest turquoise comes from the lowest areas of the etched plate, while the brightest sanguine comes from the top surface areas.

Lithography and Serigraphy

PART III

Jase Clark, *Gates Gate*, 2013, color serigraph with watercolor,
30 x 22 inches (76.2 x 55.9 cm). Courtesy of the artist.

XP *Many Roads to The Bridge* M. DeVittini 2005

10

Lithography

The word lithography is derived from ancient Greek words meaning "stone" and "writing." Lithography is a planographic (flat-surface) method of reproduction that is based on the simple principle that water repels oil. In traditional lithography, an image is drawn with a greasy substance on the smooth surface of a limestone lithographic stone. The stone is then treated with a mixture of acid and gum arabic, which microscopically etches the portions of the stone not protected by the grease-based drawing mediums. When the stone is subsequently moistened, these etched areas retain water. Oil-based ink is rolled on the stone, sticking to the image areas while being repelled by the wet non-image areas. The inked stone is then printed on paper.

Michael Pellettieri, *Many Roads to the Bridge*, 2002, lithograph, 14 $\frac{7}{8}$ x 10 $\frac{13}{16}$ inches (37.8 x 27.5 cm). Courtesy of the artist.

Although numerous print shops today still use limestone stones, other substrate materials for lithography, such as metal and polyester plates, were introduced during the twentieth century. These newer surfaces are manufactured to retain water, just as a stone's grain does, and are often easier to process. Some are photo-sensitized. The limestone lithographic stone, however, remains the best surface for subtlety and tonal quality in hand-drawn lithography.

L'ABBÉ LOUP,

en pauvre contrebandier.

Devant le noir Soleil de la MÉLANCOLIE, Lénore apparaît

A Brief History

Lithography was invented accidentally. In 1796, the German playwright and actor Alois Senefelder (1771–1834) was searching for a cheap way of self-publishing his dramatic works. He experimented with using greasy, acid-resistant ink on a smooth, fine-grained stone. After successfully printing from an etched stone, Senefelder became convinced that this new method of reproduction had great commercial potential, so he abandoned his theatrical career and devoted the rest of his life to promoting the new process. He experimented with ink formulas and color printing; he invented the lithographic pencil (made of wax, soap, and lampblack), which was the key to creating an oleophilic ("oil-liking") image; and he perfected methods of transferring paper drawings and lettering to stone. When other artists realized they could directly draw on stone, with the print exactly replicating the drawing, lithography spread throughout Europe and eventually to the United States and the rest of the world.

Opposite, clockwise from top left:

Tomomi Ono, *Seed-Flow VI*, 2002, lithograph on stone, 7 ¼ x 7 ½ inches (18.4 x 19 cm). Courtesy of the artist.

Honoré Daumier, *L'Abbé Loup en Pauvre Contrebandier*, 1833, lithograph, 9 ⅜ x 6 ½ inches (31.43 x 22.86 cm), from the series *Bal de la Cour* that appeared in *Le Charivari*. Los Angeles County Museum of Art.

Odilon Redon, *À Edgar Poe (Devant le Noir Soleil de la Mélancolie, Lénore Apparaît)*, 1882, lithograph, sheet measures 17 ¼ x 12 ¼ inches (43.82 x 31.12 cm), from the series *À Edgar Poe*. Los Angeles County Museum of Art.

Michael Pellettieri, *The Heights*, 2005, lithograph, 16 x 28 inches (40.6 x 71.1 cm). Courtesy of the artist.

EARLY LITHOGRAPHY IN EUROPE

The American-born president of London's Royal Academy, Benjamin West (1738–1820), was the first artist in England to try lithography. Henry Fuseli and William Blake also did some prints on stone. After visiting Senefelder's Munich studio, Charles Hullmandel established his print shop in London in 1819 and convinced numerous well-known artists to try lithography. Hullmandel increased lithography's tonal range by developing a method for cross-hatching with the lithographic pencil, and he patented a process, which he called lithotint, of diluting tusche washes. (Tusche, which is pronounced TOOSH, is a greasy substance that, when mixed with water or solvents, prints with a range of tonality, from light gray to black.) Hullmandel's print shop remained highly influential in English lithography until the mid-nineteenth century.

Although it originated in Germany, lithography did not become a truly creative medium until French artists embraced and refined the process. No artist made better use of the medium than Honoré Daumier (1808–1879). Known for his lithographic caricatures, Daumier waged a long-running campaign of scathing cartoons targeting the bourgeoisie, the incompetent French government, and the corrupt legal establishment. Apart from the works of Daumier, lithography in France during the first part of the nineteenth century was used mainly in book illustration; then, in the 1860s, a number of prominent artists started exploring its possibilities.

A BRUSH FOR THE LEAD.

Currier & Ives, *A Brush for the Lead: New York "Flyers" on the Snow*, 1867, lithograph from a drawing by Thomas Worth, dimensions unavailable. Library of Congress.

Because lithography is so direct, perfectly reproducing a brushstroke or line drawing, it greatly appealed to painters, becoming their preferred printmaking medium. Édouard Manet (1832–1883) experimented with lithography for years, and renowned artists such as Paul Cézanne, Edgar Degas, Henri Fantin-Latour, and Camille Pissaro made lithographs of great artistic merit, as did the Symbolist artist Odilon Redon (1840–1916). An especially gifted and prolific maker of lithographs, Redon was a visionary and a precursor of the Surrealist movement of the twentieth century. As Donald Saff and Deli Sacilotto have written, "Redon was among the first artists to represent images of dreams and evocations of the unconscious."

LITHOGRAPHY COMES TO AMERICA

John Pendleton established the first American lithography shop in Boston in 1825, but the best-known nineteenth-century American lithographers are the duo known as Currier & Ives. Nathaniel Currier (1813–1888) opened a print shop in New York in 1834, at first producing journalistic images of current events. But when James Merritt Ives (1824–1895) joined the studio in 1852, the name Currier & Ives became synonymous with decorative

hand-colored lithographs depicting biblical stories and scenes from American life. Several creative artists, including Fanny Palmer and Louis Maurer, collaborated with Currier & Ives to produce these popular sentimental images. While hardly artistically experimental, Currier & Ives prints constitute a valuable record of how Americans lived in the nineteenth-century.

THE DEVELOPMENT OF COLOR LITHOGRAPHY

Color lithography's beginnings date to the very outset of lithographic technique, with Senefelder and, later, others experimenting with ink formulas and color processes. In 1837, the Franco-German lithographer Godefroy Engelmann (1788–1839) invented chromolithography, in which each color is printed from a separate stone. Color lithography was soon in high demand, and color prints were sold to an eager public at a lower cost than etchings and color engravings. But lithographic stones are heavy, hard to handle, costly, and rare in large sizes, so an alternative was needed. That alternative was eventually provided by zinc plates that, like stones, were grained to accept and retain water. (Later on, in the twentieth century, zinc was replaced with aluminum.)

Ann Winston Brown, *Illumination*, 2014, color lithograph,
22 x 30 inches (55.9 x 76.2 cm). Courtesy of the artist.

Toulouse-Lautrec produced almost four hundred prints, mostly lithographs, over his short life.

Manet's and Degas's experiments convinced their friend James Abbot McNeill Whistler to try lithography during his stay in Paris. On his return to London, Whistler met the printer Thomas Way, with whom he collaborated to produce a series of beautiful, subtly toned lithotint prints that were inspired by Hullmandel's method of toning with diluted tusche.

TWENTIETH-CENTURY LITHOGRAPHY

Around the turn of the twentieth century, Norwegian artist Edvard Munch (1863–1944), then living in Germany, created lithographs of some of his most famous images, including *The Scream*. Lithography was likewise embraced by Käthe Kollwitz, Max Liebermann, and Max Slevogt, as well as by members of the avant-garde group that called itself Die Brücke (The Bridge). Die Brücke member Ernst Ludwig Kirchner took an especially keen interest in lithography, developing a method combining crayon, tusche, water, and turpentine. In Munich, members of the Blaue Reiter (Blue Rider) group—Wassily Kandinsky, Paul Klee, and Alfred Kubin—also explored lithography.

In his never-ending quest to explore new forms, Pablo Picasso also took on lithography. As usual, Picasso transformed the medium in both technique and content, progressively changing his imagery so that each successive print in a series of lithographs conveyed a new idea. From 1945 through the late 1950s, he collaborated with the Mourlot brothers, who had a print shop in Paris, and this collaboration elevated lithography's status in the art world. Meanwhile, in mid-century England, David Hockney, Henry Moore, Ceri Richards,

In nineteenth-century Europe, the explosion of consumer goods—and of a middle class capable of buying them—led to the development of bright, colorful advertising art, much of it printed lithographically. French artist Jules Chéret (1836–1932), who learned lithography technique in London, produced many poster lithographs in three or four colors after his return to Paris in 1866. Alphonse Mucha (1860–1939), a Czech artist living in Paris, greatly elevated the standard of taste for poster advertisements with his elegant Art Nouveau posters advertising consumer products and theatrical events, including plays starring Sarah Bernhardt. But it was Henri de Toulouse-Lautrec (1864–1901) who transformed lithographic posters from a mere advertising medium to high art. Inspired by ukiyo-e prints, Toulouse-Lautrec's lithographs often combine exquisite crayon work with flat colored forms and hand-drawn lettering. Relentlessly portraying the lively nightlife of the Montmartre area of Paris,

Edvard Munch, *Self Portrait with Skeletal Arm*, 1895, lithograph, 18 x 12 ⅜ inches (45.7 x 31.4 cm). Munch Museum.

and Graham Sutherland all contributed to reestablishing lithography in the public eye.

Lithography was revived in the United States when June Wayne opened the Tamarind Lithography Workshop in Los Angeles in 1960. Richard Diebenkorn, Sam Francis, Leon Golub, Louise Nevelson, Kiki Smith, Terry Winters, and countless other artists have made lithographs at Tamarind. In New York, Robert Blackburn founded the Printmaking Workshop in the Chelsea neighborhood in 1948, and began printing for artists and encouraging friends to experiment with lithography.

One of those friends was Will Barnet (1911–2012), who had worked as the first official lithographic printer at the Art Students League of New York. Between 1951 and 1952, the two collaborated on an ambitious suite of color lithographs for the contemporary art magazine *ARTnews*.

PHOTOLITHOGRAPHY AND OFFSET LITHOGRAPHY

Before the development of offset printing and the invention of photography, letterpress printing was good for text but poor for image reproduction while lithography was good for images but poor for text. Books were often printed with a combination of methods. All of that changed, and the industry was revolutionized, with the advent of photolithography and offset printing. It became possible to combine pictures, including photographic images, with text on a single printing plate.

Will Barnet, Untitled, 2001, four-color lithograph, 22 x 15¼ inches (55.9 x 38.7 cm). From the *Twenty-first Century Print Portfolio* published by the Art Students League of New York in 2002, collection of the author.

Photolithography began with the work of nineteenth-century French printers Alphonse Poitevin and Alfred Lemercier, who invented a technique in which a stone was coated with bichromated albumen, enabling them to print as many as three hundred prints from a photographic image. The offset lithographic printing process was created in New York City in 1847 by Richard March. March's rotary offset press, in which curved plates were placed on a revolving cylinder, was much faster than older flatbed printing presses.

Today, the vast majority of commercial lithographic presses use the offset method, in which the inked plate does not come in direct contact with the paper. Instead, the image is first transferred to a blanket, usually made of rubber, which makes the impression on the paper. Because of this double transfer—first to the blanket and then to the paper—the plate image is not a reversed, or mirror, image. The offset method is commercially superior because the metal plate suffers much less wear when put into contact with the soft, elastic blanket than it would if it had direct contact with the paper. Moreover, the blanket is better than a metal plate at pressing the ink into the paper's surface.

Today, offset printing plates are usually made of aluminum with a photosensitive coating. With new exposure methods and computer-to-plate systems, other polymer-based plate materials have been developed. In fine-art lithography, artists continue to draw and paint on limestone stones but now

Side view of the Takach lithography press at the Art Students League of New York.

also use aluminum plates and the newer polyester plates. Polyester plates can also be laser printed with photos, enabling photographic imagery without the use of chemicals. For photographic imagery in fine-art lithography, however, nothing can replace the precision of Fujifilm aluminum plates, sold with a factory-coated light-sensitive emulsion. A newer brand of similar plates is called P&Z Posi-Blue Positive Lithographic Plates.

Equipment and Materials

The basic principle of lithography has remained unchanged since its beginnings, and print shops around the world still use limestone stones as well as the newer aluminum plates for hand-drawn lithography. New materials and methods for lithography continue to evolve, however, and nowadays Pronto polyester plates are often used for hand-drawn lithography and for small editions, while photo-sensitized aluminum plates are used for larger editions in photolithography, because of their high degree of reliability.

EQUIPMENT FOR PRINTING

The lithography presses most commonly in use in the United States today are those made by Takach Press Corporation, the Conrad Machine Co., and the now-defunct Charles Brand company. Older designs, such as the Fuchs & Lang presses, remain in use in some studios.

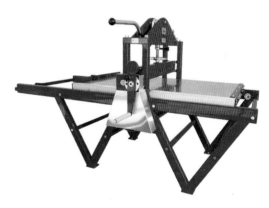

Takach lithographic press, floor model. Courtesy of Takach Press Corporation.

Besides the press itself, lithography printing requires a tympan and a selection of scraper bars of varying widths. The tympan is a smooth, flat sheet of plastic that is placed between the blotter and the scraper bar and helps the print slide smoothly through the press under considerable pressure. (The tympan is lubricated with tympan grease or petroleum jelly.) Scraper bars are made of hardwood (such as boxwood) or hard synthetic material. The bottom of a scraper bar is covered with leather and is in contact with the tympan while printing.

Graining a stone with a levigator at the Art Students League of New York.

LITHOGRAPHIC STONES AND PROCESSING TOOLS AND MATERIALS

Today, lithographs are printed from traditional lithographic stones or from lithographic plates of various kinds. Let's look first at lithographic stones and the equipment and materials needed to process them:

> A lithographic stone is made of almost pure limestone (94 to 98 percent calcium carbonate) and has a natural affinity for accepting grease. A stone's color, which can range from yellow to blue-gray, indicates its quality: Grayer stones are denser and harder; grease penetrates them more uniformly, and they can accept an extremely fine grain. Yellow stones are softer and cannot be grained as finely as harder stones, which may cause printing problems.

> Carborundum, or silicon carbide, is used as an abrasive to grain lithographic stones—that is, to erase previous imagery after the stone has been editioned and to prepare it for a new image. New lithographic stones are at least 3 inches thick so that many images can be etched and grained out over the course of the "life" of the stone. Carborundum grit comes in a variety of textures, designated by numbers ranging from 80 (coarse) to 280 (very fine.)

> A levigator is a heavy, smooth-faced steel disk used to grain a stone. The levigator is approximately 12 inches in diameter and 1½ inches thick; both its top and bottom edges are beveled to ⅛ inch. A handle is screwed into a hole in the disk, permitting a circular rotation. (A second lithography stone is often substituted for the levigator in the last stage of the graining procedure, described on page 182.)

> A graining rack is needed to grain and wash the stones. Because they must support the heavy stones, graining racks are made of strong, durable materials such as hardwood or plastic. The graining rack is equipped with a water faucet and hoses and sits above a drainage system so that the carborundum grit can be washed off as a stone is grained.

Lithographic drawing materials: pencils, crayons, tusche, gum arabic.

LITHOGRAPHIC PLATES

Ball-grained aluminum plates are a good alternative to lithographic stones and offer several advantages: Aluminum plates are readily available, low in cost, lightweight, easily transportable, and require much less storage space than stones. Unlike a stone, which must be regrained for each new image, an aluminum plate comes with its ball-grained surface ready to use, and the plate is used only once. When working with multiple colors it is convenient to have multiple plates ready to use instead of having to grain and clean a number of stones. However, an aluminum plate is less porous than a stone, with a medium-grained plate equivalent to a stone grained with 220 carborundum grit. (A stone is grained with a grit up to 280.) A plate can be drawn or painted on like a stone, but should not be scratched or scraped. Because its grain is less refined, a plate can be less stable than a stone, and delicate washes painted on a plate will not print or hold as well as they would on a stone. However, transfers and photomechanical processes are very effective on aluminum plates.

Because it is thin, an aluminum plate requires a backer on the press to raise it to a printable height and provide a hard and level support. Backers must be at least 2 inches thick; aluminum backers, slate slabs, and large lithographic stones are all used for this purpose.

Besides aluminum plates, a number of other kinds of plates are used in contemporary lithography. These include photo-sensitized Fujifilm plates, P&Z Posi-Blue Positive Plates, Toray Waterless Plates, and Pronto polyester plates, all of which are dealt with later in this chapter.

DRAWING AND ERASING MATERIALS

These materials are used to draw on plates or stones:

- Lithographic pencils and crayons are made of greasy wax, black pigment, soap, and shellac. The shellac content determines the grade of the crayon or pencil: Crayons are available in seven grades of hardness, from #00 (softest) to #5 (hardest); lithographic pencils, made exclusively by William Korn, Inc., come in five grades, from #1 (softest) to #5 (hardest). Both crayons and pencils may be used with water to form dense lines or wash-like effects.

- Tusche, available in liquid or solid form, is made of wax, tallow, soap, shellac, and lampblack and is used to produce a wide range of washes as well as solid tones. Tusche is water soluble; distilled water is

recommended for making delicate washes. Various textural washes can be obtained by combining tusche with a solvent such as Gamsol, turpentine, or alcohol. A mixture of alcohol and tusche (without water) may be carefully ignited to produce an exquisite wash.

» Sanguine Conté crayons may be used to sketch out a design before using litho pencils and tusche. The sketch will not print because there is no grease in the crayon.

» Gum arabic is used to stop-out the edges of the stone and is also an effective stop-out material for sections of drawing. Because gum arabic is water soluble, turpentine washes and pencils and crayons work well with this technique.

» Erasing materials such as pumice stones, razor blades, snake slip correction pencils, and rubber hones or erasers may be used for deletions on a lithographic stone or plate. Caution must be exercised with these materials, and excessive abrasion must be avoided to avoid ruining the grain of the stone or plate.

ADDITIONAL PROCESSING MATERIALS

These materials are also used to process lithography stones and plates:

» Nitric acid for etching stones

» Phosphoric acid or citric acid for etching plates

» Tannic acid for making TAPEM (see page 201)

» Powdered rosin for processing stones

» Talcum powder for processing plates

» Cotton balls for cleaning plates (counter-etching)

» Small and large flat, soft brushes for applying gum arabic and etches

» Alcohol for diluting tusche

» Lithotine, Gamsol, and liquid asphaltum for processing stones and plates

» Two water bowls and two large sponges for dampening stones and plates

» Cheesecloth for buffing stones and plates

» Lithographic ink for roll-up

» Spatulas for ink

» Leather brayer for black ink

» Composition brayers for colored ink

» Scraper, paper towels, and vegetable oil for cleanup

» Masking tape and a large newsprint pad for use on the press

» Apron and gloves for protection

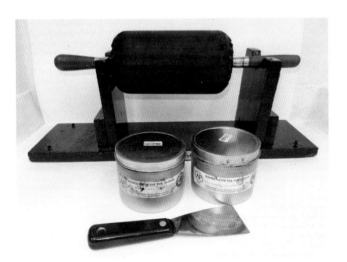

Leather brayer with lithographic inks and spatula.

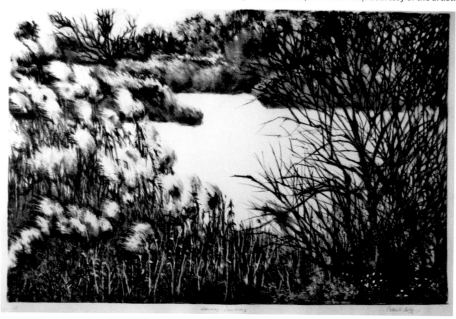

Catherine Muhly, *Gateway Sanctuary*, 2014, lithograph on stone, 22 x 34 inches (55.9 x 86.4 cm). Courtesy of the artist.

INK, ROLLERS, AND PAPER

Most lithographic inks were originally formulated for the offset industry but are easily modified for hand-printing. Brands available in the United States and Canada include Superior, Hanco, Graphic Chemical & Ink Co., and Gamblin. Oil-base lithographic ink has three main components: the pigment, the additives, and the vehicle in which the pigment and additives are suspended. Additives include

> Modifiers, which stiffen or loosen the ink. Magnesium carbonate stiffens ink, and lithographic varnish loosens it. (Grades of lithographic varnish range from #0, which adds grease to the ink, to #8, which loosens the ink without adding grease.)

> Reducing compounds, such as Easy Wipe (from Graphic Chemical & Ink) and Setswell (from Hanco), which decrease the ink's surface tension.

> Drying retarder, such as oil of cloves, which slows down the drying time of ink.

A variety of rollers are used in lithography. Leather rollers are used for black-and-white printing, and rubber or composition rollers are used for color. Ideally, the roller should be wider than the image to be printed but narrower than the stone or plate. Small composition brayers are also effective for spot-printing color.

Printing papers for lithography are much the same as those papers used for intaglio (see page 77). Arches Cover, BFK Rives, Somerset, and Copperplate papers are all suitable. Textured papers should be avoided, since lithography works best on smooth surfaces. Although paper prints better when dampened, it is not as critical to print with dampened paper in lithography as it is in intaglio.

Stone Lithography

In relief and intaglio, the processing of the block or plate is separate from the printing: First the block is carved or the plate etched, and then the image is printed. Lithography is very different.

In lithography, printing is an integral part of processing and etching the image: The stone or plate is first etched with the drawing materials still on it, then is re-etched and printed with ink to stabilize the image. Stones are sometimes etched a third time and processed with ink again before the edition printing begins. Therefore, processing and printing are parts of a single, continuous process.

GRAINING A LITHOGRAPHY STONE

At the end of an edition, the lithographic stone is recycled for the next image. Graining is the first step in preparing a stone to receive a drawing. It removes the dirt and grime from the previous greasy image, which have penetrated the surface, and also provides the tooth that will provide a water reservoir for repelling the non-image areas and receive the drawing material in the image areas. The ink is first removed from the stone with solvent, and the edges of the stone are rounded with a metal file. The stone is covered with water in the graining rack, and carborundum #80 is sprinkled evenly over the entire surface. The printmaker uses a levigator to grain the limestone, moving it over the surface in rounded patterns from side to side and diagonally. When the black carborundum grit turns grayish white, indicating that it has run its course, the stone is carefully washed in water, another layer of a finer grade of carborundum grit is sprinkled on, and graining resumes. It is important to wash the stone well after each graining, to avoid scratching the stone with any leftover, larger carborundum grit from the previous graining. This process is repeated until all five sizes of carborundum grit (# 80, #120, # 180, #220, #280) have been used, and the stone is perfectly smooth and clean. For the final graining, using the finest grit of carborundum, a second lithographic stone—laid facedown on the stone being grained—may be used instead of the levigator as the graining tool. The stone's surface must be perfectly flat to ensure proper printing, so a straight-edged metal ruler is used to check the flatness, making sure the center of the stone has not been grained more deeply than the edges.

BLACK-AND-WHITE LITHOGRAPHY ON STONE

Working with master printer Tomomi Ono, Michael Pellettieri processed a large stone lithograph for a black-and-white print. First, the stone was grained with carborundum grit, using a levigator and finishing with a second graining stone, and its edges were filed with a metal file. When the stone was smooth and clean, gum arabic was painted on the margins to define the image area. As shown in the photo below, Pellettieri then used a set of greasy Korn crayons and pencils, combined with tusche, to draw a mirror image of his original design on the smooth stone tablet.

First Etch

The first etch stabilizes the image and desensitizes the non-image area. The aim is to chemically separate the image and non-image areas on the stone so that the image areas will be hydrophobic (consistently rejecting water and receiving ink) while the non-image area will be hydroscopic (receiving water and rejecting ink). In the process given on pages 184–85, master printer Tomomi Ono assisted artist Michael Pellettieri in performing the first etch.

Michael Pellettieri drawing a mirror image of his sketch on the lithographic stone using a set of grease pencils. Photo courtesy of the artist.

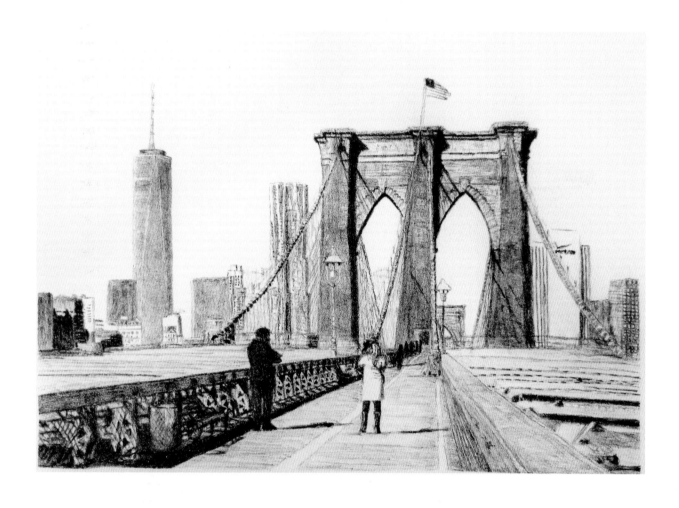

Brenda Berkman, *World Trade Center Viewed from the Brooklyn Bridge*, 2014, lithograph on stone, 9 x 12 inches (22.9 x 30.5 cm). Courtesy of the artist.

First Etch Process

1 Michael Pellettieri placed the stone on the bed of the press, as shown in the photo. Lithographic stones (and plates) are always drawn leaving a margin 2 to 3 inches wide all around to provide adequate start and finish spaces when the stone goes through the press. Pellettieri marked the location of the stone's front margin (where the stone will first go under the press's pressure) by placing a narrow strip of masking tape on the press frame and another, matching strip of tape on the side of the press bed. The location of the stone's back margin (where the image will stop printing) was also marked as well with masking tape.

2 Tomomi Ono then applied a mixture of talcum and rosin powder over the entire surface of the drawing and wiped off the excess with a paper towel. Talcum powder protects the image from being washed out with water and helps the etch solutions sit evenly on the stone's surface; rosin protects crayon work from being burned by corrosive nitric acid.

3 Pellettieri and Ono then did the first etch. Usually, the etching solution used in stone lithography is a combination of gum arabic and drops of 70% nitric acid, but at the Art Students League the nitric acid for stone lithography is diluted to 35%, for safer and more subtle etches. The technique the artist has used when drawing on the stone affects the etching process: For example, overlays of multiple washes may look delicate but may require a stronger etch. Unlike intaglio, in which a plate is usually submerged in an acid bath, lithography requires that the surface of the stone (or plate) be etched locally with different strengths of acid, depending on the character and amount of drawing medium(s) on each area of the image. The photo shows Ono checking the pH of etch mixtures with litmus paper.

4 Etching solutions of various strengths were prepared in advance, and areas of the stone were tested. The photo shows notes Pellettieri made on the margin of the stone regarding strengths to be used in various areas. Usually, an etching table—based on the particular

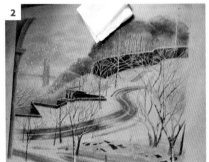

Photos in this series courtesy of Michael Pellettieri.

image and the experience of the artist or master lithographer—is devised to help determine the ratios of acid to gum arabic for crayons of differing grease content. In general, a weaker etch is used for less greasy crayons, and a stronger etch for greasier crayons. Dark and scratched areas must also be strongly etched to ensure that very small areas between crayon marks do not fill with ink during printing.

5 Ono starting etching the sky areas. The lightest etching solution is first applied to the entire stone. For a #1 crayon, 15 drops of nitric acid are added to 1 ounce of gum arabic. The printmaker applies the etch with a soft wide brush and uses the brush to keep the solution moving on the surface for 4 minutes. The stone is then buffed and dried with clean soft cheesecloth.

6 The medium-strength etching liquid was then used to spot-etch scratched areas and areas with medium tone (in between the lightest and the darkest tones). For a #1 crayon, 18 drops of nitric acid are added to 1 ounce of gum arabic.

This etch is applied with a smaller brush, and the solution is kept moving for 2 minutes. The surface of the stone is then blotted with paper towels to absorb the solution and dried.

7 As shown in the photo, Ono applied a local etch of 17 drops of acid mixed with 1 ounce of gum arabic on parts of the tusche area. (This spot-etch is applied with paper towels.) The strongest etching solution was then used on areas with the darkest tones. For a #1 crayon, 20 to 25 drops of nitric acid are added to 1 ounce of gum arabic; the solution is kept on the stone for 2 minutes before blotting and drying.

8 Finally, Ono applied gum arabic to the whole surface of the stone to even it out and to replace the etch prior to inking. The stone was then buffed and set aside overnight to "settle" the stone, letting it fully absorb the etch. (When working on an aluminum plate, the resting time is only 45 minutes.)

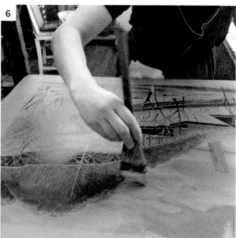

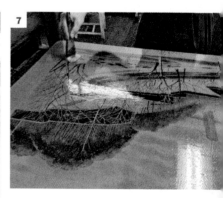

T and bar registration marks scratched on a stone.

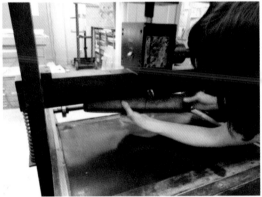

Sonomi Kobayashi sets the scraper bar on the press. Photo courtesy of the Art Students League of New York.

Registration Setup

In lithography, the printing paper is usually smaller than the stone or plate; registration marks are used to align the paper consistently on the printing surface, ensuring that all runs will line up identically.

For a single-run print, the simplest registration system is the T and bar method: A T and a bar are scratched into the stone or plate where the center of each sheet of paper will be placed when printing. The T is at the "front" of the image (closest to the press's scraper bar), and the bar is at the "back" (farthest from the scraper bar). The center points are also marked with a pencil on the back of each sheet of paper. After the stone or plate has been inked, the paper is carefully laid on top: First, its edge is placed against the top of the T; then the bars are lined up at the other end.

Paper Preparation

The printing paper is torn with a straight edge to the desired size, and the leading and trailing edges' centers are marked with a pencil. You should pre-stretch the paper by running each sheet of dry paper individually through an etching press so that it will be ready for the hard pressure of the lithographic press.

The paper is placed printing-side up on newsprint and is dampened with a water sprayer. A clean sponge is used to spread the water evenly. After being blotted with newsprint, the dampened paper is stacked and wrapped in plastic to retain its moisture. A large newsprint pad is placed on top of the dampened pack to keep it flat. (Some artists choose to print with dry paper, depending on the paper and the image.)

Press Preparation

A scraper bar that is narrower in width than the stone or plate but wider than the image is inserted into the press and screwed tightly in place, as shown in the photo above. The placement of the stone on the press is marked at the front margin (the start mark) by taping narrow strips of masking tape on the press frame and the side of the press bed. The place where the stone's back margin is aligned under the scraper bar (the stop mark) is marked, as well. Proofing paper is laid on the stone, and four sheets of newsprint, for padding, are laid on top of the proofing paper, completely covering the stone. The front top surface of the tympan (just above the beginning of the image area) and the leather on the scraper bar are greased using a spatula.

Then the pressure is set on the press. The procedure is demonstrated here by artist Sonomi Kobayashi.

Setting the Pressure on the Press

1 The masking tape marks on the side of the printer bed and on the press body are lined up. The clutch below the printer bed is engaged, and the handle wheel rotated until it clicks to the set position of the bed. The handle is held with the right hand while the printer bar is lowered with the left hand (shown). There should be no resistance.

2 The pressure screw is tightened as tightly as possible by turning it clockwise (shown). The pressure bar is then returned to an upright position, and the pressure screw turned another three-quarter turn clockwise.

3 Check the pressure of the press by pushing the printer bar down. The bar should not go all the way down without applying pressure when pushing it. Apply pressure to lower the printer bar and turn the handle, as shown, to make the bed of the press move from left to right.

4 After setting the pressure, the clutch is disengaged, the bar is pulled up with the left hand, the bed is pulled out (shown), and the tympan and padding are removed from the stone.

Photos in this series courtesy of the Art Students League of New York.

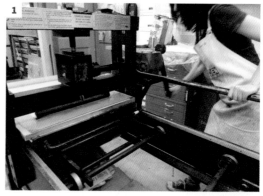

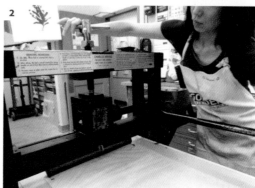

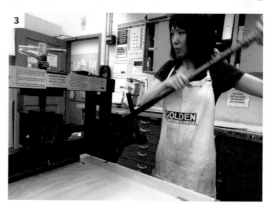

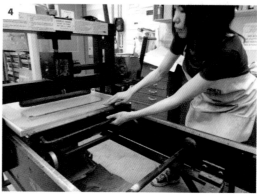

Inking the Stone

When the pressure is set, the stone is ready to be inked. Note that the big leather lithography brayers/rollers are used only for black ink. After each use, a leather brayer is rolled with ink and wrapped in plastic wrap or aluminum foil for storage; the ink, which never dries, acts as a conditioner for the leather. The inking steps are demonstrated here by Tomomi Ono, working on a lithograph by Michael Pellettieri.

1 Before printing, the leather brayer is scraped with a spatula to remove the old ink. The spatula is then loaded with new ink, which is spread diagonally on the inking slab and then rolled with the leather brayer, rolling back and forth in both directions about twenty times to create a thin, even film of ink. In the photo, Ono has spread and rolled out two different black inks on the inking slab: a crayon black and a roll-up black. The larger brayer is inked with the stiffer crayon black, used for lighter passages. Another smaller leather brayer is inked with a greasier 50/50 mixture of the two inks, used for darker passages. Using two different inks and rollers makes sense when working on a large stone with an image with a variety of tones; a smaller stone would be inked with one roller only.

2 Here, Ono has selected the scraper bar (wider than the image but narrower than the stone), centered the bar in the bar holder, and screwed it tightly in place. She has moved the press bed to align with the scraper bar on the upper part of the stone, with the image area centered below the scraper bar.

3 Now, Ono carefully wipes all the drawing mediums off the stone with paper towels and Gamsol, revealing the etched drawing under the crayon.

4 Then Ono rubs a mixture of ink and solvent on the stone with a paper towel to help make the stone receptive to ink. The stone is then buffed evenly with paper towels.

5 Then Ono washes the stone with a dampened sponge to make the non-image area receptive to water and the image area receptive to ink.

6 Ono then charges the brayer with ink by rolling it five times back and forth on the inking slab, rotating the placement of the brayer each time. After wetting the stone with a sponge to repel ink from the non-image area, she rolls ink on the stone twice (shown). This process of charging the brayer with ink (five times), wetting the stone (each time), and rolling ink on the stone back and forth (twice) is repeated five to eight times. Using the larger brayer, the ink is rolled on the whole stone in a different direction each time. The smaller brayer is then used in the same way to roll the greasier ink onto the darker areas of the image.

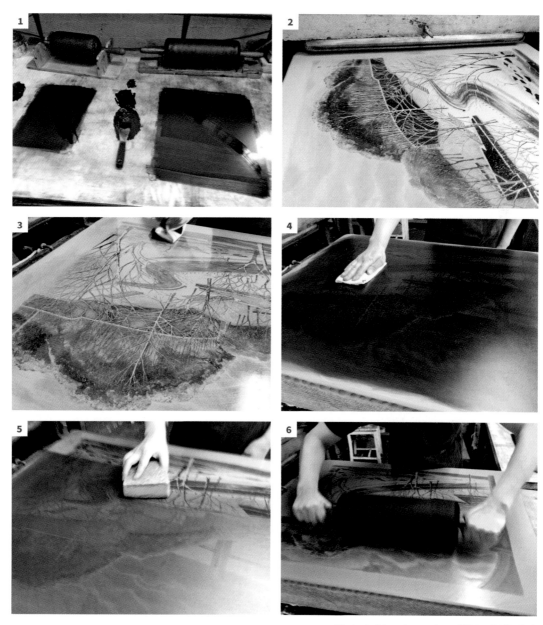

Photos in this series courtesy of Michael Pellettieri.

Second Etch

When the stone has been properly inked and the image is at full strength, it is time for the second etch. A second etch, which is recommended for an edition of fifteen or more prints, ensures a deeper penetration of the image into the stone, because the greasy litho ink can stand a stronger etch than delicate tusche or crayon work. After dusting the stone with rosin and talcum, a mixture of 1 ounce of gum arabic and 10 drops of nitric acid is brushed on the stone for 3 to 4 minutes, then let dry. When ready to print, the old ink is washed off the stone with solvent, and the stone is re-coated with a little ink mixed with solvent, again to make the stone receptive to ink, and then carefully buffed. Sponging and inking the stone resumes as before, until the image appears fully inked.

Tomomi Ono pulling a proof off the stone for Michael Pellettieri. Photo courtesy of Michael Pellettieri

Proofing the Stone

The photo above shows Tomomi Ono pulling the proof for Michael Pellettieri's lithograph *Fort Tryon*. Here are the steps for proofing a stone:

1 Place newsprint proofing paper on the stone, and cover it with newsprint padding.

2 Place the tympan on top of the padding, and spread grease on the upper part of the tympan.

3 Line up the bed at the start mark on the side of the printer and on the press frame.

4 Engage the clutch and rotate the wheel handle until the clutch clicks.

5 Lower the printer bar and rotate the wheel handle until the stop mark on the side of the bed lines up with the mark on the press frame.

6 Disengage the clutch, pull the bar up, pull the bed out, and remove the tympan and padding.

7 Slowly pull the proof from the stone.

After several proofs on newsprint, the final print of Michael Pellettieri's lithograph *Fort Tryon*, opposite, was editioned on Hahnemühle Copperplate paper.

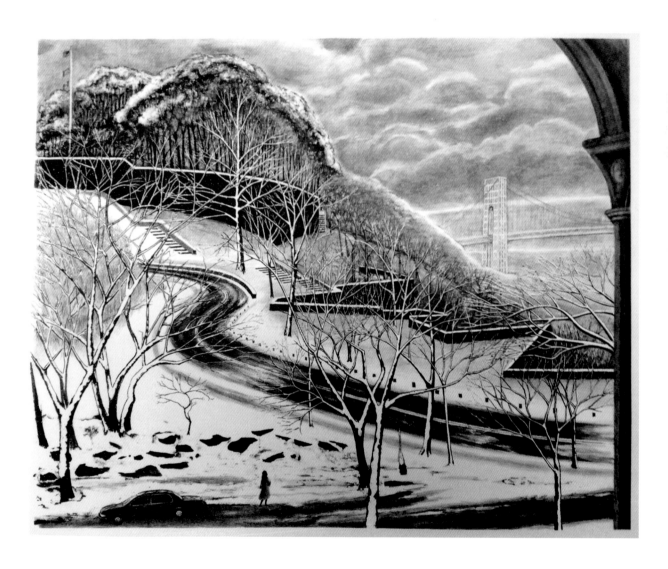

Michael Pellettieri, *Fort Tryon*, 2014, lithograph on Hahnemühle
Copperplate paper, 19 ⅞ x 25 ⅜ inches (50.5 x 64.5 cm). Courtesy
of the artist.

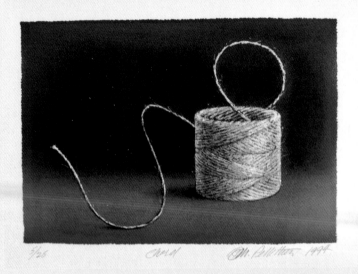

Michael Pellettieri, *Chord*, 1994, stone and plate color lithograph, 10 ½ x 15 ¼ inches (26.7 x 38.7 cm). Courtesy of the artist.

PRINTMAKER PROFILE: **Michael Pellettieri**

michaelpellettieri.com

"Being a printmaker . . . informs my approach to painting, as well as my approach to looking at art."

Michael Pellettieri's work is essentially autobiographical and personal. Rather than selecting his subjects, he lets them select him. Visual experiences all around him have become the catalyst for his work. His earliest etchings were of people on the subway. Occasionally, he still delves into the realm of the figure or an iconic still life. His figurative prints and paintings are also personal.

He is stimulated by variety in both his mediums and his subjects. He was born in Manhattan and raised in the Bronx; he went back to Manhattan for his education and has continued to live there for more than forty years. His many trips around New York have left an impression. He sees the city's dynamics, the changes in light as the sun moves across the sky every day and changes position in the sky throughout the year, throwing shadows of different shapes and sizes and creating an endless variety of light and dark patterns.

Today, most of Pellettieri's work is of locations at which he has lived or worked in New York City. Usually, there is a moment when a familiar place comes into view, appears different, and provokes him to initiate a new work. He follows this up with drawings that are reworked until the image on the paper resonates. He is fascinated by daily visual experiences, and on sojourns out of New York his subject invariably becomes the new visual horizon or human landscape. These scenes, however, are not as persistent a subject as New York. The city offers Pellettieri geometry, order, and chaos that are just waiting to be seen.

Lithography appeals to him for its autographic, direct impact. Working on the luxurious surface of the stone comes closer to working on paper or canvas than any other printmaking process. Traditional stones offer a wide variety of mediums for creating images, and the stones make it possible to change or transform the image even after one has begun printing.

Making prints heightens Pellettieri's awareness of the inherent relationship between image and the ground; when making prints, he is aware that the paper is the ground and that the way the ink relates to the paper is critical to the print's success. The whiteness or color of the paper has to function both as a positive and a negative form, as well as being a support for the ink, which must also play a similar dual role. He says, "Being a printmaker heightens my awareness of this relationship and informs my approach to painting, as well as my approach to looking at art."

COLOR LITHOGRAPHY ON STONES

Artist and master printer Tomomi Ono works on lithographic stones in very subtle colors. Her *Day and Night Sky XII*, pages 194–95, printed in color on two stones, shows the delicate quality of her work as well as the strength of her compositions. The day-sky stone was inked with a roll-up gradation of pale blue to pale beige, while the night-sky stone was inked in black. In another elegant creation, *Dot I*, shown at right, she chose to work in earth tones, including sepia.

In color lithography, a separate stone or plate is used for each color, and all the stones are registered on the same paper. There are several methods of registration, including these:

> The pinhold method, in which two pins are punched diagonally through the top and bottom of the paper and lined up with two corresponding marks scratched on the stone. (Registration marks must be scratched on the stone, not just drawn, because drawn marks will not hold through the lithographic process.)

> The acetate method, in which a proof of the main design, including registration marks, is printed on clear acetate. The registration marks on the acetate are matched on successive stones (or plates) and paper. Some artists prefer to work from one printed-acetate only, registering and printing the second, third, and fourth stones or plates from that one acetate. Other artists, working more intuitively without a specific plan of action, might prefer printing a separate acetate from each stone or plate before proofing. The layered acetates, printed in color, act as guides for further composition and decisions about how to layer colors.

Registration marks can also be taped or marked directly on the stone or plate.

Dry paper is used for printing color lithographs, because dampened paper stretches differently depending on the amount of moisture it contains, making it extremely difficult to control the registration. If a stone has delicate washes that would be difficult to print on dry paper, it can be printed on dampened paper first, and then the rest of the colors can be printed when the paper is completely dry.

On page 196 are some of the steps Tomomi Ono followed when creating a seven-color stone lithograph.

Tomomi Ono, *Day and Night Sky XII*, 2011, color lithograph
(two stones), 13 x 20 inches (33 x 50.8 cm). Courtesy of the artist.

Multi-Stone Color Lithography Process

1 Each stone is processed as described in the preceding section on black-and-white lithography. After the second etch, the drawing mediums are removed from the stone with solvent and replaced with ink in order to test the strength of the etch. The photo shows Ono pulling a proof in black ink after the second etch.

2 Color printing can now begin. First, the artist prepares a roll-up of blue ink fading to transparent. This will be used for the background tone.

3 The blue-green cerulean color is rolled on the key stone and printed and registered.

4 A second stone is inked with a deeper blue and printed. The final print, shown opposite, has a total of seven colors, including ochre, white, and orange, delicately blended and impeccably registered.

Photos in this series courtesy of Tomomi Ono.

Tomomi Ono, *Sky*, 2014, seven-color lithograph, 12 x 18 inches
(30.5 x 45.7 cm). Courtesy of the artist.

"My skies are not scientific star maps. They are the skies of my senses."

Tomomi Ono bases some of her work on classic Asian literature. The prints in her *Seed-Flow* series, one of which is shown opposite, were inspired by Japanese writer Kamo no Chomei's Hojoki (1212), in an essay about impermanence. Eighth-century Chinese poet Li Bai's poem "Overlooking Lushan Waterfall" inspired her to create *Milky Way II* in 2010. She is also moved by the work of artists Kiki Smith, for her severe observation of the human and natural worlds, and James Turrell, for his spiritual and dynamic work with nature.

Ono believes the landscape and cultural background of her native country, Japan, have influenced her artistic views. She attaches importance to space and simplicity, and embraces a philosophy that celebrates the boundlessness of nature over the transience of individual life. All of her images imply the presence of life, and she wants the viewer to feel part of it.

Ono's art is a gathering of external and internal experience. The theme of the *Seed-Flow* series is "life existence" and the transience of that existence, which remains only while water continues to run through one's body. Her early subjects were picked from everyday life: fruits that had been abandoned in the refrigerator for several months, dried seeds that were either at the beginning or end stage of life. They all represented a moment of life, belonging to the order of nature.

After completing the *Seed-Flow* series, Ono in 2008 started her *Sky* series, focusing on the themes of life-force energy and the propagation and continuation of life cycles. The stars are depicted very subtly in the day skies of these prints, so faintly that the viewer needs to look closely to see them. In reality, of course, stars are not visible in daylight, although they exist all the time. Ono sees the day stars as the existence of life in the sky, beyond the clouds and sunlight. About the *Sky* series, she says, "Sparkling stars in the clear night skies were inspired from a lonely night train trip in the Alps over twenty years ago. The dramatic panorama of the night sky always lived inside me as one of my most beautiful experiences. My skies are not scientific star maps. They are the skies of my senses."

Tomomi Ono, *seed-fountain*, 2004, color lithograph, 9 x 7 inches
(22.9 x 17.8 cm). Courtesy of the artist.

Sonomi Kobayashi, *Seen-Unseen*, 2014, lithograph on aluminum, 15 x 22 inches (38.1 x 55.9 cm). Courtesy of the artist.

Hand-Drawn Lithography on Aluminum

When working with an aluminum plate, first round the corners of the plate with scissors and lightly file them to avoid damage to rollers and the scraper bar. The safest and easiest method of washing, or counter-etching, a plate is to rinse it in hot running water and then clean it with a wad of cotton a couple of times. After the final rinse in hot water, drain the plate and blot it with clean newsprint. Use a fan or hair dryer to evaporate any remaining moisture. Leaving any water on a plate will cause oxidation and interfere with the drawing. An aluminum plate will also rapidly oxidize if left exposed to air, and it can be contaminated by dirt or grease. New, freshly ball-grained plates have little oxidation, but the older a plate is, the deeper the layer of oxidation.

Highly oxidized plates can be cleaned with a mild counter-etching solution of citric acid and water: Wearing rubber gloves and safety glasses, mix ¼ teaspoon of monohydrate citric acid crystals with 10 ounces of warm water. After counter-etching, rinse the plate with hot water and dry.

Sonomi Kobayashi painting tusche washes on an aluminum plate.

Drawing materials for aluminum are the same as for a stone: lithographic pencils, lithographic crayons, and tusche. The harder pencils and crayons produce subtle, delicate tones, while softer ones produce deep, rich black tones. Note, however, that the greasy pencils and crayons can easily clog the grain on a metal plate. Washes on a plate look different from how they do on a stone, so it is a good idea to make a test plate to see the possibilities the aluminum offers.

Tusche is applied with soft brushes. When pooled on the plate and left undisturbed for a few minutes, it creates reticulation, a pattern of interlacing lines that will print as an interesting texture. Washes should be applied lightly, as they will print darker than they appear on the plate. Repeatedly painting an area with tusche will force the grease down into the grain and cause the wash to darken when inking. When thinning tusche for use on aluminum, use distilled water rather than tap water to avoid minerals and impurities that may cause clotting. Mixtures of tusche and different solvents cause various visual effects with unique characteristics: Alcohol breaks the grease up into small clumps, creating spotted patterns; paint thinners dissolve the grease in tusche, leaving spotted areas that will take ink during roll-up.

Solid areas and lines can be drawn with a mixture of 1 part liquid asphaltum, 1 part Lithotine solvent, and 1 part Charbonnel black ink.

ETCHING AN ALUMINUM PLATE

To desensitize the non-image areas to grease and make them water receptive, the plate must be etched with TAPEM (tannic acid plate etch mixture), a mixture of gum arabic, phosphoric acid, and tannic acid. (See the sidebar at right for the TAPEM recipe and etching formulas.) During printing, a good desensitizing gum will cling to the surface of the plate in the non-image areas and remain hydrophilic in the negative areas.

TAPEM AND ETCHING FORMULAS

TAPEM, or tannic acid plate etch mixture, is the etch formula for aluminum. (Nitric acid is not used with plate lithography because it is harmful to the surface of the aluminum.) TAPEM can be prepared in a large quantity in advance. The recipe is as follows:

- 42 ounces tannic acid
- 76 ounces gum arabic
- 1 ounce phosphoric acid

Mix the tannic acid and gum arabic in a 1-gallon plastic or glass container (not a metal container), and carefully add the phosphoric acid to the mixture. (If tannic acid is unavailable, a mixture of gum arabic and phosphoric acid may be substituted: Mix 1 ounce of gum arabic plus 20 drops of phosphoric acid to replace TAPEM, or mix 1 ounce of gum arabic with 6 drops of phosphoric acid to replace the 50/50 etch described below.)

Etches of varying strengths are formulated by mixing TAPEM with additional gum arabic. The following formulas are listed in order of increasing strength:

- $\frac{1}{4}$ TAPEM to $\frac{3}{4}$ gum arabic
- $\frac{1}{3}$ TAPEM to $\frac{2}{3}$ gum arabic
- $\frac{1}{2}$ TAPEM to $\frac{1}{2}$ gum arabic, referred to as "50/50"
- $\frac{2}{3}$ TAPEM to $\frac{1}{3}$ gum arabic
- $\frac{3}{4}$ TAPEM to $\frac{1}{4}$ gum arabic

The pH of gum arabic varies from brand to brand, and the strength of etches can be checked with litmus paper. The pH can be lowered by adding drops of phosphoric acid. If necessary, more gum arabic or some magnesium carbonate can be added to raise the pH. An extremely greasy image may require a lower pH than what is found in TAPEM, requiring the addition of a few drops of phosphoric acid. Most print studios have etch charts, but printmakers should make adjustments to these formulas based on experience.

In the first step of the etching process, the entire plate is coated with pure gum arabic. Delicate areas of the image are avoided in the initial application of the etch mixtures and are etched last using either pure gum arabic or leftover and weaker etch mixture already on the plate. The total etch time is 1 to 3 minutes, or 5 minutes for spot-etch washes. Here is the procedure:

1 Apply and buff talcum powder to the plate with a cotton pad. (Rosin is not used on plates.) Talcum powder helps the water-soluble etch adhere to the edges of the greasy drawing particles and prevents the drawing materials from smearing.

2 Using a soft brush, paint a thin layer of gum arabic on the entire surface of the plate to prevent the grease from adhering to the negative areas.

3 Using another soft brush, paint TAPEM on all the dark values of the drawing. (Stronger etches can be created with additional phosphoric acid.) Then, using the brush used in step 2, paint the plate again with pure gum arabic, and lightly buff it with soft cheesecloth. A thin layer of gum adheres better to the plate than a heavy one, which may cause flaking.

4 Allow the plate to rest for 45 minutes, until the acid is completely inert, before going on to roll-up.

Roll-up Process

Just as with a lithographic stone, only the image areas of an aluminum plate will accept the ink when the plate is rolled with oil-based ink.

Use a large brayer on a clean, flat surface to roll out the ink. Apply a fresh film of gum arabic to the plate and buff it lightly with soft cheesecloth. The film must be applied very thinly and evenly so that it can be easily washed away with solvent. Then follow the procedure below when rolling up and proofing the plate.

Rolling Up and Proofing an Aluminum Plate

1 Remove the drawing materials from the plate with Gamsol or Lithotine solvent and paper towels.

2 Then coat the plate with liquid asphaltum thinned with Gamsol or Lithotine to protect the image and make the plate ink-receptive. Buff the plate to wipe way any excess so that the film is quite thin all across the plate.

3 Using a sponge and water, wet the plate to dissolve the base layer of gum arabic, and then sponge again over the entire image with a clean sponge to dissolve the remaining asphaltum and gum arabic. Any excess gum or water may damage the image at this point, so it is important to work quickly. While keeping the plate damp with a sponge to repel the ink from the negative areas, roll black ink onto the plate, alternately sponging and rolling the ink in all directions until the image is fully visible on the plate. When the plate is dry, apply a second etch, repeating steps 1 to 4 in the previous set of instructions. (Note: A second etch is not really necessary for small editions of 1 to 15 prints.) The plate is now ready to be proofed and printed.

4 As the image is proofed on several sheets of newsprint, leftover ink from each proof builds up on the plate, which is now ready for the first print. Lay a dampened printing paper on the inked plate, as shown.

5 Place newsprint padding and the tympan on top of the printing paper, and smear grease on top of the tympan where the plate will first encounter the scraper bar.

6 Release the clutch and lower the printer bar while turning the handle of the press to move the press bed through the press.

7 After pulling the press bed back in its original position, remove the tympan and padding and pull the print off the plate.

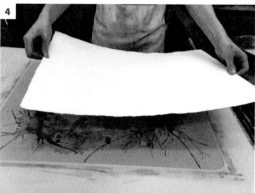

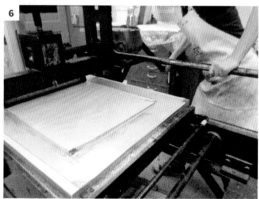

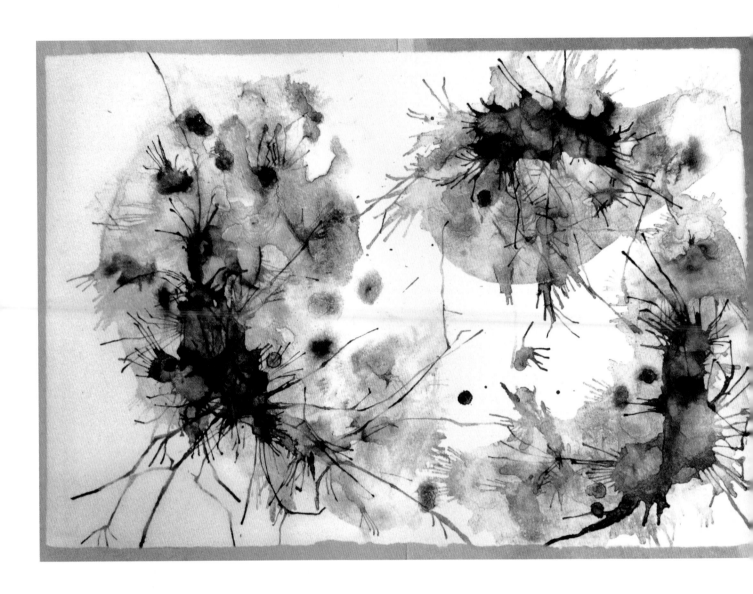

Sonomi Kobayashi, Untitled, 2014, lithograph on aluminum,
15 x 22 inches (38.1 x 55.9 cm). Courtesy of the artist.

RECIPES FOR COUNTER-ETCHING

Wear rubber gloves and safety glasses while mixing a counter-etch solution. Mix the solution in a well-ventilated area, and make sure water is readily available for rinsing the skin in case of splashes. Good, reasonably safe counter-etch formulas for aluminum follow; both work well, though the first is stronger:

❯ Phosphoric/hydrochloric acid formula
- 1 ounce phosphoric acid
- 1 ounce hydrochloric acid
- 1 gallon water

❯ Citric acid formula
- 1/4 teaspoon monohydrate citric acid crystals
- 10 ounces water

COUNTER-ETCHING TO MAKE ADDITIONS

Additions may be made if the plate is counter-etched prior to redrawing. Without counter-etching, additions will roll up only partially, if at all, and will deteriorate during printing. The original etch has established a protective molecular film of absorbed gum arabic on the negative areas of the plate, and counter-etching removes this film, allowing the surface to again become grease-receptive. Recipes for counter-etch solutions appear in the sidebar at right. Strong counter-etches are not recommended because they damage the surface grain of the plate.

To apply the counter-etch, first wet the plate. (Pouring counter-etch on a dry plate may create marks.) Then, using a clean sponge, wash the plate with water to remove the gum arabic. It is important to use a clean sponge to avoid depositing contaminants (salts) on the surface. Then pour the counter-etch solution onto the middle of the plate and move it evenly across the whole image with a cotton pad for 1 minute. Then rinse the plate in water. Repeat this process twice more. Once the plate has been given a final rinse and allowed to dry, it is ready for additional drawing.

MAKING DELETIONS

Before the first etch or even after a plate has been rolled up, it is possible to make deletions on small areas with a solvent such as acetone, which cleans out the grease reservoirs of the plate. Carefully apply the solvent with a cotton ball, to remove the drawing material, and then re-etch the plate. To remove large areas of drawing, it is better to use a gum arabic solution: Gum and buff the plate after etching, then completely wash the drawing off the plate with Lithotine or Gamsol. Deep-clean the plate with acetone, then carefully paint over the areas intended for deletion with a thin layer of a mixture of 1 ounce of TAPEM and 8 to 10 drops of phosphoric acid. Then buff the plate down with a thin layer of liquid asphaltum, wash it with a wet sponge, and immediately roll it up with black ink. The deleted areas will not take the ink. Now, you may add new drawing and re-etch the plate.

A rubber hone such as the Brightboy Weldon Roberts retouch stick may be used as an eraser on a plate at any point. If used after the plate is rolled up, the image should be dusted with talcum to avoid smearing, and after erasing the plate must be sponged with water, dusted with talcum again, and then re-etched.

Photolithography

Traditional film photography has a full, continuous range of tones, from the purest whites to the deepest blacks. With the exception of traditional photogravure on aquatinted copper, however, reproductive processes cannot print a continuous tone, and the range of tones must therefore be mechanically created. Photolithography, like photo-etching (see page 143), relies on halftones made of minuscule dots, visible only with a magnifying loupe, to reproduce an image. With photolithography however, the halftones can be much smaller—133 to 220 lpi (lines per inch), compared to 85 to 100 lpi for photo-etching—because the sensitizing emulsion on the lithographic plate does not have to be etched to the same depth as a photo-etching plate. The halftone image converts tonality into solid dots of equal density but differing size. When exposed on a plate, inked, and printed on paper, the dots seem to blend, creating the illusion of tones.

COMPUTER-GENERATED TRANSPARENCIES

Photolithography requires a halftone transparency and, if a color image is to be printed, a color separation to generate color transparencies to be exposed to the plate. A color separation is an electronic record of the placement, density, and screen angles of each of the four process colors—cyan, magenta, yellow, and black, together referred to as CMYK. To produce a full-color photolithograph, the colors must be digitally separated in CMYK Mode using Adobe Photoshop and then printed in black and white on separate transparencies with a laser printer or photocopier.

Laser printers and photocopiers produce a standard resolution between 220 and 240 dpi (dots per square inch), which is the highest recommended resolution for hand-printed lithographs. When an image is color-separated, positives of the separations are printed on laser transparencies. Images that are too big for ordinary home-office laser printers can be output by a commercial printing company.

The top photo opposite shows the color-separated plates I used for my photolithograph *Onto the Lake 1*, shown opposite, bottom. When doing a color separation, first scan the image if you do not already have a digital file. Open the digital file in Photoshop, and follow this procedure:

1 In the Image menu, go to Image Size; in the Document Size window choose dimensions, in inches, that will fit the transparency. Set the resolution to 300 dpi.

2 In the Image menu go to Mode and choose CMYK.

3 In the Image menu go to Image Rotation and choose Flip Horizontal. This will produce the correct orientation when the transparencies are printed.

These four Fujifilm plates were color-separated and processed for *Onto the Lake 1*.

Sylvie Covey, *Onto the Lake 1*, 2012, photolithograph on Fujifilm plates, 14 x 20 inches (35.6 x 50.8 cm).

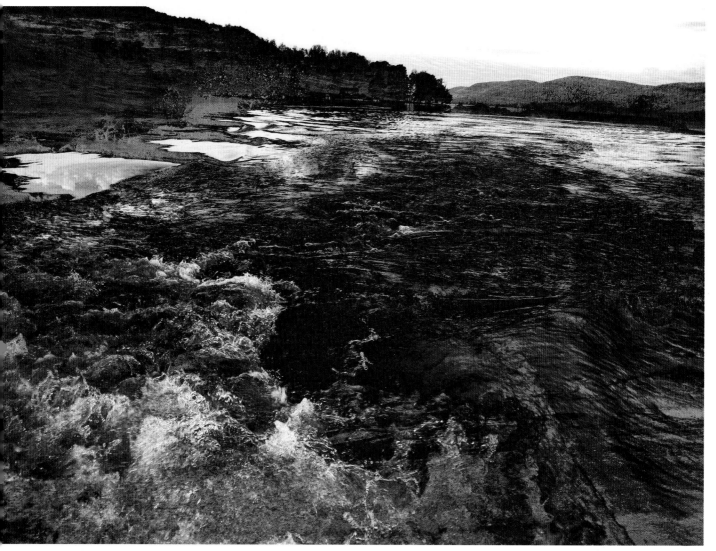

4 Connect your computer to your laser printer. In the File menu go to Page Setup, and check the orientation of the image. Then go to File > Print with Preview; in the Color Management window, you will see that the printer is already set to Separations, because the image is a CMYK file. In the Print window output section, check Corner Crop Marks and Labels. The corner crop marks will serve as registration marks, and the labels will indicate which color is being printed.

5 Print each color on transparencies using the printer's default settings. If possible, load the transparencies manually, one at a time, to avoid jamming. The colors will print in the order of cyan, magenta, yellow, and black because that is how the separations are read electronically. However, when hand-printing, you should print the lighter colors before the darker colors: yellow, magenta, cyan, and finally black. Each sensitized plate is light-exposed to the transparency, processed, and printed to reproduce the full-color spectrum of the image.

Sandra Frech, *Potteries Françaises*, 2009, Fujifilm plate photolithograph, 16 x 30 inches (40.6 x 76.2 cm). Courtesy of the artist.

WHICH PRESS FOR PHOTOLITHOGRAPHS?

When hand-printing photolithographs, you can use either an etching press (see page 80) or a lithography press (page 177). (The lithography press is essential only when working on stone.) When using a lithography press, the T and bar and acetate registration method is required. When using an etching press, as I do, the printed corner crop marks and labels on the transparencies are essential for cutting each plate to the exact size of the image and for identifying the CMYK separations.

PHOTOLITHOGRAPHY WITH FUJIFILM PLATES

In my opinion, Fujifilm and P&Z Posi-Blue plates provide the most accurate means for hand-printing full-color photolithographs. The plates are highly reliable, easy to process, and durable enough for editions of one hundred or more prints. When safely stored away from white light, unprocessed Fujifilm plates last for years.

When using Fujifilm plates, first digitally color-separate your image in Photoshop and print the CMYK laser transparencies following the instructions just given. Place each color separation on a separate plate and expose it to UV light. After development, wash the emulsion off the non-image areas. The plates are dampened when inking, with the wet, non-image areas repelling the oil-based ink. Careful registration and printing of the four plates re-creates the full color of the image.

To process Fujifilm plates for color photolithography, follow these simple steps. The first three steps should be performed away from direct sunlight; if a darkroom is not available, at least cover the windows and turn full-spectrum lights off, using a yellow safelight instead.

1 Under yellow safelight, cut four Fujifilm plates to fit the image, if you will print on an etching press. (If you will print on a litho press, cut the plates 2 inches larger than the image all around.) Tape the edges of the transparencies to the emulsion side of the plates, toner to emulsion; do not place tape on the image area. Label each plate on the back to identify its color separation: cyan, magenta, yellow, or black.

2 With the transparencies taped to them, expose the plates to UV light. As with photo-etching (see page 143), you must test beforehand to determine the right exposure time, which will depend on the light-exposure unit.

3 Develop the plates one by one in a solution of 1 part DP4 developer to 7 parts water.

4 Once the plates have been developed, it is safe to work in full white light. Gently dry each plate with newsprint and gum it with Fujifilm FN-6 gum or thin, diluted gum arabic (1 part gum arabic to 3 parts water).

5 The Fujifilm plates can be printed on a lithographic press (on paper smaller than the plate) or on an etching press.

6 Fujifilm plates are inked and printed in the same way as stones or aluminum plates: Sponge the plate with water to dampen it, and roll it repeatedly, in all directions, with a thin layer of ink. Proof each plate and print it on Mylar (acetate) first, for registration purposes.

MATERIALS FOR PHOTOLITHOGRAPHY WITH FUJIFILM PLATES

These supplies are required for Fujifilm-plate photolithography. The plates, developer, and finishing gum are available from professional lithographic suppliers:

❭ FPS-N Fujifilm plates

❭ Laser transparencies for color separation

❭ Laser printer for printing transparencies

❭ UV light-exposure unit

❭ DP4 developer

❭ Tray for developing plates

❭ Fujifilm FN-6 finishing gum or diluted gum arabic for gumming the plate

❭ Wide soft brush for gumming

❭ Fujifilm Multi Cleaner MC, for cleaning the plate

❭ Lithographic inks

❭ Sponge and water

A new brand of plates very similar to Fujifilm plates is now available in art supplies stores under the name P&Z Posi-Blue positive lithographic plates, with P&Z cleaner and P&Z developer. It works the same as Fujifilm plates.

PRINTMAKER PROFILE: **Dan Williams**
dankeithwilliams.com

"When collaborating with a model, what I do is best described as a fusion of art and performance."

Dan Williams's background in graphic design led him to create magazine and album covers long before the advent of the personal computer and desktop publishing. From the mid-1980s on, he became deeply involved in the evolution of graphic design and was one of many who advocated giving graphic designers technological tools.

Working with graphic arts led to digital photography and eventually to printmaking, where Williams feels most comfortable working with Photoshop, photolithography, and pigment transfer. Most of his work has social or political undertones. After sometimes overstating his ideas, he feels he has now come to a place where his message is more subtle and nuanced. He sees what he creates as therapy that helps him to cope with some of the injustices he sees in the world, real or imagined. Although he often works with models, a lot of his subject matter comes from his hometown of Beaufort, South Carolina. A major theme is nature, usually beautiful and serene but sometimes approached with a deep, dark subtext.

Williams often shoots pictures that take him back to childhood, addressing some difficult and unresolved issues regarding the human condition. He says, "I try to recapture places and emotions from my childhood because they represent the calm, uncomplicated life that I often dreamt of. I then incorporate those dream images with the reality of conflict, pain, and uncomfortable, suppressed elements of my life. When collaborating with a model, what I do is best described as a fusion of art and performance."

Dan Williams, Untitled, 2014, pigment transfer, 16 x 22 inches (40.6 x 55.9 cm). Courtesy of the artist.

Dan Williams, *Man-Creek*, 2014, pigment transfer, 16 x 24 inches
(40.6 x 61 cm). Courtesy of the artist.

Below is the procedure Dan Williams followed when processing and printing a photolithograph with four Fujifilm plates.

Fujifilm-Plate Photolithography Process

1 Williams color-separated the digital image shown and laser-printed the CMYK separations on four transparencies.

2 He taped the transparencies on the plates and exposed them to UV light, then developed them, washed them in water, and quickly dried them with newsprint to avoid watermarks before buffing them with a thin layer of gum. The photo shows the exposed, developed plates. Note that the image has been horizontally flipped.

3 Williams inked and printed the yellow plate first, then the red plate. The photo shows the printed image after these first two printings.

4 The blue and black plates were printed on top of the yellow and red, resulting in the full-color photolithograph shown. After printing, Williams cleaned the plates with Fujifilm plate Multi Cleaner MC, gummed them with FN-6 gum, and wrapped them in newsprint for storage.

MATERIALS FOR PHOTOLITHOGRAPHY WITH TORAY WATERLESS PLATES

Here are the materials you'll need for waterless photolithography with Toray plates. The first three items are available from professional lithography suppliers:

> Toray positive Waterless Plates

> HP-7N developer for developing the plates

> MD-20 dye solution (optional)

> Piece of a wool blanket or other tightly woven woolen material

> Light exposure unit

> Protective gloves

PHOTOLITHOGRAPHY WITH TORAY WATERLESS PLATES

Toray Waterless Plates, developed for commercial photo-offset printing, are difficult to develop by hand (rubbing the developer on the plate is cumbersome) but are much easier to print than other plates because they do not have to be dampened. Instead of water, the silicone coating acts as the ink repellent in the non-image areas, and the printing paper stays flat and dry.

As with a Fujifilm plate, a Toray plate is covered with a halftoned image printed on a laser transparency and then exposed to UV light; the UV light hardens the non-image areas. When a developer is rubbed on the plate using a wool cloth, the image areas soften and become ink receptive, and the silicone left on the hardened non-image areas repels the ink. The shelf life of a Toray plate is from four to eight months, after which the photosensitizer on the silicone coating becomes inactive.

1

2

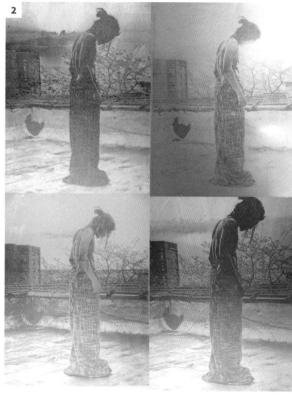

3

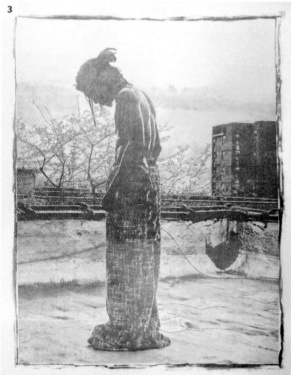

4

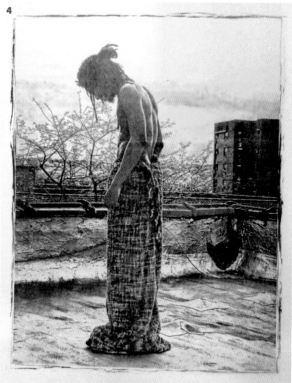

Photos in this series courtesy of Dan Williams.

Dan Williams, *Muse 1*, 2013, four-color photolithograph,
22 x 30 inches (55.9 x 76.2 cm). Courtesy of the artist.

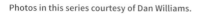

Toray plates work best with higher-contrast images. As with the Fujifilm plates, it is critical to avoid white light on the plate until the exposure is done; if a darkroom is not available, use very low light and cover the windows. Here are the steps to follow when processing a Toray plate:

1 Peel the protective plastic sheet off the silicone side of the plate.

2 Place the transparency facedown on the plate, toner to emulsion.

3 Expose the plate to UV light. (Conduct prior testing for appropriate timing.)

4 Remove the transparency. Now, working in normal white light, soak the woolen developing pad in HP-7N developer. Make sure to wear protective gloves!

5 Using the soaked pad, rub the developer on the plate until the image has an even texture all over.

6 Rinse the plate with water, dry it with paper towels, and ink and print.

Because no water is used when inking Toray plates, very tacky ink is needed to ensure that only the image areas receive the ink, and that the silicone repels ink from the non-image areas. The Superior ink company makes a line of inks, called Aqua-Not, that are very effective for waterless lithography. If the Aqua-Not brand is not available, add magnesium carbonate to regular lithographic ink until it becomes very stiff. When inking, roll a thin layer of Aqua-Not or stiffened ink onto the plate very quickly, moving the roller across the plate in all directions. Toray plates may be printed on either an etching press or a lithography press.

MATERIALS FOR PRONTO POLYESTER LITHOGRAPHY

Here are the materials you will need for printing with polyester plates. The plates are available at art supplies stores:

- ❯ Pronto polyester plates
- ❯ Laser printer
- ❯ Waterproof drawing mediums (permanent markers, tusche, grease pencils)
- ❯ Newsprint
- ❯ Two bowls, one for water and the other for 3 teaspoons of gum arabic
- ❯ Large sponge cut in half for dampening the plates
- ❯ Fountain solution for Pronto polyester plates and ordinary toothpaste, for cleaning the plate
- ❯ Lithographic process inks (cyan, magenta, yellow, black, white, transparent base)
- ❯ Setswell or Easy Wipe ink modifier to reduce the tack of the litho inks
- ❯ Magnesium carbonate or litho varnish #8

Pronto Polyester Lithography

The advantage of working with Pronto polyester plates is that there is no need to print transparencies or to expose the plates to UV light or develop them. The image is printed directly onto the plate, which is a paper-thin polyester sheet, by a laser printer. A disadvantage of this technique is that the polyester plate's pores fill up quickly, meaning that a new plate must be created after about four prints unless the printer's lpi (line dot per square inch) setting is lowered. Most laser printers print images at more than 133 lines per inch; the lpi should be reduced to 75 for Pronto polyester plates.

Sylvie Covey, *Into the Sea 6*, 2010, Toray Waterless Plate
lithograph, 10 x 16 inches (25.4 x 40.6 cm).

Jennifer Vignone, Untitled, 2014, seven-color Pronto polyester
hand-drawn lithograph, 15 x 14 inches (38.1 x 35.6 cm). Courtesy
of the artist.

Polyester plates can also be drawn on by hand. When creating an image by hand, use waterproof drawing mediums such as ballpoint pens, permanent Sharpies, or lithographic pencils or crayons, or paint on the plate with tusche. Laser-printer toner powder diluted with solvent or even plain water can also be used to create tone, but it must be fused by heat to the Pronto plate because if the medium is not waterproof or properly fixed to the plate, it will dissolve when the polyester plate is dampened with water.

Artist Jennifer Vignone creates multiplate polyester-plate lithographs like the one shown opposite by drawing on Pronto plates with Sharpies and Pilot Super Color markers.

When doing color separations with a laser printer, follow the same procedure you would if printing transparencies (see page 206). The laser printer's heat will fuse the toner to the plate. Manually load the polyester plates one by one into the laser printer.

Pronto polyester plates can be printed on an etching press, in which case the edges of the plate are trimmed to the size of the image before inking, or on a lithography press, in which case the printing paper must be smaller than the plate. The plate is dampened with a sponge and water, rolled with oil-based ink, and then printed. The ink should be lithographic ink, but loosened up with Setswell or Easy Wipe, because very tacky ink will pull the toner off a polyester plate and damage the image. The plate should be cleaned after each print— washed with fountain solution and rubbed with toothpaste in detailed, difficult-to-clean areas—to keep the white areas from filling up. Keep the plate damp by sponging it with water while cleaning.

John Salvi, *Red Triumph Dream*, 2010, lithograph on polyester plates, 10 x 16 inches (25.4 x 40.6 cm). Courtesy of the artist.

Artist John Salvi has worked with Pronto polyester plates for many years. Because he prefers to work in a large format, Salvi has his polyester plates color-separated by a commercial printer. On the next page are the steps Salvi followed when creating an untitled four-color Pronto polyester plate lithograph.

Pronto Polyester Plate Process

1 After the image was color-separated and printed on four Pronto polyester plates, Salvi trimmed the plates and labeled the back of each to identify the color separation (C, M, Y, and K). He coated each plate with gum arabic to make the image areas more receptive to ink, and then dampened the plate with a sponge and rolled the toner areas with ink, sponging the non-image areas clean with water. Salvi inked the yellow plate first.

2 Salvi then printed the yellow plate on an etching press. (Because polyester plates have the same thickness as paper, it is easier for registration purposes to lay the paper on the press bed and place the polyester plate on top.)

3 Here, Salvi is pulling the yellow printed plate from the paper.

4 Inking and printing resumed, with the red plate next. The final print, after the blue and black plates were printed, is shown opposite.

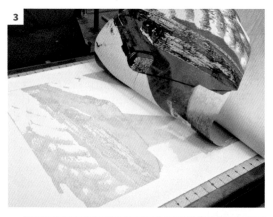

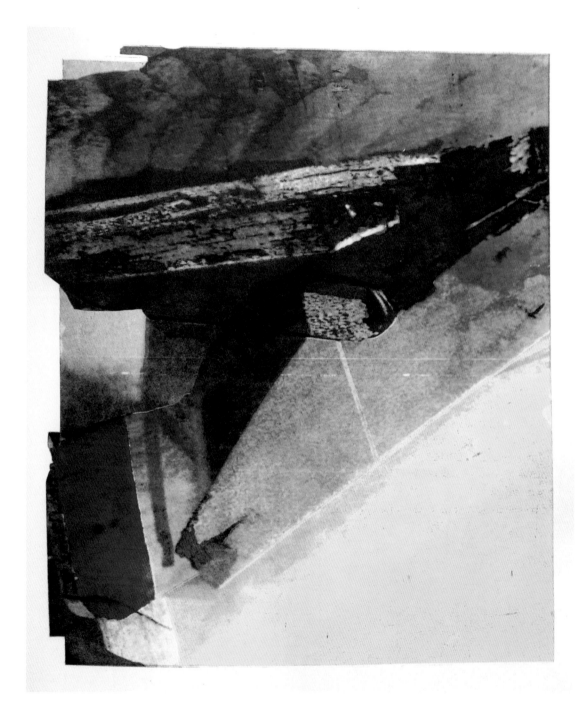

John Salvi, Untitled, 2014, polyester Pronto lithograph,
22 x 30 inches (55.9 x 76.2 cm). Courtesy of the artist.

John Salvi was born near the sea and retains a lifelong love for all things associated with the ocean. His source of inspiration presents him with endless lessons in dynamism, cycles of change, renewal, and the effects of reflected light. His artwork is at times subtle and serene, then quickly shifts into a tempest whose magnitude of primal energy is inspiring. The sweeping gestures of ink are attempts to capture of engagement. Perfection of a technique, minute detailing, and technical excellence in printmaking are all admirable artistic pursuits but, for Salvi, are better left to those inclined toward small brushes, cross-hatching, and diminutive themes. Without apology, but with a respectful nod to all who choose the etcher's needle or engraver's tools, Salvi prefers robust, muscular dynamics in his prints. He embraces the notion of Small moments winnowed, snatched from a grand continuum that has no reasoned history, no mortal bounds, no restraints beyond my own imagination."

PRINTMAKER PROFILE: John Salvi
johnsalvi.net

"My images give visual proof of their timeless existence. Captured moments, now, unapologetically, clearly focused."

John Salvi, *A Horse of a Different Color*, 2014, polyester color lithograph, 22 x 30 inches (55.9 x 76.2 cm). Courtesy of the artist.

some of that watery environment's tension while tempering its raw turbulence with flattened, quiescent areas between areas of intensity and mercurial, fickle restlessness.

Spontaneous, consummate moments of inspiration, untempered by restraints of time and space, direct him in expressing what the image will be. Color and gesture prevail, whether he is using Plexiglas plates inked for a monotype or transforming photographs on the computer into color-separated plates to be inked for final, hand-pulled prints.

Salvi's work is ephemeral in its dalliance with the mind, its dance with color, and its strategy art making as play.

It is Salvi's hoped-for intention that his artwork portray reflections of the sublime, flashing insights into mind, encounters with what exists beyond the ordinary. Hopefully, each creation becomes his own visually animated story. His work is cerebral in that it tangibly reveals what his mind knows. About his images, Salvi says, "Art— imagined in a fleeting moment that may have begun in another lifetime, temporarily unremembered, suspended in time, until this creative, restorative moment. Art— thrust into the present. My images give visual proof of their timeless existence. Captured moments, now, unapologetically, clearly focused.

Paper Lithography

Plain photocopies can also be used as lithographic plates. In paper lithography, a photocopy is coated with gum arabic, dampened with water, and printed. When printing multiples, you must replace the photocopy often because the paper quickly falls apart.

Paper lithography works best with high-contrast images with lots of black and white areas but few grays. Detailed imagery will not work as well as images that are bold and close-up. Because of the instability of the paper, this lithographic method is not at all precise, but it produces very interesting painterly effects. Paper lithography can be done in monochrome or even as a color separation. A color paper lithograph can also be created without color separation, simply by photocopying the same image three times and printing it first with yellow, then red, and then a light blue ink. The resulting print is a very painterly version of the original image.

To make a paper lithograph, artist Ann Winston Brown starts with a color monotype background, then prints a paper lithograph image inked in black on top of the monotype. She uses high-contrast images, photocopying them on ordinary office paper and tearing the photocopy into abstract pieces. She coats the paper with gum arabic and wets it with a sponge to create a resist on the non-image areas, then inks it with oil-based ink. The ink is rolled three times with a brayer, starting from the center of the paper and moving toward its edges to avoid tearing. The photo to the right shows Winston Brown printing imagery from a paper lithograph atop a colorful monotype; the final print is shown at bottom right.

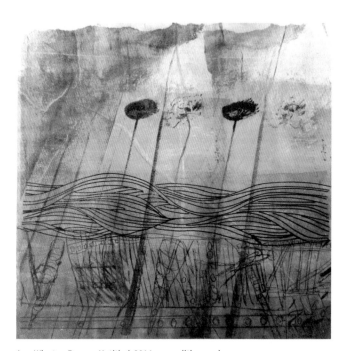

Ann Winston Brown, *Untitled*, 2014, paper lithograph, 12 x 12 inches (30.5 x 30.5 cm).

PRINTMAKER PROFILE: Ann Winston Brown

piermontfineartsgallery.com

Once abstracted, many of these impressions merge into a vocabulary of colors, forms, lines, and textures that repel and attract, overlap and intertwine.

Ann Winston Brown's background as a textile designer has definitively influenced her choices in printmaking. She prefers texture and uses light and bright colors. Her prints are to be savored and absorbed. Her way of working is building texture upon texture, shape upon shape, and color upon color to achieve depth. She takes hundreds of photos when traveling around the world and uses many as inspirations and starting points for her prints. Winston Brown makes good use of Photoshop—enhancing images, altering them, and experimenting with double exposures to extrapolate from reality. She sometimes uses enlarged tiled images for different prints, and often works on several images at the same time to keep her momentum going and her eye fresh.

Winston Brown loves the physical act of printmaking, whether working on a monoprint, etching, or lithograph. The challenge of going through each step is inspiring to her. As the process evolves, she looks for ways to achieve more, to go beyond what is already there. She embraces accidents and incorporates them into the final piece. Winston Brown's work is spontaneous, experimental, and almost entirely abstract, though sometimes incorporating figurative photographic images. She draws from a store of conscious, unconscious, fragmented, and complete visual experiences. Once abstracted, many of these impressions merge into a vocabulary of colors, forms, lines, and textures that repel and attract, overlap and intertwine. Winston Brown's prints are designed to engage viewers and involve them in the artistic process and experience.

ALTERED STATES I Ann Winston Brown

Ann Winston Brown, *Altered States I*, 2014, paper lithograph with
monotype, 18 x 18 inches (45.7 x 45.7 cm). Courtesy of the artist.

O.P. Retrospection ~~~signature~~~

11

Serigraphy

In serigraphy, also called screen printing, a porous mesh screen receives the ink; the image is created by blocking off areas of the screen with an impermeable material to form a stencil that will not allow ink to penetrate. Meshes were originally made of human hair, and then of silk (hence the familiar term silkscreen), but nowadays most mesh is made of man-made fibers. The finely woven screen is stretched over a frame of wood or aluminum.

Masaaki Noda, *Retrojection*, 2003, serigraph, 30 x 22 inches (76.2 x 55.9 cm). Courtesy of the artist.

When screen printing, the printmaker uses a squeegee to force ink through the mesh openings and onto the printing paper. If the print will have more than one color, the first stencil is washed out of the mesh, a second stencil is drawn, and a second color is printed through the mesh. This process of printing one color at a time is repeated until the work is complete, and serigraphs can sometimes take more than a hundred different screen pulls to create all the hues required for the image.

Masaaki Noda, *Hemisphere*, 2005, serigraph, 14 ¹/₂ x 20 ¹/₂ inches (36.8 x 52 cm). Courtesy of the artist.

Jason Clark, *Gates Gate*, 2013, watercolor and serigraph, 30 x 22 inches (76.2 x 55.9 cm). Courtesy of the artist.

A Brief History

The use of stencils to create repeated designs dates back to the ancient Egyptians, Greeks, and Romans, all of whom used stencils in decoration. Numerous peoples around the globe have long employed simple stencils in printing fabrics, but a technique that we would recognize as screen printing did not emerge until the Song Dynasty (960–1279) in China; it later spread to other Asian countries, including Japan. Early Asian screen printers forced dye or pigments through screens using stiff brushes or dabbers.

Screen printing was introduced to Western Europe from Asia sometime in the late eighteenth century but was not widely used in Europe until silk mesh from the East became more commonly available. Silk was used as a stencil-carrier for printing textiles, and although silk has now been replaced by polyester mesh, the technique remains a major means of printing fabrics today. The birth of industrial screen printing came in 1907, when Samuel Simon first patented screen printing in England. The technique was used to print fancy wallpaper as well as linen, silk, and other fine textiles.

It was also in the early twentieth century that the commercial sign industry adopted screen printing for large, bold, colorful billboards. At first, stencils were made from a then-new shellac film tissue, but the shellac tissue was later replaced by a superior, lacquer-based material that allowed stencils to be hand-cut with great precision. Another advance took place in the 1910s, when a group of west coast U.S. printers experimented with photo-reactive chemicals mixed with glues and gelatin compounds. These inventors—Roy Beck, Charles Peter, and Edward Owens—developed a light-sensitive emulsion that could be used to create photo-imaged stencils. Today, commercial screen-printing uses a sensitizer called diazo powder that is far less toxic than the chemicals used by Beck, Peter, and Owens. Although less sensitive to light, diazo powder produces sharper images and is less harmful to the environment.

Masaaki Noda, *After Serenity*, 2003, serigraph, 22 x 30 inches
(55.9 x 76.2 cm). Courtesy of the artist.

THE BEGINNINGS OF FINE-ART
SCREEN PRINTING

Because the medium was so strongly identified
with commercial printing, however, fine artists
long ignored screen printing's creative possibilities.
That changed in the early 1930s, when American
printmaker Anthony Velonis (1911–1997) began
conducting experiments that would ultimately
transform silkscreen printing from a commercial
process to a fine-art medium. The federal gov-
ernment's Works Progress Administration aided
in this transformation, commissioning Velonis to
write a booklet, *Technical Problems of the Artist:
Technique of the Silk Screen Process* (1938), that was
distributed to WPA art centers across the United
States. In 1939, Velonis became a cofounder of the
Creative Printmakers Group in New York City.
The group's shared screen-printing studio intro-
duced the silkscreen process to many serious
artists who went there to have editions printed.
Vincent Longo worked as a colorist at Creative
Printmakers Group, as did Jackson Pollock, and
the print shop eventually became the most impor-
tant silkscreen shop of the era. It was at about this
time that the word *serigraphy*, which combines the
Latin word *seri* ("silk") and the Greek word *grapho*

("to write"), first appeared. It was coined by Carl
Zigrosser, then curator of prints, drawings, and
rare books at the Philadelphia Museum of Art, to
distinguish fine-art from commercial silkscreens.

SERIGRAPHY FROM THE 1960S TO TODAY

Because of its close connection with commer-
cial printing methods, screen printing was ideally
suited to the new aesthetic of the 1960s. Artists
such as Tom Wesselmann, Roy Lichtenstein, Jasper
Johns, and Robert Rauschenberg brought it to the
forefront of post–Abstract Expressionist art. James
Rosenquist happened to be a billboard painter in
the late 1950s, and this gave him the perfect train-
ing for applying sign-painting techniques to his
ultra-large-scale works. No artist, however, did
more for fine-art serigraphy than the so-called
"Pope of Pop," Andy Warhol (1928–1987). Warhol
used hand-drawn images for his early silkscreened
paintings, but he soon switched to photographic
images, including pictures appropriated from
newspapers and magazines. When doing portraits,
he transferred photographs to canvas—usually
a series of canvases—and then painted them
in uncompromising, sometimes garish colors.

Warhol's work overturned traditional fine-art concepts in several ways: By making a series of paintings from the same screen, he negated the idea of the uniqueness of the work of art. And by insisting that the registration be slightly off in his editioned screen-print portraits, he challenged fine-art quality standards, producing images that intentionally looked like photos in cheaply printed magazines.

Serigraphy thus became the means through which a generation of artists appropriated the language of commercial printing for a fine-art end. Screen-printing materials are so affordable, and the basic technique is so easy to learn, that the medium became a favorite means of communication and expression in subcultures ranging from the hippies of the 1960s to today's DIY (do it yourself) movement. Beyond fine art, screen prints have adorned everything from T-shirts to concert posters to record covers.

Equipment and Materials

One advantage of serigraphy is that no press is needed for printing. Another is that large prints in multiple colors can be produced more easily in this medium than in any other. The basic setup is a sturdy table and a place to dry the prints.

Equipment for screen printing includes the following:

❭ **Silkscreen frames.** These can be purchased premade and prestretched or constructed using two-by-two or three-by-three straight clear pine boards and then stretched with mesh. The mesh is stapled on the frame, and wide gaffer tape is used to seal the edges. Aluminum-frame screens are now available in most print shops, prestretched and ready to use.

❭ **Vacuum printing table.** A vacuum table's top—called the baseboard—is made of

steel or waterproof Masonite pierced with numerous small holes. A power vacuum pump sits under the baseboard. Ideally, the baseboard should be 2 inches larger, all around, than the biggest frame you will use. The screen frame is mounted on the baseboard from the frame's upper edge, attached with pin hinges or a hinge bar. Frame register guides are commercially available. During printing the screen must be propped up to feed and register the paper, so the baseboard is also equipped with a leg prop. (A tall container can also be used as a prop.) When the screen is lowered onto the table for printing, the vacuum is turned on, causing air to be sucked through the holes of the table. The vacuum holds the printing paper firmly in place on the baseboard while preventing it from sticking to the underside of the screen.

> **Squeegee.** This tool, used to distribute the ink over the screen surface and force it through the fabric onto the printing paper, consists of a smooth plastic or rubber blade, about half an inch thick, inserted into a handle, usually made of wood. The squeegee should be an inch wider than the image on both sides to ensure full coverage.

> **Dryer rack.** A commercial wire dryer rack is the most efficient way to dry and store large numbers of prints. However, prints can also be hung to dry on a string with clothespins.

> **Light exposure unit.** This is the same type of unit used for photo-etching and photolithography.

> **Wash-up sink with power hose.** You will need a power hose to wash the emulsion off the screen after exposure but before printing.

Silkscreen frame attached to a vacuum table with hinges.

A vacuum table for silkscreen. The top (baseboard) is pierced with tiny holes, and the vacuum is set underneath.

Basic Screen Printing Techniques

The easiest and most efficient method of fine-art screen printing is the stencil method with photo emulsion. It can be done with a single screen or multiple screens and with a single stencil or multiple stencils.

In the single-frame method, a frame is prepared with mesh and masking tape. In a darkroom, the mesh is coated with light-sensitive emulsion and let dry in the dark. The image is drawn or digitally output on a transparency, which is placed on the coated frame, drawing-side facedown. When exposed to UV light, the non-image areas are hardened. The transparency is removed and the frame is power-washed. The soft emulsion on the image area washes away, which lets the ink through when printing. Note: The image on the film must be 100 percent opaque so that no light is allowed through the positive image area. Films that are not 100 percent opaque may cause difficulties during washout. Hold the film up to the light: If you can see light coming through the black area of the film, print another copy and stack them together or go over the film with an opaque pen.

A single frame can easily be cleaned and prepared for the next color and design. When using multiple colors, however, it is often useful to have several frames ready and coated with emulsion. Multiple stencils can also be used on the same frame, altering the image with each pass of ink and each different stencil shape.

The screen can be reused after cleaning. If the design is no longer needed, then the screen can be "reclaimed"—that is, cleared of all emulsion and used again. The reclaiming process involves removing the ink from the screen, then spraying on stencil remover to remove all the emulsion. Stencil removers come in liquid, gel, and powdered form. (The powdered types have to be mixed with water before use.) After the stencil remover has been applied, the emulsion must be washed out using a power hose.

SERIGRAPHY PROCESSING AND PRINTING MATERIALS

These materials are available in general art supplies stores:

- ❯ Gaffer tape to seal the inside of the frame
- ❯ Opaque drawing mediums (permanent Sharpies, India ink) for drawing on transparencies
- ❯ Transparencies to be drawn on or output digitally
- ❯ Diazo-based photo-emulsion gel (Holden's #250) for exposing the image
- ❯ Emulsion removers (Standard's propylene glycol liquid and Holden's HO-100 reclaimer gel)
- ❯ Block-out pens for blocking areas on the screen
- ❯ Water-based inks for printing
- ❯ Transparent base for mixing with inks
- ❯ Paper towels and Gamsol for cleanup

Standard's propylene glycol and Holden's #250 photo-emulsion gel for silkscreen.

Artist Masaaki Noda has used paper stencils extensively, tearing multiple stencils to produce an exquisite layering of soft transparent colors. His prints often have close to a hundred layers, and sometimes even more. Noda's technique is to print a layer of ink, then lay a torn sheet of paper stencil over the print and print another layer of ink, repeating this process numerous times. The paper stencils define the shapes of each layer; their soft, irregular edges combined with the extremely low-density, transparent inks that Noda uses give his prints a luminescent, watercolor-like effect. For an edition, Noda prints each layer a number of times. The photos below show various stages in the development of Noda's serigraph *The Point of Contact*, which was printed with eighty-four different layers.

The Point of Contact, layer 12. All photos in this series courtesy of Masaaki Noda.

The Point of Contact, layer 25.

The Point of Contact, layer 48.

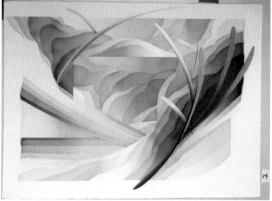

Masaaki Noda, *The Point of Contact* (final print, with 84 layers), 1993, serigraph, 22 x 30 inches (55.9 x 76.2 cm). Courtesy of the artist

PRINTMAKER PROFILE: **Masaaki Noda**

oldprintshop.com/cgi-bin/gallery.pl?action=browse&creator_id=13054

"To survive in the art world you have to stand up for yourself, create your own world, and you have to know your place in the history of art and make history new."

Masaaki Noda is a renowned sculptor, painter, and printmaker who continues to leave his mark with public commissions from the governments of Japan, Greece, China, and the United States.

Noda believes that philosophy is related to history, and that life and society give us reasons to become, or support, artists. While working as a journalist for the Japanese newspaper *Chugoku Shimbun* from 1992 to 1995, he was given the opportunity to interview some of the best-known artists of our time, including Jeff Koons, Roy Lichtenstein, Chuck Close, James Rosenquist, Nam Jun Paik, Elizabeth Murray, Sean Scully, Bernar Venet, Gerhard Richter, Lucas Samaras, and the printmaker Kenneth Tyler, among many others. He asked them all why they became artists, how they survived in the art world, and how they kept a decent quality of life as an artist. Venet and Richter, like many others Noda interviewed, saw art as a discipline: An artist must have the determination and will to take risks and must meet and work with the right people. Samaras thought an artist should focus on how to remain in art history for the next thousand years.

In his own work, Noda expresses the abstract by using the language of reality. He started working with serigraphy early in his career. He was interested in color, and the medium had a clear process and allowed for a lot of color variation. While still in Japan, he used opaque ink and vividly contrasting colors, and his images were hard-edged mathematical constructions. After his arrival in New York in 1977, however, Noda realized that a modern city does not need such cold, mechanical work, and so he began using the stencil technique with multiple transparent rainbow layers.

Noda's goal was to make a print look like a painting. He created soft edges by tearing rice paper for the stencils and started mixing transparent ink with oil paint, creating depth by multiplying transparent layers. The technique allows him to join movement and space. The many layers of transparent color create a three-dimensional effect on paper, and the search for three-dimensionality in serigraphy eventually led him to sculpture. For Noda, screen printing and sculpture are intertwined; both mediums give him endless freedom and new vision. About his career, Noda says, "To survive in the art world you have to stand up for yourself, create your own world, and you have to know your place in the history of art and make history new."

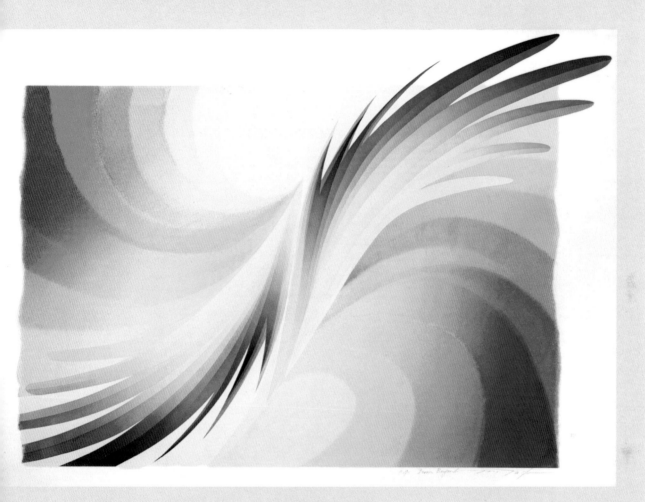

Masaaki Noda, *From Beyond*, 1986, serigraph, 22 x 30 inches
(55.9 x 76.2 cm). Courtesy of the artist.

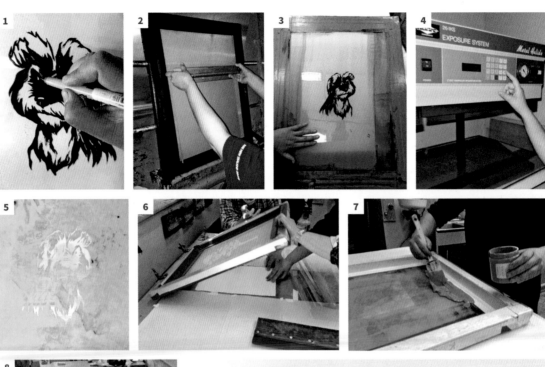

Photos in this series courtesy of Soyeon Kim.

Soyeon Kim, Untitled, 2014, four-color serigraph, image 10 x 7 inches (25.4 x 17.8 cm). Courtesy of the artist.

Artist Soyeon Kim used a single frame and two separate stencils to create a serigraph with this method. The steps she followed are given here.

Single-Frame Screen Printing Process

1 First, Kim drew the original image with a Sharpie on a transparent overlay. (The image may be drawn or painted directly on the overlay or printed as a positive transparency on a laser printer.)

2 Then she selected a framed screen and coated it with photo emulsion. (To coat the screen, prop the screen frame vertically and push the emulsion up from the bottom with a squeegee, creating a thin layer.)

3 The screen was then left to dry in a darkroom for several hours. Once it was dry, Kim placed the positive transparency on the coated screen frame in the light exposure unit.

4 She set the light exposure unit for the appropriate exposure.

5 After exposure, Kim washed the screen thoroughly with water with a high-pressure power hose. The areas of the emulsion that were not exposed to light (the image areas) dissolved and washed away, leaving a negative stencil on the screen. Before beginning to print, it is important that you leave a margin around the edges of the image, extending to the frame, to provide a place for laying out the printing ink. When the surface of the image, commonly referred to as a the pallet, is dry, tape the edges with wide pallet tape, to protect the image from unwanted ink.

6 Kim then laid the screen frame mesh-side down on the vacuum table and fastened it with pin hinges at the top edge. She prepared the ink, mixing it with transparent base to make the color less opaque. With the screen frame in the up position, she placed the printing paper on the vacuum table, lining it up with the registration marks taped on the table.

7 In this photo, the first color has already been printed. In preparation for adding blue ink to the image, Kim poured some ink into the margin at the bottom of the screen.

8 Kim lowered the screen to rest flat on the table, turned the vacuum on, and, with the paper securely in place, spread the ink with the squeegee, applying pressure to force the ink to go through the mesh onto the printing paper.

9 Then she turned off the vacuum and raised the screen to reveal the print. Notice that the print is not the reverse but a copy of the screen image. (This is one way in which screen printing is unlike most other printmaking processes.) When printing additional colors, Kim placed acetate stencils on the paper to protect some areas. The final print, shown opposite, bottom right, is a four-color serigraph print.

Chine-Collé, Mixed Media, and New Printmaking Techniques

□

PART IV

12

Chine-Collé

The term *chine-collé* (pron., SHEEN koh-LAY) combines the French words for "tissue" (*chine*) and "glued," or "pasted" (*collé*). Chine-collé is not a printmaking technique per se but rather a way of transferring an image to a thin, delicate paper (or other material, such as silk) while simultaneously bonding that surface to a heavier supporting paper. The bonding, which happens during the printing process, permits the printmaker to print on a material such as Japanese rice paper, capturing subtle details from the plate without damaging the fragile paper. In chine-collé, the image is often printed on a colored paper that contrasts with the support paper surrounding it. Chine-collé may be applied to a single sheet of thin paper or to several layers of different sizes, shapes, and colors. The technique can be used in relief, intaglio, or lithography printing.

Francisco Feliciano, *Dry Lotus Pod*, 2009, etching aquatint with chine-collé (Echizen Shikibu Gampi-shi tan 17–18 gsm and Arches Cover white 250 gsm support paper), image 18 x 12 inches (45.7 x 30.5 cm), support 30 x 22 inches (76.2 x 55.9 cm). Courtesy of the artist.

There are several methods for applying glue in chine-collé:

❯ **Direct print method.** The plate is inked and placed ink-side up on the bed of the press. The thin paper is trimmed to the desired size—the exact the size of the plate, or a larger size to provide a margin around the image, or even a smaller cutout shape. The chine-collé paper is then misted with water. Water-based paste is applied to the back of the thin paper with a soft, wide brush, and the thin paper is laid glue-side up on the plate. (If the thin paper is colored on just one side, brush the glue on the other side and lay the colored side facedown on the inked plate.) A dampened backing sheet is placed on top of the thin paper, and the ensemble is run through the press.

▶ **Alternative direct print method.** Gluing on the inked plate. The water-based glue used for chine-collé can make very thin papers (20 gsm and below) wet, fragile, easy to tear, and difficult to handle and position accurately. With thin papers covering large plates, the gluing should be done after the dry chine-collé paper has been positioned on top of the inked plate to facilitate the handling of the thin paper. Again, place a dampened backing sheet on top of the thin paper, and run the ensemble through the press.

▶ **Pre-pasted method.** Another method is to apply paste on the back of the trimmed thin paper and then allow it to dry. When ready to print, place the thin paper on the inked plate, glue-side up, and mist the paper with water to reactivate the dried glue before laying the dampened backing sheet on top and running the ensemble through the press. This is a good method when doing large-format chine-collé, because it is far easier to handle a large sheet of thin paper when it is dry rather than wet. (Although you will avoid tearing the paper, some curling may occur.) Another advantage of pre-pasting is that you can store pre-pasted paper indefinitely. There are two disadvantages: Because the paper is trimmed dry, you must take into account how the paper will expand when it is dampened before printing. Also, the pre-pasted paper will curl when drying.

MATERIALS FOR CHINE-COLLÉ

Chine-collé requires the following materials:

- ▶ Thin Japanese papers such as Gampi or colored rice papers
- ▶ Heavier paper for the backing sheet (BFK Rives, Somerset, Arches Cover, Fabriano, etc.)
- ▶ Methyl cellulose paste or wheat paste glue
- ▶ Wide, soft brush for applying the glue
- ▶ Mister or spray bottle for misting the thin chine-collé paper
- ▶ Water tray for dampening the backing paper

Francisco Feliciano, *River Oats*, 2009, etching aquatint with chine-collé (Echizen Shikibu Gampi-shi deep tan paper 17–18 gsm and Arches Cover white 250 gsm support paper), image 18 x 12 inches (45.7 x 30.5 cm), support paper 30 x 22 inches (76.2 x 55.9 cm). Courtesy of the artist.

Francisco Feliciano, *Mallow Seed Pods*, 2011, etching with chine-collé (Echizen Shikibu Gampi-shi tan paper 17–18 gsm and Arches Cover 250 gsm support paper), image 12 x 18 inches (30.5 x 45.7 cm), support paper 22 x 30 inches (55.9 x 76.2 cm). Courtesy of the artist.

In the demonstration here, Francisco Feliciano assisted Patricia Acero in printing her sugar lift plate with a single chine-collé paper.

Chine-Collé Using a Single Thin Paper

1. After choosing a chine-collé rice paper, Feliciano trimmed it so that it was half an inch larger than the etching plate all around. To trim it, he wet the edges of the paper with a brush dipped in water to facilitate the tearing of the paper and to preserve the rice paper's characteristic deckle edges.

2. Then he brushed methyl cellulose glue onto the chine-collé paper.

3. Next, he placed the chine-collé paper on the inked plate, glue-side up.

4. Next, Feliciano placed a dampened sheet of backing paper on top, and ran the plate and papers through the press.

5. After the print was pulled, Patricia Acero used a paper towel to smooth the deckle edges of the rice paper to make it adhere better to the support paper. The final print is shown opposite.

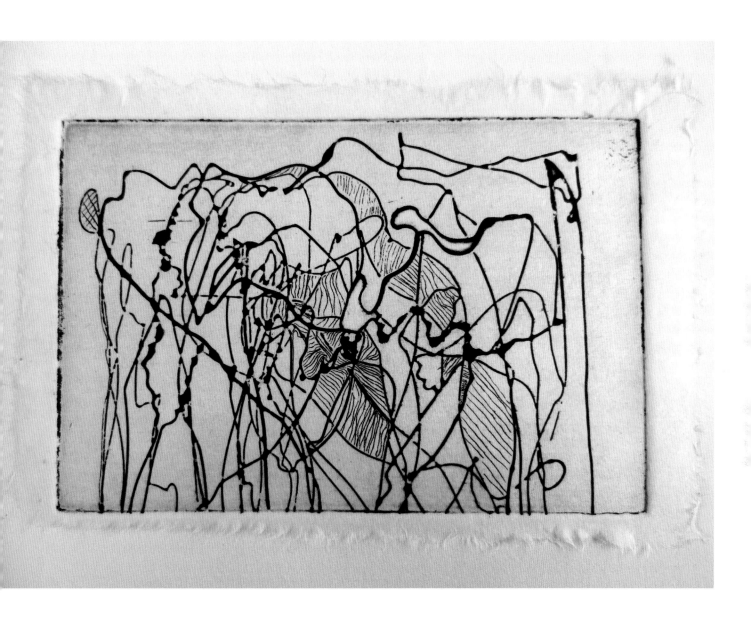

Patricia Acero, Untitled, 2014, sugar lift etching with
chine-collé (Echizen Shikibu Gampi-shi light paper 17–18 gsm,
7 x 9 inches, and Arches Cover cream 250 gsm support paper),
image 6 x 8 inches (15.2 x 20.3 cm), support 13 x 15 inches
(33 x 38.1 cm), printed in collaboration with Francisco Feliciano.
Courtesy of the artists.

In this demonstration, Feliciano fuses two chine-collé papers to the support paper.

Chine-Collé Using Two Thin Papers

1 After etching the aquatinted copper plate, Feliciano chose two chine-collé papers: a Japanese Gampi paper to receive the image and a Kitakata paper to create a "frame" around the image. (He liked the Gampi paper because of its refined texture and delicate ochre color and the Kitakata because of its antique tint and deckle edge.) The photo shows the assembled materials: the etched plate, inks, a mister, a brush, and the papers, including the Arches Cover he would use for the support. The support paper was soaked for 20 minutes prior to printing.

2 Using a blade, Feliciano trimmed the Gampi paper to the size of the plate (shown). He wet the edges of the Kitakata paper with a brush, then tore them to keep the deckle. The size of the second paper was half an inch larger, all around, to create a "paper frame" around the image, inside the margins of the backing sheet.

3 He then inked the copper plate, first with black and then, after wiping, with other colors in some areas, blending them à la poupée. The photo shows the inked plate.

4 After misting the Gampi paper with a light spray of water, he used a soft, wide brush to apply wheat-paste glue to it with the inked plate positioned underneath, then placed the plate with the Gampi paper on it on the bed of the press. He then applied glue to the Kitakata paper, as shown in the photo. This heavier paper, larger than the plate, is easier to lay down wet on the plate than is thinner Gampi paper, especially when it has been cut exactly to the size of the plate.

5 The glue-coated Kitakata paper was placed on top of the Gampi paper, followed by the Arches Cover support paper. Feliciano ran the ensemble through the press and then lifted the print from the plate, as shown. All three papers were now bonded together. The final print is shown opposite, bottom right.

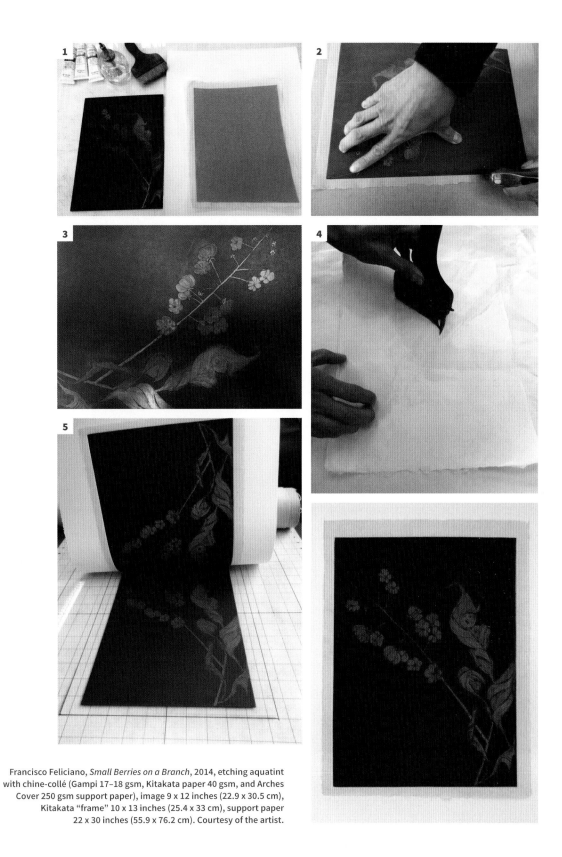

Francisco Feliciano, *Small Berries on a Branch*, 2014, etching aquatint with chine-collé (Gampi 17–18 gsm, Kitakata paper 40 gsm, and Arches Cover 250 gsm support paper), image 9 x 12 inches (22.9 x 30.5 cm), Kitakata "frame" 10 x 13 inches (25.4 x 33 cm), support paper 22 x 30 inches (55.9 x 76.2 cm). Courtesy of the artist.

Yet another method of doing chine-collé is to cut shapes of colored paper and sandwich them between a thin, translucent Gampi paper and the backing sheet. The colored shapes will show through, giving the work a delicately toned effect. The demonstration here gives some of the steps Francisco Feliciano followed when creating his print *Silver Dollars*.

Chine-Collé with Cutout Shapes

1 Feliciano etched and inked a copper plate with rounded leaf shapes. He cut matching shapes from a deep orange Moriki Kozo paper.

2 Next, Feliciano placed a sheet of Echizen Shikibu Gampi-shi paper, cut to the size of the image, on the inked plate, and applied paste on top, before laying the cut shapes of orange Kozo paper precisely on the matching etched areas of the plate. The top of each orange shape was also brushed with paste.

3 Feliciano then laid a sheet of Arches Cover on top and printed the sandwiched chine-collé papers, achieving the muted-color composition shown opposite.

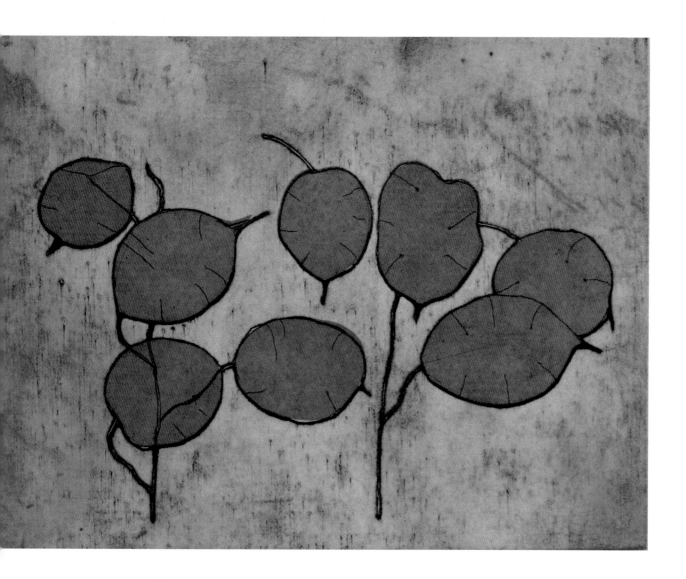

Francisco Feliciano, *Silver Dollars*, 2010, etching with chine-collé
(Moriki deep orange Kozo 40 gsm and Echizen Shikibu Gampi-shi
17–18 gsm papers), image 9 x 12 inches (22.9 x 30.5 cm), support
paper 22 x 30 inches (55.9 x 76.2 cm). Courtesy of the artist.

The very delicate, translucent, tissue-thin Japanese Gampi paper enhances the play of light, giving his chine-collé prints their own inner illumination.

Francisco Feliciano is intrigued and visually excited by plant forms and dying nature, whether dried roses or seed pods, dried wildflowers bought from a market, a fallen branch, dried hydrangeas in winter, fields of golden river oats along the Hudson River at the end of summer, or a graveyard of sunflower heads. Feliciano feels that living flowers all look alike, but they gain individual personalities, becoming unique beings, as they die.

Feliciano sees art as a release from mundane everyday life. When drawing and preparing a plate, time ceases to exist for him, and he experiences a quiet, Zen-like feeling. A dialogue occurs between him and his subject as he waits and wonders what surprise the finished plate and image will present him with.

After years of working in lithography, Feliciano now prefers the sculptural feel of intaglio, with the raised inked lines adding a third dimension to the paper. To capture the light emanating from within, he uses the chine-collé method almost exclusively, preferring to print on fine Japanese Gampi paper and sometimes on silk. The delicacy of these mediums allows him to capture much finer detail than would be possible on regular printing paper, and the variety of colors of the Japanese papers gives him a wider palette with which to express himself. In addition, the very delicate, translucent, tissue-thin Japanese Gampi paper enhances the play of light, giving his chine-collé prints their own inner illumination.

About his method, Feliciano says, "The paper's weight is very important for chine-collé. For example, with Moriki, Yatsuo, and Kitakata papers that fall in the 45–30 gsm range, the glue can be applied while the paper is on a table, and then the glue-coated chine-collé paper can be positioned on the plate. Paper below 20 gsm, however, needs to be placed dry on the inked plate, misted with water, and then coated with glue.

"I use an orchid mister and spritz over the Gampi. The tiny rivulets of water landing on the paper are sufficient to allow the Gampi paper to relax and stick to the plate. I apply the methyl cellulose glue with a wide hake brush, starting from the center and working my way out. It is very important to work the glue into the paper and remove all excess for a successful chine-collé print.

"I avoid working with 11 gsm paper for chine-collé because the lightness of this paper causes it to buckle and tear."

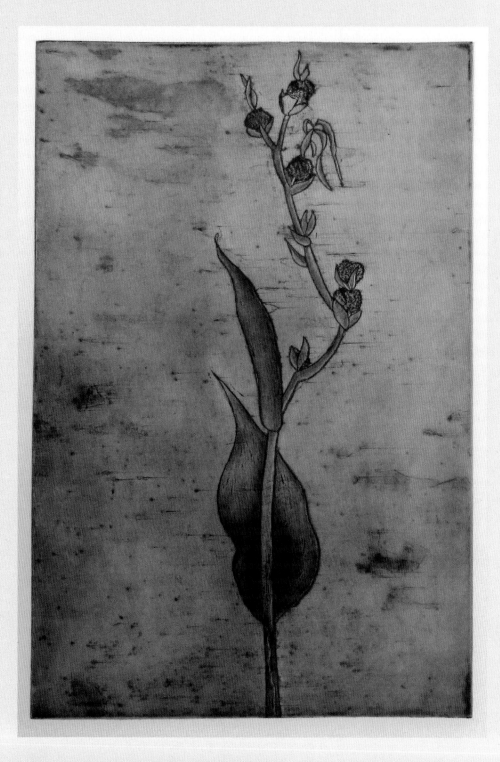

Francisco Feliciano, *Canna*, 2015, etching with chine-collé (Echizen Shikibu Gampi-shi tan paper), image 18 x 12 inches (45.7 x 30.5 cm), on Arches Cover white 30 x 22 inches (76.2 x 55.9 cm). Courtesy of the artist.

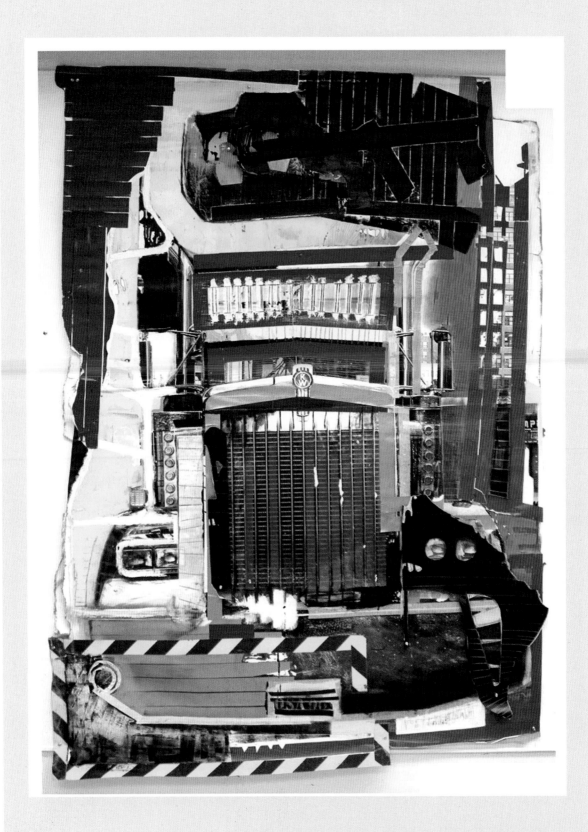

Mixed Media

In the visual arts, the term *mixed media* refers to artworks in which more than one medium has been employed: painting, collage, ink drawing, traditional or digital print-making techniques, and so on. Mixed media works are done on a variety of substrate surfaces and can be two-dimensional or three-dimensional.

Marcin Wlodarczyk, *The Truck*, 2010, mixed-media print, 96 x 40 inches (243.8 x 101.6 cm). Courtesy of the artist.

Because every artist working in mixed media uses different materials and techniques, there is no way to summarize the mixed-media approach to making art. Therefore, this chapter looks at six mixed-media printmakers—Richard Pitts, Jase Clark, Slavko Djuric, Shelley Thorstensen, Janet Millstein, and Marcin Wlodarczyk—and the techniques used by each to create highly inventive works of art.

Richard Pitts

For the project described here—a large installation work entitled *Totems*—Richard Pitts approached the task as a traditional woodblock relief printmaker. But the work went beyond ordinary woodcut because he mounted his prints on a series of square wooden columns to create three-dimensional montages that combine printmaking with sculpture. Most of the time, Pitts printed the designs for all four sides of each totem before mounting them on wooden planks and assembling the columns, but on occasion he mounted the prints directly on columns he had already constructed. The step-by-step here provides a look at his mixed-media process.

1 The very long woodcuts for *Totems* were printed from carved pine planks. First, Pitts painted the pine planks with abstract motifs using India ink. He then carved out the unpainted areas with woodcarving tools, as shown.

2 Pitts inked the carved boards on the bed of the press. Because the boards were 8 feet long—much longer than the bed of the press—inking and printing occurred in consecutive stages, section by section.

3 The carved pine boards were sometimes printed on canvas and sometimes on Fabriano paper in different colors. Here, Pitts is printing on canvas. After each carved board was fully printed, Pitts placed a new, blank board beside it and carefully lifted the print from the carved board and placed on the new board for mounting.

4 The printed canvas was then laminated onto the blank pine board.

5 The photo shows Pitts pulling a print made on a canvas that he had colored by hand before printing. After making all the prints and gluing them to boards, Pitts nailed the boards onto four-sided posts. (Sometimes he glued prints directly onto pre-constructed four-sided posts.) In the resulting "totems," the relief prints emerge as a sculpture. A view of the Totems installation appears opposite, bottom.

Photos in this series courtesy of Richard Pitts.

Richard Pitts, *Totems* installation in the rotunda at the Larkin Center, Yonkers, New York, on view from 2014 to 2016. Courtesy of the artist.

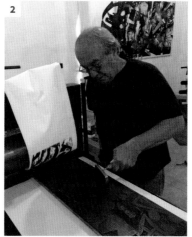

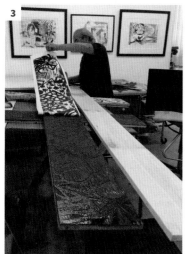

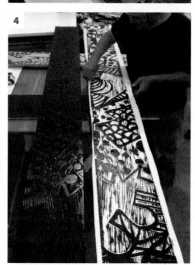

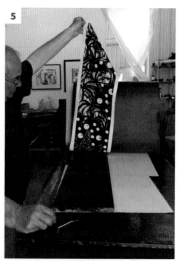

A noted painter and sculptor, Richard Pitts has also produced a tremendous number of prints in all mediums, including numerous three-dimensional assemblages of relief prints mounted on wood.

In the introductory essay "Material States: Collage Memoirs of Richard Pitts," from Pitts's 2013 book *Fragmented Memories*, New York City critic and curator Jill Conner writes:

PRINTMAKER PROFILE: **Richard Pitts**
richardpitts.com

"My art is about the imagination expanding emotional experiences that increase the capacity for feeling a full life."

Richard Pitts began as a figurative artist who explored standard motifs such as landscapes and the traditional nude figure as interpreted through figure-life drawing classes that involved the live model posing at the center of the studio. Pitts was part of the New York School that emerged in the 1950s as America's avant-garde. The New York School grew from the performative nature of Abstract Expressionism, as practiced by Jackson Pollock and Willem de Kooning, and also consisted of poets, musicians and dancers who sought to embrace freedom in their work as the new symbol of Postwar Modern art.

When he was a teenager, Pitts worked for a local newspaper and was fascinated with the hot-type technology in the composing room. The relief-printing process of taking an image from the drawing board to the printed newspaper made a lasting impression. Proofreading galleys and proofing imagery for advertisements impressed him as artistic processes with unlimited potential. He connected to printmaking as a creative process, and to this day he sees printmaking as a medium for spontaneous artistic development, not just a reproductive process. The artists who influenced him most were printmakers as well as painters, from Rembrandt to Picasso. Matisse's transition from the famous cutouts to screen-printed images was also an inspiration, as was Rauschenberg's work with photo processing and image transfer, combining the printmaking process with three-dimensional structures and opening up the whole definition of what printmaking can be.

As a painter, sculptor, and printmaker, Pitts approaches his work as a visual language. This untranslatable language is capable of unlocking experiences and creating knowledge in the same way that poetry unlocks new experiences. Art, like the language of mathematics, expands our experience of the universe and opens us to a fuller life. His relief prints are very direct, cut from pine boards (often as long as 8 feet) and printed on paper or canvas. The bold print is then applied to a three-dimensional support. Wanting to transcend the print, giving it a physical presence, Pitts says, "My art is about the imagination expanding emotional experiences that increase the capacity for feeling a full life."

Discussing his process, he says, "My printmaking today combines the relief print with a stenciling technique and collage processes. These relief prints are printed from an eight-by-ten-by-one-inch white pine board. I paint the abstract motif with India ink on the board. I then cut out all the unpainted areas on the board, leaving the black motif intact and ready for printing. I use both sides of the board. I use canvas and Fabriano paper to print on. The canvas is prepared with an underpainting of different colors. When printed on with black oil-based relief ink, it appears to have a stained-glass-window effect. When the print is dry, I then mount it directly onto a wood plank from the same wood as the woodcut. If there is any overlap, I trim the print with an X-Acto knife so that it fits exactly to the side of the post. After doing this four times, I have a totem-like three-dimensional print."

Richard Pitts, *Mother Goose*,
2013, relief-printed assemblage,
36 x 30 x 30 inches
(91.4 x 76.2 x 76.2 cm).
Courtesy of the artist.

Richard Pitts, *173aa*, 2012,
color relief assemblage,
45 x 30 x 12 inches
(114.3 x 76.2 x 30.5 cm).
Courtesy of the artist.

Jase Clark

Artist Jase Clark creates complex and subtle compositions, adding layer after layer of various mediums. The steps here provide a look at the process he followed when creating the work *Myr-i-ad*, using etching, serigraphy, and watercolor monoprint.

1 First, Clark drew the central image and etched it on a zinc plate. After proofing the etching a number of times, he printed a two-color serigraph around the outside edge of the paper, giving it an aged look. In the next step, he sprayed monoprints from hand-cut stencils onto it using compressed air, hand-pumped air, and various inks applied as watercolor, with different transparencies and different sheens of matte or gloss. The photo shows the image at an intermediate stage, after many layers of monoprint have been built up but before the artist has printed the next layer of hand-cut masking overlays.

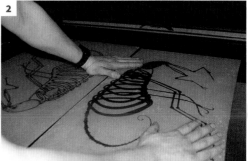

2 Next, Clark cut large shapes that had been saved from earlier works and silkscreened them on the print. The photo shows him placing transparent laser images on a screen coated with light-sensitive emulsion.

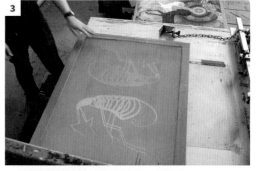

3 After exposure, the screen was washed to ready it for printing. Here, Clark is preparing the screen on the vacuum table.

4 After printing, Clark pulled the print off the vacuum table (shown) and then placed the next print under the screen. The final print, shown opposite, conveys the sense that any image from this series of prints can float through or onto this new, well-composed image, giving the work a planned but also random appearance.

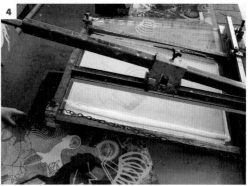

Photos in this series courtesy of Jase Clark.

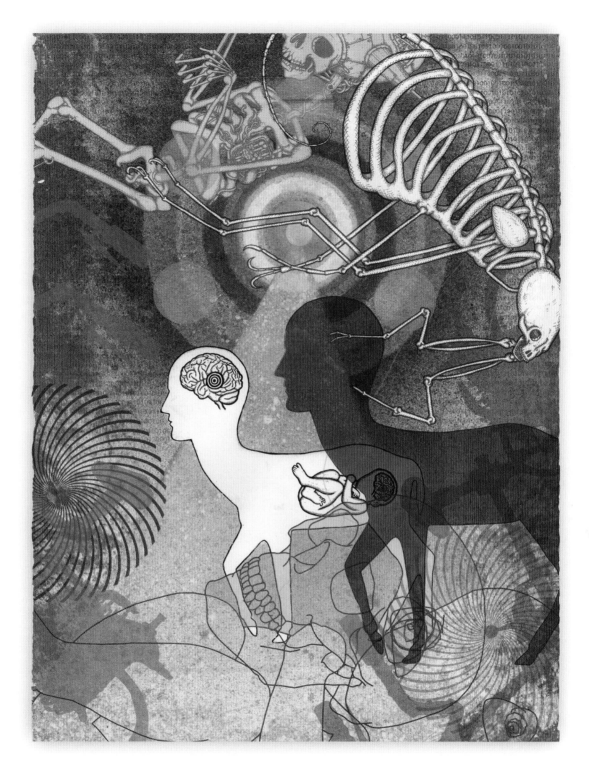

Jase Clark, *Myr-i-ad*, 2013, mixed-media print with etching,
stenciled watercolor monoprint, and serigraphy, 30 x 22 inches
(76.2 x 55.9 cm), courtesy of the artist.

PRINTMAKER PROFILE: Jase Clark

JaseClark.com

"I see the age-old question 'What is the imagination, and where does it come from?' as underlying every work I make."

Jase Clark is interested in exploring the duality and structure of human existence. On the one hand, he sees the veiled life we lead under various restraints imposed by society and the cloud of consumerism. On the other, he feels an underlying interconnectedness existing between each of us as humans and in the universe with its intrinsic beauty and complexity. These ideas manifest themselves through various visual forms and images, some complex and some simple everyday icons. Through the repetition of imagery, he explores the depth and understanding of an image in its endless incarnations and also produces a physical manifestation of the infinite possibilities of our multidimensional reality.

Clark does not attempt to take any particular side or express any one specific belief. He wants to create a glimpse into a world that has multiple layers—one where reality is beyond reality and yet still visible. He seeks to express a fascination with everything in our universe.

Reading and listening to many progressive thinkers who are dealing with major issues in life, Clark finds that his greatest artistic inspiration comes more from philosophers and scholars addressing various topics—from both modern-day and ancient philosophies—rather than from other artists. He aims at creating visual depictions of personal understandings about our physical and metaphysical reality, always in a constant state

of change. He views the use of printmaking as a metaphor for his approach to making art. For Clark, printmaking deals with order, structure, time, and problem solving, but also with chance happenings—much like our existence as humans. By taking an idea and bringing it to life by translating it into a physical form Clark begins his journey of understanding an image. He says, "I see the age-old question 'What is the imagination, and where does it come from?' as underlying every work I make. Everything I create is unique to me because it was produced using the filter of my own imagination and my own perceived reality."

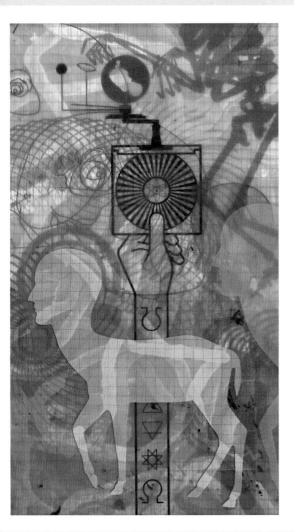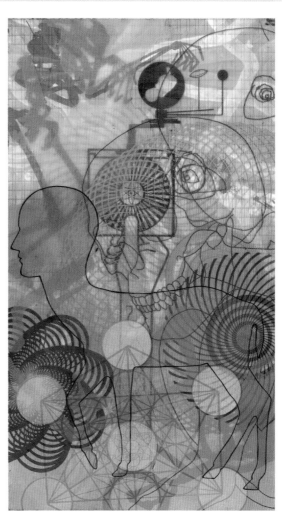

Jase Clark, *Dis-am-big-u-ate*, 2011–2013, serigraph, Plexiglas,
26 x 14 inches (66 x 35.6 cm). Courtesy of the artist.

Slavko Djuric

In 2014, artist Slavko Djuric created a mixed-media book, entitled *In Debpths*, that consists of eighty-four prints made using relief, linogravure (in which the linoleum is etched as well as cut), and Pronto polyester plate lithography. About this work, Djuric says, "I've been experimenting even more, trying to make my prints overcome themselves in a process of almost becoming installations. I've been cutting them out free of the background, building paper objects, binding them into books. For this book named *In Debpths*, I chose to work on a large scale and to end up with something collapsible with dimensions varying from a huge wall installation to a (deep) pocket-size book. Another big idea that recently came to me is about merging already familiar techniques and materials. The faces I drew are not actual portraits but rather genuine expressions of human-animal state of mind. They were then printed in darker hues of blue, brown, and black over already existing linocuts. This is how I got these final-edition variable mixed-media prints that ended up in the book, with some minor corrections.

"To actually bind them together in this book, I obviously needed to do some editing: I firstly cut down the total number of 140 prints to 84, then neatly trimmed them down to the same size and finally figured out how to lay them out. Putting the book together was not easy, but once I was done with gluing, making covers and a slipcase, there it was: two sister books with forty-two prints each, all organized in three accordion rows. They open up in a wall installation that is over eight feet wide and five feet tall."

Slavko Djuric, *In Debpths*, 2014, mixed media (twin books of 42 prints each), measuring 8 x 5 feet (2.43 x 1.52 m) when unfolded. Courtesy of the artist.

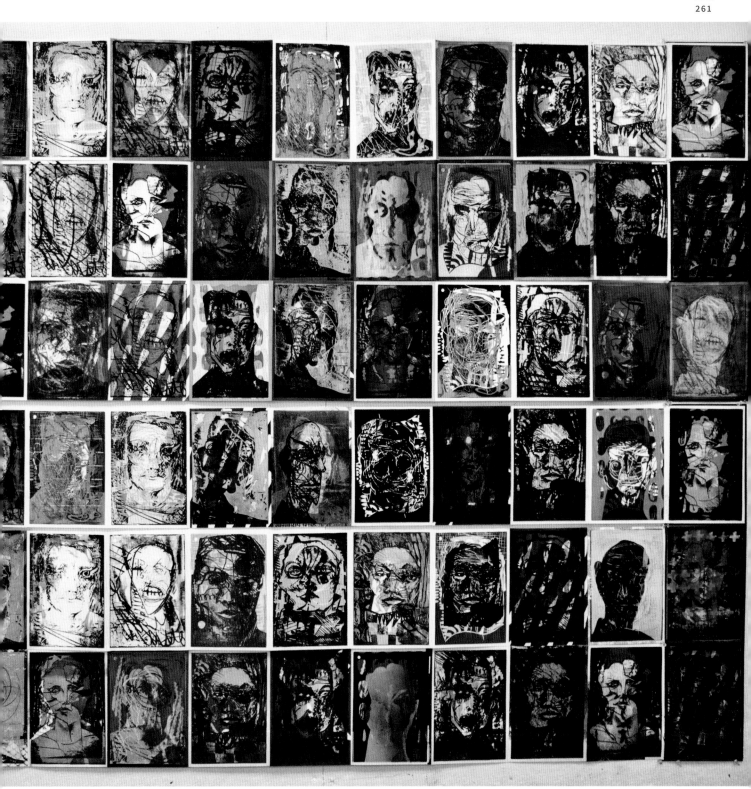

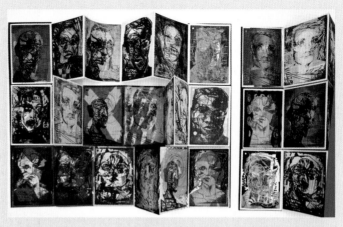

Assembling the prints for
In Debpths.

PRINTMAKER PROFILE: **Slavko Djuric**
slavkodjuric.com

"I'm a romantic and a meliorist, a crusader who believes the world can be made better by human effort, and a workaholic who simply believes in Good."

Slavko Djuric quotes Paul Klee: "It is convenient to have the right to be chaos to start with." Djuric feels that endless invisible possibilities already exist in the emptiness at the beginning of the artistic process. He often finds himself staring at a blank paper or screen, starting to recognize shades and shapes, reflecting on his thoughts and ideas. Djuric does not create chaos; he embraces it and chisels from it, sometimes starting from an accidental stain, a paper texture, or some other given or unintended stroke or shape. He is intuitive and spontaneous, not afraid of making mistakes but instead making them work for him. Using his experience and knowledge, he lets the game guide him, not always being certain about how exactly the final image will look. As a result, most of his images end up being multilayered and somewhat lyrical and oneiric but also bold and robust. Whether working on a portrait, a landscape, or both merged together, Djuric likes to save the natural dualism that exists inside of the image. He looks for something that opposes the image itself, something that fights against its content and fulfills it at the same time. He puts a question mark on what we see and how we see it. One could say he is a figurative artist driven by the unseen, by the expressiveness and passion that hides beneath the surface of every random subject he chooses.

Djuric strongly believes in the idea of progress coming from confrontation, and he salutes each new concept in art. Never able to blindly follow one particular art movement, he refers to many. He thinks of his work as an embryo that eventually develops into a beautiful human being. He says his work is about "growth, from chaos through the forest of symbols, emotions and thoughts, to an adult piece of art that belongs to the moment we live yet is universal." And about himself, he says, "I'm a romantic and a meliorist, a crusader who believes the world can be made better by human effort, and a workaholic who simply believes in Good."

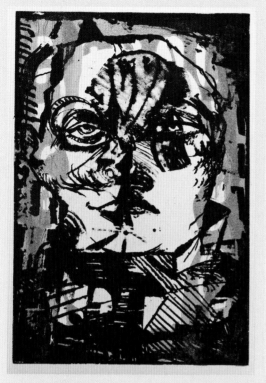

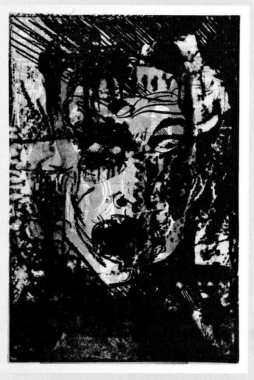

Pronto polyester plate print in multiple colors (with plate), from *In Debpths*.

A portrait with three-color background, from *In Debpths*.

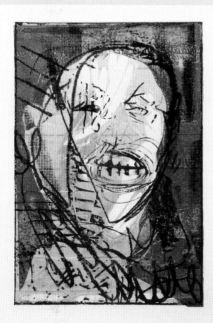

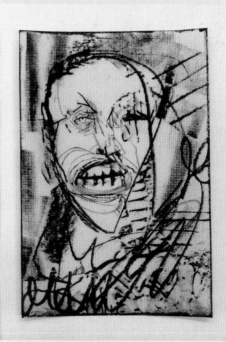

A portrait with two-color background, from *In Debpths*.
All photos in this group courtesy of Slavko Djuric.

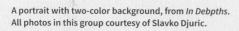

Shelley Thorstensen

Artist Shelley Thorstensen combines several printmaking techniques in one print, because for her each technique—intaglio, lithography, and silkscreen—has a specific strength. Here is how she describes her 2013 print *On Any Given Day*, which is a combination of etching, engraving, spit bite aquatint, mezzotint, and relief with chine-collé: "*On Any Given Day* came over time from dreams and observed forms. I can explain the function of the parts in relation to their service. This print presents a scope, or slice, of possibilities. On any given day, we don't know what will happen. On any given day, we can guesstimate circumstances if things remain relatively stable in our universe. Odds are even. On any given day, 'any team can win.'" Some process images from the creation of *On Any Given Day* appear here.

1 Thorstensen started by proofing a spit bite aquatint and etching-engraving over a textured background printed from a surface roll and relief plates. The photo shows a close-up area of the textured background with part of the spit bite aquatint proof.

2 She then created six mezzotint plates with various designs. Here is a proof of one of the mezzotint plates.

3 As she worked on the print, Thorstensen posted notes about her process.

4 Spit bite plates and mezzotints plates were proofed with Sekishu chine-collé paper. She then mounted the chine-collé paper, on which various elements had been printed, on BFK Rives paper. The final print is shown opposite.

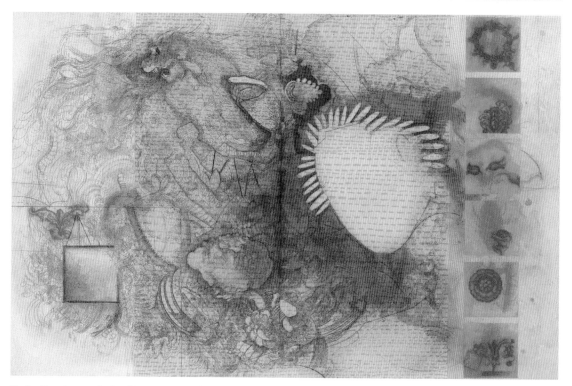

Shelley Thorstensen, *On Any Given Day*, 2013, mixed print mediums (etching, engraving, spit bite aquatint, mezzotint, relief) with chine-collé, 36 x 24 inches (91.4 x 61 cm). Courtesy of Dolan/Maxwell gallery.

"We are relaters of information."

Shelley Thorstensen sees her work as a direct expression of consciousness, as in a feedback loop where the bilateral symmetry of plate to print directly reflects her body, her imprint. She sees it as a psychological means to literally face herself while making work. She feels that while working on a plate, one stands behind yet in front of oneself, as if unmediated, and that this phenomenon occurs throughout the processes intrinsic to the medium: in the conceiving, the making, and the reflecting. Thorstensen is consistently and continually intrigued by what this process offers emotionally and aesthetically. She works from her dreams. In dreams, she watches objects and characters in developing situations. As if using some kind of stop-action feature, she can hone in on the feel and features of a figure and the complicated dream-space environment. Characters make cameos over a number of nights; dreams pick up where they left off. Later, she quickly draws diagrams of her dreams.

She uses all printmaking mediums equally, depending on what she is trying to attain. What once was the domain of a medium—the mark made on a matrix delivered in an imperceptibly seamless manner just below our visual threshold for recognition of duplicity and duplicate—is now only one possible outcome. About the layering that is so important to her work, Thorstensen says, "We speak the language not only of the separate and specifically non-linked nature of shape, color, contrast, saturation, placement, texture, and form, but of whatever we dub the margins of content, each with seemingly endless permutations. We now layer everywhere—in fashion, in furnishings, in meaning, in what we call Photoshop, and in what we call printmaking. We are relaters of information."

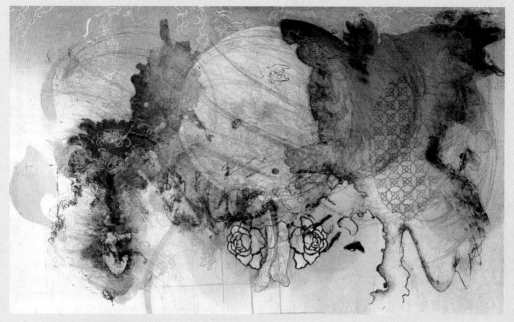

Shelley Thorstensen, *Rhyme and Reason*, 2013, etching,
lithograph, and silkscreen, 36 x 24 inches (91.4 x 61 cm).
Courtesy of Dolan/Maxwell gallery.

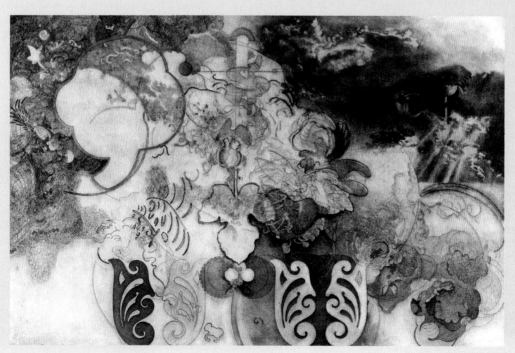

Shelley Thorstensen, *Forgiving Nature*, 2010, full scan, etching,
aquatint, and mezzotint, 36 x 24 inches (91.4 x 61 cm). Courtesy
of Dolan/Maxwell gallery.

Janet Millstein

Janet Millstein is an artist and professional graphic designer who frequently mixes different mediums. In the print shown at right, she did a pigment transfer on BFK Rives paper before monoprinting from Plexiglas painted with etching and litho inks.

For her print *View from Above*, Millstein mixed monoprint with color-separated Pronto polyester plates to create a full-color print with painterly effects. Some of the steps in her process are given below.

1 First, Millstein taped a digital aerial photograph on the back of a Plexiglas sheet to serve as a painting guide. She mixed oil-based inks to provide color enhancements and painted them on the Plexiglas.

2 She proofed the yellow and magenta polyester plates on BFK Rives paper and added some color enhancements printed from ink painted on the Plexiglas.

3 She then removed the photograph from the back of the Plexiglas to inspect the painted colors and then printed the Plexiglas plate on a sheet of paper using an etching press. The four color-separated polyester plates were then printed on the monoprint. The final print, shown at right, has a painterly quality.

Photos in this series courtesy of Janet Millstein.

Janet Millstein, *View from Above*, 2012, monoprint and four-color polyester plate lithograph, 12 x 12 inches (30.5 x 30.5 cm). Courtesy of the artist.

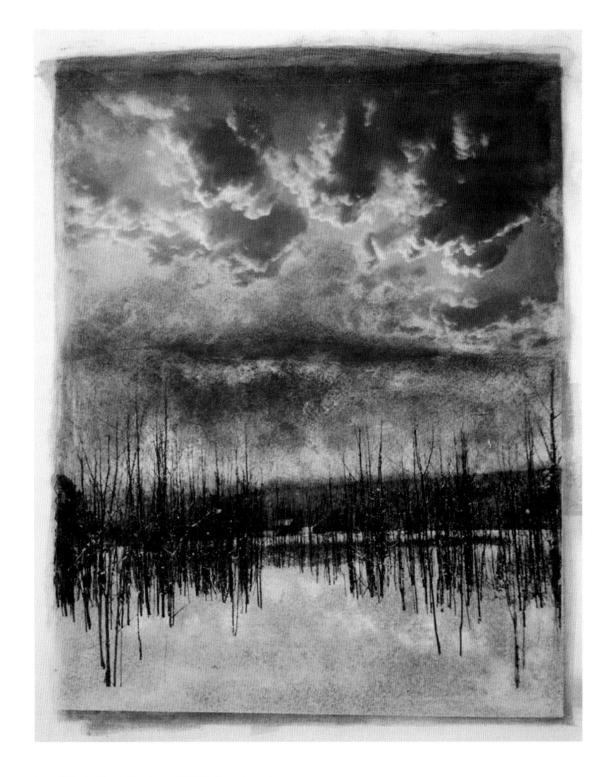

Janet Millstein, *Clouded Landscape #2*, 2012, pigment transfer
and monoprint, 16 x 20 inches (40.6 x 50.8 cm). Courtesy of
the artist.

Some of Janet Millstein's prints appeared in the 2010 Females on the Fringe show at the Corscaden Barn, in Keene Valley, New York. In a review of that show in *The Free George* online magazine, Monica Sirignano wrote:

In Janet Millstein's photolithography, we're presented with rich, haunting images of Americana. Scenes that we've come to view as typical are transformed here

Millstein, a graphic designer by trade, makes art by merging photography with digital and traditional printmaking techniques. She is drawn to landscapes, with or without human influence or structures. The wild, dark beauty of the Adirondack Mountains, where she has a home, is a constant source of inspiration. A fleeting glimpse of a decaying barn or a ray of light in the woods is transformed

PRINTMAKER PROFILE: **Janet Millstein**
janetmillstein.com

"I love the process and I love the sense of expectation as a print is revealed."

through the use of photography, digital rendering and traditional printmaking, into vivid, ethereal works that captivate the viewer with their intense beauty and use of dark, rich colors.

It is this color choice, along with skillful illumination techniques, that allows Millstein to shroud her viewers in this sense of otherworldliness and times past, but it's the images themselves that keep the viewer grounded. For captured here are scenes that have become part of our everyday existence—images of a church, a man in a tractor, a barn, to name just a few. These "ordinary" settings evoke bonds of familiarity, especially for those who dwell in the Adirondacks, as they may recognize the landscape as a backdrop to much of her work.

into a work on paper. She strives to capture a lingering perception of having been in that place, and she wants the viewer to be drawn in, to imagine having been there, too. This process allows her to play and explore varying layouts, combinations, and themes. She thinks in terms of layers, transparency, color blends, and the way the ink will sit on the paper, but she also appreciates the degree of chance involved in printmaking: "Printmaking requires thinking and planning, yet experimentation and risk are also integral to the process," she says. "I love the process and I love the sense of expectation as a print is revealed."

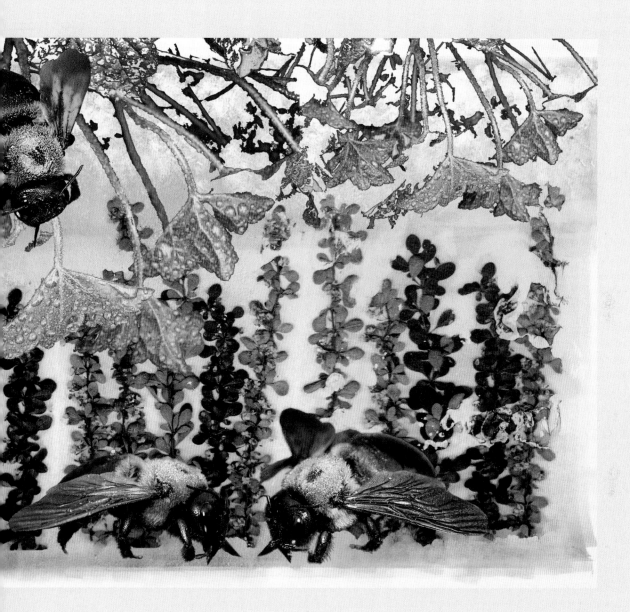

Janet Millstein, *Barberry Bees*, 2013, monoprint and transfer,
22 x 30 inches (55.9 x 76.2 cm). Courtesy of the artist.

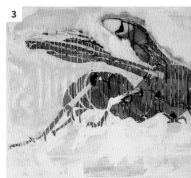

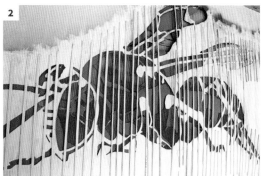

Photos in this series courtesy of Marcin Wlodarczyk.

Marcin Wlodarczyk

Artist Marcin Wlodarczyk works on impulse, printing from Plexiglas and various other inked surfaces, adding stencils, transfers, and colored tape to his images, and tearing layers and folding areas to achieve sculptural prints with a 3-D effect. Here is a look at Wlodarczyk's process when creating his work *Grasshopper*.

1 To begin with, Wlodarczyk drew an image of a bee with ink on paper laid on the press bed. He then placed a second sheet on top, ran the ensemble through the press, and lifted a print from the original ink drawing.

2 He then cut a stencil following his print shape and placed it on top of cut colored papers. He glued strips of mat board to the back of the stencil.

3 The top of this image shows the stencil with tan paper and black ink underneath. Wlodarczyk monoprinted several colors through the first stencil. He then cut more stencils and monoprinted them in layers, adding strips of black tape.

4 One version of the finished bee is shown in this photo. Wlodarczyk works intuitively, without planning, and makes multiple versions from one concept. He adds tape strips as an integral part of his work. The bottom of the image shows another version of the work, with colored ink and black tape.

5 Wlodarczyk constantly mixes different prints together. His insect images morph into new insects and merge in different compositions. He assembles prints, folds them, and mounts them on a board, creating a background with colored papers and strips of colored tape. The completed 3-D mixed-media work is shown opposite.

Marcin Wlodarczyk, *Grasshopper*, 2014, mixed-media print, 36 x 27 inches (91.4 x 68.6 cm). The artist has chosen to show the work with a smaller frame laid on top of the print. Courtesy of the artist.

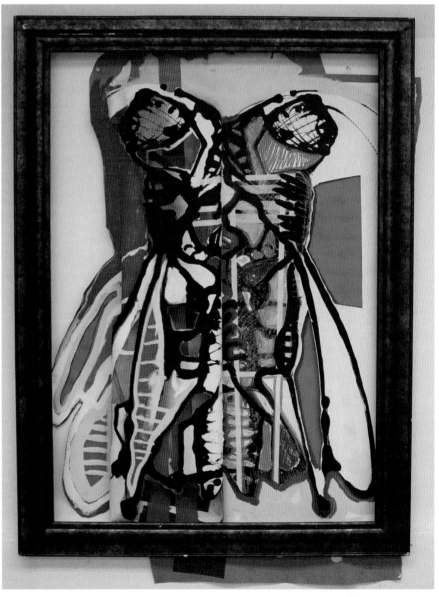

Marcin Wlodarczyk sees himself as a painter first, but he likes the process of printmaking. Working in large format, Wlodarczyk starts with one printing process, such as relief, etching, or transfer, and then adds multiple layers of colored masking tape and collage to the printed images, creating a variety of textures. He gets satisfaction from this layering because it is like painting.

PRINTMAKER PROFILE: Marcin Wlodarczyk
marcinmarcin.com

"It is a challenge to find yourself in society, but I now realize it is possible to express yourself and to find your own way in the art world."

ink onto a surface becomes almost meditative as he indulges in the beauty of the moment, redirecting the image and hoping to transform the concept into a new idea.

Wlodarczyk works impulsively, from gut feeling, and his imagery is a flow from subject to non-subject. His *Rooster* series of prints—one of which is shown opposite—started from a childhood memory of his grandmother's rooster. The rooster

people viewing the work (below) have seen this design as a cage—as if he were caging the shark. This cage metaphor has grown on him, and he now claims it as his own.

Wlodarczyk says this about the role of the artist: "I ask myself often what makes me an artist, or what makes what I do art. Is being an artist a job? Am I going to teach? I had to make hard choices to keep my personal space, to preserve a freedom of ongoing creation. I think of the future, and I refuse to be boxed in a category. It is a challenge to find yourself in society, but I now realize it is possible to express yourself and to find your own way in the art world."

Wlodarczyk's prints are never "finished" in the ordinary sense of the word; rather, they represent moments in a never-ending, ongoing process. The moment of spontaneity and the realization of this moment in a physical object, as when a plate is scratched or a piece of wood is carved, is a precious, fast-moving experience. Wlodarczyk sees the essence of art in the creative process of building up an image and finally presenting it as the last stage of its journey. The first stroke is deep inside, hidden under another stroke of paint or ink that totally changes the work's direction, making it what it was never meant to be in the first place. The physical aspect of printmaking is, for him, another world in which rolling oily, slow-drying

became a subject, a symbol, the minute it was drawn, but then the image was reworked until the symbol disappeared. The work has no content; it is just the expression of a moment.

While surfing in Costa Rica a few years ago, Wlodarczyk saw a big shark in the ocean. That event triggered a normal fear but also a new awareness of his environment. The shark image became a recurring subject and metaphor in his art, symbolizing a constant search for self-awareness, and a question mark regarding how to survive in this world. As has been mentioned, Wlodarczyk often adds colored masking tape to his printed images, creating a linear, geometrical design, and sometimes the linear composition takes over. Some

Marcin Wlodarczyk, *Bull II*, 2011, mixed-media print,
34 x 32 inches (86.4 x 81.3 cm). Courtesy of the artist.

Marcin Wlodarczyk, *Rooster*, 2013, mixed-media
print, 22 x 30 inches (55.9 x 76.2 cm). Courtesy of
the artist.

Marcin Wlodarczyk, *Dawn Patrol (Shark)*, 2014,
mixed-media print, 34 x 70 inches (86.4 x 177.8 cm).
Courtesy of the artist.

Digital Transfers

Transfer is the technique of lifting an image from one substrate and depositing it on a new surface. Robert Rauschenberg's transfers of newspaper articles and photographs to canvas broke the mold in mixed-media printmaking in the 1960s. The concept of lifting an image or text from a newspaper, thereby transforming current events into fine art, was revolutionary. Many artists since have followed Rauschenberg's lead. Transfers are done manually and are directly printed onto print or canvas, making each transfer unique. A transfer can be repeated, but will never look exactly the same as the previous one.

Sylvie Covey, *Reflection 37*,
2014, pigment transfer,
22 x 30 inches
(55.9 x 76.2 cm).

When artists began doing transfers, they used solvents that were very toxic. Today, transfers are done with safer substances such as Citrus Solv, a liquid household cleaning product, or Citrus Strip, an odorless gel used for paint stripping. (Despite the relative mildness of these products, you should wear protective gloves when using them.)

I often use transfer in my work, and my current digital transfer technique transfers inkjet inks onto a variety of substrates using hand sanitizer, which contains gel alcohol. This is the safest transferring method I have found. Any hand sanitizer with 65% gel alcohol content will work. Using an inkjet printer, I first print the image on an inkjet transparency. (Laser-printed transparencies will not work for this process, because the toner fuses to the transparency and will not release from the support.) Some inkjet film acetates work better than others; I use the classic transfer film sold by dassart.com, an online vendor that sells supplies for digital art mediums. Other brands, such as the transfer film from inkaid.com, also work well. For the transfer to succeed, the paper to which the pigment is transferred must absorb the gel alcohol evenly; smooth printmaking papers such as BFK Rives, Arches 88 silkscreen paper, and Somerset printmaking paper are all suitable. Many papers, including watercolor papers, are unsuitable for this technique.

The transfer method can, by the way, be done with or without a press. A rolling pin used with pressure is sufficient for transferring inkjet pigments.

MATERIALS FOR DIGITAL TRANSFER

Digital transfer requires just a few tools and materials:

❯ Inkjet printer

❯ Inkjet transparencies

❯ Hand sanitizer with 65% alcohol gel

❯ Squeegee for spreading the gel

❯ BFK Rives or other printmaking paper

❯ Etching press or rolling pin

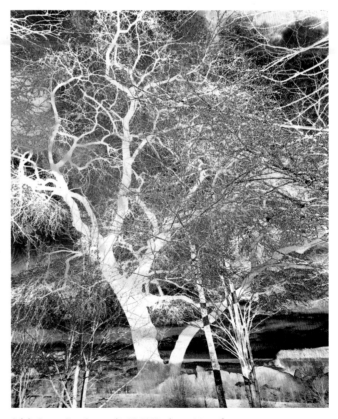

Sylvie Covey, *Tree Composite 25*, 2012, pigment transfer on paper, 22 x 30 inches (55.9 x 76.2 cm).

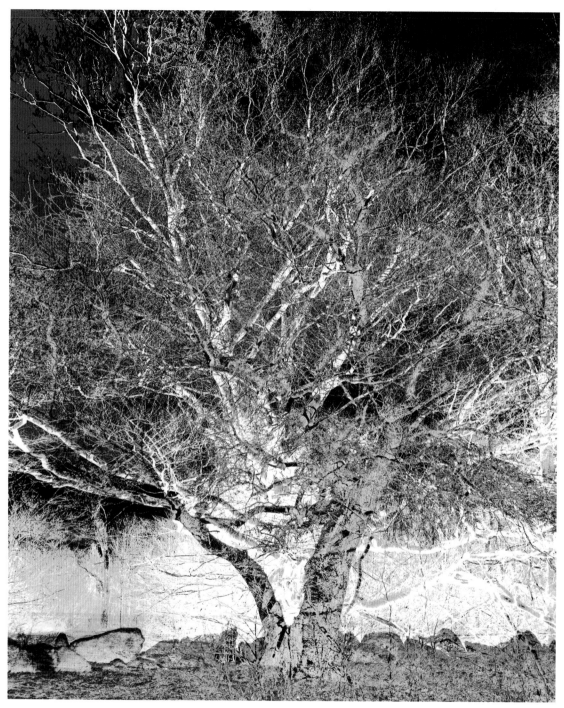

Sylvie Covey, *Tree Composite 27*, 2012, pigment transfer
on paper, 22 x 30 inches (55.9 x 76.2 cm).

The process I followed when making my digital transfer print *Out of This World #3* is given below.

Digital Transfer Process

1 First, I prepared the image on the computer using Photoshop. (Open the image in Photoshop. From the Image menu go to Image Rotation > Flip Horizontal, then to Image > Adjustments > Levels. Adjust the levels by moving the Shadows and Highlights arrows so that the image histogram is nested exactly between the two arrows. Next go to Image > Adjustments > Hue & Saturation; lower the Saturation slider by 10 to 15%. I recommend that you always lower the saturation, because the transfer usually prints darker than the original.) I loaded the inkjet printer with an inkjet transparency, adjusted the image orientation in the Print menu, and printed the image on the transparency. I then trimmed the edges of the transparency to eliminate any margin around the image, as shown in the photo.

2 I laid the transparency on the printing paper, centered it, and made light pencil marks at each corner to indicate where the image would be transferred and to ensure even margins. I then placed the printing paper facedown on the bed of the press and pumped hand sanitizer onto the back of the printmaking paper at regular intervals, as shown.

3 I used a squeegee to spread the gel evenly over the whole surface of the paper. I then flipped the paper over and pumped and spread gel on the front of the paper, as well.

4 When the paper was saturated with just the right amount of gel on both sides, I laid the inkjet transparency pigment-side down on the printing side of the paper, guided by the pencil marks I had made earlier.

5 I ran the transfer through the press under low pressure to avoid wrinkles. I then peeled the transparency off the paper, to which the ink had been transferred. The final print is shown opposite.

Sylvie Covey, *Out of This World #3*, 2014, pigment transfer
on BFK Rives paper, 22 x 30 inches (55.9 x 76.2 cm).

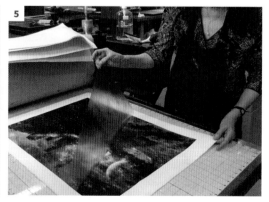

I see printmaking as a continuous learning experience and a physical process. The physical component of printmaking involves a third dimension: Etched plates and lithographic stones become microscopically sculpted surfaces where acids have, in a metaphorical sense, bitten away or enhanced reality. Different metals are bitten in different acids, grounds are made soft or hard, and

PRINTMAKER PROFILE: **Sylvie Covey**
sylviecovey.com

"I search for a world where senses are exhilarated, where altered colors are real, where we are endless and the air, the mountains, and underwater all are one."

stones react to different strengths of acid. The hand tools used to mark the metal or the stone, the crayons, etching needles, burins, roulettes, and scrapers demand both strength and dexterity. The physicality of printmaking is even more pronounced in the printing process. The printer's hand touches this third dimension of an etched plate, which is accentuated by the length of time it sits in the acid. These fine grooves determine how much ink is held and how deeply the dampened paper will emboss. The printing press responds to laws of gravity and compression, muscle and sweat, wise adjustments to the pressure gauge, and careful timing to control the humidity of the paper. When all is done well,

the paper picks up most of the ink on an etched plate or stone. This process is like preparing a superb meal, and there is an absolute high reward in that concentration.

I go after the temporal, vulnerable, and random nature of our being, which I feel is often defined by gender. In a way, I re-create the subject in spatial and multiple fragmentations with the use of multiple exposures, layers, and transparencies. I want to upset the stability of representation by working with constant movement, dissolution, repetition, and multiple layers. It is as if I wish to render representation abstract. As if I were adjusting the focus of a camera, I use different printmaking techniques—etching/aquatint, photo-etching, photolithography, and photogravure. These various mediums offer different grades of sharpness and quality in the printed result. By using aquatint, halftones, or continuous-tone film on zinc, copper, or aluminum plates, I seek to achieve another level of visual plurality. When working with models, I subvert the documentary reality of the photographic image to reveal

different aspects of eroticism that can be read in many ways. I think of eroticism not as a formal aspect of my work but rather as part of the process of seeing and being seen, in order to create a portrayal of the objects of our desires.

I like the freedom of making digital images, with so many options in sizes and support materials and the challenge of learning new visual languages. Through continued explorations in digital photography combined with printmaking, I search for a world where senses are exhilarated, where altered colors are real, where we are endless and the air, the mountains, and underwater all are one. As our dreams and realities constantly feed each other, I want to explore those places where one envisions a world in layers of true and imagined spaces, colors, and dimensions.

Sylvie Covey, *Into the Sea 11*, 2012, digital print on canvas, 30 x 40 inches (76.2 x 101.6 cm).

Sylvie Covey, *Out of This World #20*, 2014, pigment transfer on BFK Rives paper, 22 x 30 inches (55.9 x 76.2 cm).

Post-Digital Graphics

The core of modern printmaking is to improve reproductive means of graphical communication. The use of digital manufacturing techniques in printmaking is revolutionary—but only in a sense. Although artists' adoption of computer numerical control (CNC) tools and related devices has resulted in novel printmaking processes, these processes still conform to enduring printmaking convention, in that the print is produced through physical interaction with a transfer mechanism. For the process described in this chapter, I use the term *post-digital* because it goes beyond just using a computer; and I use the word *graphics* in the chapter's title because techniques like those created by Mike Lyon marry printmaking with drawing and other graphic mediums.

Mike Lyon, *Carrie Robe*, 2013, drawing and watercolor print, 76 x 43 inches (193 x 109.2 cm). Courtesy of the artist.

Mike Lyon has been called a father of post-digital printmaking because of his extraordinary use of digital technologies. He has created large drawings, paintings, and woodblock prints using computer software that he has written or adapted to control machinery, and he has invented or adapted the machinery itself in order to manipulate traditional tools and materials using very unconventional methods. In his own words: "I'm an experimenter, an artist, a scientist, an engineer. My need to make stuff is fulfilled in the studio."

In my opinion, the fact that Lyon writes all of his own software codes demonstrates that he is creating his own matrix and therefore making original prints. The matrix, in this case, is the software code, which opens the world to a new era in which digital drawing is also fine-art printmaking. Giclée or dye-sublimation prints can be produced by an artist or print shop more or less just by hitting the "print" button, but there is no print button in Lyon's studio, and what he is doing is something completely new.

In the catalogue for the 2009 exhibition of Mike Lyon's prints and drawings at the Marianna Kistler Beach Museum of Art in Manhattan, Kansas, senior curator Bill North wrote:

> *Mike Lyon's recent, large-scale prints and drawings are the result of his inventive adaption of digital technology and robotic machinery. The artist's work also testifies to his keen interest in Japanese aesthetics and printmaking techniques. Lyon is not seduced by the bells, whistles, and whiz-bangness of digital technology. Computers and machines are among the many tools in his kit, much like paintbrushes or drawing implements. They are the means by which he seeks to realize his conceptions, by moving directly from his mind to the object.*

In 2002, Lyon successfully married the mediums of photography and woodblock printmaking. He would photograph his model, scan the negative in Photoshop, determine the number of gray levels he wanted, create a layer for each level, and work interactively, reducing the image complexity and adding layers of tones until the image felt optimal and reasonable to carve. (For more on Lyon's CNC woodblock technique, see page 45.) Then, in 2004, Lyon acquired a ShopBot, a CNC tool that is designed for precision cutting, drilling, and carving of wood, metal, plastic, and other materials. The ShopBot works like a plotter that

DRAWINGS OR PRINTS (OR BOTH)?

When looking at Mike Lyon's CNC drawings, you may ask why I also define them as prints. After all, the drawings are produced with drawing tools—pen, pencil, and so on—by moving the tool across paper, although these drawings are precisely repeatable because the path of the tool is controlled programmatically. That makes them like prints, but why are they original prints and not mere reproductions? Because we define an original print as an image printed from an original matrix. Mike Lyon writes his own programs and codes to create his images. The programs and codes therefore are the original matrix, producing drawings that are also original prints.

moves across a surface, along X and Y axes, to create a drawing and can also move a cutter up and down along a Z axis to cut various shapes in three dimensions. This tool enabled Lyon to carve much larger blocks. Later that year, he was able to retrofit the router assembly with ink pens, making a giant drawing machine.

Lyon begins with bitmapped digital photographic files. But bitmapped images can suffer a loss of resolution when scaled, so he converts the bitmap files to vector files, which can be scaled to any size without affecting quality. As he does with his woodcuts, Lyon uses the vector data to generate instructions to move the ShopBot router bit along the X, Y, and Z axes for each drawn line. The enormous drawings produced in this manner comprise many layers of intricate marks and require substantial amounts of programming and drawing

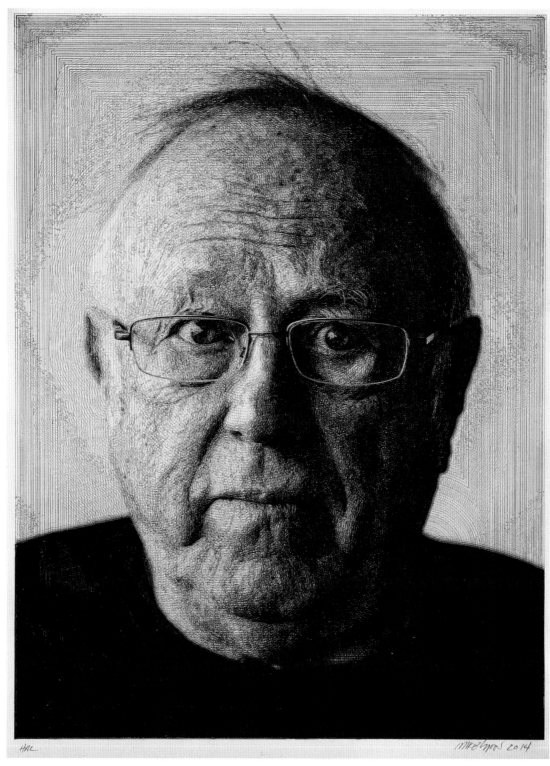

HAL

Mike Lyon, *Hal*, 2014, drawing in five colors on paper,
30 x 22 inches (76.2 x 55.9 cm). Courtesy of the artist.

time. For example, Lyon's portrait *Jon*, right, required more than 12 million lines of code and took more than 240 hours to draw. A detail of the drawing, opposite, shows the complexity of the line patterns. Commercial printmaking historically evolved to produce prints more and more rapidly and efficiently, but Lyon's processes are the antithesis of commercial efficiency, since the pen is moved over the paper at about the same speed as if he were drawing by hand. In addition, because a drawing is accomplished in multiple layers, the same area of the paper may be drawn again and again: When a 32-layer drawing in black ink is completed, the blackest areas will have been over-drawn 32 times while the lightest areas will have been drawn only once. The overall drawing process is therefore even slower than drawing by hand, but more rewarding to Lyon. For him, inventing diverse programs to produce an image is a big part of the creative process.

For a number of years, portraiture has been Lyon's main subject. In an April 2013 article in the *Kansas City Star*, writer Dana Self commented on a show of Lyon's work at Sherry Leedy Contemporary Art:

Mike Lyon, *Jon*, 2006, ink on paper, 75 x 45 inches (190.5 x 114.3 cm), permanent collection of Daum Museum of Contemporary Art. Photo courtesy of the artist.

Portraiture identifies us civically on passports and driver's licenses, and emotionally through photographs by friends and family. Mike Lyon's monumental pen-and-ink portrait drawings are feats of technical know-how and expressiveness. While it is easy to get lost in the technical details of how he computerizes the image and automates the pen, more important is how Lyon marries individualized physicality with dynamic interior identity. In one sense the portraits are simple and elemental, yet paradoxically, that straightforwardness and their enormity sensationalize them, in the best possible way, by focusing on something singular about each sitter. Many have quirky expressions or seem caught in a conversational moment. While honorific portraiture diminishes emotional content for ide-

alized perfection, Lyon's portraits are emotive and specific, as he emphasizes the aesthetic characteristics he finds most interesting, such as wavy hair, or an expressive mouth. The question of how to organize the visual and conceptual data that accrete as a portrait of a person is fundamental to Lyon's work. While he answers the query technologically, he also answers it psychically. Each portrait coalesces identity into an ambitious exchange between sitter, artist and viewer.

Lyon has produced several of his drawings in editions. One was commissioned by the Marianna Kistler Beach Museum of Art, at Kansas State University, for a 2009 exhibition. This work, called *Jessica Paper Doll*, is particularly interesting because it falls outside familiar classifica-

Mike Lyon, detail of *Jon*. Courtesy of the artist.

tions: On a single sheet of paper, approximately 5 feet wide by 12 feet long, a CNC machine drew repeated images in red, blue, and black ink. After this grid of forty identical drawings depicting a woman and various articles of clothing was completed, Lyon tore it into 40 "prints," each measuring 10 by 15 inches. Although this work does not fit neatly into any box, it has characteristics both of an original drawing and of a print. It might be said that before the sheet was torn apart, it was a pen-and-ink drawing, but that after the sheet was torn into pieces, it became a multiple—that is, an edition of prints. (Actually, the Beach Museum commissioned an edition of thirty prints, so after the drawings were complete and torn apart, Lyon assembled and numbered an edition of thirty, keeping several outstanding examples and several more flawed examples as artist's proofs.)

This *Jessica Paper Doll* project took three full months and an enormous amount of work. To begin with, Lyon asked his model to bring a lot of clothing changes to his studio, and he took hundreds of photos of her standing in the same pose wearing different outfits. The artist then used Photoshop to edit several images, choosing clothing and accessories, and experimented with ways of arranging the model and the various garments. The photos on the following page document the rest of his process.

Drawing with the CNC Router

1 When Lyon had programmed the CNC router and was ready to draw, he mounted the paper—a sheet of 300-pound, hot-pressed Lanaquarelle measuring 54 by 140 inches and nearly one-eighth of an inch thick—on the bed of the CNC machine. For drawing, he used Pigma Micron 005 refill cartridges of just the right diameter to fit into a quarter-inch pneumatic quick-coupler, which was epoxied onto a solenoid core with some added weights. The photo is a close-up image of the weighted jig with solenoid and pneumatic coupling, which allowed the cartridges to be easily changed.

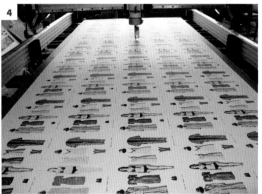

2 This photo shows the CNC router drawing the red color for *Jessica Paper Doll*. The cartridges were changed numerous times as they ran dry or clogged up. More than a dozen were required for each color.

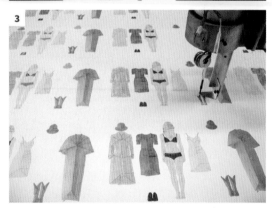

3 Next, blue ink was drawn over the completed red drawings.

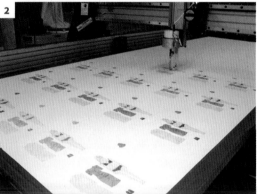

4 Then the black ink was drawn over the red and blue. The title and signature were also drawn at this stage. After the grid of three-color drawings was completed, Lyon tore the sheet into the forty drawings constituting the numbered, signed edition. One of these is shown opposite.

All photos in this series courtesy of Mike Lyon.

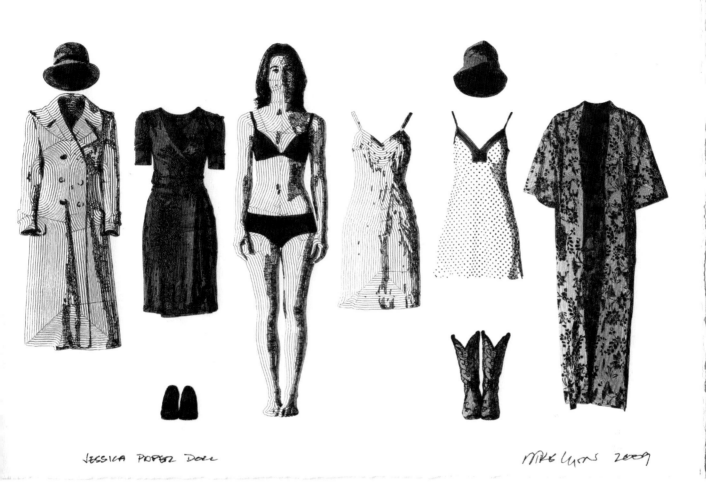

Mike Lyon, *Jessica Paper Doll*, 2009, three-color ink drawing
on paper, edition of 30, each 10 x 15 inches (25.4 x 38.1 cm).
Courtesy of the artist.

Mike Lyon

mlyon.com

"The rhythm and movement of these miles and miles of meandering ink trails are chant-like—long sutra recitations which reverberate and conjure something familiar."

When asked what draws him to the figure, Lyon responds that it is quite natural for all of us, that we are just wired that way: As infants, nursing at our mother's breast and gazing up at her face, we immediately become attuned to the subtlest nuance of posture and expression and quickly learn how to get what we need—attention, affection, warmth, sustenance, admiration, a wipe. He says that we cannot survive alone and are less likely to survive our first few years if we are insensitive. As adults, Lyon feels that almost all of us remain extremely sensitive to the moods of those around us; we know right away when someone is angry, hurt, embarrassed, happy, or available.

Our antennae are always unconsciously quivering.

Faces particularly hold his interest, especially when there is a certain ambiguity of expression, which echoes in his mind as he automatically tries to sense whether the person is angry, interested, anxious, dismissive, dangerous, appealing, or . . . what? When seeing a person, the face—a window to the soul—is the first place he looks, in total fascination.

In his woodblock printing and machine-assisted drawing and painting, Lyon works from photographs he takes. The most important selection criterion is simple: The image has to "cry out" to be art.

Lyon describes one sensation he has while drawing: "The rhythm and movement of these miles and miles of meandering ink trails are chant-like—long sutra recitations which reverberate and conjure something familiar, something that is the sum of all the lines, something 'simple' that is easy to understand all at once."

Mike Lyon, *Dinh*, 2013, five-color ink drawing on paper, 30 x 22 inches (76.2 x 55.9 cm). Courtesy of the artist.

Following pages: Mike Lyon, detail of *Dinh*. Courtesy of the artist.

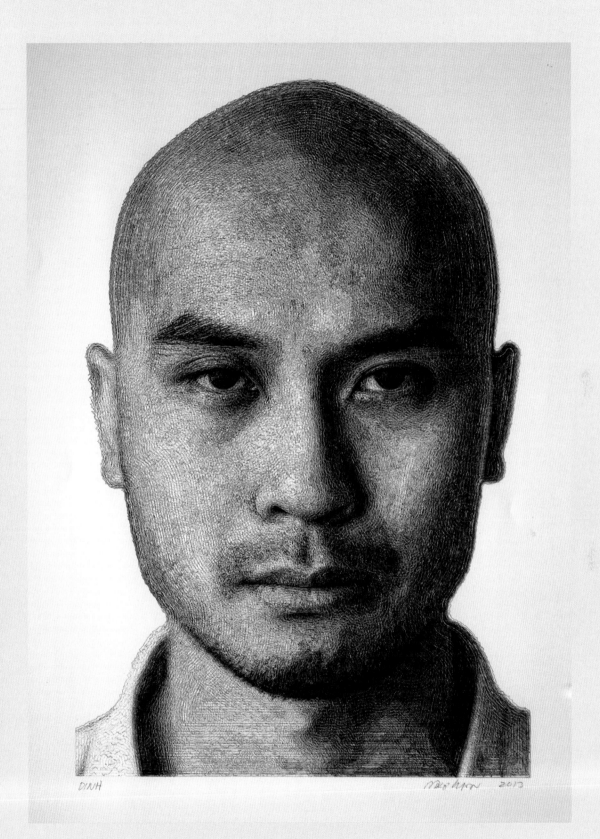

DINH

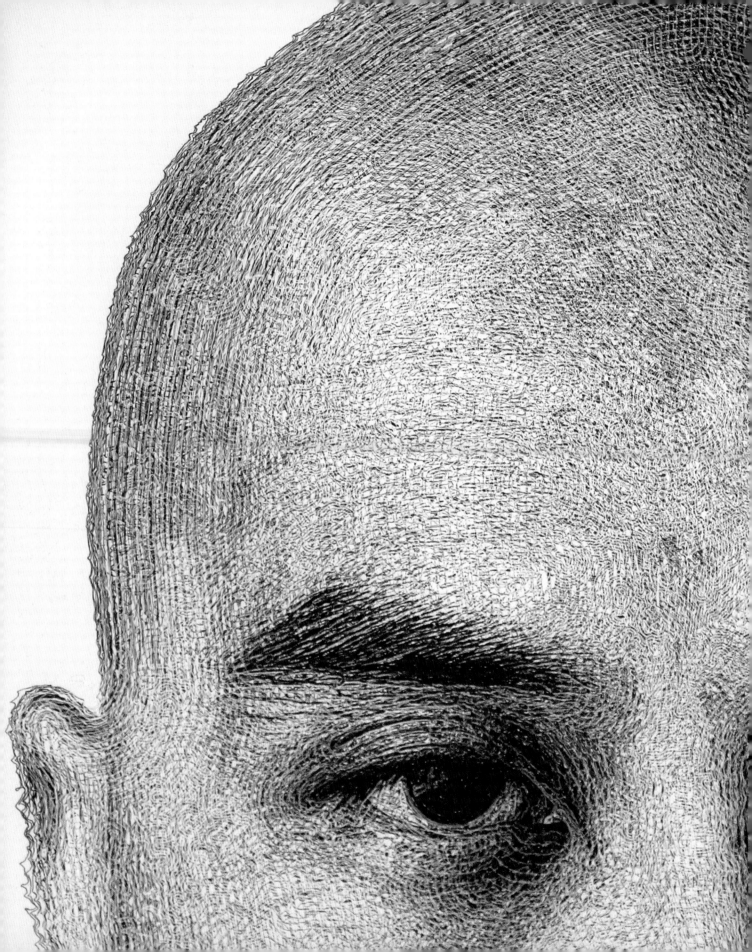

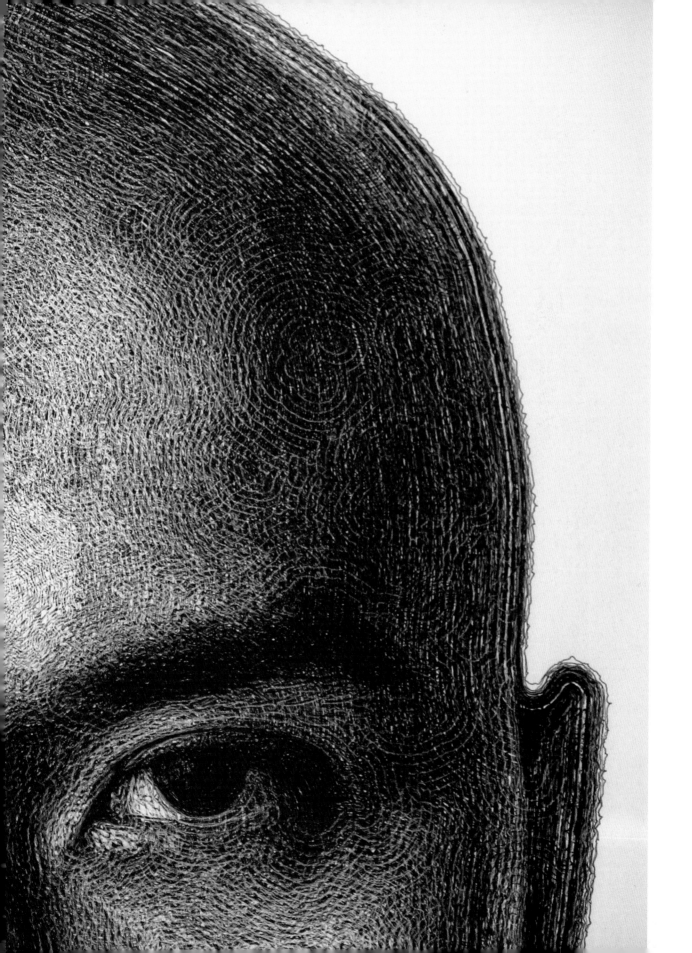

RESOURCES

Print Studios, Publishers, and Galleries

Center for Contemporary Printmaking
(Norwalk, CT)
contemprints.org

Cirrus Editions (Los Angeles, CA)
cirrusgallery.com

ConeEditions Press (East Topsham, VT)
cone-editions.com/contact.html

Constellation Studios (Lincoln, NE)
constellation-studios.net

Graphicstudio (University of South Florida,
Tampa, FL)
graphicstudio.usf.edu/gs/gs_about.html

International Print Center New York
(New York, NY)
ipcny.org

Landfall Press (Santa Fe, NM)
landfallpress.com

Lower East Side Printshop (New York, NY)
printshop.org/web/

Marlborough Graphics (New York, NY)
marlboroughgallery.com/galleries/graphics

Mojo Portfolio (Union City, NJ)
mojoportfolio.com

Nash Editions (Torrance, CA)
nasheditions.com

The Old Print Gallery (Washington, DC)
oldprintgallery.com

The Old Print Shop (New York, NY)
oldprintshop.com

Pace Prints (New York, NY)
paceprints.com

Peter Blum Editions (New York, NY)
peterblumgallery.com/editions

Ribuoli Digital (New York, NY)
ribuolidigital.com

Robert Blackburn Printmaking Workshop
Program/Elizabeth Foundation
for the Arts (New York, NY)
rbpmw-efanyc.org

Solo Impression, Inc. (Bronx, NY)
soloimpression.com

Two Palms (New York, NY)
twopalms.us

Women's Studio Workshop (Rosendale, NY)
wsworkshop.org

Web Resources for Japanese-Style Printing

Japanese Woodblock Prints of Jacques
J.F. Commandeur
jacquesc.home.xs4all.nl

McClain's Printmaking Supplies
imcclains.com

Printmaking Equipment and Supplies

GENERAL

Dick Blick Art Materials
dickblick.com

New York Central Art Supply
nycentralart.com

Renaissance Graphic Arts, Inc.
printmaking-materials.com

Takach Press Corporation
shop.takachpress.com

Talas
talasonline.com

PRINTING PRESSES

Charles Brand Presses
charlesbrandpresses.com

Conrad Machine Co.
conradmachine.com

Takach Press Corporation
takachpress.com

LIGHT EXPOSURE SYSTEMS

Fabcon: Olec Brand Imaging Systems
fabcon.com

COPPER AND ZINC PLATES

CG Metals
cgmetals.com

PRINTING INKS

Gamblin
gamblincolors.com

Graphic Chemical & Ink Co.
graphicchemical.com

Hanco Ink
hancoink.com

Superior Printing Inks
superiorink.com

PIGMENTS AND BINDERS

Guerra Paint & Pigment
guerrapaint.com

ACRYLIC MEDIUMS AND PAINTS

Golden Artist Colors, Inc.
goldenpaints.com

DIGITAL GRAPHICS SUPPLIES

DASS ART
dassart.com

Digital Art Supplies
digitalartsupplies.com

FUJIFILM PLATES, P&Z POSI-BLUE PLATES, TORAY WATERLESS PLATES, AND COMMERCIAL LITHOGRAPHIC SUPPLIES

Metzger Inc., H.A.
myprintresource.com/company/10006653/
metzger-inc-ha

Renaissance Graphic Arts
printmaking-materials.com

PHOTOGRAVURE POLYMER PLATES

Boxcar Press
boxcarpress.com

Solarplate Etching
solarplate.com

POLYMER PHOTO-ETCHING FILM AND SODA ASH DEVELOPER

Capefear Press
capefearpress.com

PRECOATS AND PIGMENT TRANSFER FILM

InkAID
inkaid.com

PRESS-N-PEEL FILM

Techniks
techniks.com

TORAY WATERLESS PLATES AND DEVELOPER

Griso Print Solutions
griso-chemie.com

TRANSFER PAPERS

Lazertran
www.lazertran.com

Z*ACRYL

Takach Press: Z*Acryl Etching System
takachpress.com/access/zacryl.htm

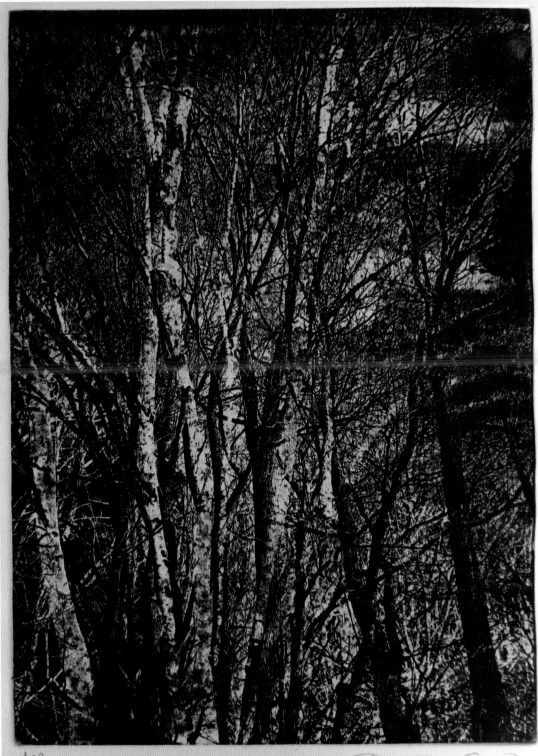

A/P

FOR FURTHER READING

Paul Catanese and Angela Geary. *Post-Digital Printmaking: CNC, Traditional and Hybrid Techniques.* London: A&C Black, 2012.

Marjorie Devon. *Tamarind Techniques for Fine Art Lithography.* New York: Harry N. Abrams, 2009.

Ann d'Arcy Hughes and Hebe Vernon-Morris. *The Printmaking Bible: The Complete Guide to Materials and Techniques.* San Francisco: Chronicle Books, 2008.

William M. Ivins Jr. *Prints and Visual Communication.* Cambridge, Mass.: MIT Press, 1969.

George F. Roberts. *Polyester Plate Lithography.* Boise, Idaho: Writers Press, 2001.

John Ross, Clare Romano, and Tim Ross. *The Complete Printmaker: Techniques, Traditions, Innovations.* New York: The Free Press, 1991.

Deli Sacilotto. *Photographic Printmaking Techniques.* New York: Watson-Guptill, 1982.

Donald Saff and Deli Sacilotto. *Printmaking: History and Process.* New York: Holt, Rinehart and Winston, 1978.

Brian Shure. *Magical Secrets about Chine Collé: Pasting, Printing, Mounting, and Leafing Step-By-Step.* San Francisco: Crown Point Press, 2009.

Dan Weldon and Pauline Muir. *Printmaking in the Sun.* New York: Watson-Guptill, 2001.

George Whale and Naren Barfield. *Digital Printmaking.* New York: Watson-Guptill, 2003.

Emily York. *Magical Secrets about Aquatint: Spit Bite, Sugar Lift & Other Etched Tones Step-by-Step.* San Francisco: Crown Point Press, 2008.

Sylvie Covey, *Birches*, 2015, toner transfer photo-etching, 10 x 16 inches (25.4 x 40.6 cm).

ABOUT THE AUTHOR

Sylvie Covey was born in France and studied graphic arts at the École Natio-
nale Supérieure des Arts Décoratifs in Paris. She left France in 1976 and, while
traveling around the world, studied art in Indonesia and Japan. Eventually, she
immigrated to the United States, where she earned a BA from SUNY Empire
State College in 1993 and an MFA from Hunter College, CUNY, in 1996.

In 1980, Covey established her printmaking studio in Midtown Manhattan,
where she continues to pursue work in all print mediums, currently concentrat-
ing on digital and photographic printmaking techniques. She teaches printmak-
ing and Photoshop at the Fashion Institute of Technology, the Art Students
League of New York, and the Art Center of Northern New Jersey.

She has exhibited in numerous galleries and museums in the United States,
Europe, South America, and Asia. Her work appears in numerous collections,
including those of the Metropolitan Museum of Art, the New-York Historical
Society, the New York Public Library prints collection, the Museum of the City
of New York, and the National Museum of Kraków, Poland, as well as several
corporate collections.

Covey is the author of *Photoshop for Artists: A Complete Guide for Fine Artists,
Photographers, and Printmakers* (2012), also published by Watson-Guptill.

INDEX

Published in the United States by Watson-Guptill Publications, an imprint of the
Crown Publishing Group, a division of Penguin Random House LLC, New York.
www.crownpublishing.com
www.watsonguptill.com

WATSON-GUPTILL and the WG and Horse designs are registered trademarks
of Penguin Random House LLC

Library of Congress Cataloging-in-Publication Data
Covey, Sylvie.
Modern printmaking : a guide to traditional and digital techniques / Sylvie Covey.
—First Edition.
 pages cm
1. Prints—Technique. I. Title.
NE850.C68 2016
769'.1—dc23

 2015015473

Hardcover ISBN: 978-1-60774-759-8
eBook ISBN: 978-1-60774-760-4

Printed in China

FRONT COVER IMAGE DETAILS, FROM TOP TO BOTTOM:
Vincent Longo, *B&W Overlap*, 2008, woodcut, 25 x 36 inches; Karen Kunc, *Graphite
drawing from Along an Even Horizon*, 2013, woodcut, 14 x 50 inches; Sylvie Covey,
The Inner World, 1979, viscosity etching on zinc, 18 x 36 inches.

BACK COVER IMAGE DETAIL:
Svetlana Rabey, Untitled, 2013, three-plate spit bite etching aquatint, 24 x 36 inches.

Design by Kara Plikaitis

10 9 8 7 6 5 4 3 2